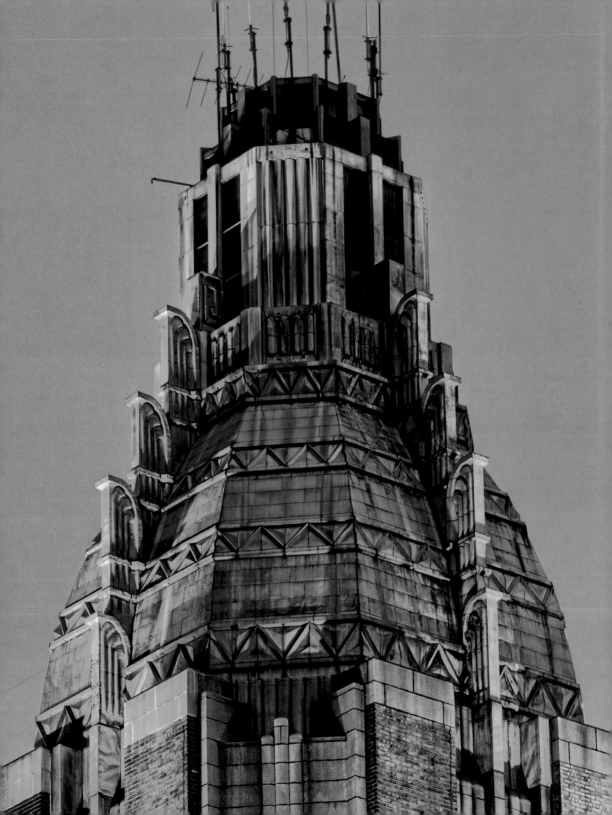

Reuel Golden

New York

TASCHEN

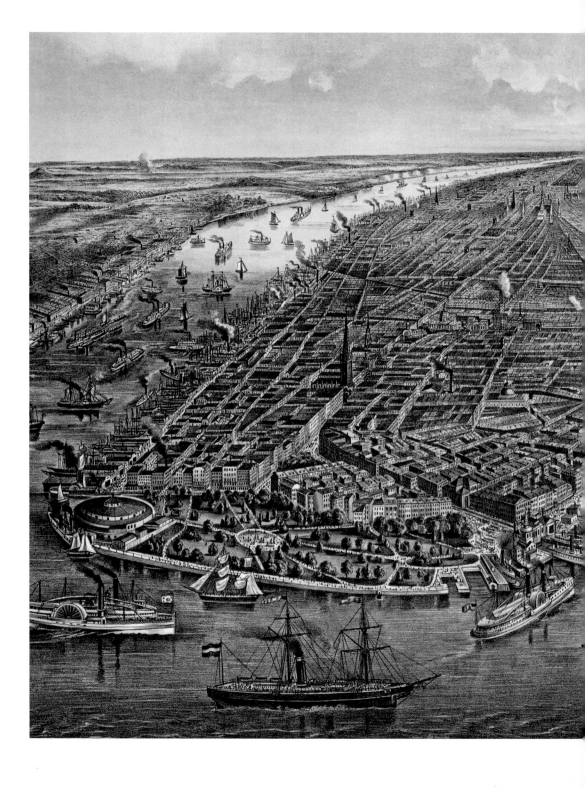

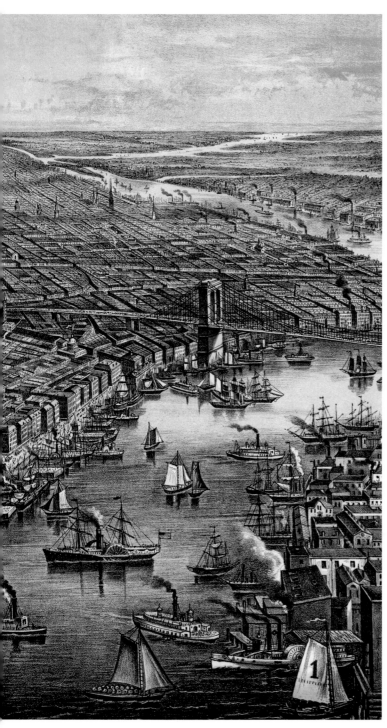

ALFRED STIEGLITZ (1864)
"J.D." JEROME DAVID SALINGER (1919)
"GRANDMASTER FLASH"
JOSEPH SADDLER (1958)

Anonymous

An artist's rendition of New York, which at the time consisted of just the island of Manhattan, nestling between the Hudson River (on the left) and the East River (on the right). The illustration perfectly conveys the beauty of New York's natural harbor, 1856.

Eine künstlerische Darstellung von New York, das zu dieser Zeit nur aus der Insel Manhattan zwischen dem Hudson River (links) und dem East River (rechts) bestand. Die Illustration bringt die Schönheit des New Yorker Naturhafens zum Vorschein, 1856.

Vue d'artiste de la ville de New York qui, à l'époque, ne comprenait que l'île de Manhattan, entre l'Hudson (à gauche) et l'East River (à droite). L'illustration traduit à la perfection la beauté du port naturel de New York, 1856.

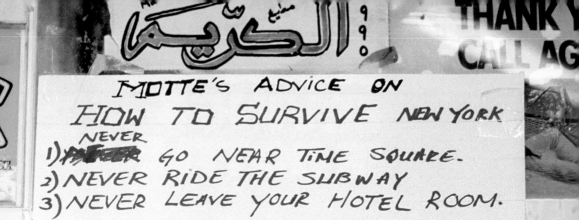

MOTTE'S ADVICE ON
HOW TO SURVIVE NEW YORK

1) ~~AFTER~~ NEVER GO NEAR TIME SQUARE.
2) NEVER RIDE THE SUBWAY
3) NEVER LEAVE YOUR HOTEL ROOM.
4) NEVER TALK TO STRANGERS.
5) NEVER LOAD YOUR GUN WITH BLANKS
6) NEVER USE A PUBLIC BATHROOM.
7) NEVER CARRY ANY $ OR A WALLET WITH CREDIT CARDS.
8) NEVER STOP AND STARE ~~UPWARD~~ UPWARD AT THE EMPIRE STATE BLDG.
 " A SURE SIGN OF A TOURIST "
9) NEVER WEAR GOLD, DIAMONDS OR A ROLEX WATCH.
10) NEVER HOLD A MAP IN YOUR HAND.
11) NEVER MAKE EYE CONTACT.
12) NEVER FORGET THAT NY is A

WONDERFUL CITY AND YOU'RE
HAVING A GREAT TIME.

ISAAC ASIMOV (1920)
ROBERT SMITHSON (1938)
CUBA GOODING, JR. (1968)

"Other cities always make me mad
Other places always make me sad
No other city ever made me glad
Except New York."

"I LOVE NEW YORK," MADONNA, 2005

Janette Beckman

Motte's advice on "How to Survive in New York City." Taken on Avenue C in the East Village, which was then known as Alphabet City, 1986.

Motte's Advice – „Tipps zum Überleben in New York City." Das Foto entstand auf der Avenue C im East Village, damals noch Alphabet City genannt, 1986.

Les conseils de Motte sur «Comment survivre à New York.» Photo prise Avenue C dans l'East Village, un quartier que l'on appelait jadis Alphabet City, 1986.

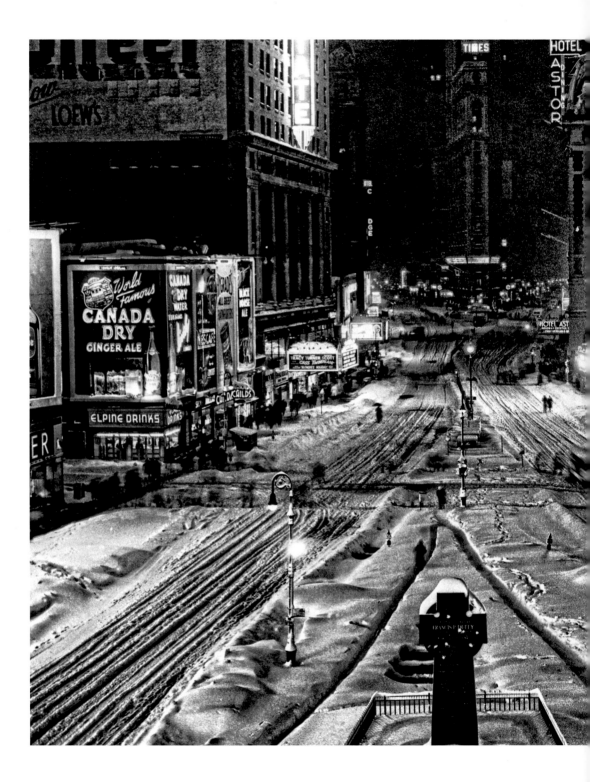

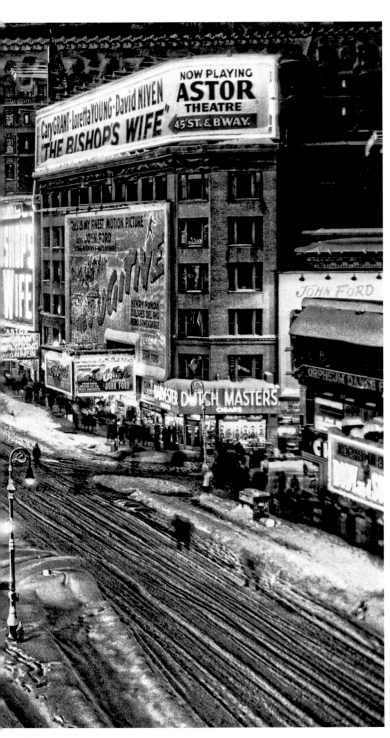

Herb Scharfman

Times Square coated in white,
bereft of traffic, 1947.

Times Square im Schnee und
ohne Autos, 1947.

Times Square enneigé, vidé
de ses voitures, 1947.

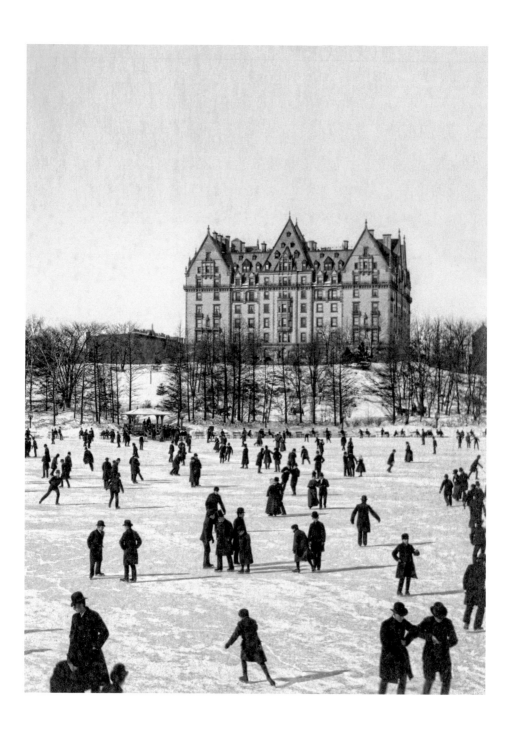

"The Park is laid out to meet the convenience of all classes of the people; and, indeed, it affords something to gratify each individual taste."

THE NEW YORK TIMES, 1863

John S. Johnston

Ice skating in Central Park. This wintery scene looks like something out of a Brueghel painting. The opulent apartment building in the background is the famous Dakota (later the residence of John Lennon), on 72nd Street, 1890.

Eislaufen im Central Park. Die winterliche Szene sieht aus wie ein Gemälde von Brueghel. Das luxuriöse Apartmentgebäude im Hintergrund ist das berühmte Dakota Building (der spätere Wohnsitz von John Lennon) an der 72nd Street, 1890.

Patinage à Central Park. Cette scène d'hiver fait penser à une peinture de Brueghel. Le luxueux immeuble d'appartements au second plan est le fameux Dakota (par la suite la résidence de John Lennon), sur la 72e Rue, 1890.

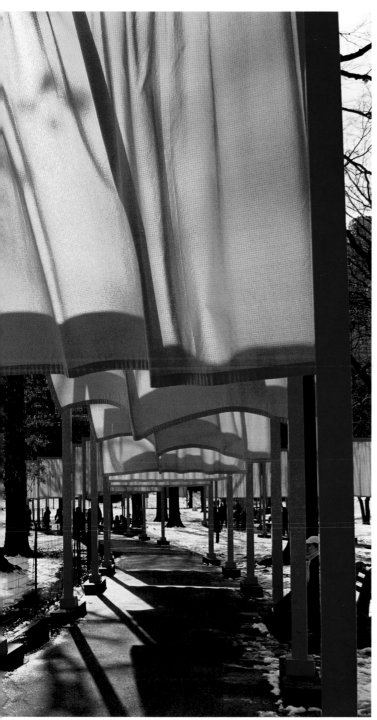

Wolfgang Volz

The Gates, Central Park. The installation created by the artists Christo and Jeanne-Claude consisted of 7,503 gates placed along 37 kilometers of footpaths in Central Park. At the top of each gate, a saffron-colored, free-flowing fabric was suspended. The art installation was up for two weeks in February, 2005.

The Gates, Central Park. Die von den Künstlern Christo und Jeanne-Claude geschaffene Installation bestand aus 7503 Toren, die auf einer Länge von 37 Kilometern auf Fußwegen im Central Park aufgestellt wurden. Von jedem Tor hing eine safrangelbe flatternde Stoffbahn herab. Die Installation konnte im Februar 2005 zwei Wochen lang besichtigt werden.

The Gates, Central Park. Cette installation des artistes Christo et Jeanne-Claude se composait de 7503 portes installées le long de plus de 37 kilomètres d'allées de Central Park. Au sommet de chaque porte était suspendu un panneau de toile couleur safran sensible au vent. L'installation a duré deux semaines en février 2005.

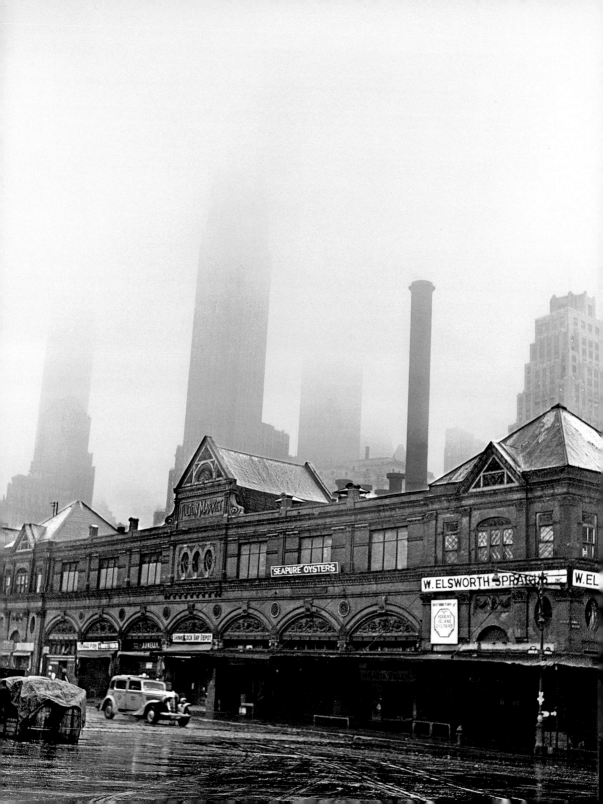

"New York, you are an Egypt! But an Egypt turned inside out. For she erected pyramids of slavery to death, and you erect pyramids of democracy with the vertical organ-pipes of our skyscrapers all meeting at the point of infinity of liberty!"

THE SECRET LIFE OF SALVADOR DALÍ, SALVADOR DALÍ, 1948

Gordon Parks

The Fulton Fish Market. Despite its name, the market on South Street, near the East River, occupied the same location from 1822 until 2005, when it relocated to Hunts Point, in the Bronx. The need for more modern amenities and the soaring values of Manhattan real estate instigated the move, 1942.

Der Fulton Fischmarkt. Der Markt, der sich ab 1822 in der South Street in der Nähe des East River befunden hatte, wurde 2005 nach Hunts Point in der Bronx verlegt; den Anstoß für diesen Umzug gaben die Notwendigkeit einer moderneren Ausstattung und die steigenden Immobilienpreise in New York, 1942.

Le Fulton Fish Market. Malgré son nom, ce marché aux poissons de South Street, près de l'East River, occupa le même endroit de 1822 à 2005, lorsqu'il fut transféré à Hunts Point dans le Bronx, sous la pression des prix de l'immobilier à Manhattan et la nécessité de disposer d'installations plus modernes, 1942.

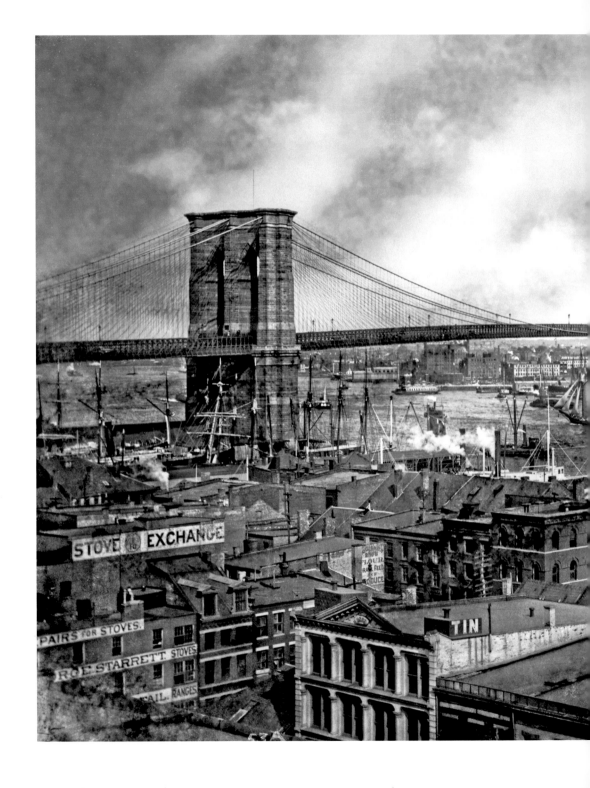

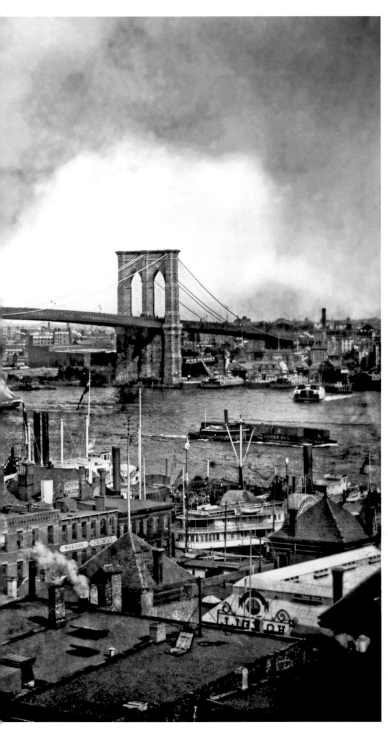

Anonymous

Brooklyn Bridge. One of the great engineering marvels of the Industrial Age, the Brooklyn Bridge opened in 1883. The photograph also shows the bustling port on the tip of Manhattan, 1890.

Brooklyn Bridge. Die Brooklyn Bridge gehört zu den technischen Wunderwerken des Industriezeitalters und wurde 1883 eröffnet. Das Foto zeigt auch das lebhafte Treiben im Hafen an der Südspitze von Manhattan, 1890.

Pont de Brooklyn. Ce pont appartient à l'histoire des exploits de l'ère industrielle. Il ouvrit en 1883. La photographie montre également l'activité du port à la pointe de Manhattan, 1890.

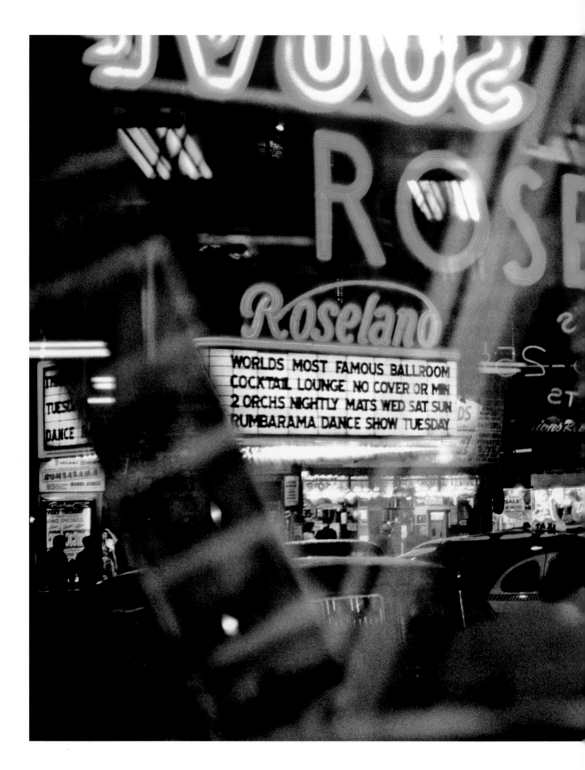

CAROLINA HERRERA (1939)

Marvin Newman

The Roseland Ballroom was on Broadway and 51st Street, and during its glory years people such as Louis Armstrong and Glenn Miller performed there. It was torn down in 1956, and moved to its current location, a block north, on 52nd Street, 1954.

Der Roseland Ballroom befand sich am Broadway und an der 51st Street, und während seiner glanzvollen Jahre traten dort Künstler wie Louis Armstrong und Glenn Miller auf. Er wurde 1956 abgerissen und an seinen jetzigen Ort, einen Block weiter nach Norden in die 52nd Street, verlegt, 1954.

Le Roseland Ballroom se trouvait sur Broadway et la 51e Rue. Pendant ses années de gloire, des musiciens comme Louis Armstrong et Glenn Miller y jouèrent. Il fut démoli en 1956 et déménagea à son adresse actuelle, un bloc plus loin, sur la 52e Rue, 1954.

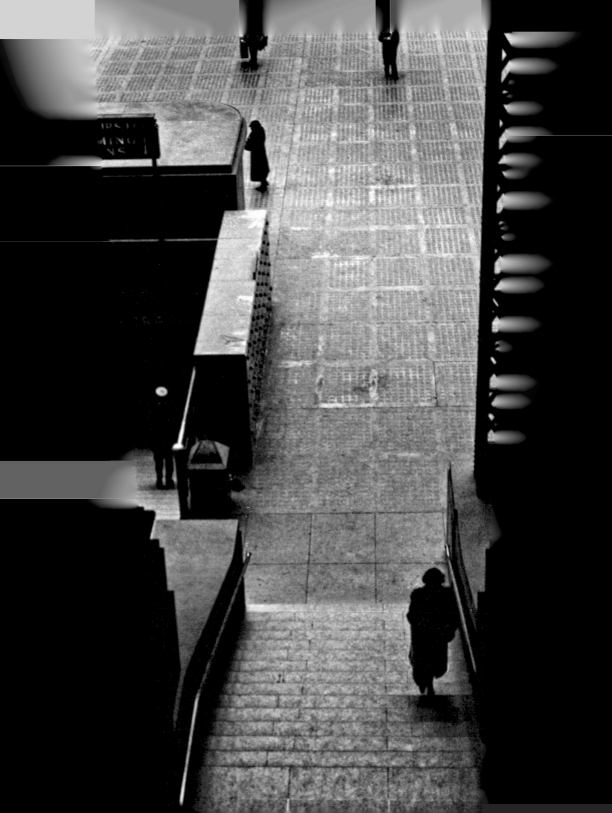

"There are eight million stories in the naked city."

NAKED CITY, 1948

Larry Silver

This is taken at Pennsylvania Station, in Midtown Manhattan between Seventh and Eighth Avenues, just south of 34th Street. The old Penn Station was demolished in 1963, and its destruction outraged even hardened New Yorkers, leading to the creation of the Landmarks Preservation Act, 1951.

Dieses Foto entstand an der Pennsylvania Station in Midtown Manhattan zwischen der Seventh und Eighth Avenue etwas südlich der 34th Street. Der Abriss der alten Penn Station im Jahr 1963 erzürnte selbst hartgesottene New Yorker und führte zur Verabschiedung des Denkmalschutzgesetzes, 1951.

Vue prise à Pennsylvania Station dans Midtown entre la Septième et la Huitième Avenue, juste au sud de la 34e Rue. La vieille gare, Penn Station, fut démolie en 1963 et sa destruction, qui scandalisa même les plus endurcis des New-Yorkais, conduisit au vote d'un texte législatif de protection, le «Landmarks Preservation Act», 1951.

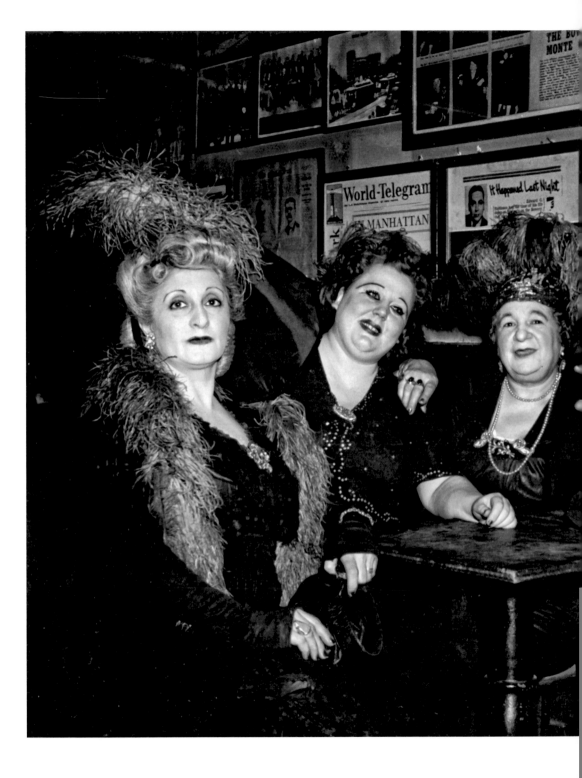

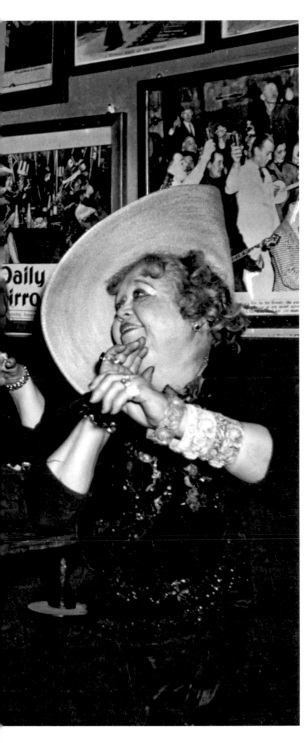

Erika Stone

It's ladies' night at Sammy's bar on the Bowery, 1946.

Ladies' Night in Sammy's Bar auf der Bowery, 1946.

Soirée de dames au Sammy's bar sur le Bowery, 1946.

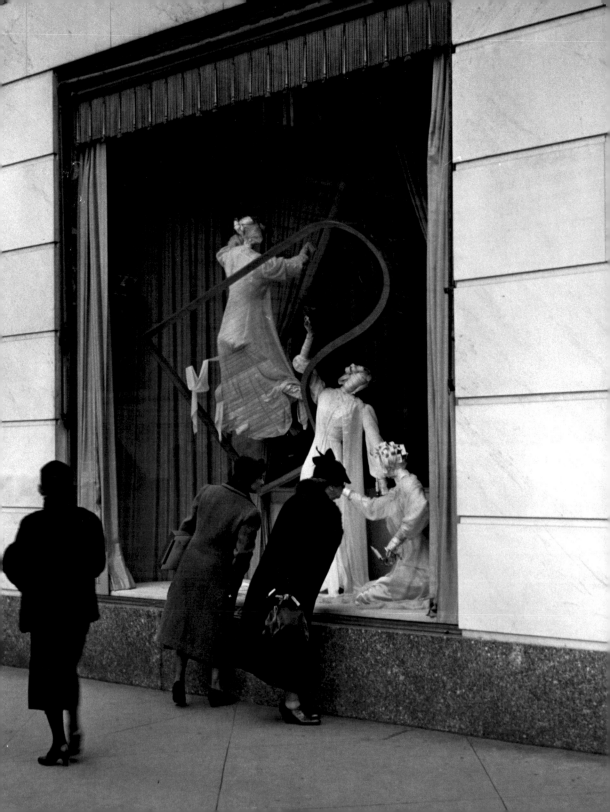

"Your chick shop in the mall
My chick burnin' down Bergdorf's
Comin' back with Birken Bags"

"30 SOMETHING," JAY Z, 2007

Russell Lee

A surreal window display at the luxury department store Bergdorf Goodman attracts curious onlookers, 1938.

Die surreale Schaufenstergestaltung des Luxuskaufhauses Bergdorf Goodman zieht die Aufmerksamkeit von Passanten auf sich, 1938.

Le décor onirique d'une vitrine du grand magasin de luxe Bergdorf Goodman pique la curiosité des badauds, 1938.

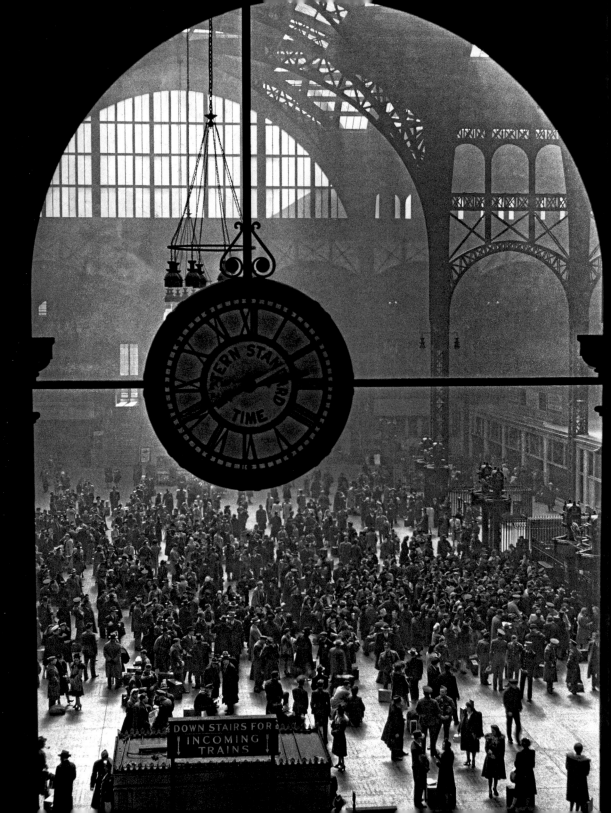

DOWN STAIRS FOR
INCOMING
TRAINS

HOWARD STERN (1954)
"RAEKWON" COREY WOODS (1970)

"I think this city is full of people wanting inconceivable things."

MANHATTAN TRANSFER, JOHN DOS PASSOS, 1925

Alfred Eisenstaedt

Interior view of the waiting room and its iron-and-glass ceiling in the original Penn Station, 1943.

Innenansicht der Wartehalle der ursprünglichen Penn Station mit ihrer Decke aus Eisen und Glas, 1943.

Vue intérieure de la salle d'attente au plafond de fer et de verre de la «Penn Station» d'origine, 1943.

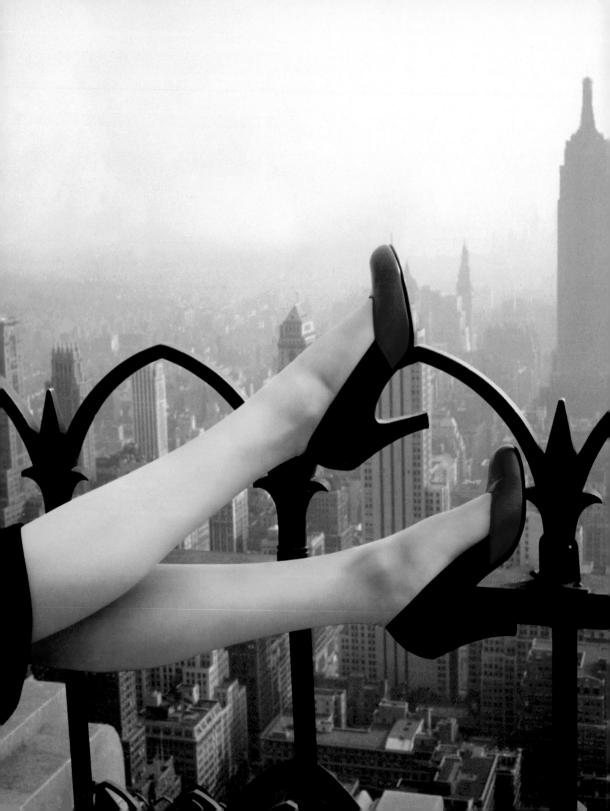

"... such clean beauty, such purity of line, such subtle uses of material, that we believe it will be studied by many generations of architects."

THE NEW YORKER, 1931

Edward Kasper

A fashion shoot for *Glamour* magazine that manages to capture the glory of Midtown and, in particular, the domineering presence of the Empire State Building, as well as these shapely shoes with equally impressive heels, 1950.

Ein Modefoto für *Glamour*, das die ganze Pracht von Midtown und insbesondere die überwältigende Präsenz des Empire State Building zeigt, sowie wohlgeformte Schuhe mit ebenso beeindruckend hohen Absätzen, 1950.

Photo de mode pour le magazine *Glamour* qui réussit à capter la splendeur de Midtown et, en particulier, la présence dominante de l'Empire State Building, aussi bien que cette paire de chaussures chics aux talons tout aussi impressionnants, 1950.

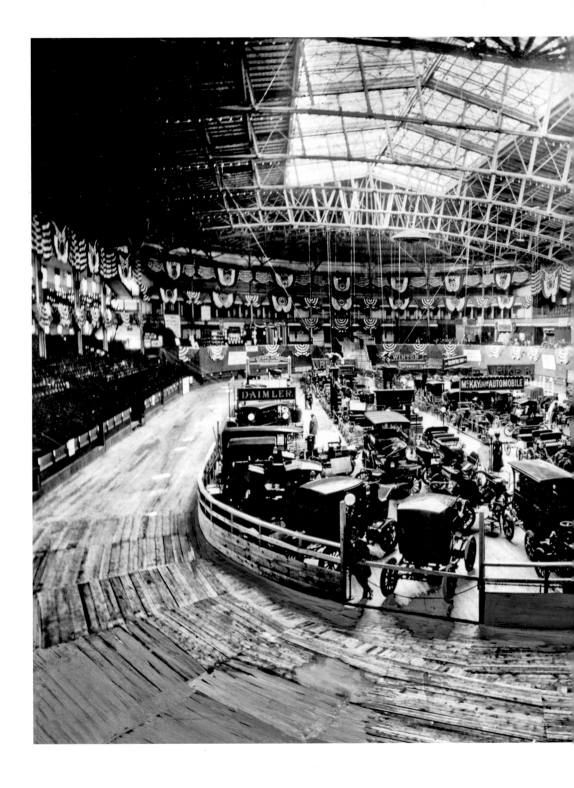

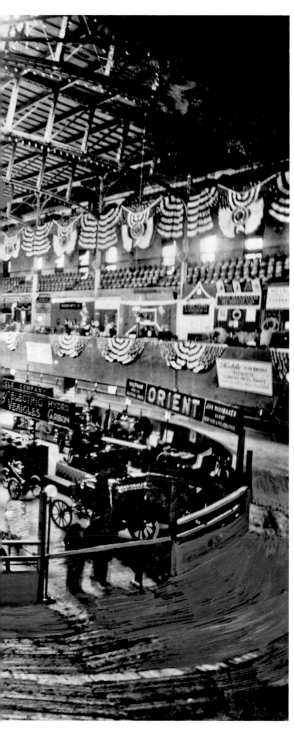

ANDY ROONEY (1919)
"LL COOL J" JAMES TODD SMITH (1968)

Anonymous

Automobile show in the city, Madison
Square Garden. For 50 cents ($12.50
by today's prices), the public could see
the latest models of what were dubbed
"horseless carriages." Sponsored by the
Automobile Club of America, it featured
66 exhibitors displaying more than 30
new cars, 1900.

Automobilausstellung in der Stadt,
Madison Square Garden. Für 50 Cent
(heute 12,50 Dollar) konnte sich das
Publikum die neuesten Modelle der
„pferdelosen Kutschen" ansehen. Auf
der vom amerikanischen Automobilclub
finanzierten Ausstellung präsentierten
66 Aussteller über 30 neue Autos, 1900.

Salon de l'automobile à Madison
Square Garden. Pour 50 cents (12,50
dollars actuels), le public pouvait venir
voir les derniers modèles de «voitures
sans chevaux». Soutenu par l'Auto-
mobile Club of America, il regroupait
soixante-six exposants présentant plus
de trente nouvelles voitures, 1900.

"To Europe, she was America. To America, she was the gateway of the earth. But to tell the story of New York would be to write a social history of the world."

THE WAR IN THE AIR, H. G. WELLS, 1908

Charles Gilbert Hine

The south side of Washington Square,
Greenwich Village, 1894.

Die Südseite von Washington Square,
Greenwich Village, 1894.

Côté sud de Washington Square,
Greenwich Village, 1894.

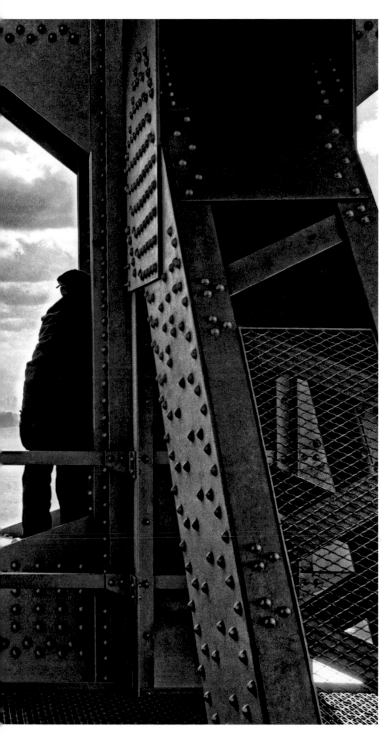

ETHEL MERMAN (1908)
AALIYAH (1979)

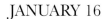

Anonymous

An alternative view of the
Manhattan skyline, 1937.

Blick auf die Skyline von Manhattan
von einem Schiff aus, 1937.

Vue du panorama de Manhattan
prise d'un bateau, 1937.

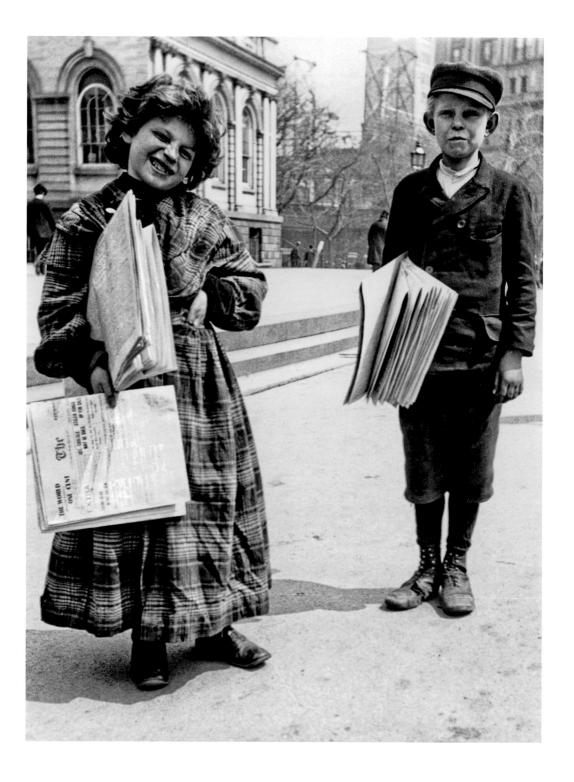

EARTHA KITT (1927)
ANDY KAUFMAN (1949)

"New York is too strenuous for me; it gets on my nerves."

AMBROSE BIERCE, 1904

Alice Austen

Children selling newspapers, c. 1896.

Kinder, die Zeitungen verkaufen, um 1896.

Enfants vendeurs de journaux, vers 1896.

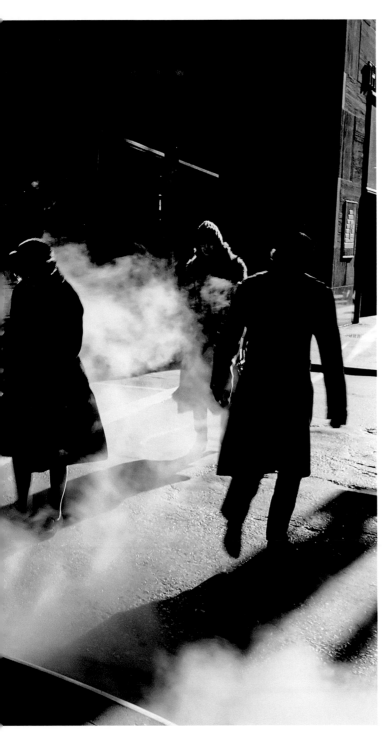

JOSEPH "JOE BANANAS" BONANNO (1905)
DANNY KAYE (1913)

Ernst Haas

Sixth Avenue. The steam, the cab, and the anonymous pedestrians casting their shadows evoke big-city alienation, 1980.

Sixth Avenue. Der Dampf, das Taxi und die anonymen Passanten mit ihren Schatten auf dem Bürgersteig rufen einen Eindruck von Entfremdung hervor, 1980.

Sixième Avenue. La vapeur, le taxi et l'ombre projetée des piétons anonymes évoquent l'aliénation de la grande ville, 1980.

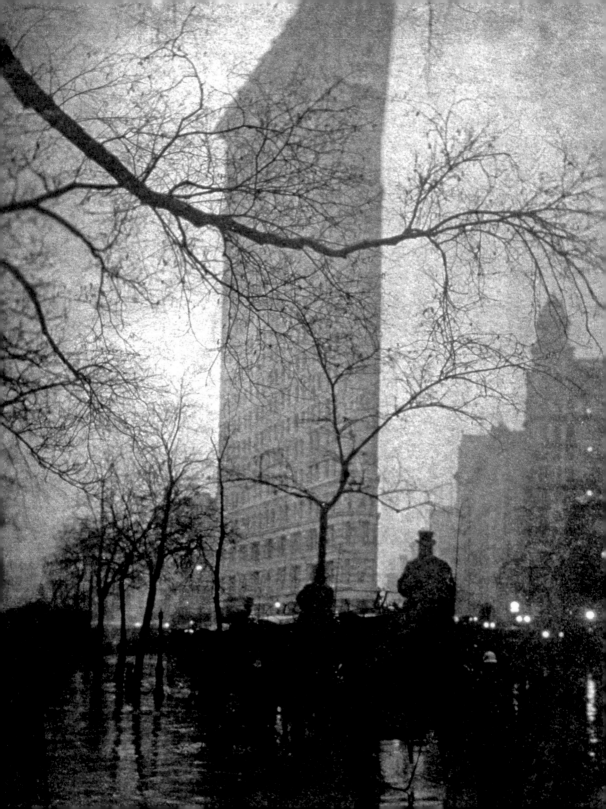

"The New York winter had presented an interminable perspective of snow-burdened days, reaching toward a spring of raw sunshine and furious air…"

HOUSE OF MIRTH, EDITH WHARTON, 1905

Edward Steichen

Flatiron Building. One of New York's landmark buildings, shot at twilight near Madison Square Park. Completed in 1902, the Flatiron Building was, at the time, one of the city's tallest structures. Its distinctive triangular shape sits on a block that separates Broadway and Fifth Avenue, 1904.

Flatiron Building. Eines der Wahrzeichen von New York, aufgenommen in der Dämmerung in der Nähe des Madison Square Park. Das Gebäude mit der ungewöhnlichen dreieckigen Form wurde 1902 fertiggestellt und gehörte zu dieser Zeit zu den höchsten Bauten der Stadt. Es steht an der Ecke zwischen Broadway und Fifth Avenue, 1904.

Flatiron Building. L'un des plus célèbres immeubles de New York, photographié au coucher de soleil près de Madison Square Park. Achevé en 1902, il était l'une des plus hautes constructions de Manhattan. Sa forme triangulaire si particulière s'explique par sa parcelle de terrain en pointe entre Broadway et la Cinquième Avenue, 1904.

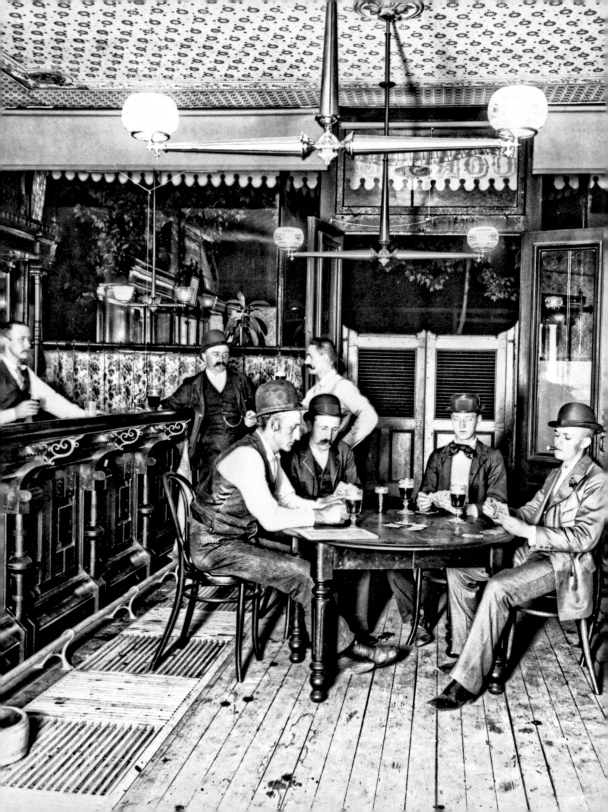

"...The drinking New Yorker, smug in his conceit of living in the metropolis... has slight conception of the true strength of the anti-liquor movement which has been sweeping through the nation of late years."

THE NEW YORK TIMES, 1914

T. H. McAllister

Card playing at a no-frills bar and these gentlemen look like regular patrons, 1898.

Beim Kartenspiel in der Eckkneipe, die Männer sehen wie Stammgäste aus, 1898.

Partie de cartes. Bar ordinaire, où les joueurs semblent être des habitués, 1898.

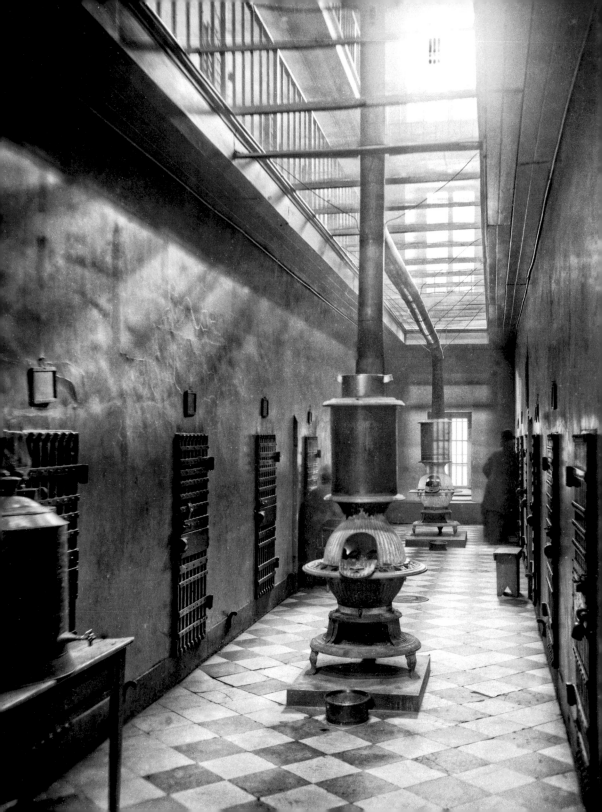

*"You can have as many
lives in New York as you
have money to pay for."*

THE DESTRUCTION OF GOTHAM, JOAQUIN MILLER, 1886

Jacob Riis

The Tombs, Murderers' Row. The interior
of New York's most notorious prison,
which occupied a whole block in Lower
Manhattan. Charles Dickens wrote,
after being given a guided tour: "What
is this dismal-fronted pile of bastard
Egyptian, like an enchanter's palace in
a melodrama? A famous prison, called
The Tombs," c. 1893.

The Tombs, Mördertrakt. Das Innere des
berühmtesten Gefängnisses von New
York, das sich über einen ganzen Block
in Lower Manhattan erstreckte. Charles
Dickens schrieb nach einer Führung:
„Was soll aber dieses Gebäude in ägyp-
tischem Bastardstil, mit der unheilvoll
aussehenden Fassade, das dem Palast
eines Zauberers in einem Melodram
gleicht? Ein berüchtigtes Gefängnis, The
Tombs (die Gräber) genannt", um 1893.

The Tombs, quartier des meurtriers.
L'intérieur de la plus célèbre prison de
New York qui occupait tout un bloc
du Lower Manhattan. Après en avoir
fait une visite guidée, Charles Dickens
écrivit : « Quel est ce lugubre monu-
ment de style bâtard égyptien, ce palais
d'un enchanteur de mélodrame ? Une
prison fameuse, appelée The Tombs
(les Tombes) », vers 1893.

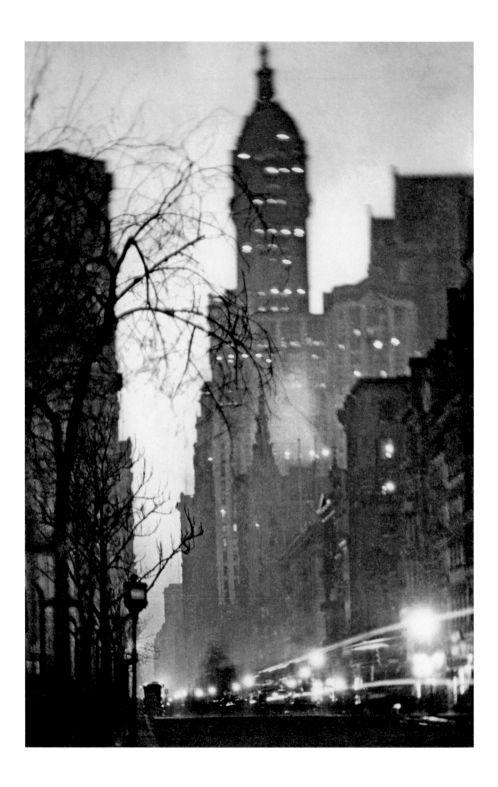

GEORGE BALANCHINE (1904)
PETER BEARD (1938)

"On its strictly social side, New-York life had always been attractive. Less provincialism existed here than at any other center in the colonies."

MEMORIAL HISTORY OF THE CITY OF NEW-YORK:
FROM ITS FIRST SETTLEMENT TO THE YEAR 1892, 1893

Alvin Langdon Coburn

The Singer Building. It was briefly the world's tallest building until it was surpassed by the Metropolitan Life Tower. Located at Broadway and Liberty Street, it was the headquarters of the eponymous sewing machine conglomerate, c. 1910.

Das Singer Building. Das Gebäude am Broadway und an der Liberty Street war für kurze Zeit das höchste der Welt, bis es vom Metropolitan Life Tower übertroffen wurde. Es war der Hauptsitz des Nähmaschinenimperiums, um 1910.

Le Singer Building. Il fut brièvement l'un des plus hauts immeubles du monde, avant d'être dépassé par la tour de la Metropolitan Life. Situé à l'angle de Broadway et de Liberty Street, il était le siège du conglomérat producteur de machines à coudre, vers 1910.

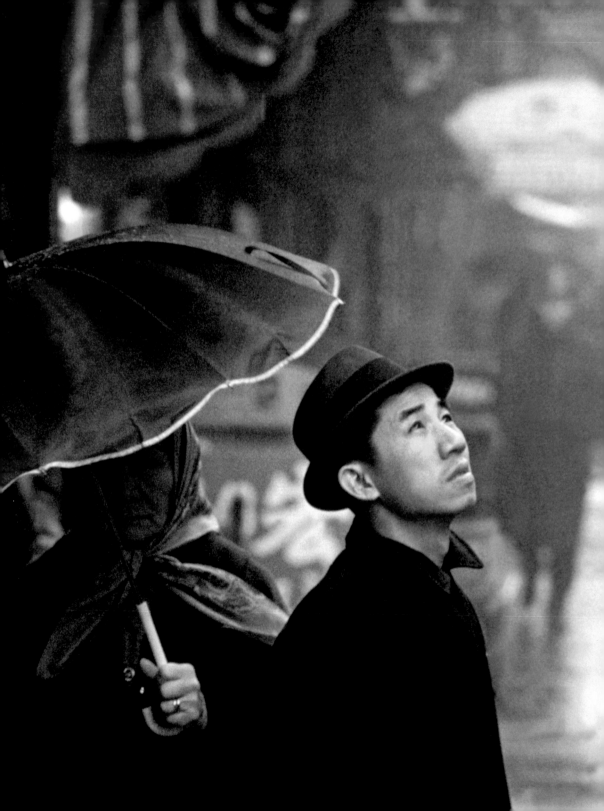

"Chinatown, my Chinatown
Where the lights are low,
Hearts that know no other land,
Drifting to and fro.
Dreamy dreamy Chinatown."

"CHINATOWN, MY CHINATOWN", WILLIAM JEROME
AND JEAN SCHWARTZ, 1910

Burt Glinn

A Chinatown resident waiting for
the rain to clear, 1964.

Ein Bewohner von Chinatown wartet
auf das Ende des Wolkenbruchs, 1964.

Un habitant de Chinatown attend
que l'averse passe, 1964.

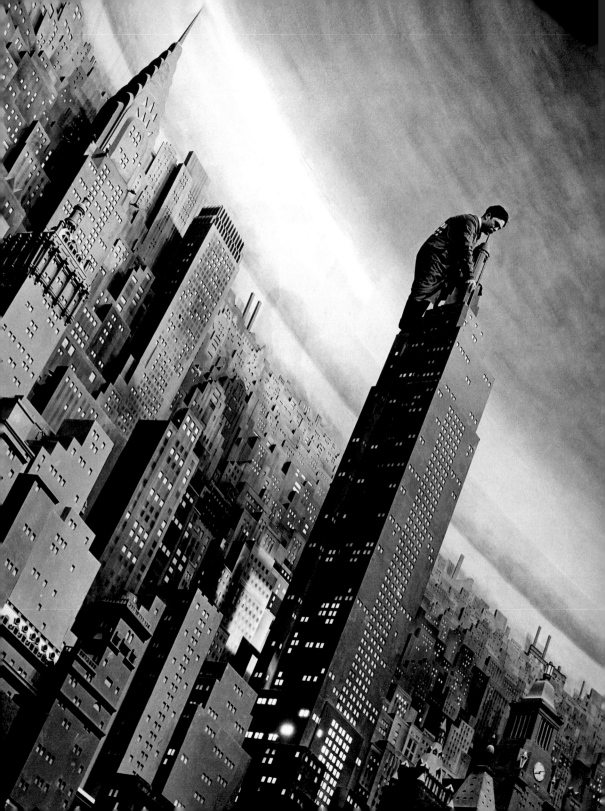

EDITH WHARTON (1862)
VITO ACCONCI (1940)
NEIL DIAMOND (1941)

"New York is not as big a city as it pretends to be."

THE LADY FROM SHANGHAI, 1946

Margaret Bourke-White

A man working atop a 32-foot replica of the Empire State Building in Consolidated Edison's New York diorama at the World's Fair of 1939.

Ein Mann arbeitet auf dem Dach eines Modells des Empire State Building im New-York-Diorama von Consolidated Edison auf der Weltausstellung von 1939.

Un homme travaillant au sommet d'une réplique de l'Empire State Building d'une dizaine de mètres dans le diorama sur New York de Consolidated Edison à l'Exposition universelle de 1939.

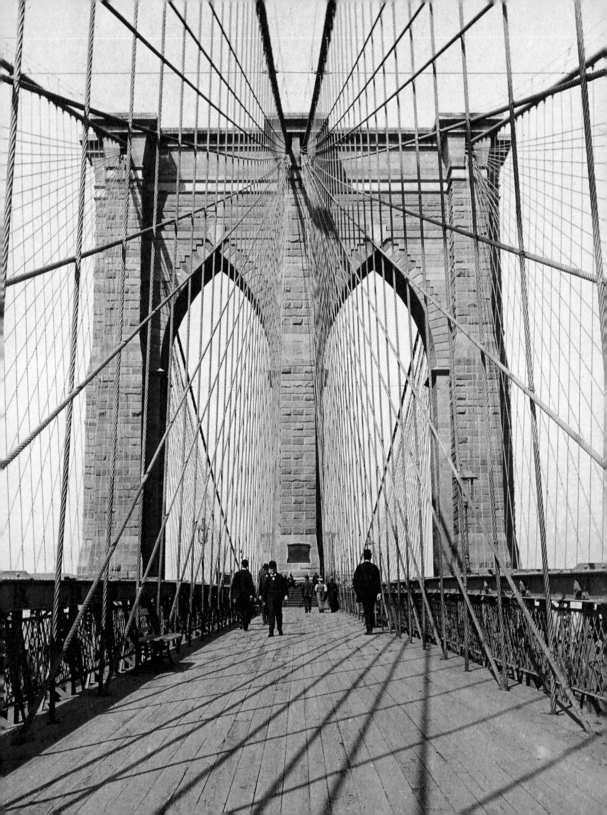

BERNARD TSCHUMI (1944)
ALICIA KEYS (1981)

"A great engineering triumph."

THE NEW YORK TIMES, 1883

Julius Wilcox

The Tower and the Cobweb. The Brooklyn Bridge's wide promenade was a distinctive feature. For the fee of one penny, people could walk from the nation's largest city to its third largest, early 1880s.

Der Turm und das Spinnennetz. Die breite Fußgängerpromenade war ein Markenzeichen der Brooklyn Bridge; gegen eine Gebühr von einem Penny konnten die Menschen von der größten Stadt des Landes in die drittgrößte hinüberlaufen, Anfang der 1880er-Jahre.

La tour et la toile d'araignée. La promenade piétonnière sur le pont de Brooklyn était une attraction. Pour un penny seulement, on pouvait aller à pied de la première à la troisième ville du pays, début des années 1880.

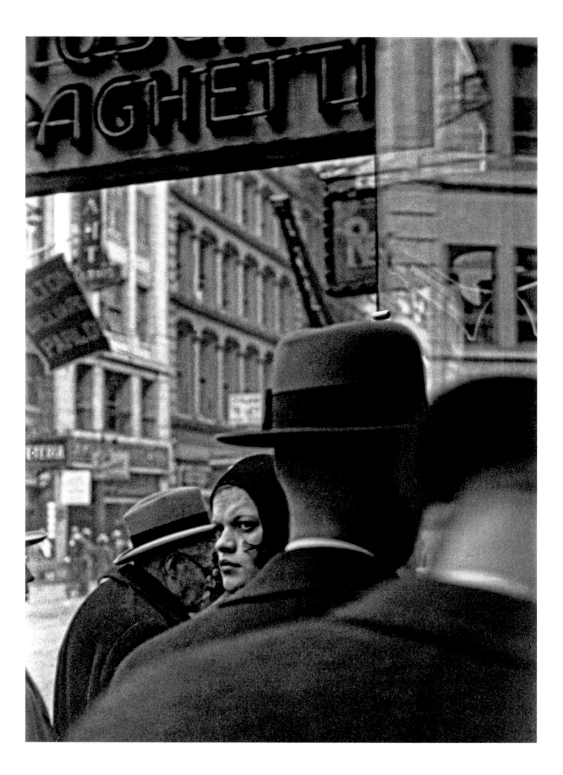

"New York is not all bricks and steel. There are hearts there too, and if they do not break, then they at least know how to leap."

PREJUDICES: *SIXTH SERIES*, H. L. MENCKEN, 1927

Walker Evans

The anonymity and relentlessness of big city life at Fulton Street in lower Manhattan, 1929.

Die Anonymität und Rastlosigkeit des Großstadtlebens in der Fulton Street in Lower Manhattan, 1929.

L'anonymat et l'hyperactivité des grandes villes : cette image a été prise Fulton Street, dans le Lower Manhattan, 1929.

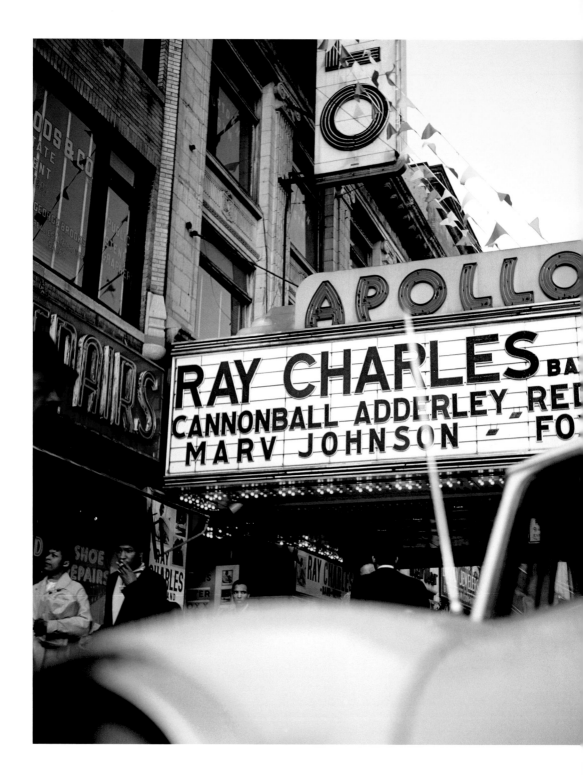

William Claxton

Ray Charles performing at one of
Harlem's landmarks, the Apollo Theater.
The club, on 125th Street, dates back
to 1915, and has featured performances
by singers such as James Brown and
Billie Holiday, 1960.

Ray Charles kommt ins Apollo Theater,
ein Wahrzeichen von Harlem. In dem
Club auf der 125th Street, der 1915 er-
öffnet wurde, traten Musiker wie James
Brown und Billie Holiday auf, 1960.

Ray Charles à l'affiche de l'un des monu-
ments d'Harlem, l'Apollo Theater. Ce
club, fondé en 1915 sur la 125ᵉ Rue, a
également accueilli des chanteurs comme
James Brown et Billie Holiday, 1960.

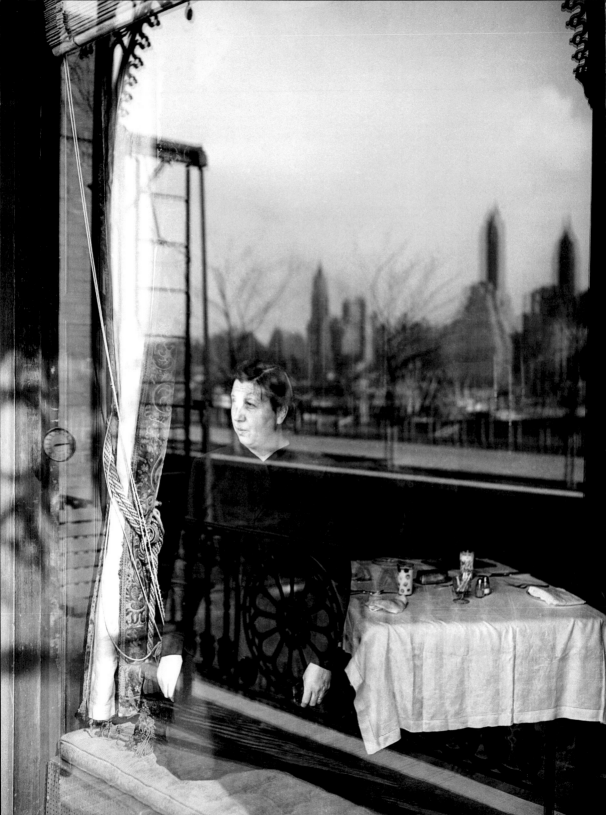

"New York blends the gift of privacy with the excitement of participation."

HERE IS NEW YORK, E. B. WHITE, 1949

Nat Fein

Slow Business Day, Brooklyn Heights. Brooklyn Heights is just across the East River from Manhattan, the skyline of which is neatly reflected in the restaurant window, 1941.

Schlechter Umsatz, Brooklyn Heights. Brooklyn Heights liegt genau auf der anderen Seite des East River gegenüber von Manhattan, dessen Skyline als Spiegelung im Schaufenster zu sehen ist, 1941.

Mauvais jour pour les affaires, Brooklyn Heights. Brooklyn Heights se trouve au bord de l'East River, en face de Manhattan, dont le panorama se reflète nettement dans la vitrine, 1941.

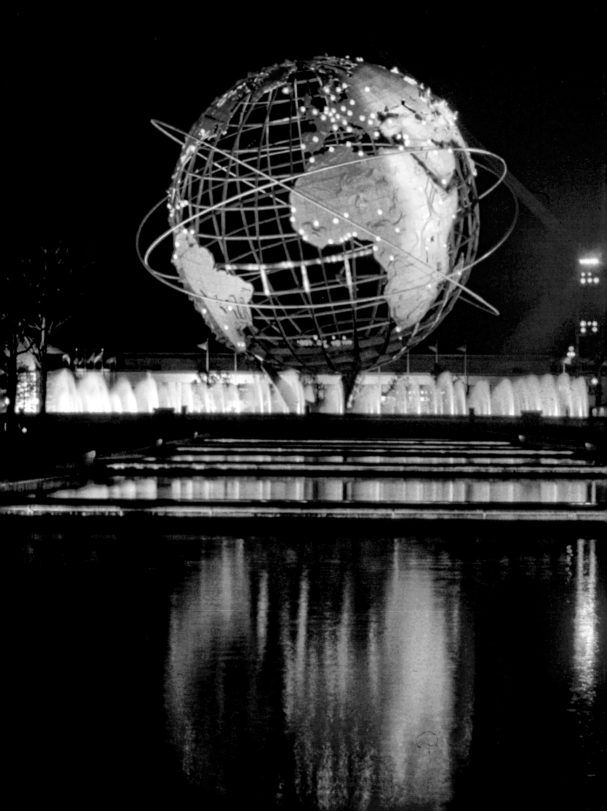

"To help us get a glimpse into the future of this unfinished world of ours, there has been created for the New York World's Fair a thought-provoking exhibit of the developments ahead of us."

GM'S FUTURAMA EXHIBIT AT THE WORLD'S FAIR, 1939

Weegee

A color distortion of the World's Fair's famous Unisphere, which is still standing today, and is a major Queens landmark, c. 1964.

Eine farbverschobene Aufnahme der berühmten Unisphere der Weltausstellung, die heute immer noch dort steht und eines der Wahrzeichen von Queens ist, um 1964.

Distorsion chromatique sur la fameuse Unisphere de l'Exposition internationale de 1964. Toujours existante, elle est aujourd'hui l'un des principaux monuments du Queens, vers 1964.

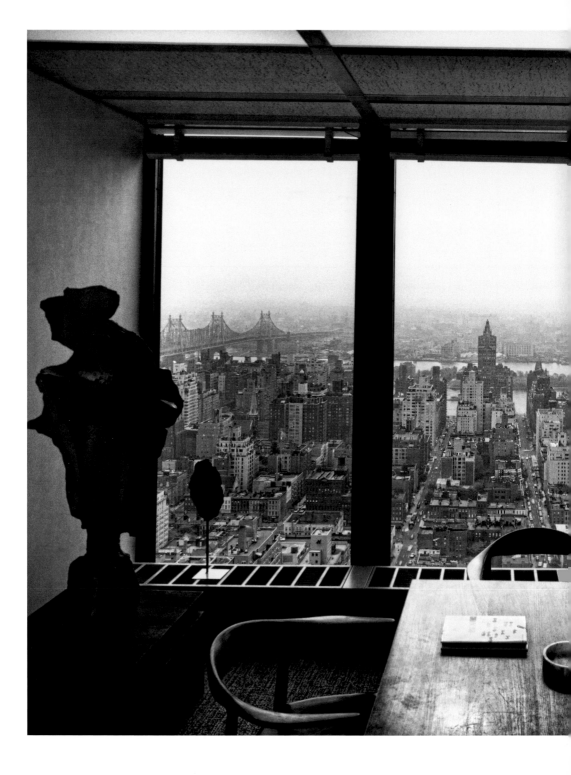

FRANKLIN DELANO ROOSEVELT (1882)

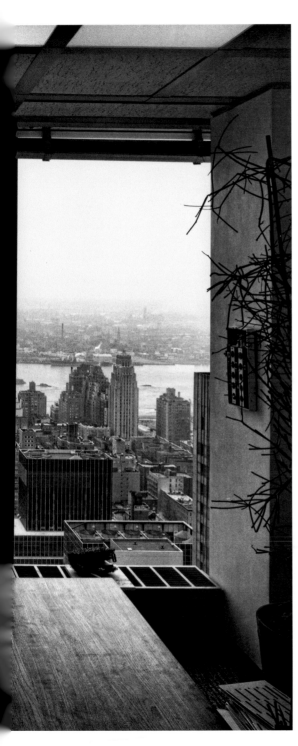

Julius Shulman

The view from architect Philip Johnson's office in the Seagram Building, designed by Ludwig Mies van der Rohe and Johnson. On Park Avenue between 52nd and 53rd Streets, the modernist classic skyscraper was built in the International Style in 1957, 1963.

Blick aus dem Büro des Architekten Philip Johnson im Seagram Building (entworfen von Mies van der Rohe und Johnson). Das Gebäude im modernen Internationalen Stil wurde 1957 an der Park Avenue zwischen 52nd und 53rd Street errichtet, 1963.

Vue du bureau de l'architecte Philip Johnson dans le Seagram Building (conçu par Mies van der Rohe et Johnson). Situé sur Park Avenue entre la 52ᵉ et la 53ᵉ Rue, cet immeuble moderniste classique fut édifié en 1957, dans ce que l'on appela alors le Style international, 1963.

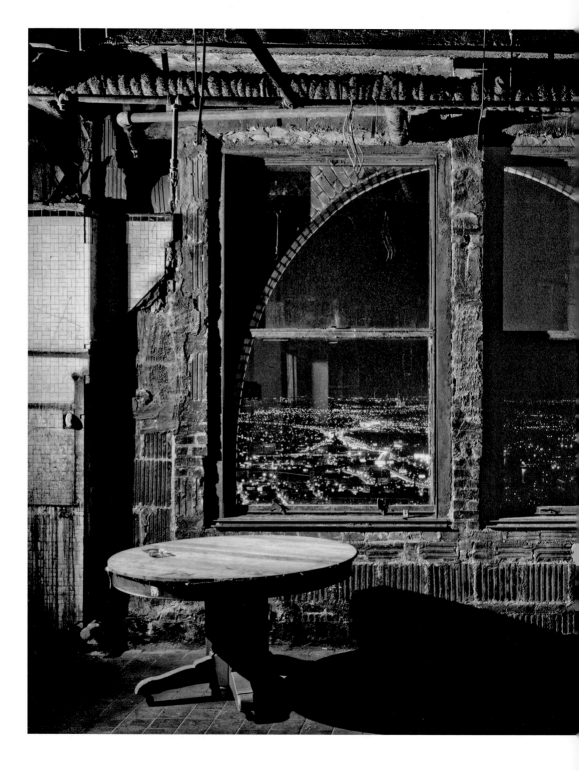

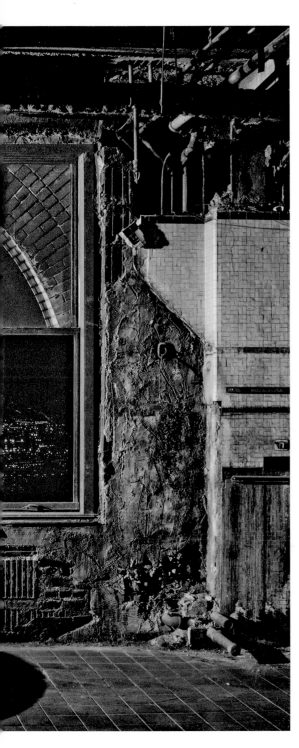

JACKIE ROBINSON (1919)
CAROL CHANNING (1921)
NORMAN MAILER (1923)
PHILIP GLASS (1937)

Andrew Bordwin

The kitchen of the Cloud Club. The Cloud Club was a long-abandoned, private gentleman's club located high above New York, atop the Chrysler Building, 1990.

Die Küche des Cloud Club. Der Cloud Club war ein lange Jahre leer stehender Herrenclub hoch oben auf dem Chrysler Building, 1990.

La cuisine du Cloud Club. Le Cloud Club fut un célèbre club privé réservé aux hommes, logé dans les hauteurs du Chrysler Building, 1990.

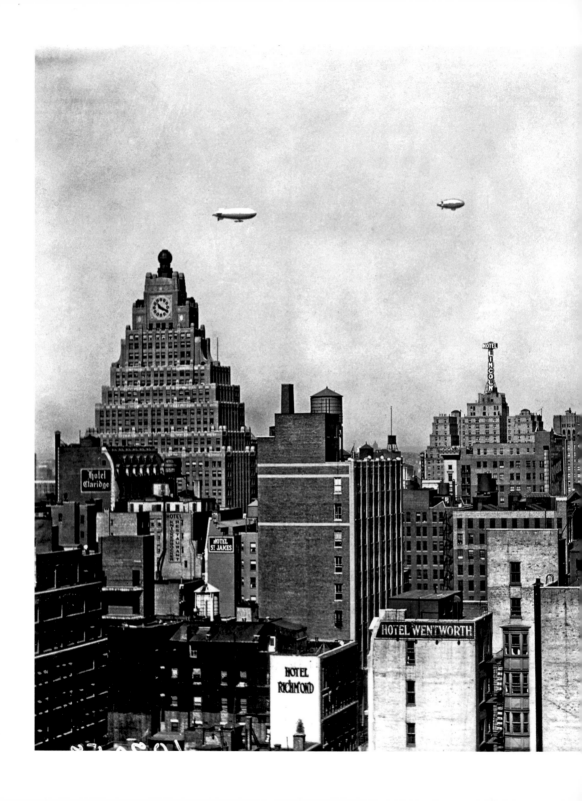

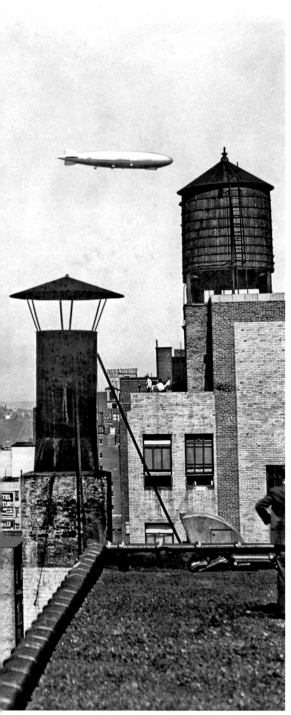

Anonymous

Dirigibles, or airships, flying over
Manhattan. The early 20th century was
the golden age of dirigibles, c. 1900.

Luftschiffe über Manhattan. Die ersten
Jahre des 20. Jahrhunderts waren die
goldene Ära der Zeppeline, um 1900.

Dirigeables au-dessus de Manhattan.
Le début du xxe siècle fut l'âge d'or
des dirigeables, vers 1900.

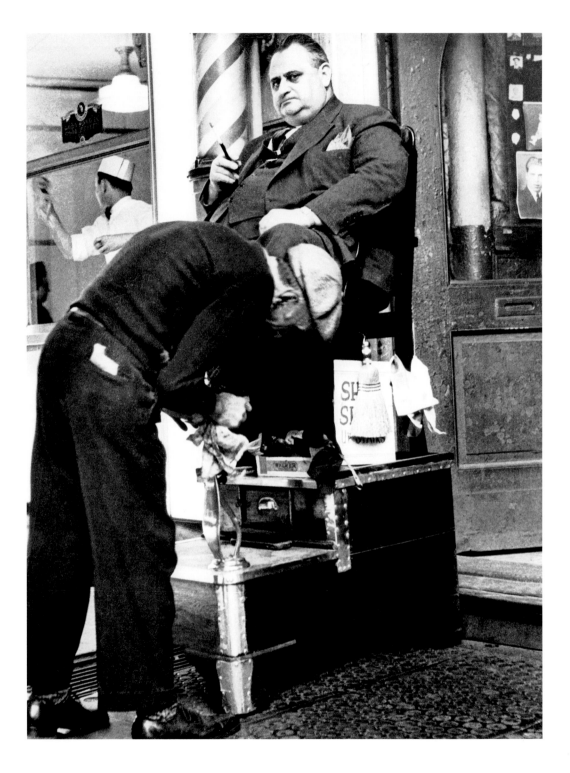

*"Is it wrong to gamble,
or only to lose?"*

GUYS AND DOLLS, 1935

Lisette Model

Petty Labor, 1940.

Hilfsarbeiten, 1940.

Petit boulot, 1940.

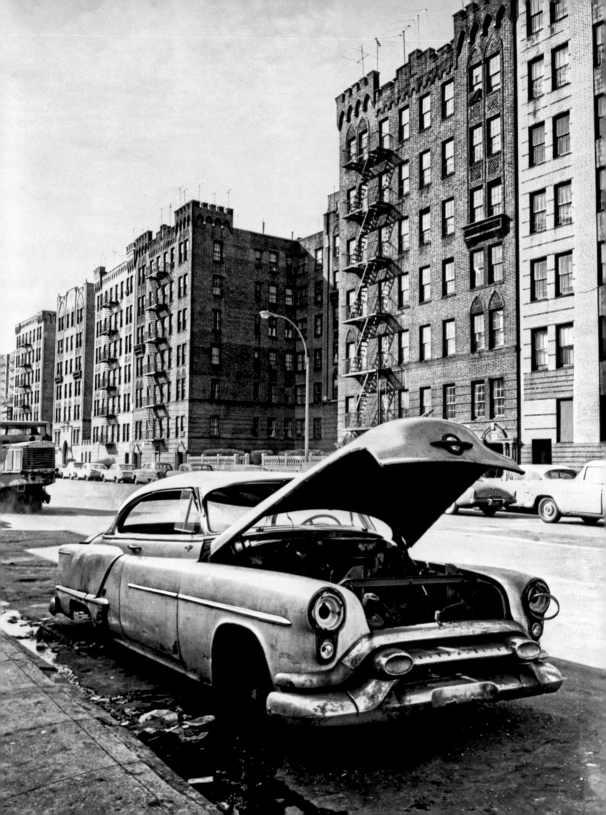

"A hundred times have I thought New York is a catastrophe… it is a beautiful catastrophe."

LE CORBUSIER, *NEW YORK HERALD TRIBUNE,* 1961

Phil Stanziola

An abandoned car in the Bronx, 1964.

Autowrack in der Bronx, 1964.

Voiture abandonnée dans le Bronx, 1964.

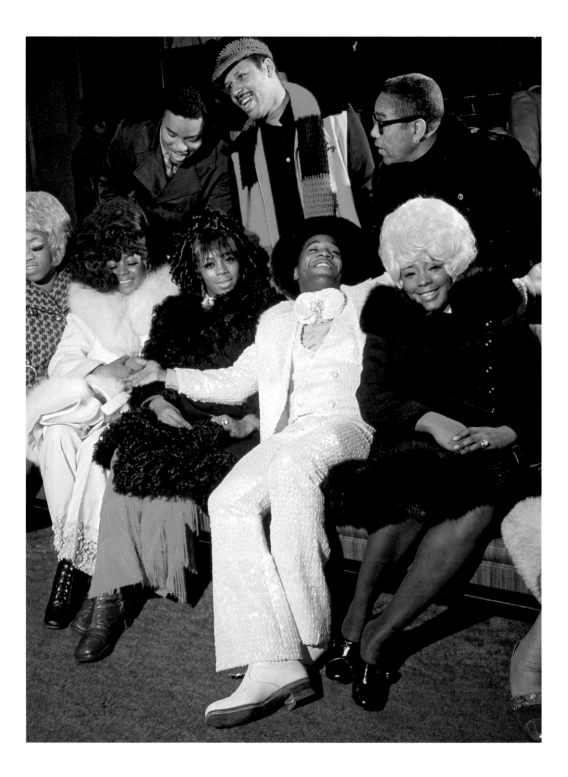

*"When it's three o'clock
in New York, it's still
1938 in London."*

BETTE MIDLER, 1978

Bill Ray

New York's finest and dandiest getting dressed up for the Muhammad Ali versus Oscar Bonavena fight at Madison Square Garden, 1970.

Die New Yorker Hautevolee hat sich schick gemacht, um den Kampf Muhammad Ali gegen Oscar Bonavena im Madison Square Garden anzuschauen, 1970.

Les dandys les plus chics de New York tirés à quatre épingles pour le combat Muhammad Ali-Oscar Bonavena à Madison Square Garden, 1970.

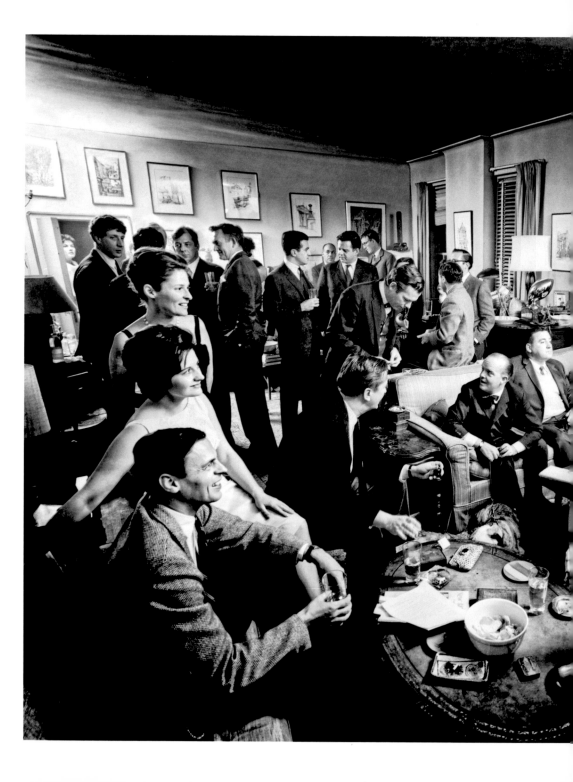

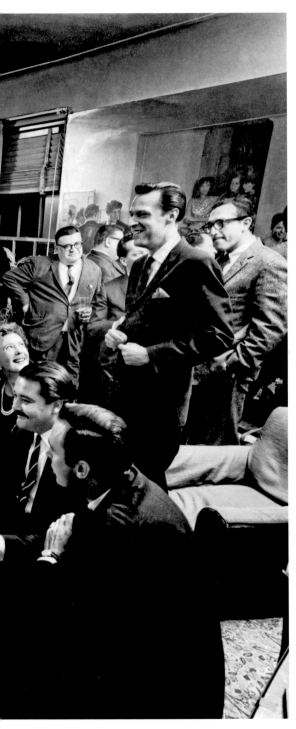

Cornell Capa

Literary Cocktail Party at George Plimpton's Upper East Side Apartment. On the sofa in the middle is Truman Capote talking to William Styron, while Mario Puzo, author of *The Godfather*, is standing at the other end of the sofa with his arm akimbo. The shot was carefully set up, and to the right, standing near the door, are some disgruntled wives and girlfriends who were told to be out of the shot, 1963.

Literaten auf einer Cocktail-Party in George Plimptons Apartment auf der Upper East Side. Auf dem Sofa in der Mitte sitzt Truman Capote. Er spricht mit Bill Styron, während Mario Puzo, Autor von *Der Pate*, mit in die Seite gestemmtem Arm am anderen Ende des Sofas steht. Die Szene ist sorgfältig arrangiert. Rechts an der Tür stehen einige missmutig dreinblickende Ehefrauen und Freundinnen, die nicht mit aufs Bild durften, 1963.

Cocktail littéraire dans l'appartement de George Plimpton dans l'Upper East Side. Au centre, sur le canapé, Truman Capote. Il converse avec Bill Styron, tandis que Mario Puzo, l'auteur du *Parrain*, est assis à l'autre extrémité, le bras replié. La photo a été soigneusement mise en scène. À droite, près de la porte, quelques épouses et petites amies pas très contentes d'avoir été écartées de la prise de vue, 1963.

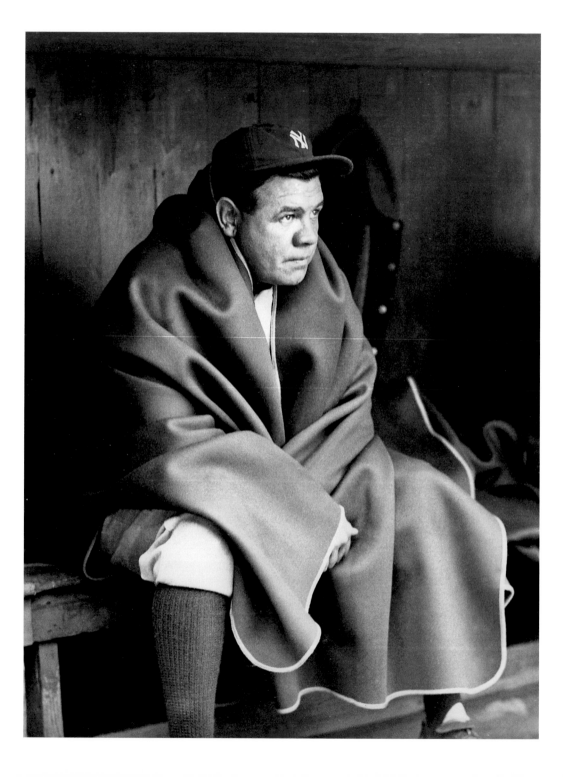

GEORGE HERMAN "BABE" RUTH, JR. (1895)
TOM BROKAW (1940)

"I'd give a year of my life if I can hit a home run in the first game in this new park."

BABE RUTH, 1923

Anonymous

Babe Ruth, of the New York Yankees, possibly the greatest baseball player who ever lived, near the end of his career, 1933.

Babe Ruth von den New York Yankees, wahrscheinlich der beste Baseball-spieler aller Zeiten, gegen Ende seiner Karriere, 1933.

Babe Ruth, des New York Yankees, sans doute le plus grand joueur de baseball de tous les temps, vers la fin de sa carrière, 1933.

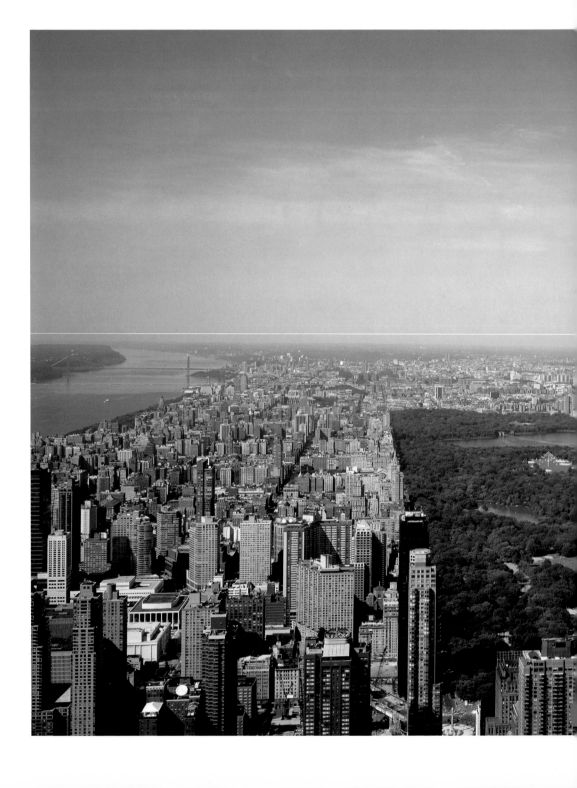

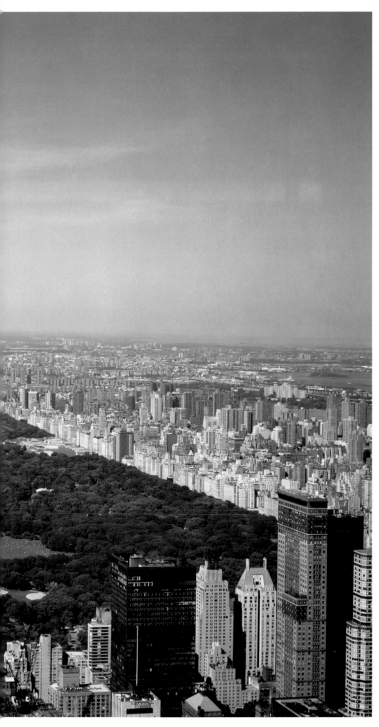

CHRIS ROCK (1965)

Carol M. Highsmith

An aerial view of Central Park, which contains 24,000 trees, 150 acres of lakes and streams, 130 acres of woodlands, 9,000 benches, 26 ball fields, and 21 playgrounds, c. 1990.

Eine Luftbildaufnahme des Central Parks mit seinen 24 000 Bäumen, etwa 60 Hektar Seen und Gewässern, über 50 Hektar Wald, 9 000 Bänken, 26 Fussballplätzen und 21 Spielplätzen, um 1990.

Vue aérienne de Central Park, avec ses 24 000 arbres, 60 hectares de lacs et cours d'eau, 50 hectares de bois, 9000 bancs, 26 terrains de jeux de balle et 21 aires de jeux, vers 1990.

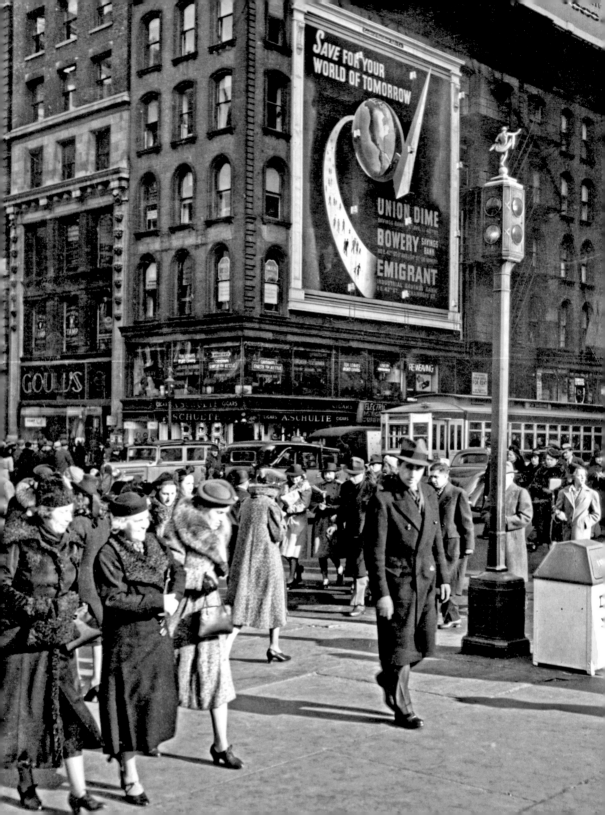

"Hello, folks!"

**STANDARD GREETING OF
THE WORLD'S FAIR, 1940**

Lee Sievan

Fifth Avenue and 42nd Street. New Yorkers hurry along in the middle of a bitterly cold day in Midtown Manhattan, 1939.

Fifth Avenue und 42nd Street. Die New Yorker hasten an einem bitterkalten Tag in Midtown Manhattan durch die Straßen, 1939.

Cinquième Avenue et 42e Rue. Des New-Yorkais se dépêchent par une matinée glaciale dans le Midtown Manhattan, 1939.

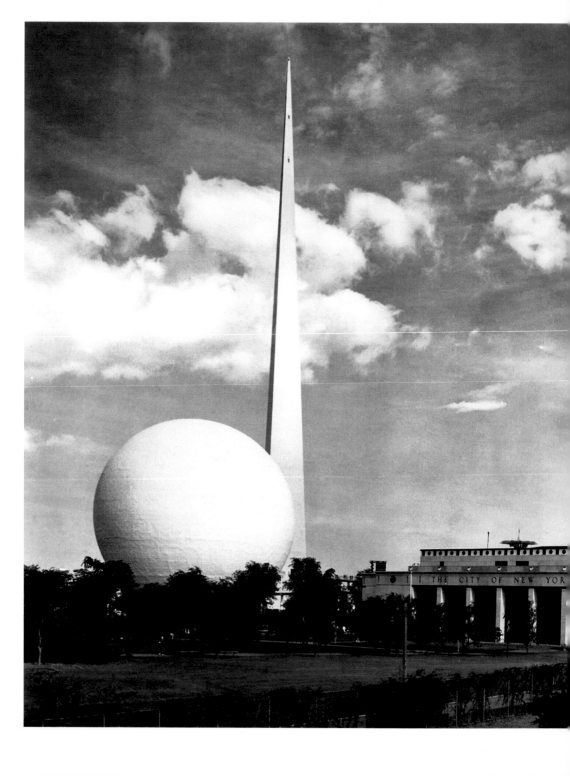

Anonymous

The 1939 World's Fair. From left to right: the Perisphere, the Trylon, and the New York City Building. The Perisphere contained the "Democracity" exhibition, a huge model of "The City of the Future." Outside this "city" were five satellite towns, with roadways connecting them back to the center of the metropolis, 1939.

Die Weltausstellung 1939. Die Wahrzeichen Perisphere und Trylon und das New York City Building (von links). Im Perisphere wurde die Ausstellung „Democracity" gezeigt, ein riesiges Modell der „Stadt der Zukunft". Außerhalb dieser „Stadt" lagen fünf Satellitenstädte mit Straßen, die sie mit dem Zentrum der Metropole verbanden, 1939.

L'Exposition universelle de 1939. De gauche à droite : le Perisphere, le Trylon, et le pavillon de la ville de New York. Le Perisphere contenait une exposition sur la «Democracity», une énorme maquette de la «Cité du futur». Autour de cette «cité» s'organisaient cinq villes satellites reliées au centre par des autoroutes, 1939.

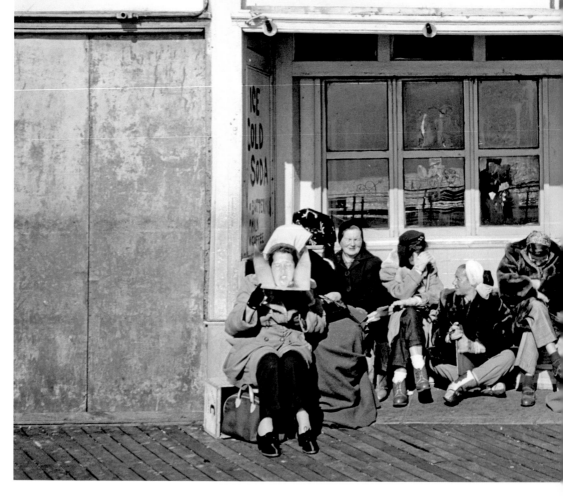

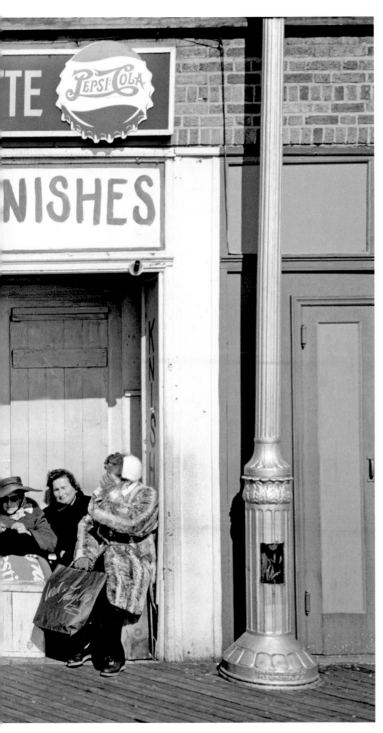

Marvin Newman

Off-season Coney Island: Locals are trying to catch some much needed rays of sunshine, 1953.

Coney Island in der Nebensaison: Einheimische versuchen, noch ein paar Sonnenstrahlen abzubekommen, 1953.

Coney Island hors saison : des passants tentent de profiter de quelques rayons de soleil tant désirés, 1953.

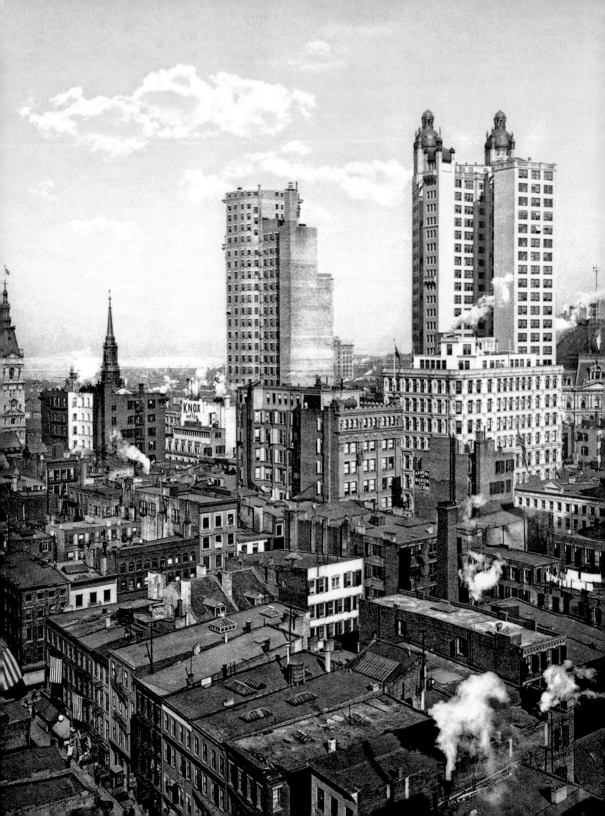

"And in the background a multitude of buildings, of pitiless hues and sternly high, were to him emblematic of a nation forcing its regal head into the clouds."

"AN EXPERIMENT IN MISERY," STEPHEN CRANE, 1894

Anonymous

The tallest buildings in the world. Chicago natives may dispute this claim, but by the first few years of the 20th century, New York had dozens of buildings exceeding 20 stories. Electric-powered elevators and a steel skeleton frame brought about this vertical revolution, 1900.

Die höchsten Gebäude der Welt. Die Einwohner Chicagos würden dies zwar bestreiten, aber Anfang des 20. Jahrhunderts gab es in New York Dutzende von Gebäuden mit mehr als 20 Stockwerken. Stahlskelettbauweise und elektrische Aufzüge hatten diese vertikale Revolution ermöglicht, 1900.

Les immeubles les plus hauts du monde. Les habitants de Chicago ne seraient sans doute pas d'accord, mais, dès les premières années du XXe siècle, New York possédait des douzaines d'immeubles dépassant vingt étages. Cette révolution verticale était due aux ascenseurs à propulsion électrique et à l'apparition des ossatures en acier, 1900.

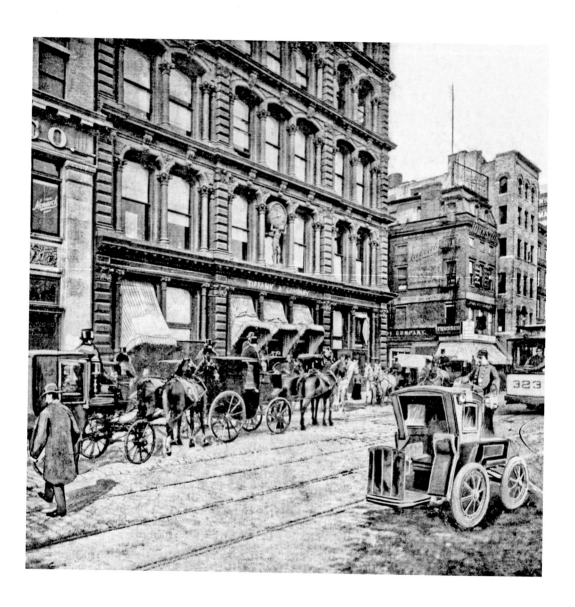

"These rocks don't lose their shape,
diamonds are a girl's best friend."

"DIAMONDS ARE A GIRL'S BEST FRIEND,"
GENTLEMEN PREFER BLONDES, 1953

Anonymous

In front of Tiffany's, Union Square. The old location of the world-famous jewelers, at 15 Union Square West. Tiffany's moved there in 1870, with *The New York Times* describing the new flagship store as a "monster iron building." In 1906, Tiffany's moved to a new store further uptown, on Fifth Avenue, 1899.

Vor Tiffany's, Union Square. Der alte Sitz des weltberühmten Juweliers in 15 Union Square West. Als Tiffany's 1870 dorthin zog, bezeichnete die *New York Times* den neuen Vorzeigeladen als „monströses Eisengebäude". 1906 bezog Tiffany's einen neuen Laden weiter nördlich in der Fifth Avenue, 1899.

Devant Tiffany's, Union Square. Le célèbre joailler était alors installé 15 Union Square West depuis 1870. *The New York Times* avait décrit ce nouveau magasin amiral comme un «monstre d'immeuble de fer». En 1906, Tiffany's s'installa dans un nouveau magasin plus haut, sur la Cinquième Avenue, 1899.

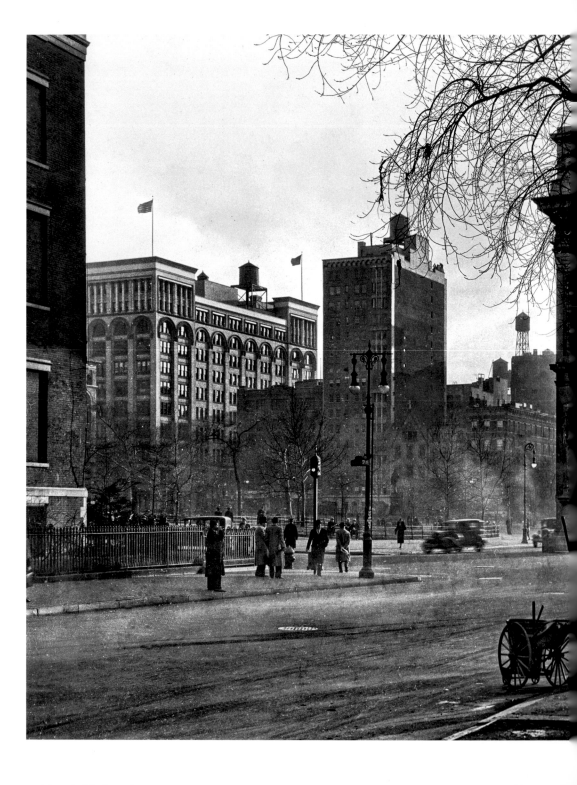

STOCKARD CHANNING (1944)

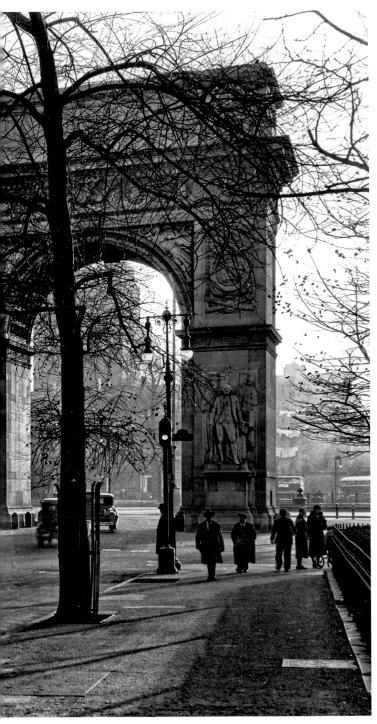

Samuel H. Gottscho

Washington Square Park. The arch, at the northern end of the park, next to the foot of Fifth Avenue, was erected in 1889 to commemorate the centennial of George Washington's inauguration, 1930s.

Washington Square Park. Der Torbogen am nördlichen Ende des Parks, dort, wo die Fifth Avenue beginnt, wurde anlässlich der Hundertjahrfeier des Amtsantritts von George Washington 1889 errichtet, 1930er-Jahre.

Washington Square Park. L'arc à l'extrémité nord du parc au départ de la Cinquième Avenue fut érigé en 1889 pour commémorer le centenaire de la prise de fonction de George Washington, années 1930.

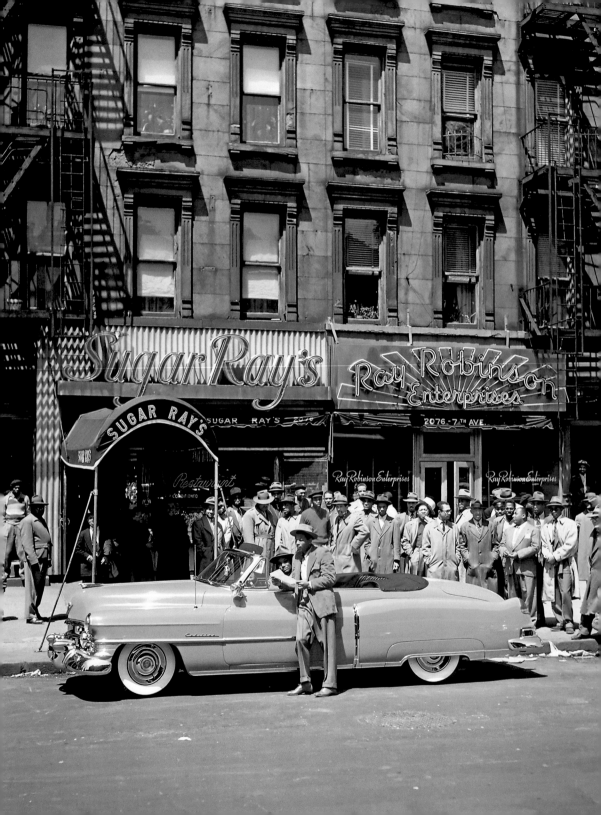

"Oh, my man, I love him so
He'll never know
All my life is just despair
But I don't care
When he takes me in his arms
The world is bright,
All right."

"MY MAN," BILLIE HOLIDAY, 1953

George Karger

Sugar Ray Robinson, one of the greatest boxers of all time, with his flamboyant flamingo-pink Cadillac outside his bar/café, Sugar Ray's, in Harlem on 124th Street. He also owned a beauty salon, a barber shop, a lingerie shop—Edna May's, named after his wife—and a real-estate business, 1950.

Sugar Ray Robinson, einer der größten Boxer aller Zeiten, mit seinem auffälligen pinkfarbenen Cadillac vor seiner Bar Sugar Ray's in der 124th Street in Harlem. Er besaß auch einen Schönheits- und einen Frisiersalon, eine Immobilienfirma und den Dessousladen Edna May's, benannt nach seiner Ehefrau, 1950.

Sugar Ray Robinson, l'un des plus grands boxeurs de tous les temps, et sa flamboyante Cadillac rose devant le café-bar Sugar Ray à Harlem dans la 124e Rue. Il possédait aussi un salon de beauté, un salon de coiffure, une boutique de lingerie – «Edna May's», nom de son épouse –, et une agence immobilière, 1950.

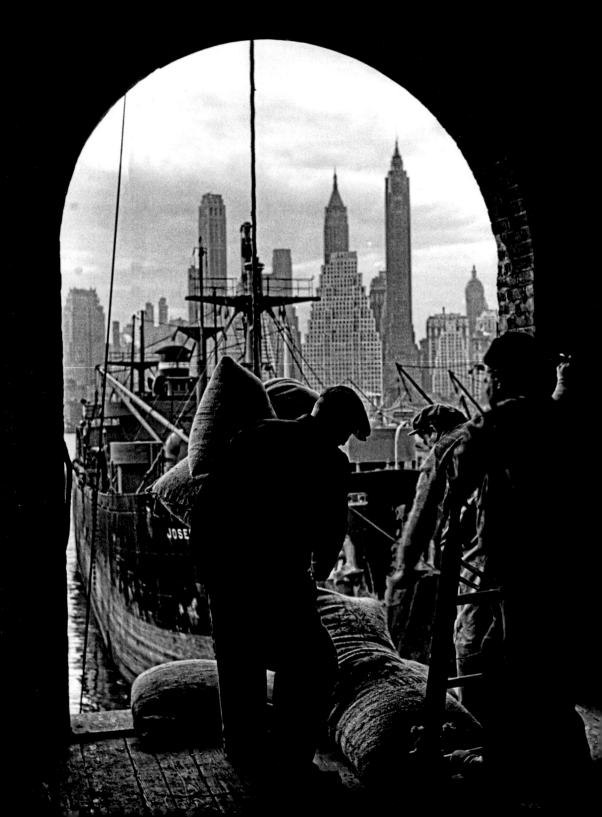

*"London is satisfied, Paris is resigned,
but New York is always hopeful."*

"MY HOME TOWN," DOROTHY PARKER, JANUARY 1928

Andreas Feininger

Unloading coffee at the Brooklyn docks, with Downtown Manhattan in the background. The docks at the time were among the largest in the United States, and had played a key role in the war effort, 1946.

In den Docks von Brooklyn wird eine Ladung Kaffee gelöscht, im Hintergrund ist Downtown Manhattan zu sehen. Die Docks gehörten in dieser Zeit zu den größten der USA und hatten im Krieg eine wichtige Rolle gespielt, 1946.

Déchargement de café sur les docks de Brooklyn, sur fond du Downtown Manhattan. Ces docks étaient alors parmi les plus vastes des États-Unis et avaient joué un rôle clé pendant la dernière guerre, 1946.

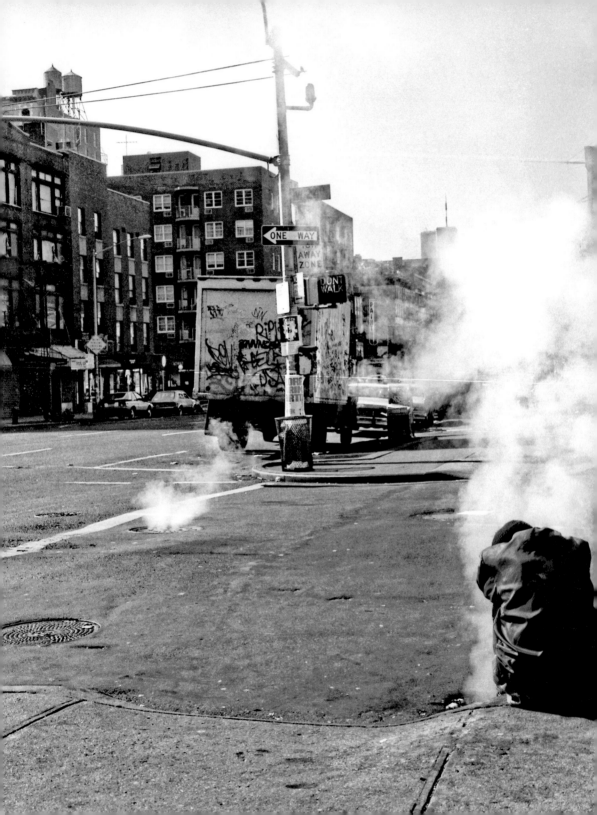

"J. Edgar Hoover, and he coulda proved to you
He had King and X set up
Also the party with Newton, Cleaver, and Seale
He ended, so get up
Time to get em back
(You got it)
Get back on the track
(You got it)
Word from the honorable Elijah Muhammad
Know who you are to be Black."

"PARTY FOR YOUR RIGHT TO FIGHT," PUBLIC ENEMY, 1988

Sylvia Plachy

Homeless in Chelsea. Successive New York mayors have tried to tackle the city's perennial problem of homelessness—some showed zero tolerance, while others adopted a more paternalistic approach. A poignant photograph of New York's forgotten population, 1985.

Obdachlos in Chelsea. Die verschiedenen New Yorker Bürgermeister haben immer wieder versucht, das ständige Obdachlosenproblem der Stadt zu lösen, manche davon mit einer Null-Toleranz-Strategie, andere mit einem paternalistischeren Ansatz. Ein erschütterndes Foto dieser vergessenen Bewohner New Yorks, 1985.

Sans-abri à Chelsea. Les maires successifs de New York se sont attaqués au lancinant problème des sans-abri, certains partisans de la tolérance zéro, d'autres ouverts à des approches plus paternalistes. Photographie poignante d'une population oubliée, 1985.

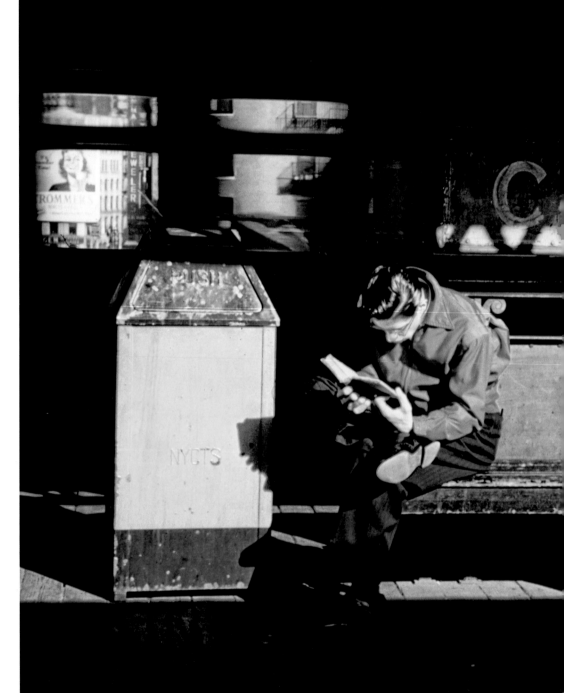

Esther Bubley

A James Dean look-alike waiting for the train at Canal Street, early 1950s.

Ein James-Dean-Doppelgänger wartet an der Canal Street auf die Bahn, Anfang der 1950er-Jahre.

Un sosie de James Dean attend le train à Canal Street, début des années 1950.

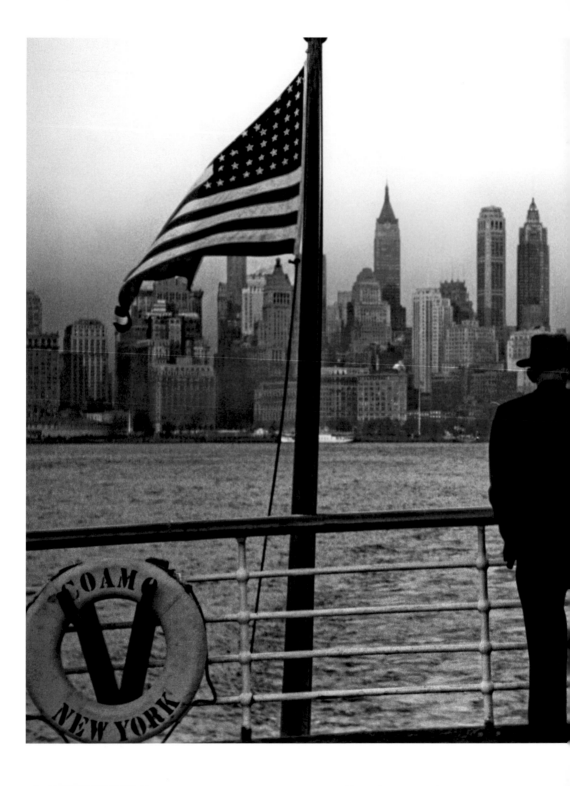

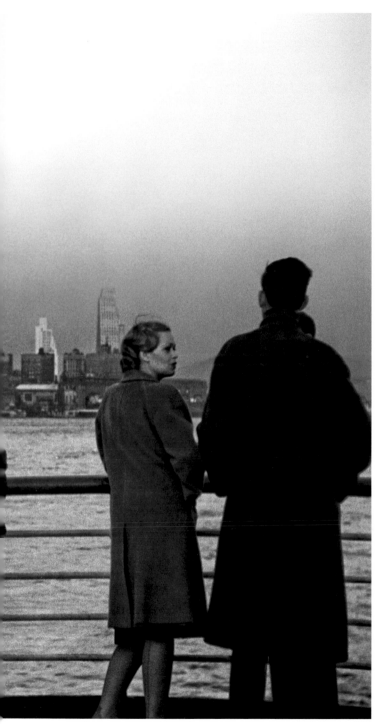

LOUIS COMFORT TIFFANY (1848)
JOHN TRAVOLTA (1954)

Jack Delano

A shot of Lower Manhattan, as seen from a departing ship. This was taken in 1941, during World War II, so the scene is especially poignant.

Eine Aufnahme von Lower Manhattan von einem auslaufenden Schiff aus. Dieses Foto entstand 1941 während des Zweiten Weltkriegs, was die Ausdruckskraft der Szene erhöht.

Superbe vue du Lower Manhattan prise d'un bateau en 1941, en pleine guerre mondiale, ce qui rend la scène particulièrement poignante.

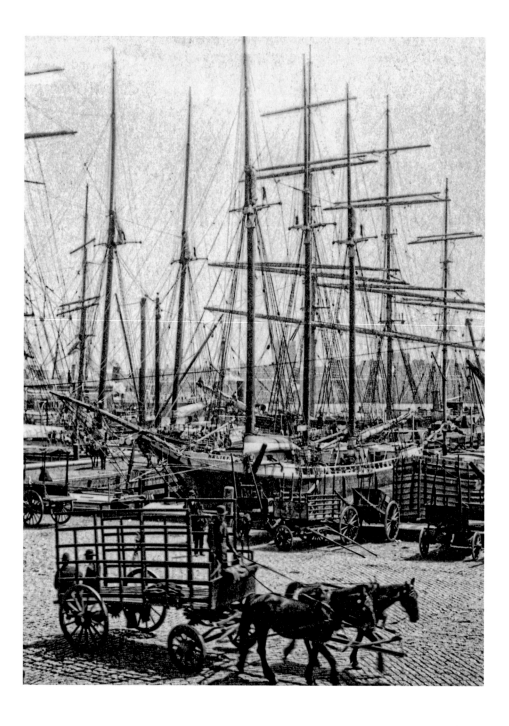

"The industrial market is destined to be the great speculative market of the United States."

CHARLES DOW, 1882

Charles Gilbert Hine

The Waterfront. New York's natural harbor is what originally attracted a maritime nation like the Netherlands to colonize the island of Manhattan in the 17th century. This image, taken more than 200 years later, shows that the harbor was still thriving and played a key role in the city's economic and commercial life, 1880s.

Hafenviertel. Der Naturhafen von New York war es, der ursprünglich eine Seefahrernation wie die Niederlande reizte, im 17. Jahrhundert die Insel Manhattan zu kolonisieren. Dieses Foto, das über 200 Jahre später entstand, macht deutlich, dass der Hafen immer noch florierte und für die Wirtschaft und den Handel der Stadt nach wie vor eine Schlüsselrolle spielte, 1880er-Jahre.

Sur les quais. Le port naturel de New York est ce qui attira, à l'origine, un pays maritime comme les Pays-Bas, pour coloniser l'île de Manhattan au XVII^e siècle. Cette image, prise plus de deux cents ans plus tard, montre qu'il était toujours très actif et jouait un rôle clé dans la vie économique de la cité, années 1880.

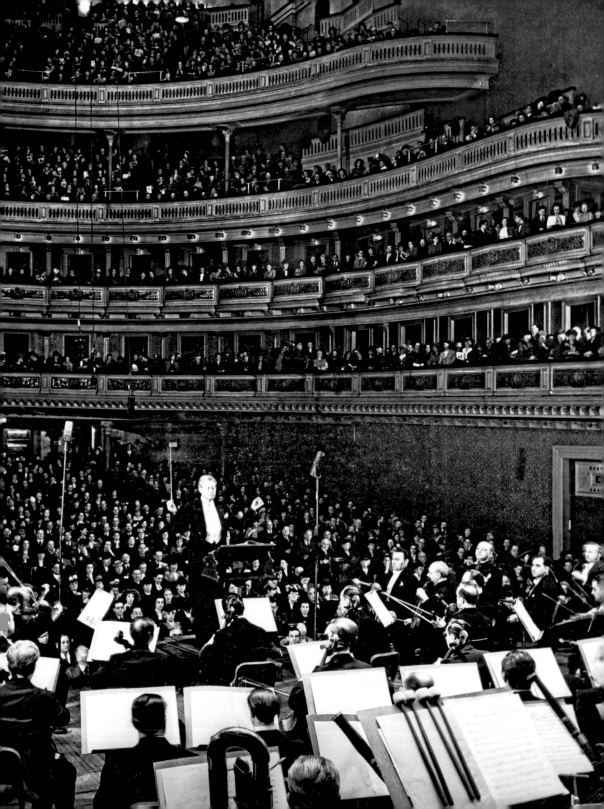

GLORIA VANDERBILT (1924)
ROY COHN (1927)

"...I like cities, and New York is the only real city-city."

TRUMAN CAPOTE, 1957

Jerry Cooke

The New York Philharmonic performing at the world-famous Carnegie Hall, 1946.

Die New Yorker Philharmoniker spielen in der weltberühmten Carnegie Hall, 1946.

L'orchestre du New York Philharmonic en concert au mondialement célèbre Carnegie Hall, 1946.

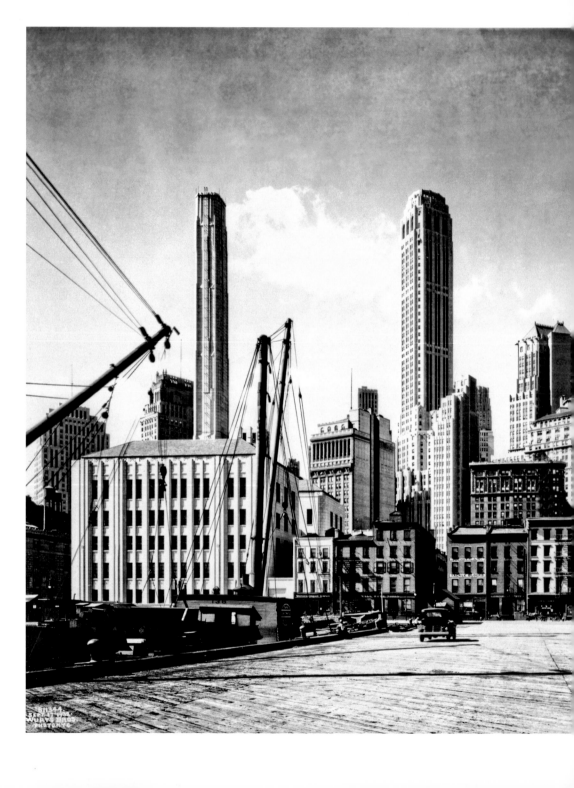

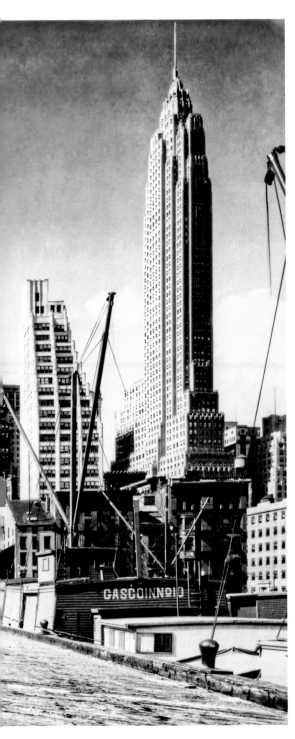

Wurts Brothers

Old New York and modern New York beautifully captured on South Street, Pier 11, near Wall Street, 1932.

Alt und Neu in New York, wunderbar fotografisch gegenübergestellt in der South Street, Pier 11, nahe Wall Street, 1932.

Le vieux New York et le New York moderne, tous deux superbement captés de South Street, Pier 11, près de Wall Street, 1932.

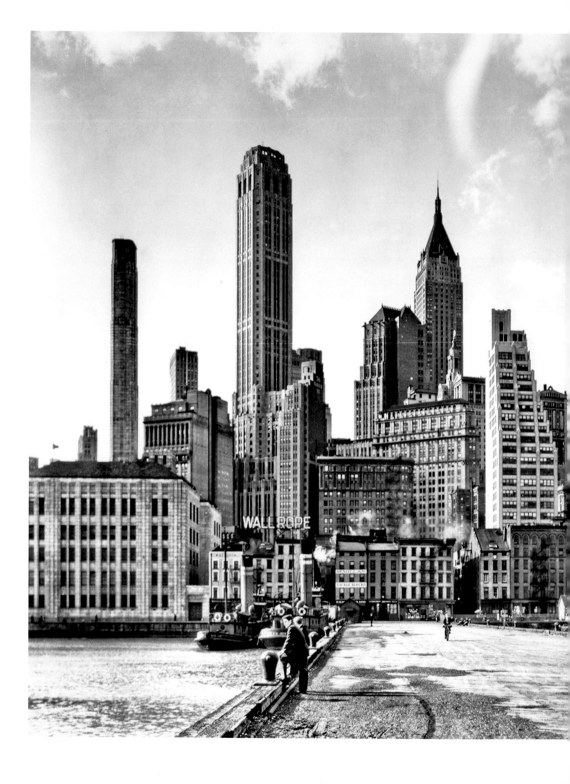

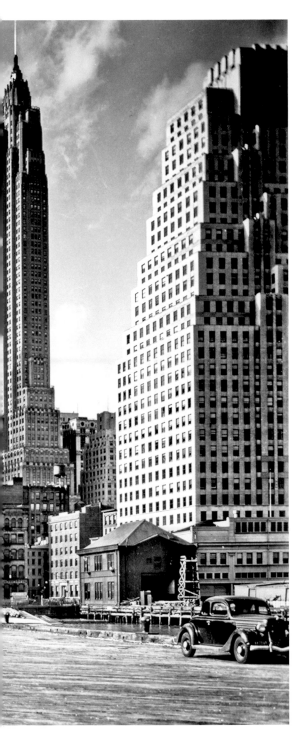

BILLY NAME (1940)
JONATHAN DEMME (1944)

Berenice Abbott

A slightly different take on the same spec-
tacular view from Downtown Manhattan
looking toward Midtown, 1936.

Eine etwas andere Aufnahme des
gleichen spektakulären Blicks von Down-
town nach Midtown Manhattan, 1936.

Deux prises légèrement différentes de la
même vue spectaculaire du Downtown
Manhattan vers Midtown, 1936.

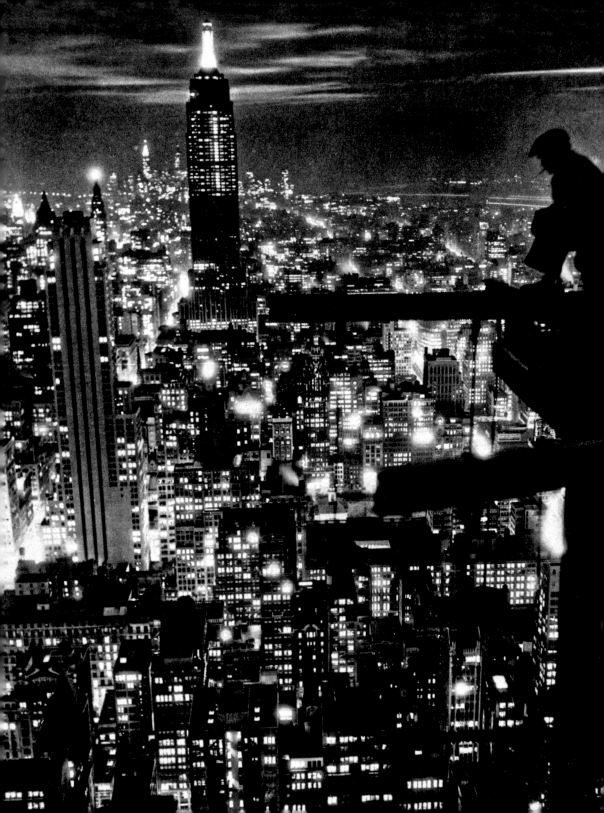

"Manhattan, Manhattan, Manhattan,
Manhattan
Manhattan madness
You've got me at last
I'm like a fly upon a steeple
Watching seven million people."

"MANHATTAN MADNESS," IRVING BERLIN, 1932

Anonymous

Night view from the RCA construction site, the building that was to become the jewel in the crown of the Rockefeller Center, 1932.

Nächtlicher Blick von der Baustelle des RCA. Das Gebäude sollte die prachtvolle Krönung des Rockefeller Center werden, 1932.

Vue de nuit prise du chantier de l'immeuble de la RCA, le futur joyau de la couronne du Rockefeller Center, 1932.

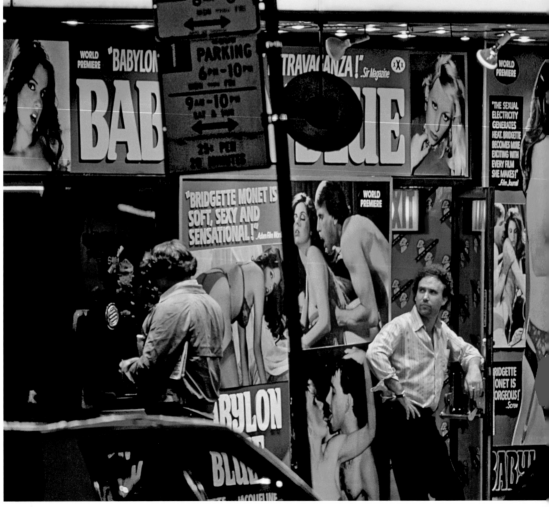

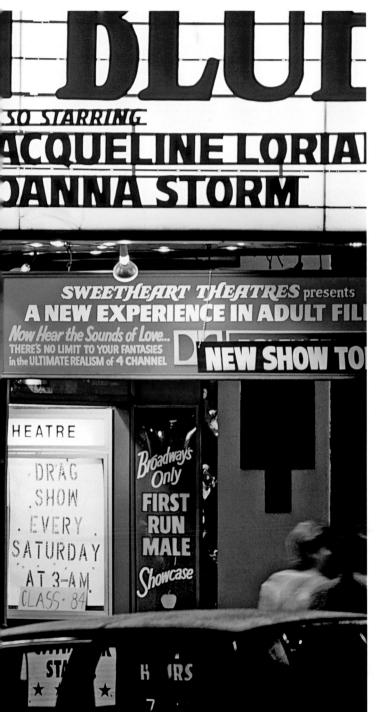

Masataka Nakano

A porno theater in Times Square. This really is an image of a bygone era. Since the revamping and sanitizing of the whole area in the early 1990s, Times Square is now a family-friendly destination, free of porn and sleaze— but, some would argue, also devoid of personality, 1980s.

Ein Pornokino am Times Square. Dieses Foto ist ein Bild aus der Vergangenheit, denn das gesamte Gebiet wurde zu Beginn der 1990er-Jahre aufgewertet und gesäubert. Times Square ist heute ein familienfreundliches Ziel ohne Pornografie und Abschaum, aber auch, wie manche sagen, ohne Persönlichkeit, 1980er-Jahre.

Un cinéma porno à Times Square. C'est en fait une image d'un passé disparu, puisque le quartier tout entier a été assaini et modernisé au début des années 1990. Times Square est aujourd'hui une destination familiale, sans pornographie ni dépravation, mais dont certains estiment qu'elle a perdu sa personnalité, années 1980.

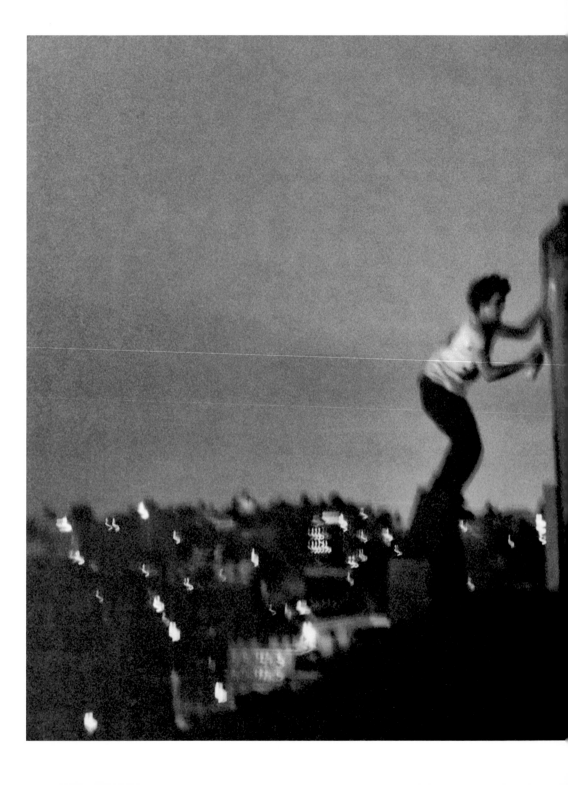

Ryan McGinley

The late artist Dash Snow tagging while
standing on a ledge of a hotel. Snow
died in 2009 from a drug overdose at
age 27, and some critics have compared
his death to the loss of Jean-Michel
Basquiat in 1988, 2000.

Der verstorbene Künstler Dash Snow
beim Sprayen auf dem Gesims eines
Hotels. Snow starb 2009 im Alter von
27 Jahren an einer Überdosis Drogen;
einige Kritiker verglichen seinen Tod
mit dem Verlust von Jean-Michel
Basquiat 1988, 2000.

L'artiste disparu, Dash Snow, taggant
debout sur le rebord de la toiture d'un
hôtel. Il mourut en 2009 d'une overdose
à l'âge de 27 ans. Certains critiques ont
comparé sa disparition à la perte de
Jean-Michel Basquiat en 1988, 2000.

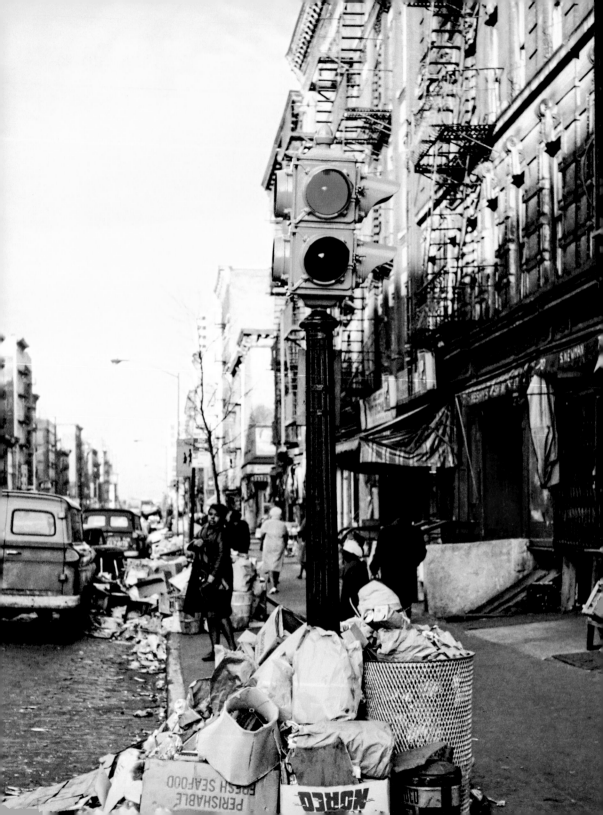

*"It's all bullshit except the pain.
The pain of hell."*

MEAN STREETS, 1973

Steve Shapiro

New York City garbage strike. By the late 1960s, the city's finances were in a mess and its disgruntled employees, including teachers and sanitation workers, seemed to be continually on strike. The garbage spilling onto the street and sidewalk is an apt metaphor for this period, 1968.

Streik der Müllabfuhr in New York City. Gegen Ende der 1960er-Jahre stand die Stadt knapp vor dem finanziellen Ruin, und die unzufriedenen Angestellten, darunter Lehrer und Müllmänner, hörten scheinbar gar nicht mehr auf zu streiken. Der Müll auf Straßen und Bürgersteigen ist eine passende Metapher für diese Zeit, 1968.

La grève des éboueurs. À la fin des années 1960, les finances de la ville étaient en pleine crise et ses employés mécontents, comme les enseignants ou les éboueurs, semblaient en grève permanente. Ces sacs d'ordures qui débordent dans la rue et sur le trottoir sont une assez bonne métaphore visuelle de cette période, 1968.

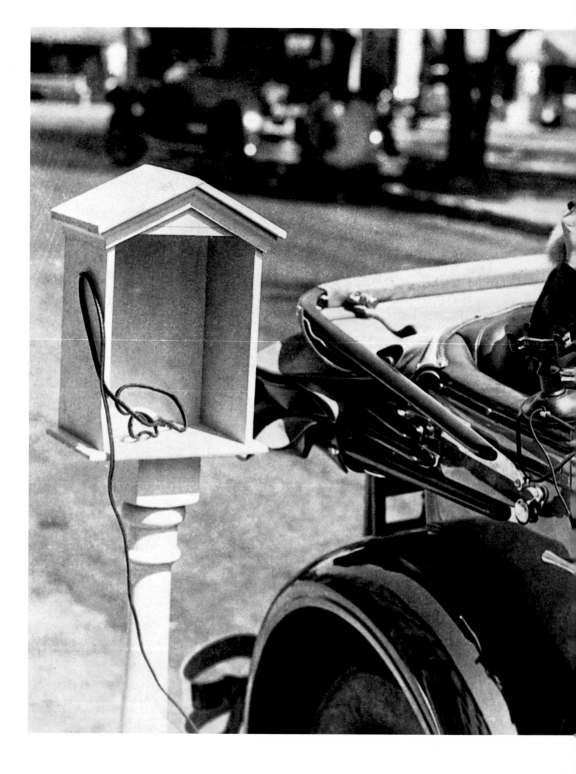

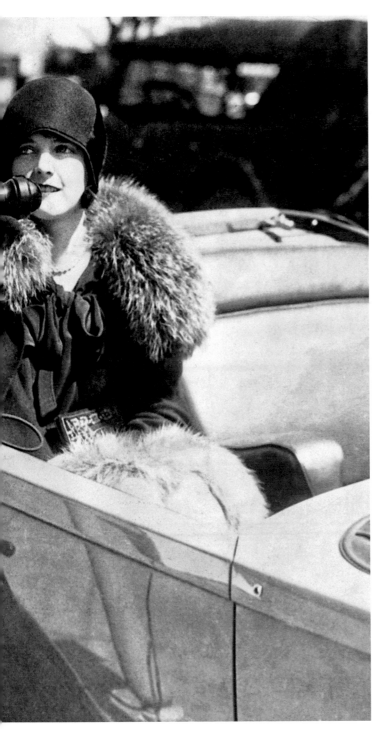

Anonymous

A fashionable lady phones from the
back seat of her open car. Some of the
larger and swankier New York hotels
supplied telephone boxes, thus enabling
their guests to contact reception and
carry out all kinds of requests and
errands, early 1920s.

Eine elegante Dame telefoniert auf dem
Rücksitz ihres offenen Wagens. Einige
der größeren und luxuriöseren New
Yorker Hotels stellten ihren Gästen Tele-
fone zur Verfügung, damit die Rezeption
kontaktiert und alle möglichen Anfragen
und Aufträge erledigt werden konnten,
Anfang der 1920er-Jahre.

Une dame élégante téléphone de l'arrière
de sa voiture découverte. Certains des
plus grands hôtels de New York propo-
saient des cabines téléphoniques privées,
ce qui permettait à leurs clients de
contacter la réception pour toutes sortes
de demandes, début des années 1920.

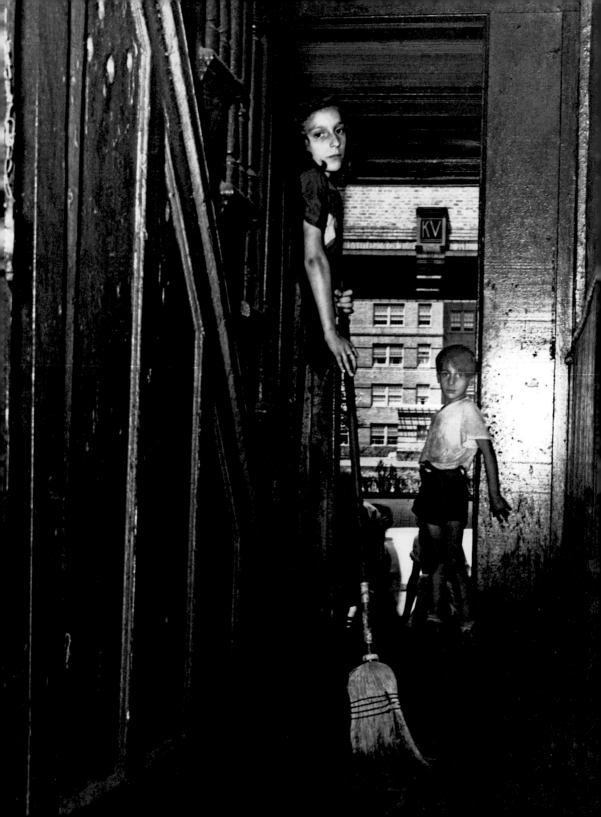

BERNADETTE PETERS (1948)
PAUL KRUGMAN (1953)
JOHN TURTURRO (1957)
JIMMY DORSEY (1904)

"New York City: an architectural jungle where fabulous wealth and the deepest squalor live side by side."

SIDE STREET, 1950

Arnold Eagle

Across Stuyvesant Town Development. Stuyvesant Town, near the East River, was a postwar housing project for returning veterans. It was built in 1942–43, but it is especially controversial because Parks Commissioner Robert Moses, who instigated the development, lobbied that the apartments be made available only to white veterans, early 1940s.

Gegenüber dem Bauprojekt Stuyvesant Town. Stuyvesant Town in der Nähe des East River war ein Wohnungsbauprojekt für Kriegsveteranen. Der Komplex wurde 1942/43 erbaut, war jedoch sehr umstritten, weil sich der Parkbeauftragte Robert Moses, auf dessen Betreiben die Anlage gebaut wurde, dafür einsetzte, dass die Wohnungen nur an weiße Veteranen vergeben werden sollten, Anfang der 1940er-Jahre.

Dans le grand ensemble de Stuyvesant Town. Stuyvesant Town, près de l'East River, était un projet immobilier destiné aux vétérans de retour de guerre. Il fut édifié en 1942–43, mais il fut l'objet de controverses. Le commissaire des parcs, Robert Moses, qui l'avait lancé, joua de son influence pour le réserver aux vétérans blancs, début des années 1940.

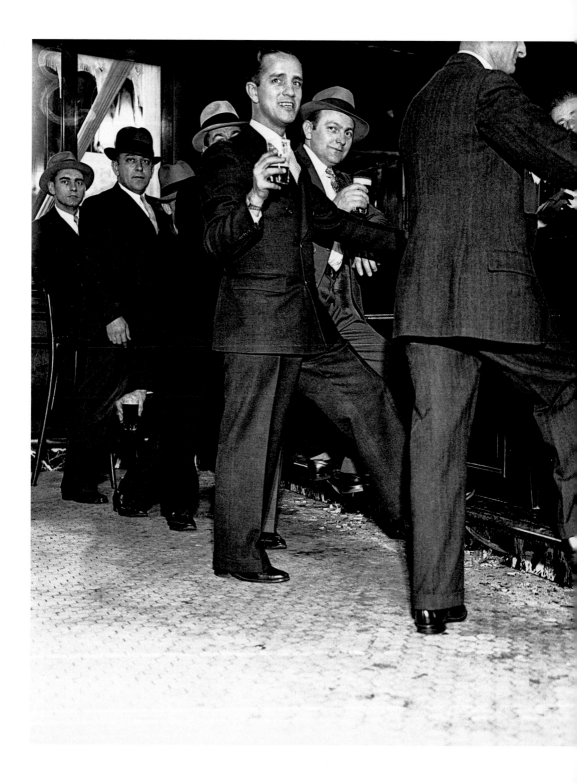

Anonymous

Celebrating the end of Prohibition
in the only way possible...by having
a drink, 1933.

Männer feiern das Ende der Prohibi-
tion auf die einzig mögliche Art und
Weise...mit einem Drink, 1933.

Hommes célébrant la fin de la prohi-
bition de la seule façon possible...en
buvant un verre, 1933.

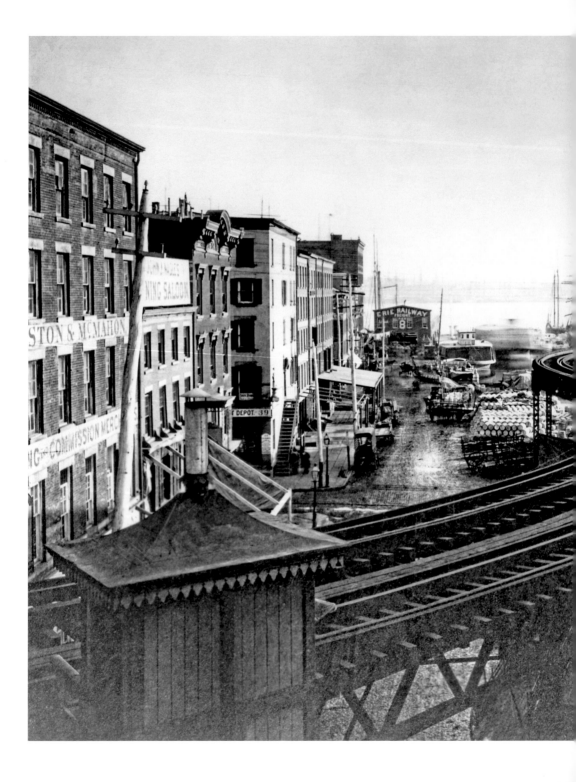

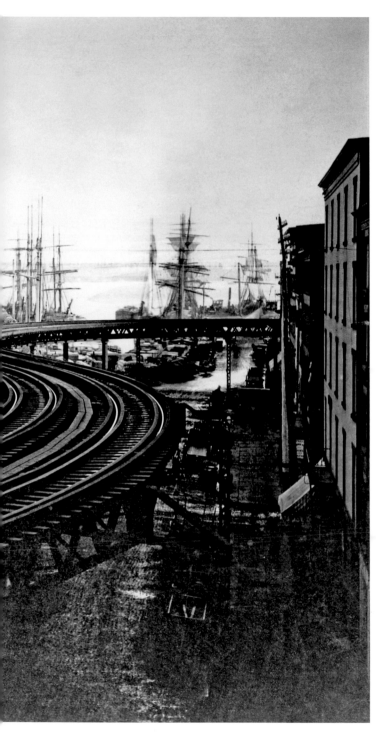

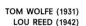
TOM WOLFE (1931)
LOU REED (1942)

Anonymous

Coenities Slip. This was the last remaining small harbor, or inlet, from the East River that ran just off Pearl Street in Downtown Manhattan. It was also the site of New York's first City Hall. The elevated train track represents modernity, while the ships moored in the harbor suggest an older New York, c. 1879.

Coenities Slip. Dieser letzte verbliebene kleine Hafen am East River lag kurz hinter der Pearl Street in Downtown Manhattan. Hier stand auch das erste Rathaus von New York. Die Gleise der Hochbahn repräsentieren moderne Technik, während die im Hafen liegenden Schiffe ein älteres New York vermuten lassen, um 1879.

Coenities Slip. C'était le dernier petit port subsistant sur l'East River au débouché de Pearl Street dans le Dowtown Manhattan. Ce fut également le site du premier hôtel de ville de New York. Le train aux voies surélevées représente la modernité, tandis que les bateaux ancrés dans le port suggèrent le passé de New York, vers 1879.

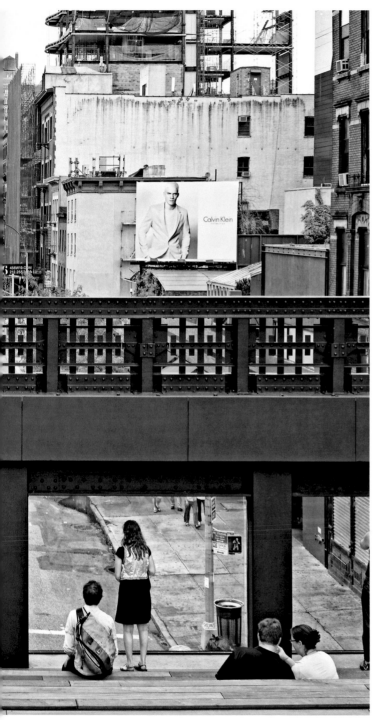

Floto/Warner

The designs for the completed High Line project extend from Gansevoort Street in the Meatpacking District to 34th Street. It runs for a mile and a half, and features an integrated landscape, meandering concrete pathways, and fixed and movable seating, 2009.

Der Entwurf für das High-Line-Projekt umfasst den Abschnitt von der Gansevoort Street im Meatpacking District bis zur 34th Street. Auf etwa 2,5 Kilometern Länge gibt es integrierte Grünflächen, gewundene Betonpfade sowie fest installierte und bewegliche Sitzgelegenheiten, 2009.

La nouvelle High Line court de la rue Gansevoort dans le quartier du Meat-packing à la 34e Rue. Sur près de 2,5 kilomètres, ce nouvel espace public est ponctué d'éléments paysagers, de cheminements sinueux en béton, de sièges fixes ou déplaçables, 2009.

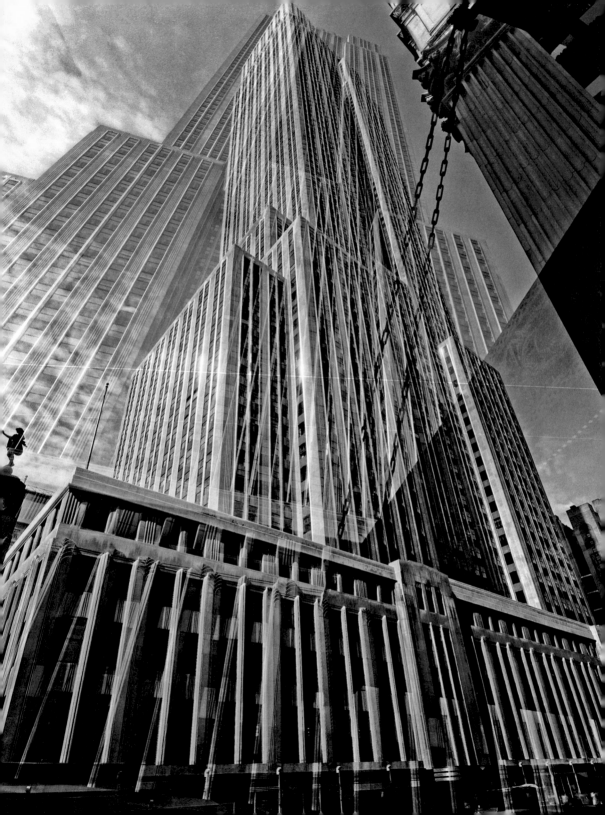

*"Walking between the magnificent skyscrapers
one feels the presence on the fringe of a howling,
raging mob, a mob with empty bellies, a mob
unshaven and in rags."*

"GLITTERING PIE," *THE COSMOLOGICAL EYE*, **HENRY MILLER, 1939**

Edward Steichen

Empire State Building. Zoning laws
stipulated that for buildings above a
certain height, exterior walls must be set
back from the street to allow light, 1932.

Empire State Building. Die Bauordnung
schrieb vor, dass die Gebäudefassaden
ab einer bestimmten Höhe zurückge-
setzt werden mussten, damit noch Licht
in die Straßen fiel, 1932.

Empire State Building. La réglementa-
tion du zonage stipulait que, pour les
immeubles d'une certaine hauteur, les
murs extérieurs devaient être en retrait
de la rue pour permettre à la lumière
naturelle de passer, 1932.

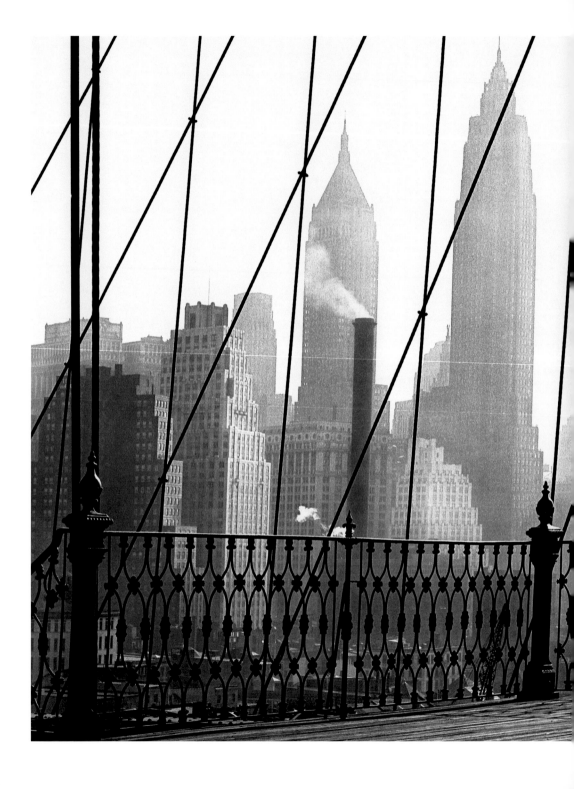

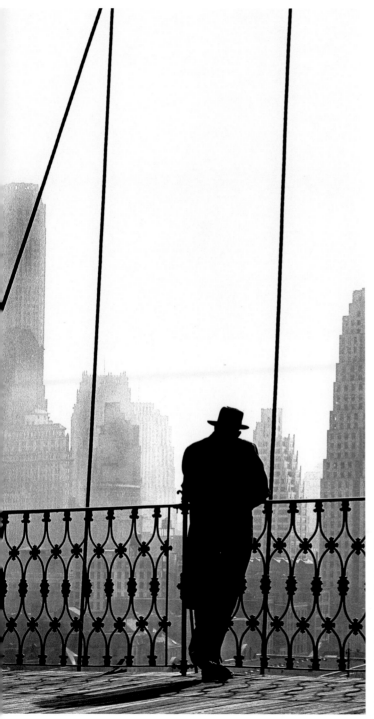

Paul Himmel

Brooklyn Bridge View. The tallest building in the photo is the American International Building, erected in 1930–32, 1950.

Blick von der Brooklyn Bridge. Das höchste Gebäude auf dem Foto ist das American International Building, das 1930 bis 1932 erbaut wurde, 1950.

Vue du pont de Brooklyn. L'immeuble le plus haut est l'American International Building, édifié entre 1930 et 1932, 1950.

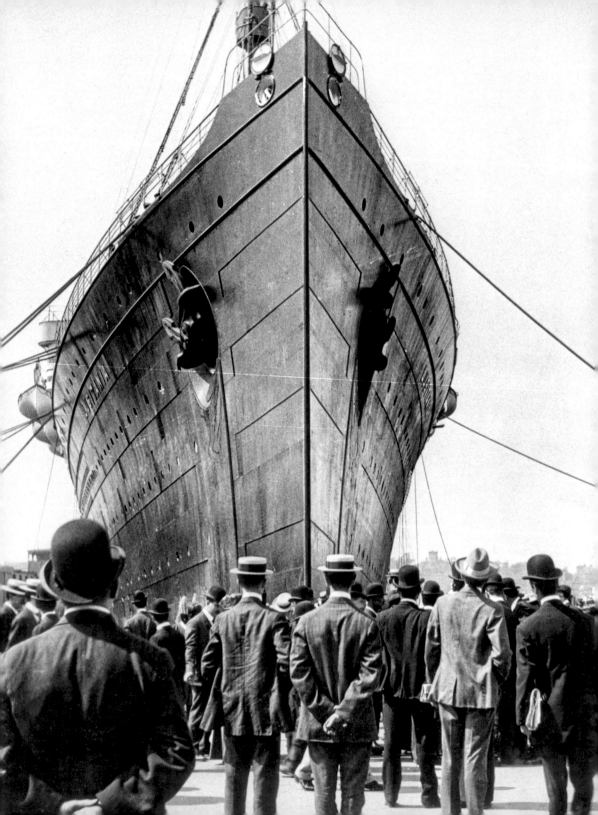

WILL EISNER (1917)
ALAN GREENSPAN (1926)

"A feller has to look sharp in this city, or he'll lose his eye-teeth before he knows it."

STREET LIFE IN NEW YORK WITH THE BOOTBLACKS,
HORATIO ALGER, JR., 1868

Anonymous

A crowd of onlookers enthralled by the British Cunard liner *RMS Lusitania* after her transatlantic maiden journey from Liverpool in 1907. In 1915, during World War I, a German U-boat sank the *Lusitania* just off the Irish coast.

Eine Zuschauermenge, fasziniert von der *RMS Lusitania* der britischen Cunard Line nach ihrer transatlantischen Jungfernfahrt 1907 von Liverpool aus. 1915, im Ersten Weltkrieg, versenkte ein deutsches U-Boot die *Lusitania* unmittelbar vor der irischen Küste.

Une foule de curieux fascinés par le paquebot de la Cunard, le *RMS Lusitania*, après sa traversée inaugurale à partir de Liverpool en 1907. Un sous-marin allemand coula le vaisseau au large des côtes irlandaises en 1915, pendant la Première Guerre mondiale.

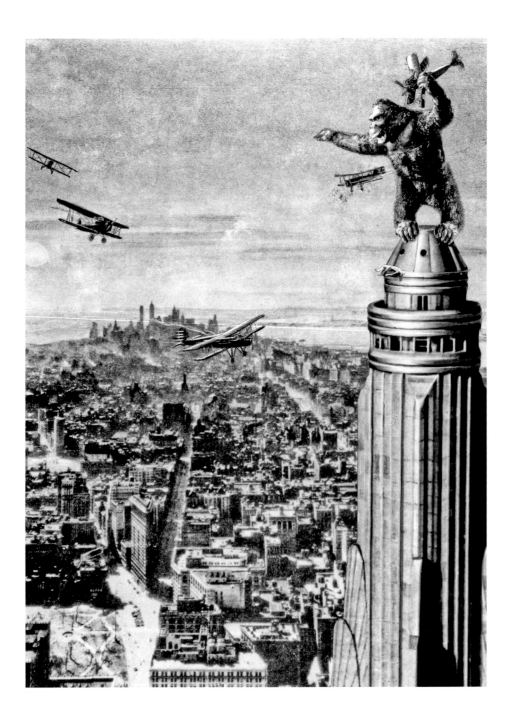

"We're millionaires, boys, I'll share it with all of you. Why, in a few months, it'll be up in lights on Broadway: 'Kong — the Eighth Wonder of the World!'"

KING KONG, 1933

Anonymous

A still from *King Kong*. The ape climbing to the top of the Empire State Building cemented the skyscraper in the public's consciousness, 1933.

Ein Standbild aus *King Kong*. Die berühmte Szene, in der der Affe am Empire State Building hochklettert, hat den Wolkenkratzer fest im öffentlichen Bewusstsein verankert, 1933.

Image extraite du film *King Kong*. Cette scène fameuse dans laquelle le singe géant escalade l'Empire State Building marquera à jamais la conscience du public, 1933.

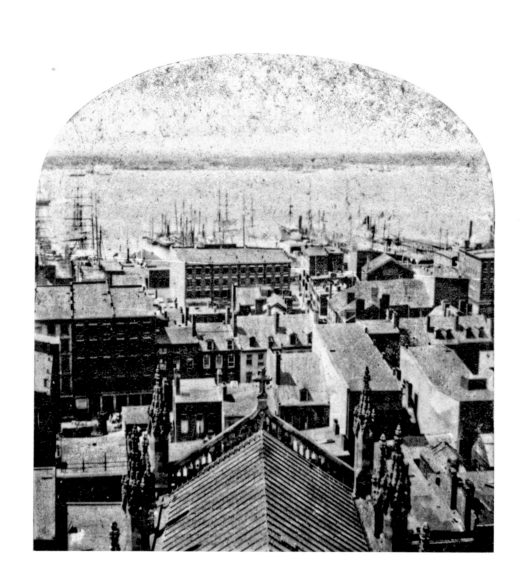

"The lofty new buildings, facades of marble and iron, or original grandeur and elegance of design... the right shops... the great Central Park... these I say, and the like of these completely satisfy my senses of power, fullness, motion..."

"DEMOCRATIC VISTAS," WALT WHITMAN, 1871

William England

View of Lower Manhattan taken from Trinity Church. Part of a stereoscopic view, taken from what was, at the time, the city's highest vantage point, c. 1859.

Ansicht von Lower Manhattan. Teil einer stereoskopischen Aufnahme vom damals höchsten Aussichtspunkt der Stadt aus, der Trinity Church, um 1859.

Vue du Lower Manhattan prise de l'église de la Trinité. Moitié d'une vue stéréoscopique, elle a été prise de ce qui était alors le point de vue le plus élevé possible sur Manhattan, vers 1859.

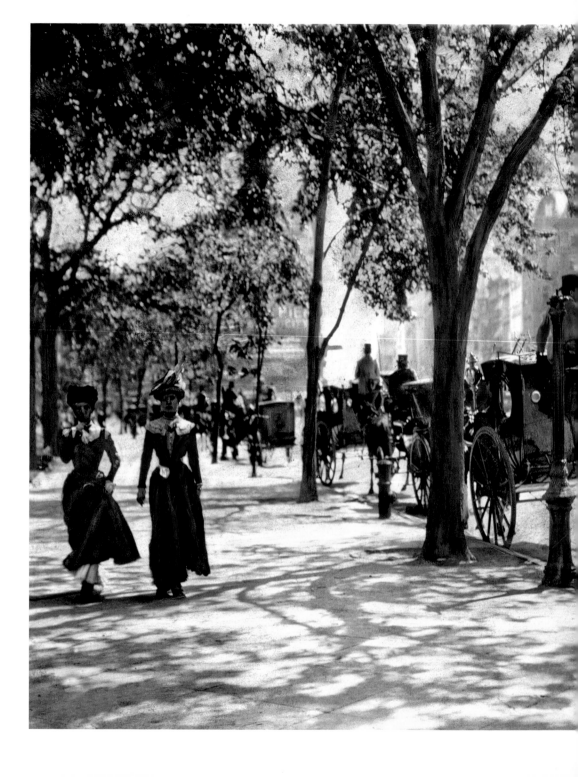

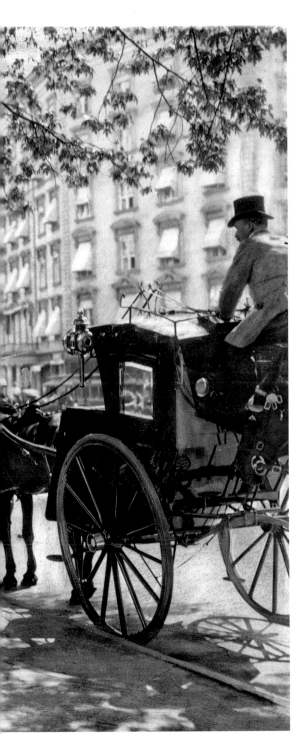

Anonymous

A carriage stand at Madison Square
Park, early 1900s.

Eine Haltestelle für Kutschen am
Madison Square Park, Anfang des
20. Jahrhunderts.

Fiacre en attente devant Madison
Square Park, début des années 1900.

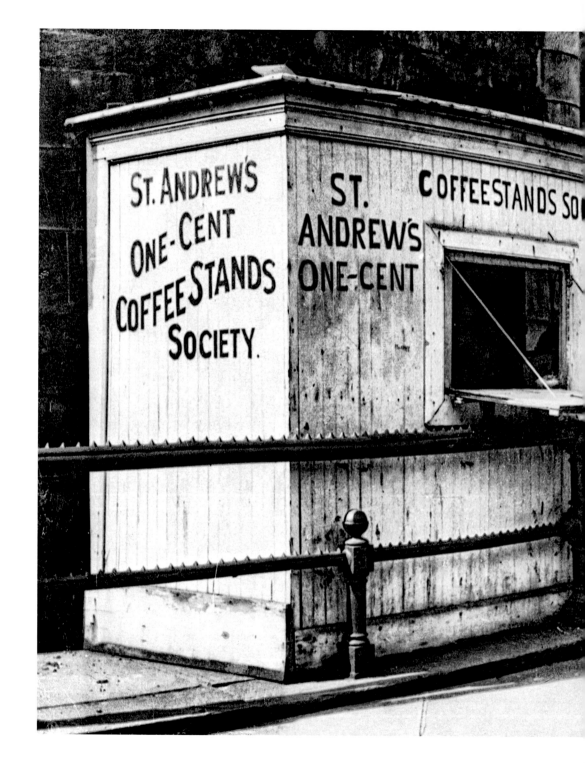

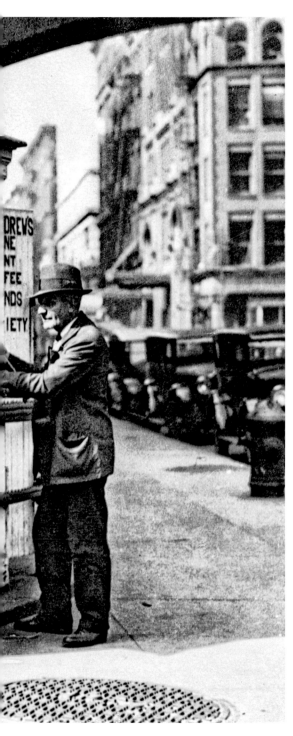

Anonymous

One-cent coffee stand, 1933.

Kiosk mit Kaffee für einen Cent, 1933.

Stand de café à un cent, 1933.

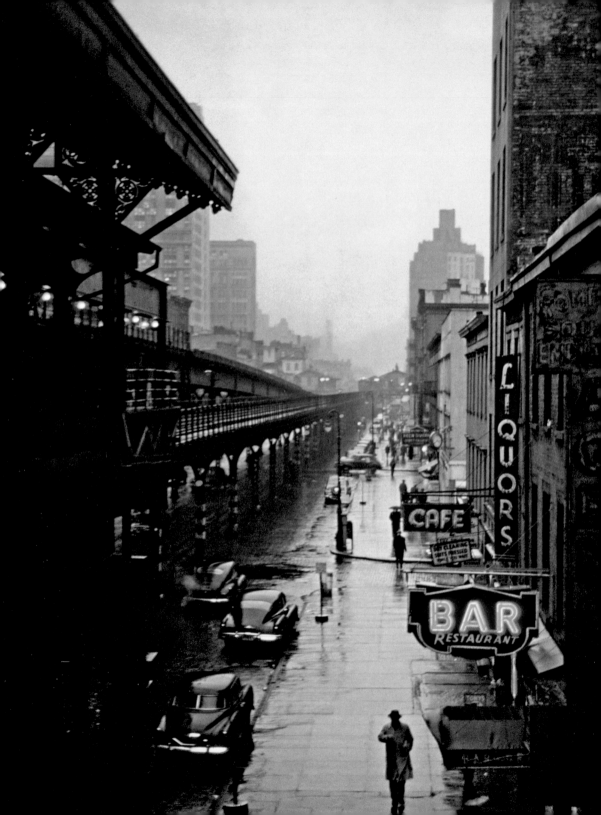

"I've been looking
for a girl every Saturday
night of my life."

MARTY, 1955

Esther Bubley

The Third Avenue elevated train was torn down in 1955, and while the streets that it ran along were suddenly flooded with light, the Manhattan landscape lost one of its most enduring features. Bubley's image was taken in 1951, a few years before the El train was demolished, and are very much a homage to the past. The elevated trains were quickly forgotten, like the horse cars before them, 1951.

Die Third-Avenue-Hochbahn wurde 1955 abgerissen. Während die Straßen, an denen sie entlangführte, plötzlich lichtdurchflutet waren, verlor Manhattan doch eines seiner markantesten Merkmale. Bubley nahm ihr Bild 1951 auf, ein paar Jahre, bevor die Hochbahn abgerissen wurde. Sie sind eine Hommage an die Vergangenheit. Wie die Kutsche vor ihr wurde auch die Hochbahn schnell vergessen, 1951.

Les voies suspendues de la Troisième Avenue furent démantelées en 1955 et les rues qu'elles empruntaient furent brusquement inondées de lumière. Le paysage de Manhattan perdit alors un de ses traits les plus marquants. L'image de Bubley date de 1951, quelques années avant la démolition du «El», et sont une sorte de salut au passé. Ces trains furent vite oubliés comme l'avaient été les voitures à cheval quelques décennies plus tôt, 1951.

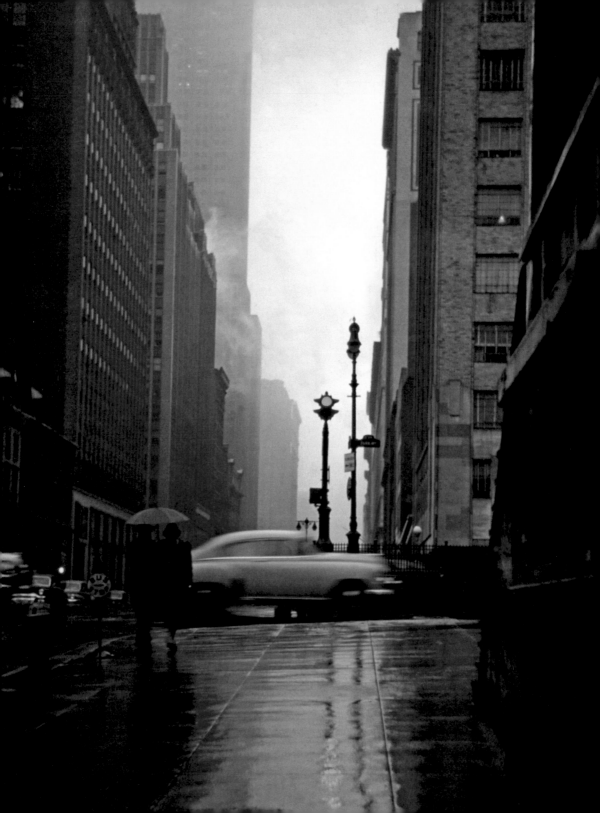

"Oh, you're going to New York and then some day we'll all hear of you, won't we?"

SINGIN' IN THE RAIN, 1952

Esther Bubley

Third Avenue on a rainy day, 1951.

Die Third-Avenue an einem regnerischen Tag, 1951.

La Troisième Avenue sous la pluie, 1951.

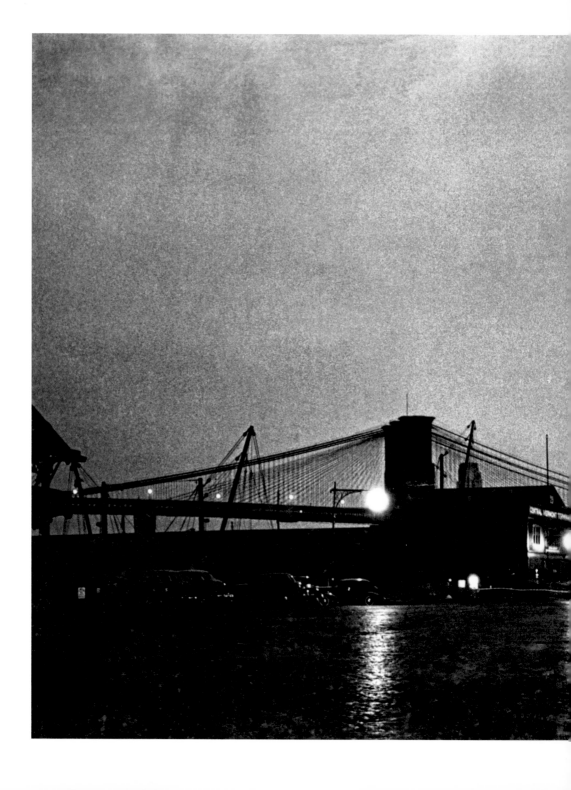

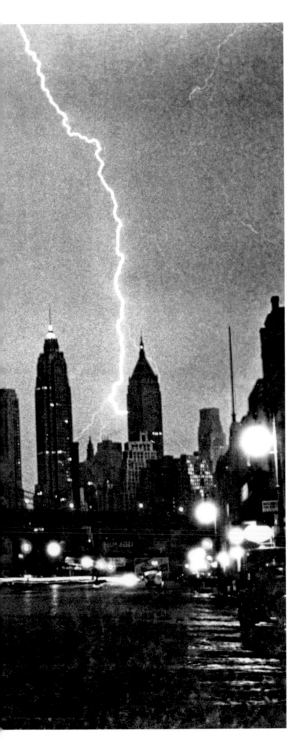

Weegee

Striking Beauty. A bolt of lightning over Manhattan dramatically captured by Weegee, 1940.

Faszinierende Schönheit. Ein Blitz über Manhattan, dramatisch fotografiert von Weegee, 1940.

Beauté frappante. Spectaculaire éclair sur Manhattan capté par Weegee, 1940.

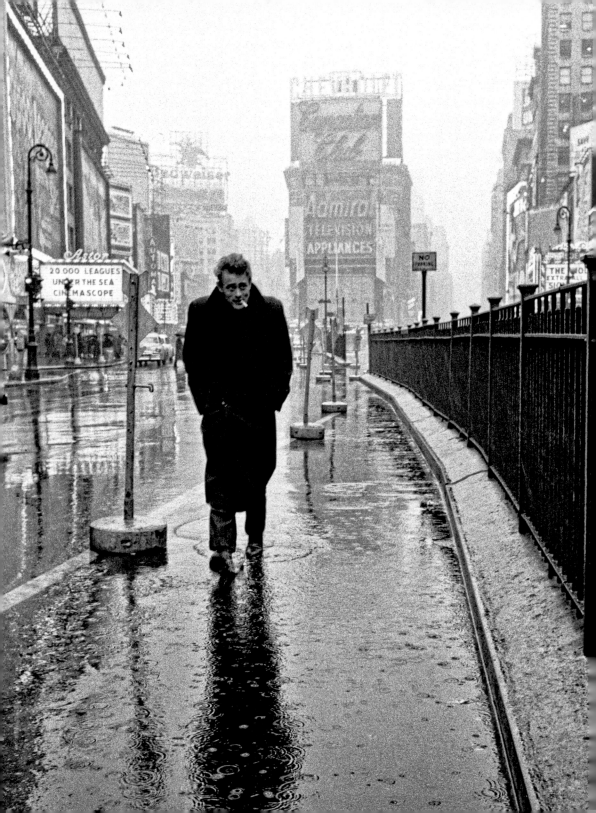

"They sprawled along the counter and on the chairs. Another night. Another drag of a night in the Greeks, a beat-up, all-night diner near the Brooklyn army base."

LAST EXIT TO BROOKLYN, HUBERT SELBY, JR., 1957

Dennis Stock

James Dean, Times Square, 1955.

James Dean am Times Square, 1955.

James Dean à Times Square, 1955.

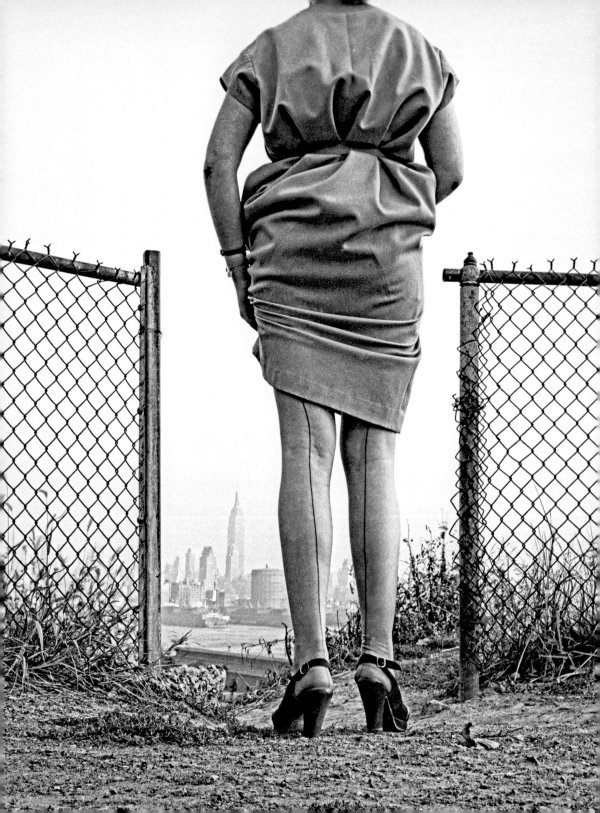

RUTH BADER GINSBURG (1933)

"Around the corner,
 Or whistling down the river,
Come on, deliver
To me!"

WEST SIDE STORY, 1957

Hanns Hubmann

Stockings and the Skyline of
New York, 1951.

Strümpfe und die Skyline von
New York, 1951.

Bas à coutures sur fond de panorama
de New York, 1951.

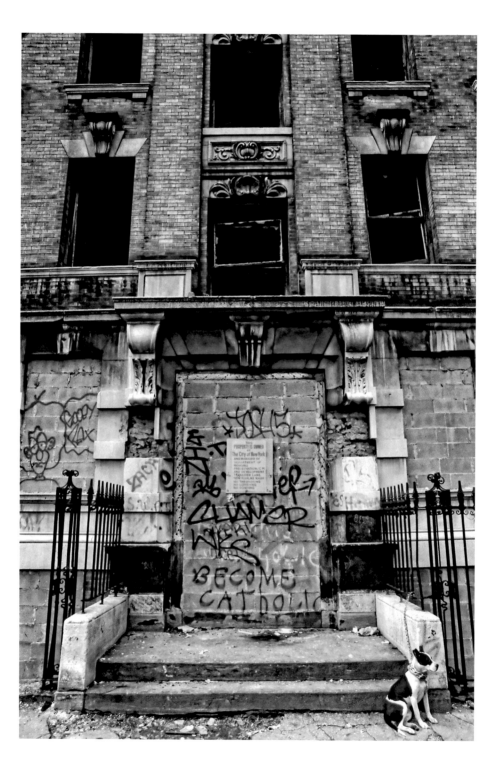

"Not only is New York City the nation's melting pot, it is also the casserole, the chafing dish and the charcoal grill."

MAYOR JOHN V. LINDSAY, 1966

Eli Reed

Condemned Building in Harlem. This was taken in the late 1980s, when Harlem was going through one of its more depressed and troubled periods. Yet, just over ten years later, Harlem experienced a renaissance, though locals resented spiraling property prices and the area's remarkable transformation, 1988.

Zum Abriss bestimmtes Gebäude in Harlem. Dieses Foto entstand gegen Ende der 1980er-Jahre, als Harlem eine seiner schlimmsten Krisen durchmachte. Doch nur zehn Jahre später erlebte der Stadtteil eine Renaissance, obwohl die Bewohner die steigenden Immobilienpreise und die bemerkenswerte Umwandlung der Gegend kritisch betrachteten, 1988.

Immeuble condamné à Harlem. Photo prise à la fin des années 1980, lorsqu'Harlem traversait l'une de ses périodes les plus déprimées et les plus troublées. Et pourtant, à peine dix ans plus tard, Harlem connut une nouvelle renaissance, même si ses habitants n'apprécient pas la montée des prix de l'immobilier et les transformations du quartier, 1988.

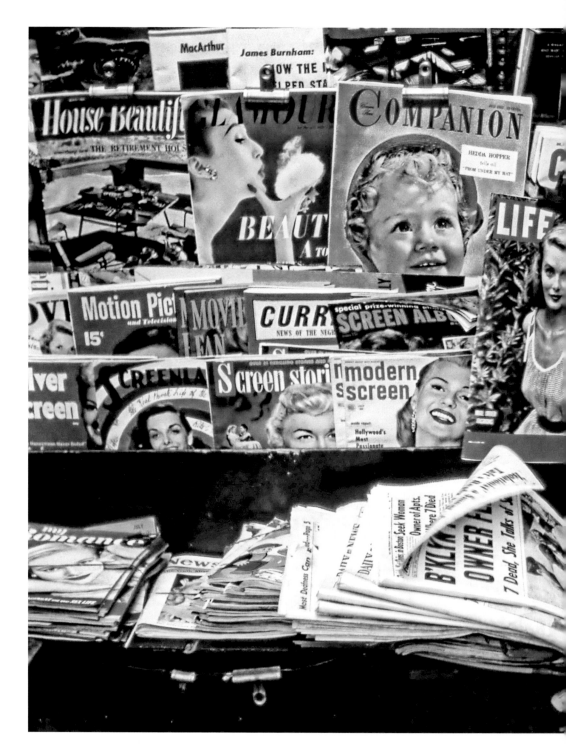

Ruth Orkin

A magazine stand during the golden age of periodicals, when the public's appetite for weekly and monthly publications appeared insatiable, early 1950s.

Ein Zeitschriftenkiosk in der goldenen Ära der Zeitschriften, als wöchentlich und monatlich erscheinende Magazine von den Lesern geradezu verschlungen wurden, Anfang der 1950er-Jahre.

Un stand de presse pendant l'âge d'or des magazines, alors que l'appétit du public pour les hebdomadaires et les mensuels semblait insatiable, début des années 1950.

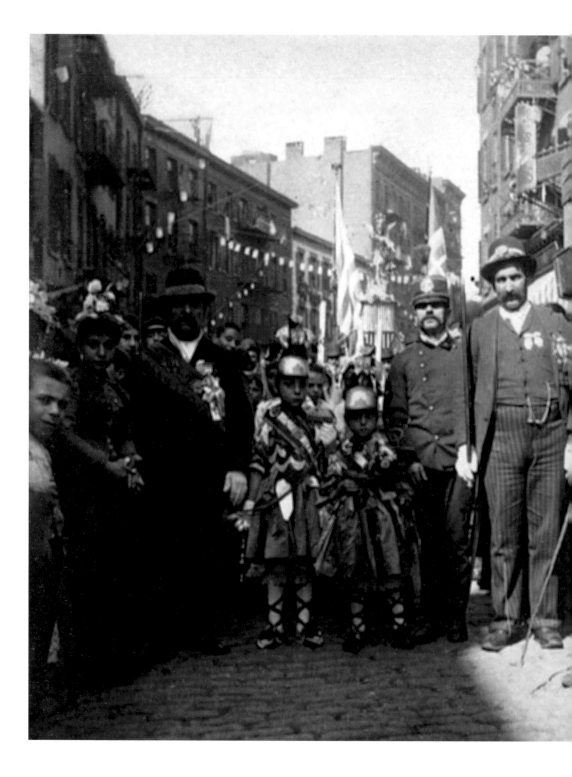

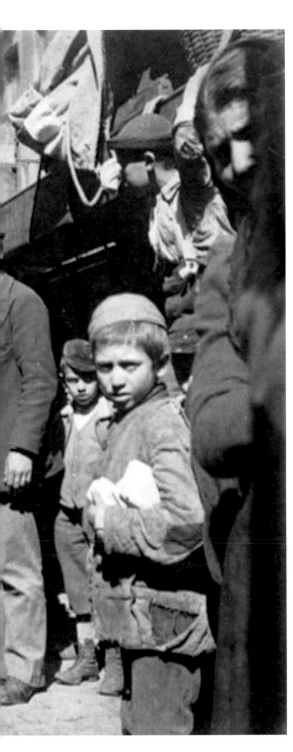

GEORGE PLIMPTON (1927)
JOHN UPDIKE (1932)

Julius Wilcox

Mulberry Bend on the Lower East
Side. Policeman, kids in costume,
and other local characters are all in
the photograph, 1892.

Mulberry Bend auf der Lower East Side.
Dieses Foto zeigt Polizisten, Kinder in
Trachten und andere zünftig gekleidete
Gestalten, 1892.

Mulberry Bend dans le Lower East
Side. Scène de rue avec policier,
enfants, et autres personnages curieu-
sement vêtus, 1892.

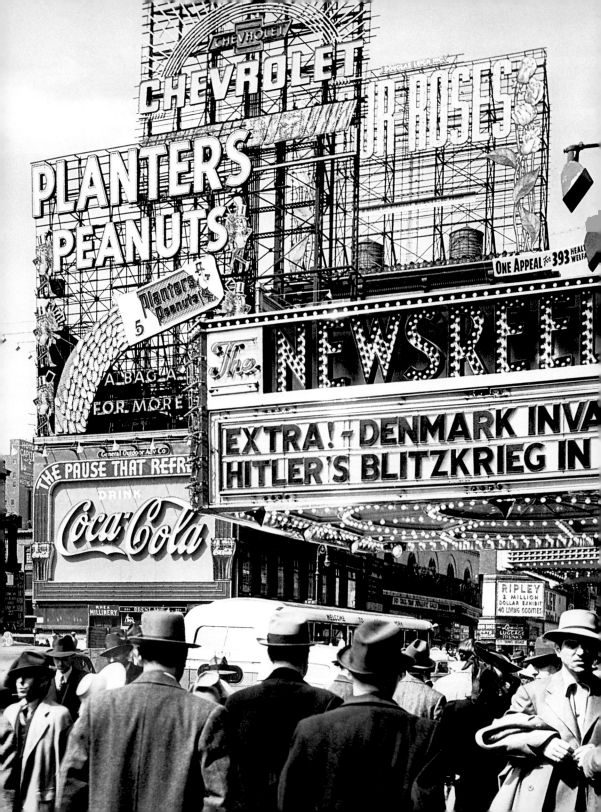

GLENN CLOSE (1947)

"I like it here in New York. I like the idea of having to keep eyes in the back of your head all the time."

JOHN CALE, 1989

Andreas Feininger

Times Square. There is something incongruous about the neon signs advertising peanuts and Coca-Cola and the movie theater advertising its latest newsreel, which is about the Nazi invasion of Denmark, 1940.

Times Square. Die Leuchtreklamen für Erdnüsse und Coca-Cola und das Kino mit seiner Ankündigung der neuesten Wochenschau über die Invasion der Nazis in Dänemark passen nicht recht zusammen, 1940.

Times Square. Il y a quelque chose d'incongru dans le rapprochement entre les enseignes au néon pour des cacahuètes et du Coca-Cola et le panneau du cinéma annonçant l'invasion du Danemark par les Nazis dans les actualités, 1940.

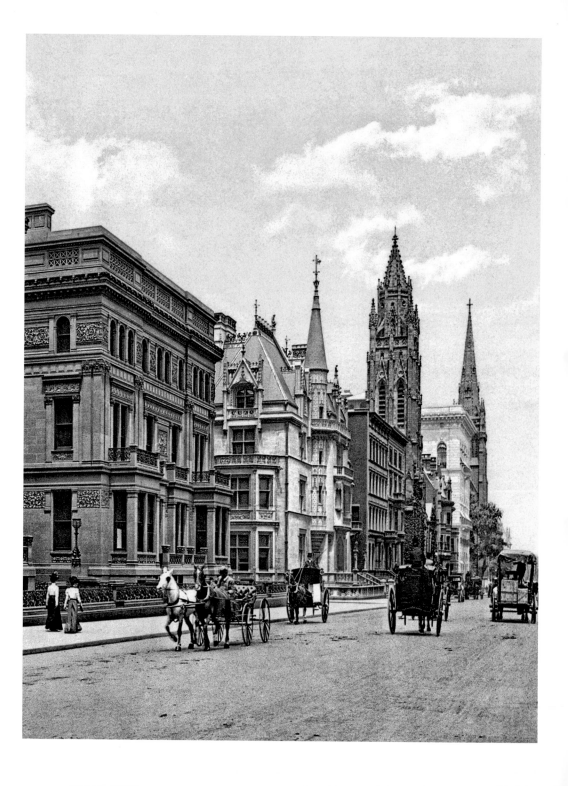

"Fifth Avenue in the fifties is officially the world's most expensive shopping street."

HUFFINGTON POST, 2010

Anonymous

Fifth Avenue and 51st Street. After Broadway, Fifth Avenue is New York's most famous street. When this image was taken, it was the place where the city's captains of industry built their fabulous mansions. St. Patrick's Cathedral, the country's largest Roman Catholic church, can also be seen in this image, 1900.

Fifth Avenue und 51st Street. Die Fifth Avenue ist nach dem Broadway die berühmteste Straße von New York. Als dieses Bild entstand, war sie der angesagteste Ort der Stadt, und die Industriemagnaten bauten hier ihre prunkvollen Villen. St. Patrick's Cathedral, die größte römisch-katholische Kirche des Landes, ist ebenfalls auf diesem Foto zu sehen, 1900.

Cinquième Avenue et 51e Rue. Après Broadway, la Cinquième Avenue est la plus célèbre artère de New York. Lorsque cette photo a été prise, c'était le lieu où les grands capitaines d'industrie faisaient construire leur résidence. On aperçoit également la cathédrale Saint-Patrick, la plus grande église catholique romaine du pays, 1900.

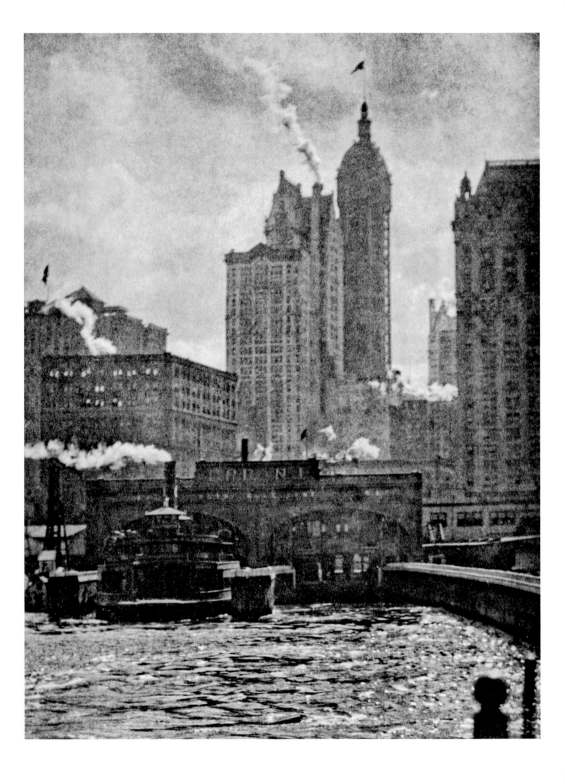

FLORENZ ZIEGFELD, JR. (1867)
HANS HOFMANN (1880)
MATTHEW BRODERICK (1962)
ROSIE O'DONNELL (1962)

"This is a city. This is New York. Twenty-two storied houses, dark soundless skyscrapers stand on the shore. Square, lacking in any desire to be beautiful."

MAXIM GORKY, 1906

Alfred Stieglitz

City of Ambition. The new skyscrapers of Downtown Manhattan rise above the New York harbor like sails on clipper ships. The port, the smoke, the boats, the skyscrapers, the title of the image, all suggest a modern city engaged in commerce, 1910.

Stadt der Ambitionen. Die neuen Wolkenkratzer in Downtown Manhattan ragen über dem Hafen von New York empor wie die Segel eines Klippers. Der Hafen, der Rauch, die Boote, die Wolkenkratzer, der Titel des Fotos – all das weist auf eine moderne Handelsstadt hin, 1910.

La cité de l'ambition. Les nouveaux gratte-ciel du Downtown Manhattan s'élèvent au-dessus du port comme des voiles de clippers. Le port, la fumée, les bateaux, les gratte-ciel, le titre de l'image, tout suggère une cité moderne dédiée au commerce, 1910.

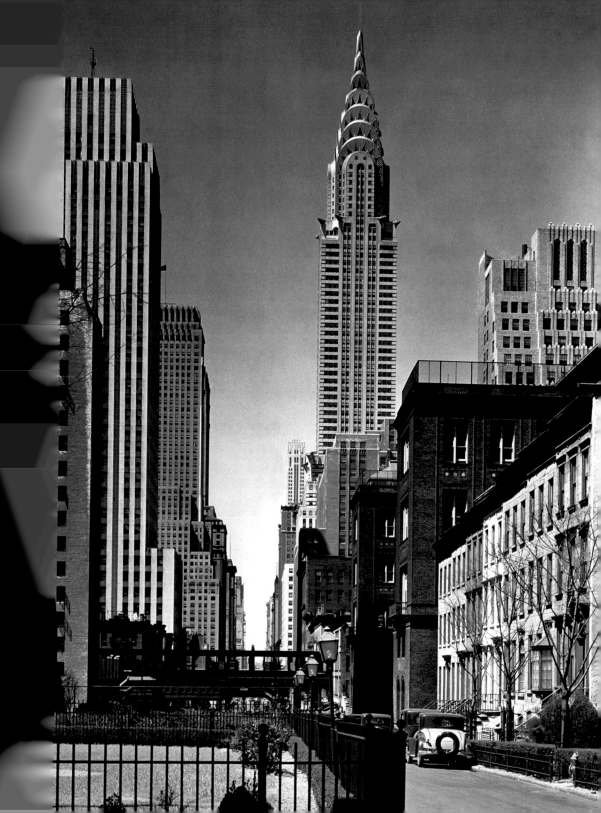

"It is distinctly a stunt design, evolved to make the man in the street look up. To our mind, however, it has no significance as a serious design"

THE NEW YORKER, 1930

Samuel H. Gottscho

The Chrysler Building and 42nd Street, photographed from Tudor City. Completed in 1928 on the East Side of Manhattan, Tudor City is a housing complex, specifically targeted for the affluent middle classes, late 1930s.

Das Chrysler Building und die 42nd Street, fotografiert von Tudor City aus. Tudor City ist ein 1928 fertiggestellter Wohnkomplex auf der East Side von Manhattan, der speziell für die wohlhabende Mittelschicht konzipiert wurde, Ende der 1930er-Jahre.

Le Chrysler Building et la 42e Rue, photographiés de Tudor City dans l'East Side. Achevé en 1928, Tudor City est un ensemble de logements spécialement destinés à une bourgeoisie aisée, fin des années 1930.

Lee Friedlander

Some of the key artists of the era, people such as Keith Haring and Jean-Michel Basquiat, started out as graffiti taggers, 1986.

Einige der wichtigen Künstler dieser Zeit, zum Beispiel Keith Haring und Jean-Michel Basquiat, begannen ihre Karriere als Grafitti-Sprayer, 1986.

Certains des artistes essentiels de la période, comme Keith Haring ou Jean-Michel Basquiat, ont commencé par être des taggers, 1986.

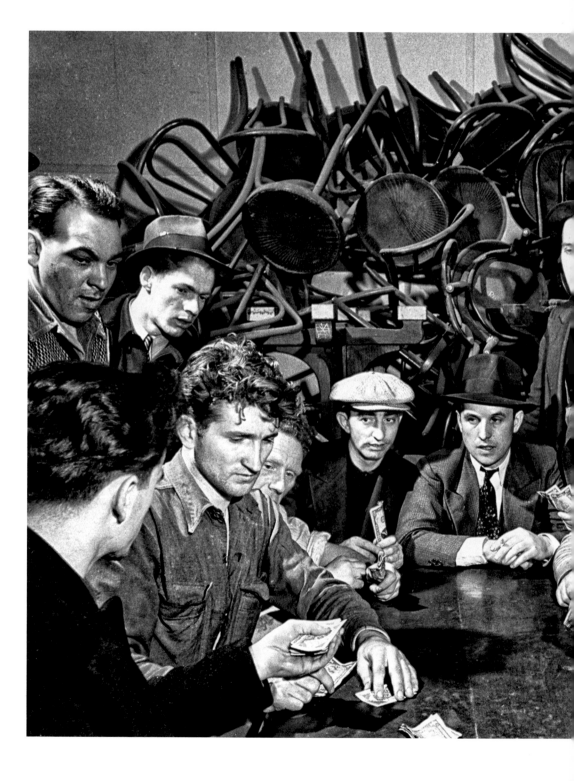

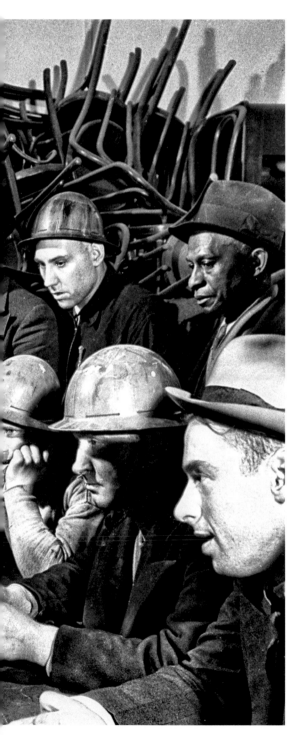

ALEX STEINWEISS (1917)
TOMMY HILFIGER (1951)

Carl Mydans

Sandhogs playing cards as they take
a well-deserved break from the strains
and dangers of the job, 1939.

Sandhogs beim Kartenspiel während
einer wohlverdienten Pause von ihrem
anstrengenden und gefährlichen Job,
1939.

Sandhogs jouant aux cartes, pause bien
méritée au milieu des difficultés et des
dangers de leur métier, 1939.

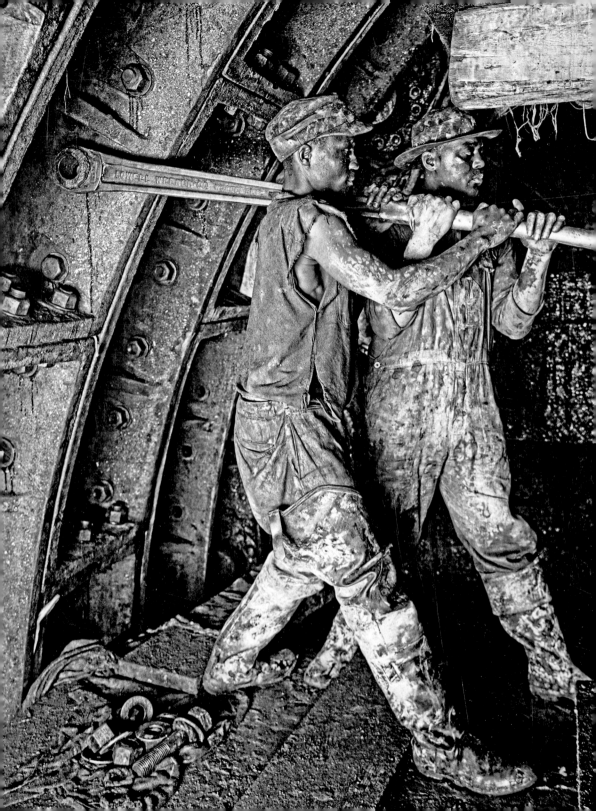

GLORIA STEINEM (1934)
SARAH JESSICA PARKER (1965)

"In a period of prodigious public expenditures, Robert Moses emerges as the most farsighted and constructive of public spenders."

"ROBERT MOSES: AN ATLANTIC PORTRAIT," CLEVELAND ROGERS, 1939

Anonymous

Sandhogs. This was the term for the workers who labored many feet below ground, building the city's sewer system, water canals, subways, tunnels, and railroad tracks, 1927.

Sandhogs. Dies war der Slangausdruck für die Männer, die viele Meter tief unter der Erdoberfläche arbeiteten und das Kanalisationssystem der Stadt, Wasserleitungen, U-Bahn-Schächte, Tunnel und Eisenbahngleise bauten, 1927.

Sandhogs. C'était le terme désignant les ouvriers qui travaillaient dans les profondeurs du sol pour creuser les égouts, les canalisations des eaux, le métro, des tunnels pour les trains et les voitures, 1927.

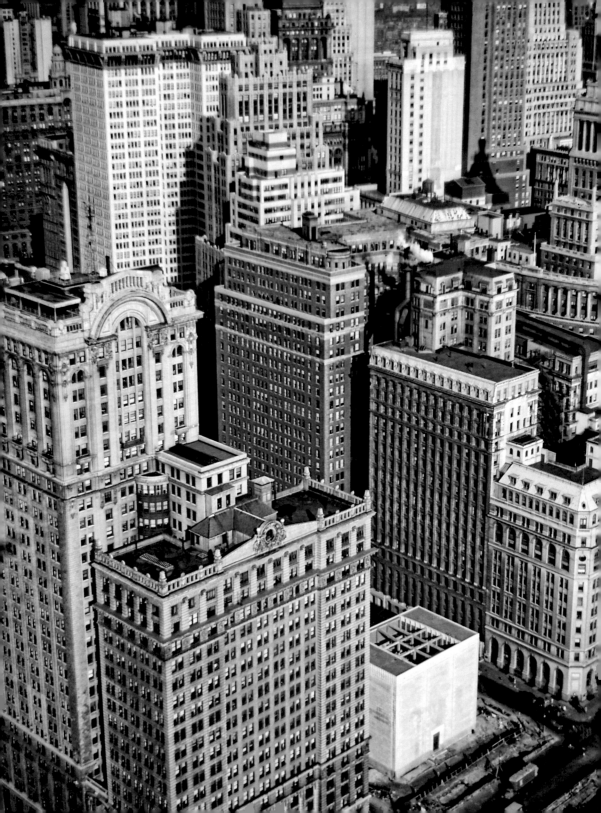

"This is the city of dreamers. And time and again, it's the place where the greatest dream of all, the American dream, has been tested and has triumphed."

MAYOR MICHAEL BLOOMBERG, 2004

Charles Rotkin

An aerial shot of Downtown Manhattan office buildings, 1950s.

Ein Luftbild von Bürogebäuden in Downtown Manhattan, 1950er-Jahre.

Vue aérienne des immeubles de bureaux du Downtown Manhattan, années 1950.

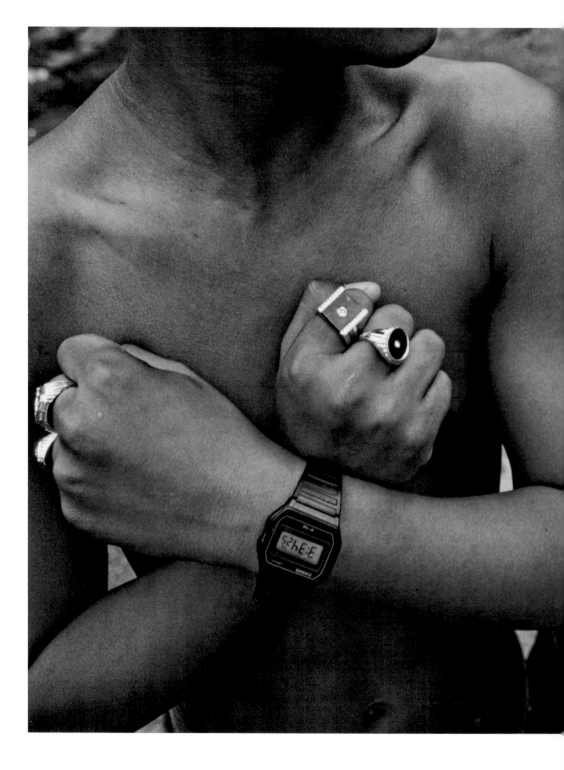

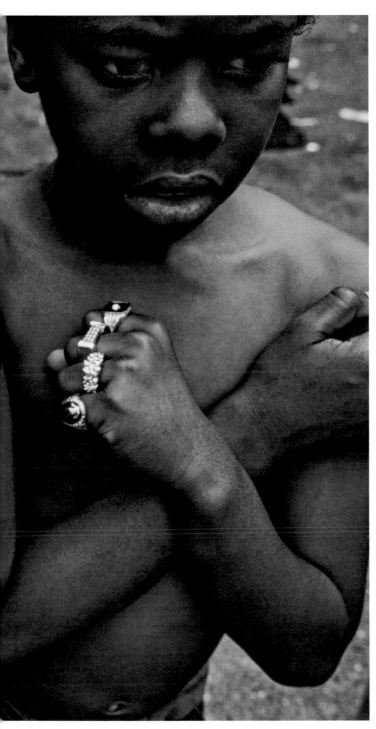

EDWARD J. STEICHEN (1879)
MARIAH CAREY (1970)

Joseph Rodriguez

The Rings. Children in Spanish Harlem showing off their decorative jewelry, 1980s.

Ringe. Kinder in Spanish Harlem zeigen stolz ihren Modeschmuck, 1980er-Jahre.

Les bagues. Des enfants de Spanish Harlem exhibent leurs bijoux de pacotille, 1980.

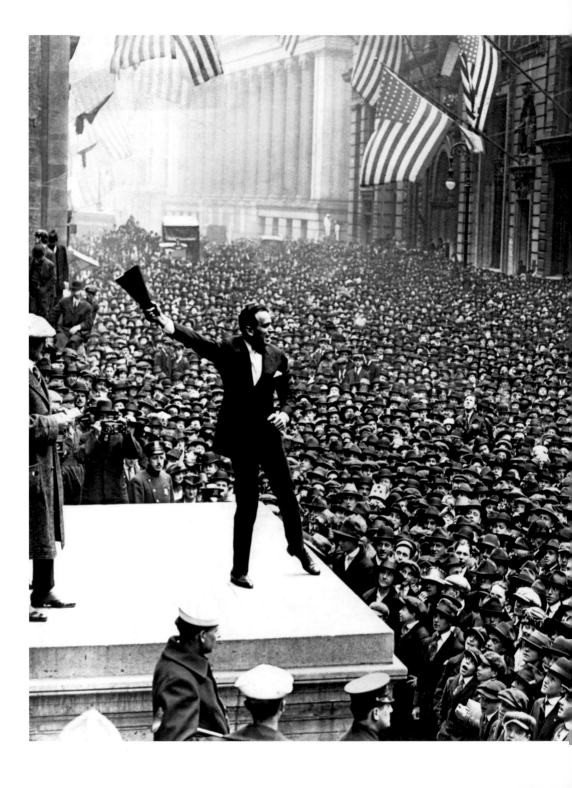

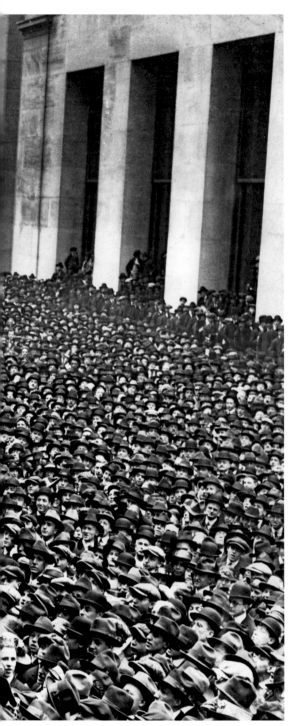

Underwood & Underwood

Silent movie star Douglas Fairbanks
on Wall Street for a rally supporting
the purchase of Liberty Bonds. These
bonds helped fund the Allied effort
during World War I, and buying them
was considered patriotic, 1918.

Stummfilmstar Douglas Fairbanks auf
der Wall Street bei einer Kundgebung
zur Unterstützung des Kaufs von
Kriegsanleihen, die den Einsatz der
Alliierten im Ersten Weltkrieg mitfinan-
zieren sollten. Der Kauf dieser Anleihen
galt als patriotisch, 1918.

La vedette du cinema muet Douglas
Fairbanks à Wall Street dans une mani-
festation en faveur de l'achat de «Bons
de la liberté». Ces bons permettaient
de soutenir l'effort de guerre des
Alliés et les acheter était une marque
de patriotisme, 1918.

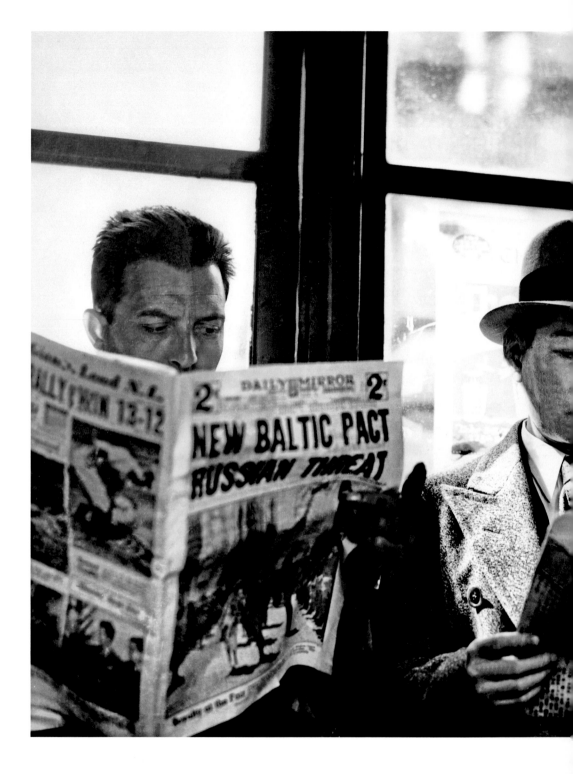

Arnold Eagle

Commuters closely following events
during World War II. The newspaper
headline refers to the terrible prospect
of an alliance between Stalin and
Hitler, 1939.

Pendler, die aufmerksam die Ereignisse
des Zweiten Weltkriegs verfolgen. Die
Zeitungsschlagzeile bezieht sich auf die
furchtbare Aussicht auf ein Bündnis
zwischen Stalin and Hitler, 1939.

Des banlieusards suivent les événements
de la Seconde Guerre mondiale. Le titre
du journal évoque la perspective terrible
d'une nouvelle alliance entre Staline et
Hitler, 1939.

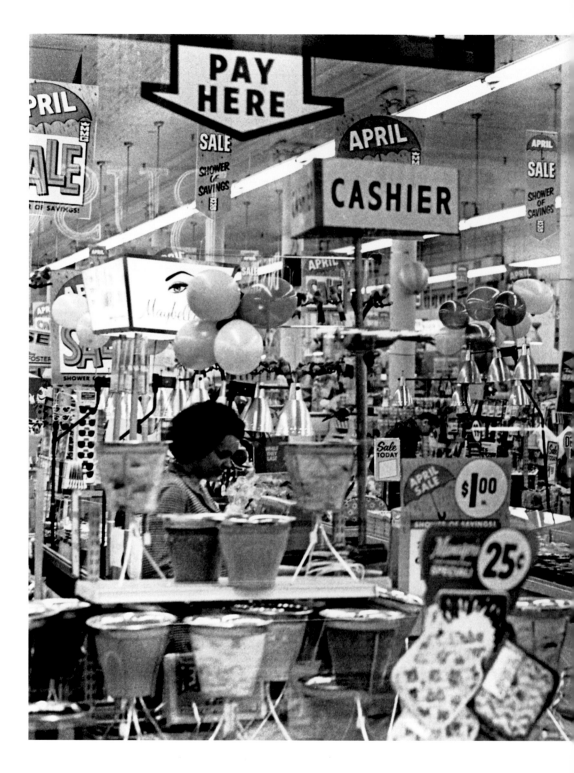

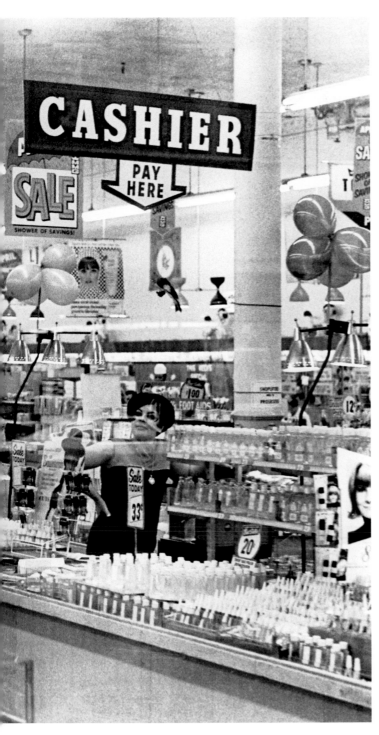

James Jowers

14th Street at Union Square, 1967.

14th Street am Union Square, 1967.

14e Rue près de Union Square, 1967.

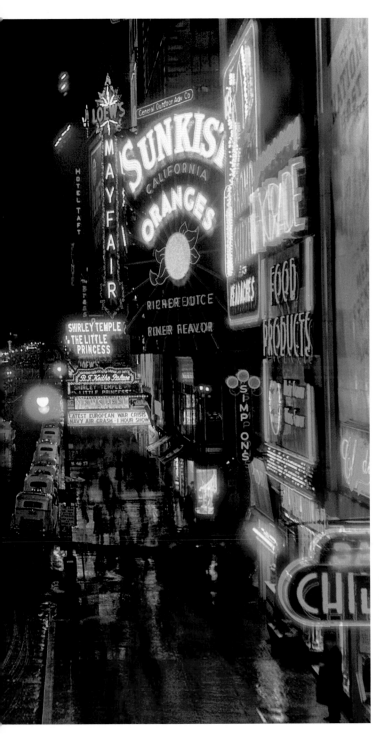

DAN GRAHAM (1942)
CHRISTOPHER WALKEN (1943)
VANESSA DEL RIO (1952)

Anonymous

Times Square on a rainy night
when the only cars out seem to
be yellow cabs, 1939.

Times Square in einer verregneten
Nacht, als anscheinend nur noch die
gelben Taxis unterwegs sind, 1939.

Times Square par une nuit pluvieuse. Les
seules voitures semblent être les fameux
« Yellow cabs », les taxis jaunes. 1939.

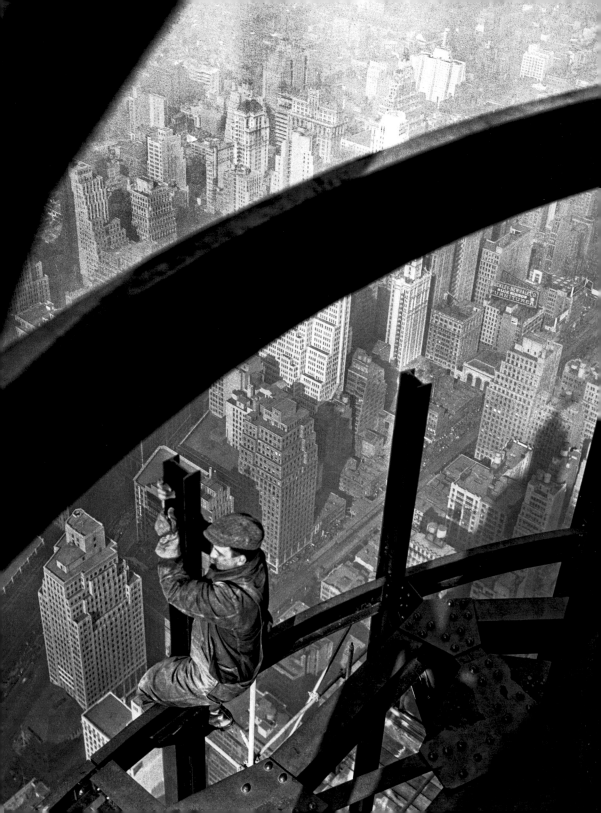

"I'm a New Yorker.
Fear's my life."

RENT, 1996

Lewis Hine

The Empire State Building, the first tower in history to surpass 100 stories, was completed in 1931. It stands on Fifth Avenue and 34th Street, c. 1930.

Das Empire State Building war der erste Wolkenkratzer mit über 100 Etagen; es wurde 1931 fertiggestellt und steht an der 34th Street und Fifth Avenue, um 1930.

L'Empire State Building fut le premier immeuble de l'Histoire à dépasser cent étages. Dressé sur la Cinquième Avenue, près de la 34e Rue, il fut achevé en 1931, vers 1930.

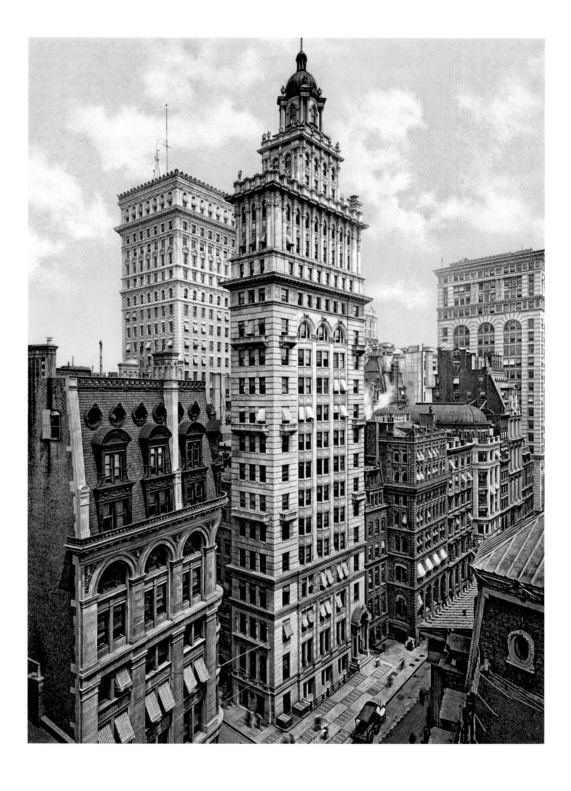

"I would give the greatest sunset in the world for one sight of New York's skyline."

THE FOUNTAINHEAD, AYN RAND, 1943

Anonymous

The Gillender Building. Located in the financial district, this was one of the city's first skyscrapers to reach 20 floors. In 1910, it was demolished and replaced by the Bankers Trust Building, which was twice its height. Architectural historians believe that this is the first example of a skyscraper being destroyed to make way for another one, 1900.

Gillender Building. Das Gebäude im Finanzviertel war eines der ersten Hochhäuser der Stadt mit 20 Stockwerken. 1910 wurde es abgerissen und durch das doppelt so hohe Bankers Trust Building ersetzt. Nach Ansicht der Architekturhistoriker war dies das erste Beispiel für den Abriss eines Hochhauses, um Platz für ein neues zu schaffen, 1900.

Le Gillender Building. Situé dans le quartier financier, ce fut l'un des premiers gratte-ciel de la ville à atteindre vingt niveaux. En 1910, il fut démoli et remplacé par le Bankers Trust Building, deux fois plus haut. Les historiens d'architecture pensent que c'est le premier gratte-ciel détruit pour être remplacé par un autre, 1900.

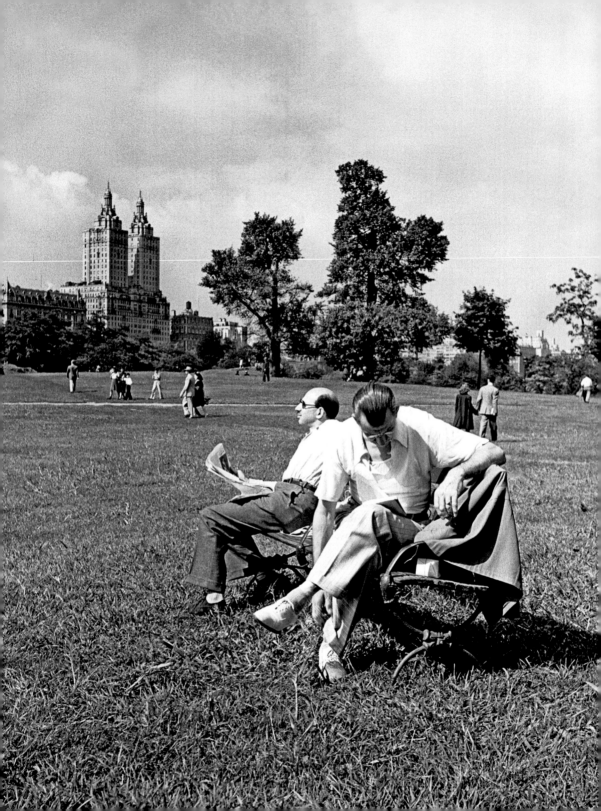

"One belongs to New York instantly, one belongs to it as much in five minutes as in five years."

THE WEB AND THE ROCK, THOMAS WOLFE, 1939

Anonymous

Central Park, 1942.

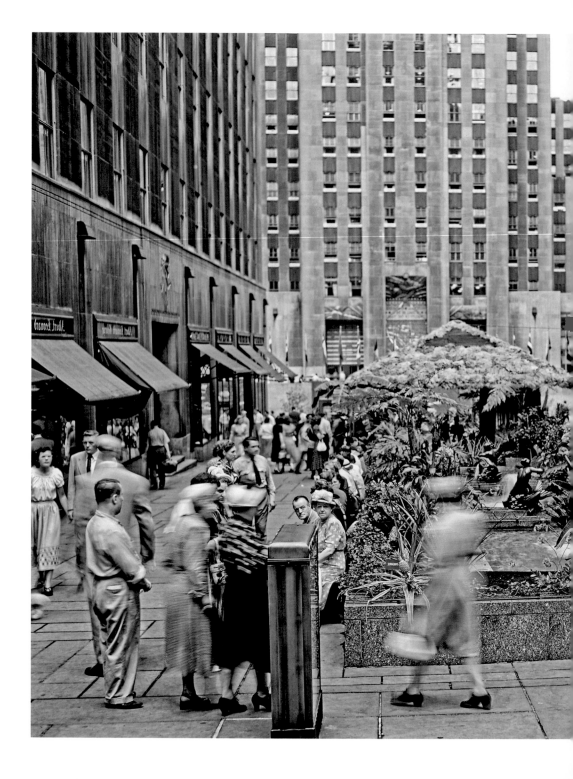

Anonymous

The famous pedestrian thoroughfare of Rockefeller Center, at 49th Street and Fifth Avenue, is where the massive Christmas tree is placed at the beginning of the holiday season. This is a rare color photograph of the "city within a city," 1949.

Der berühmte Fußgängerbereich des Rockefeller Center an 49th Street und Fifth Avenue; hier wird zu Beginn der Adventszeit der riesige Weihnachtsbaum aufgestellt. Dies ist ein seltenes Farbfoto von der „Stadt in der Stadt", 1949.

Le fameux passage piétonnier du Rockefeller Center – 49e Rue et Cinquième Avenue – où un énorme sapin de Noël est dressé chaque année au début des vacances de fin d'année. Rare photo en couleur de cette « ville dans la ville », 1949.

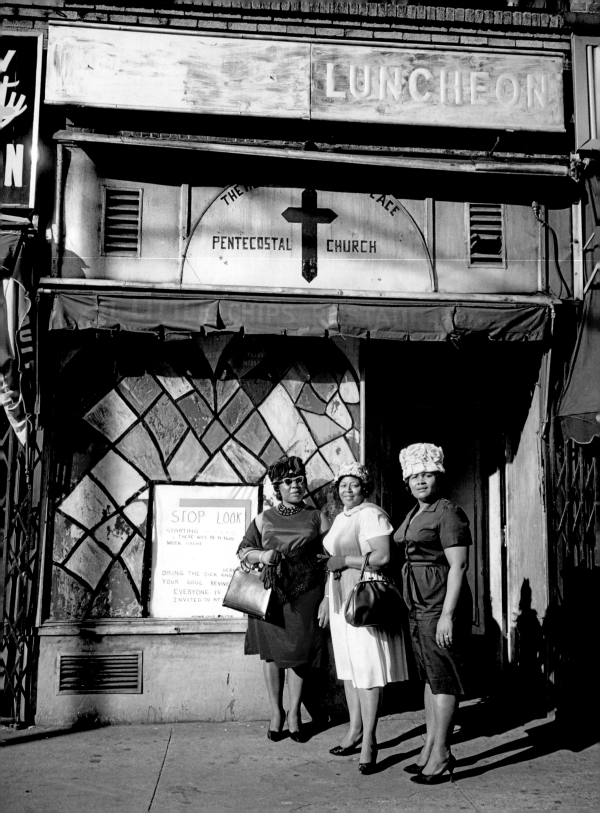

"You think the devil is someone inside the ground that's going to burn you after you're dead. The devil is right here on top of this earth. He's got blue eyes, brown hair, white skin, and he's giving you hell every day. And you're too dead to see it."

MALCOLM X, 1963

Evelyn Hofer

Three ladies outside a church, c. 1962.

Drei Damen vor einer Kirche, um 1962.

Trois dames devant une église, vers 1962.

Walter Sanders

This is a Madison Avenue bar when the street was the center of the advertising industry. This could be a still from the TV show *Mad Men*, 1961.

Eine Bar auf der Madison Avenue; diese Straße war damals das Zentrum der Werbebranche. Dies könnte ein Filmstill zu der TV-Serie *Mad Men* sein, 1961.

Un bar sur Madison Avenue, lorsque cette voie était le centre de l'industrie publicitaire. Ce fut une source d'inspiration pour la série télévisée à succès *Mad Men*, 1961

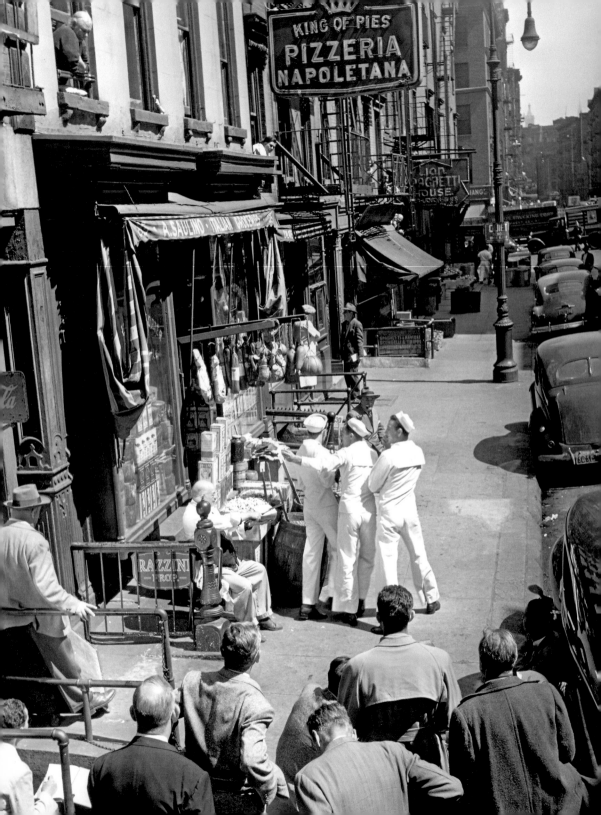

"New York, New York, it's a wonderful town.
The Bronx is up and the Battery's down.
The people ride in a hole in the ground.
New York, New York, it's a wonderful town!"

ON THE TOWN, 1949

Anonymous

Filming *On the Town* with Gene Kelly
and Frank Sinatra, 1949.

Dreharbeiten zu *Heut' gehn wir bummeln*
mit Gene Kelly und Frank Sinatra, 1949.

Tournage de *Un Jour à New York*, avec
Gene Kelly et Frank Sinatra, 1949.

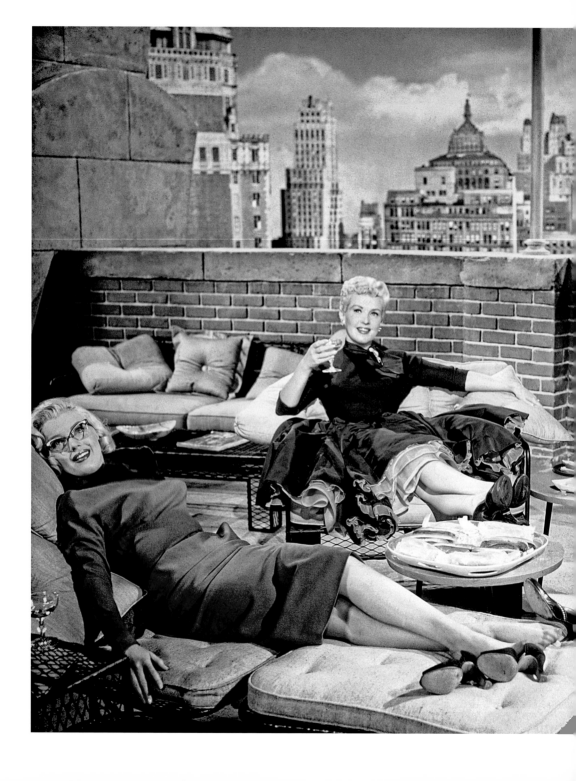

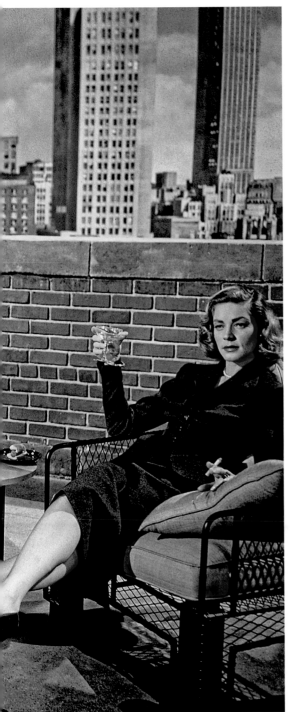

Anonymous

A movie still from *How to Marry a Millionaire* (1953), starring, from left to right: Marilyn Monroe, Betty Grable, and Lauren Bacall. In the movie, the ladies rent an apartment on Sutton Place on the East Side.

Ein Standbild aus dem Film *Wie angelt man sich einen Millionär* von 1953. Von links nach rechts: Marilyn Monroe, Betty Grable und Lauren Bacall. In diesem Film mieten die Damen ein Apartment in Sutton Place auf der East Side.

Image tirée du film de 1953 *Comment épouser un millionaire* avec, de gauche à droite : Marilyn Monroe, Betty Grable et Lauren Bacall. Dans le film, les trois célibataires louent un appartement à Sutton Place dans l'East Side.

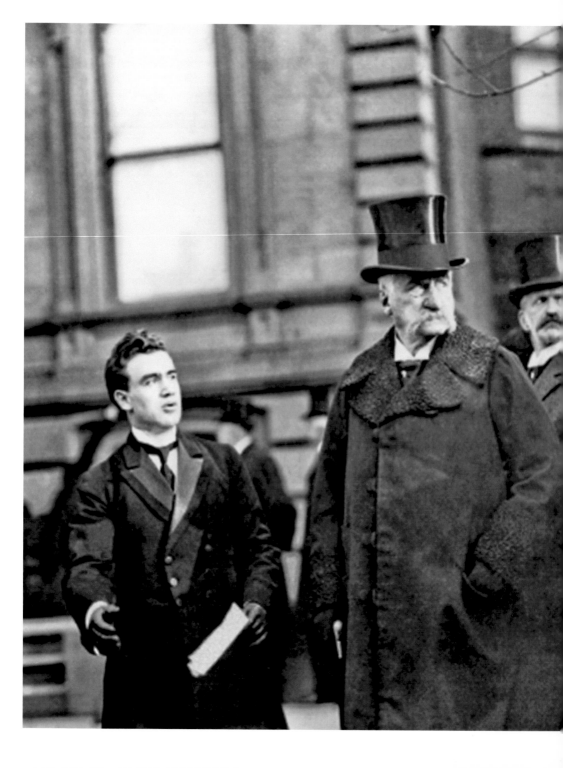

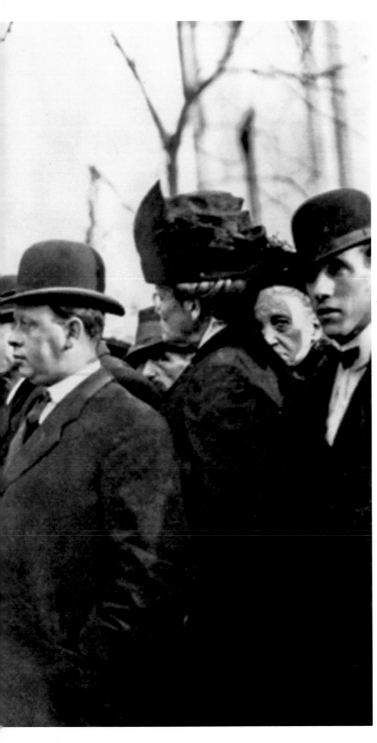

Anonymous

J.P. Morgan, one of the most powerful financiers of all time, surrounded by his entourage, c. 1911.

J.P. Morgan, einer der mächtigsten Banker aller Zeiten, umgeben von seinem Gefolge, um 1911.

J.P. Morgan, l'un des plus puissants financiers de tous les temps, au milieu de son entourage, vers 1911.

"Q-TIP" KAMAAL IBN JOHN FAREED (1970)

"New York, like a Christmas tree
Tonight this city belongs to me."

"ANGEL OF HARLEM," U2, 1987

Bill Ray

Police and boxing fan, Madison Square
Garden, 1970.

Polizisten und Boxsportfan, Madison
Square Garden, 1970.

Policiers et fan de boxe, Madison Square
Garden, 1970.

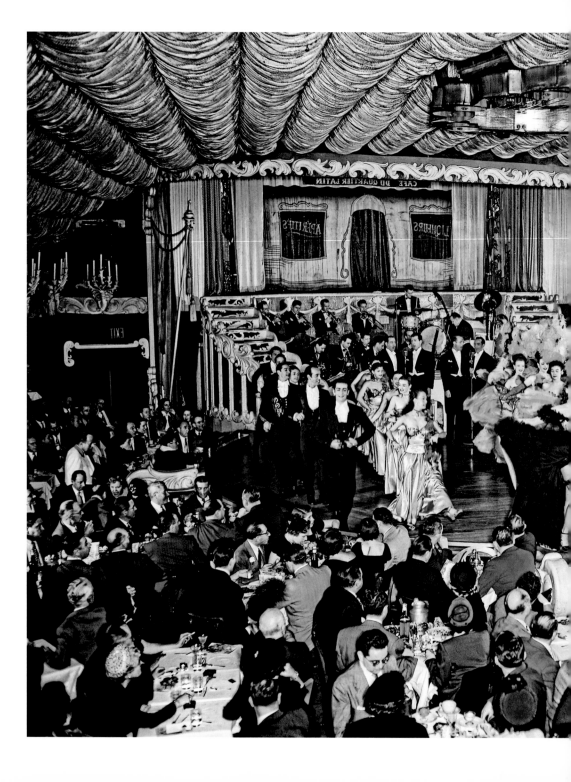

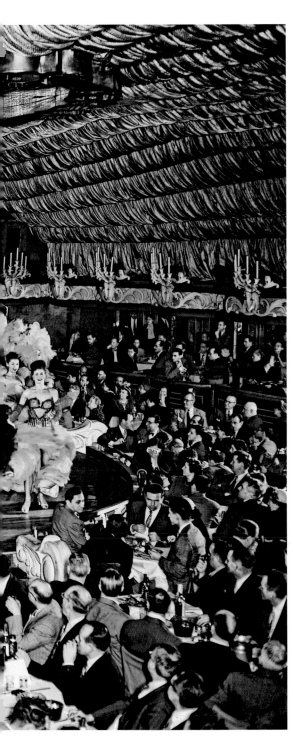

Anonymous

A floorshow at the *Latin Quarter* nightclub, 1952.

Vorstellung im Nachtclub *Latin Quarter*, 1952.

Spectacle de cabaret au *Latin Quarter*, 1952.

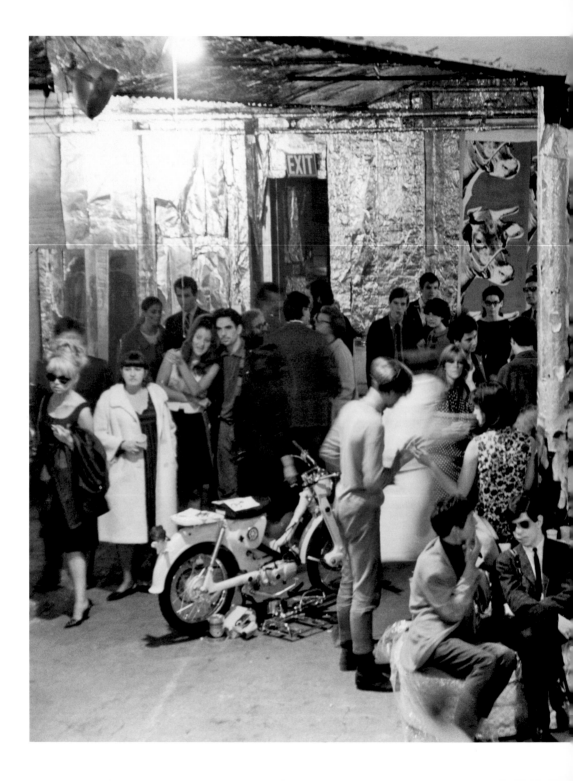

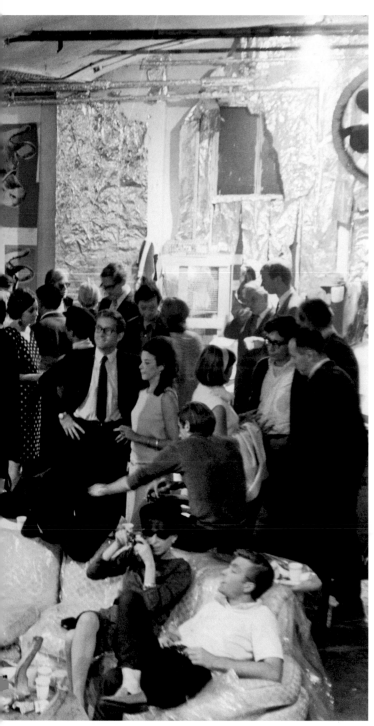

Fred McDarrah

A party at Andy Warhol's famous studio, The Factory, on 231 East 47th Street. The host is just about visible at the back of the photograph, standing near the cow prints and wearing his customary dark glasses, 1965.

Eine Party in der berühmten „Factory" von Andy Warhol, East 47th Street, Hausnummer 231. Der Gastgeber steht, gerade noch sichtbar, neben den Kuhbildern hinten im Bild und trägt seine übliche dunkle Brille, 1965.

Une soirée dans le célèbre atelier d'Andy Warhol, The Factory 231 East 47e Rue. On aperçoit l'hôte dans le fond, près des estampes de vaches, portant ses lunettes noires habituelles, 1965.

*"The most beautiful thing
I have ever seen."*

**GERTRUDE STEIN TALKING ABOUT
THE ROCKEFELLER CENTER, 1935**

Bernard Hoffman

Newsstand in Rockefeller Center. In addition to offices, an ice-skating rink, murals, and a big entertainment complex, The Rock was a major retail center. Both the vendor and the gentleman look a little too pristine to actually be working, suggesting that they are models, 1941.

Zeitungskiosk im Rockefeller Center. Im „Rock" gab es nicht nur Büros, eine Eislaufbahn, Wandmalereien und einen großen Unterhaltungskomplex, sondern auch viele Einzelhandelsgeschäfte. Sowohl die Verkäuferin als auch der Mann sind wohl Models, denn sie wirken etwas zu perfekt, um wirklich zu arbeiten, 1941.

Marchand de journaux au Rockefeller Center. En plus de ses bureaux, de sa patinoire, de ses fresques murales et d'un énorme complexe de salles de spectacles, «The Rock» était aussi un vaste centre commercial. Le vendeur et l'acheteur semblent un peu trop apprêtés pour ne pas être des mannequins, 1941.

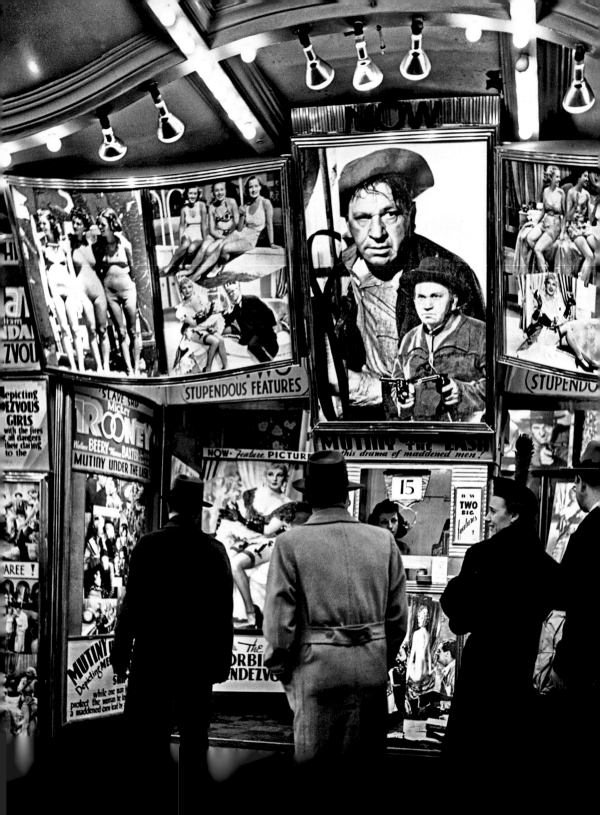

"New York and the movies seem made for each other. New York is a dynamic, restless — ideal for the constantly moving images that make up a film."

CELLULOID SKYLINE: NEW YORK AND THE MOVIES, JAMES SAUNDERS, 2002

Andreas Feininger

Times Square always had its sleazy side and here, on 42nd Street, is a small theater showing sexy movies, 1940.

Am Times Square herrschten lockere Sitten; hier auf der 42nd Street stand ein kleines Kino, das Sexfilme zeigte, 1940.

Times Square a toujours eu un côté libidineux. Ici, sur la 42e Rue, un petit cinéma propose des films sexy, 1940.

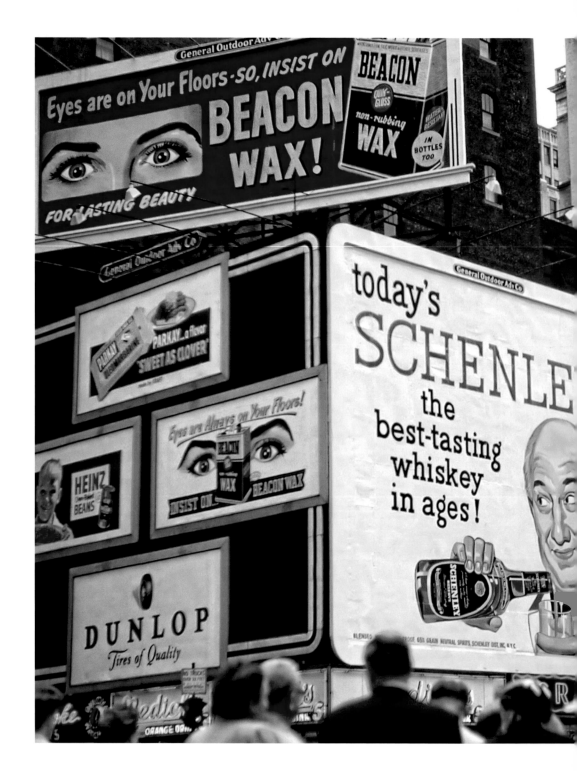

Ruth Orkin

Times Square billboards enticing postwar consumers with whiskey and floor-cleaning products, among other things, early 1950s.

Werbeplakate am Times Square verlocken die Nachkriegskonsumenten mit Whiskey und Bodenreinigungsmitteln, Anfang der 1950er-Jahre.

Les affiches de Times Square incitaient les consommateurs de l'après-guerre à acheter aussi bien du whiskey que des produits d'entretien des sols, début des années 1950.

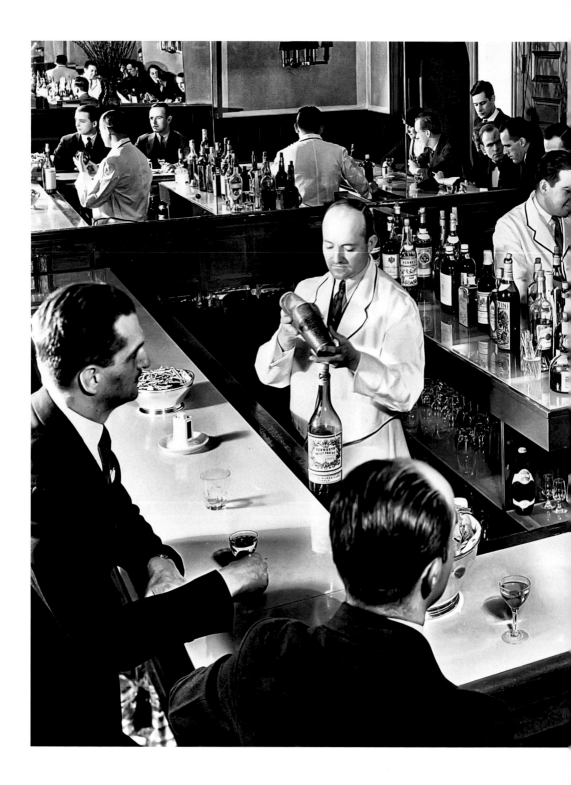

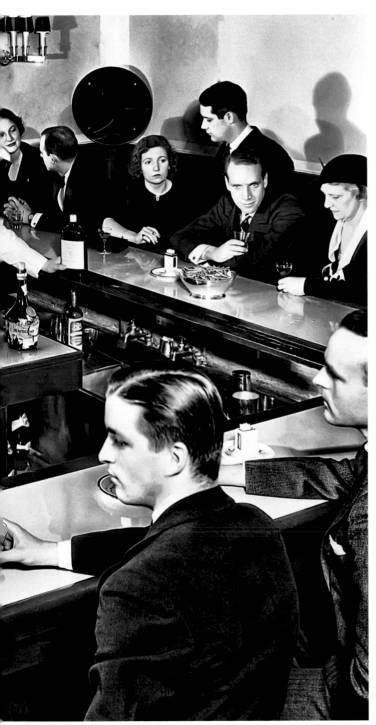

Margaret Bourke-White

One of the city's fancier speakeasies, or, rather, illegal drinking establishments, 1933.

Eins der eleganteren Speakeasies oder illegalen Kneipen der Stadt, 1933.

Un des «speakeasies» – débits de boissons quasi illégaux – les plus à la mode de la ville, 1933.

"When you leave New York, you are astonished at how clean the rest of the world is. Clean is not enough."

METROPOLITAN LIFE, FRAN LEBOWITZ, 1974

Ezio Petersen

Curtis Sliwa, the leader of the Guardian Angels. The unarmed citizen "safety" patrol unit was founded in 1979, in response to the city's rising crime rate on the subway. The group is known for its distinctive red berets, 1985.

Curtis Sliwa, der Leiter der Guardian Angels. Die unbewaffnete „Bürgerwehr" wurde 1979 als Reaktion auf die steigende Kriminalitätsrate in der U-Bahn der Stadt gegründet. Ihre Mitglieder sind an ihren typischen roten Baretten zu erkennen, 1985.

Curtis Sliwa, leader des Guardian Angels. Ces patrouilles de «sécurité», composées de citoyens non armés, ont été fondées en 1979 en réponse à la croissance du taux de criminalité dans le métro. Le groupe est célèbre pour ses bérets rouges, 1985.

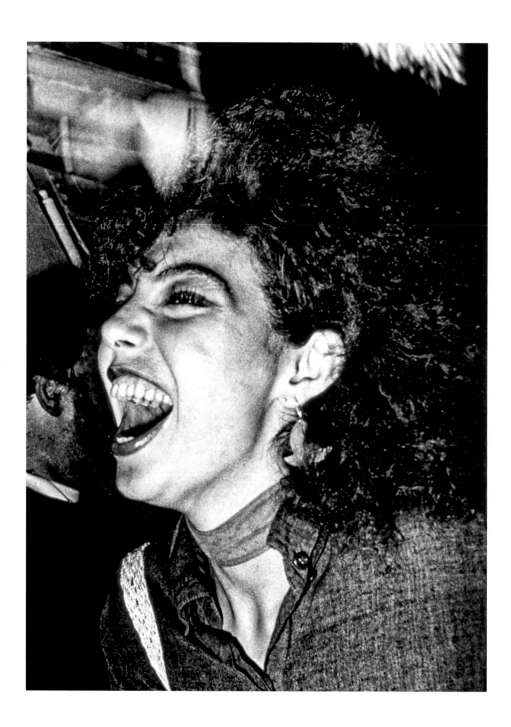

CONAN O'BRIEN (1963)

"Tad's mission in life is to have more fun than anyone else in New York City, and this involves a lot of moving around, since there is always the likelihood that where you aren't is more fun than where you are."

BRIGHT LIGHTS, BIG CITY, JAY MCINERNEY, 1984

Keizo Kitajima

East Village. This shot both celebrates and sneers at the party lifestyle, 1981.

East Village. Diese Aufnahme feiert und verhöhnt den Party-Lifestyle gleichermaßen, 1981.

East Village. Cette photo célèbre le style de vie des nightclubbers, et s'en moque en même temps, 1981.

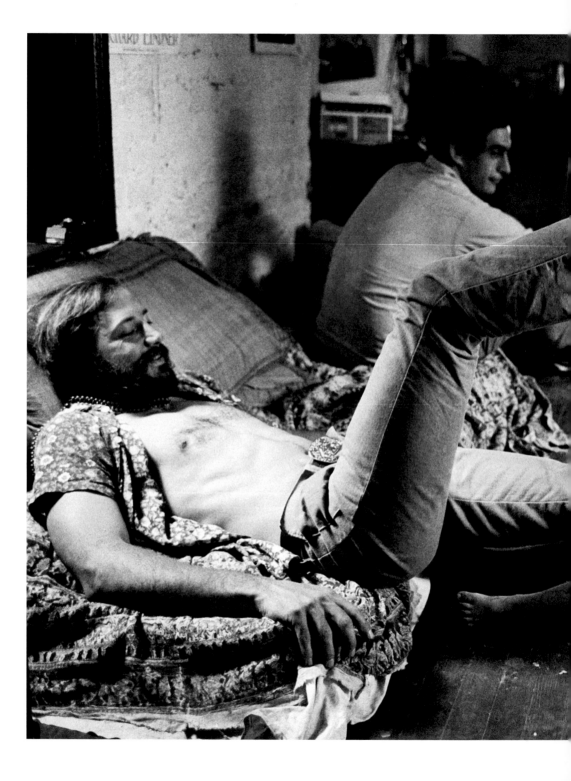

Eddie Adams

East Village commune. The neighbor-hood has a long association with various counterculture and youth movements. In the 1960s, it was New York's hippie hangout, late 1960s.

Kommune im East Village. Das Viertel ist schon seit vielen Jahren Heimat für verschiedene Gegenkultur- und Jugendbewegungen. In den 1960ern war es New Yorks Treffpunkt der Hippies, Ende der 1960er-Jahre.

East Village. Ce quartier est depuis longtemps associé à divers mouvements de jeunes et contre-cultures. Dans les années 1960, il était le repaire des hip-pies new-yorkais, fin des années 1960.

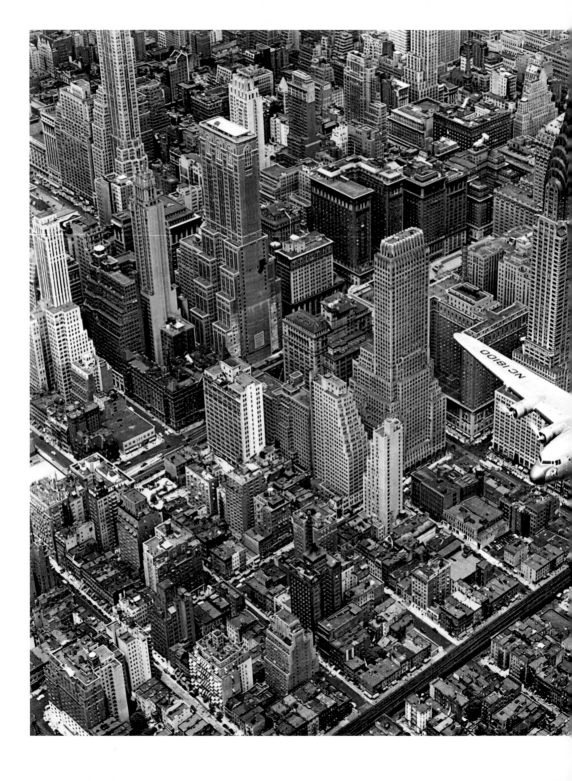

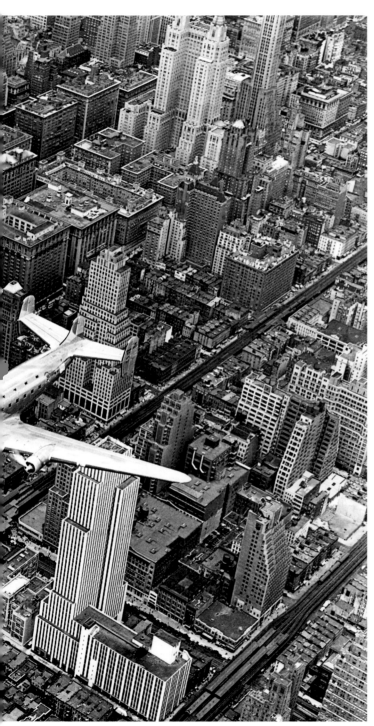

Margaret Bourke-White

The DC-4 Flying Over New York City.
From this vantage point, we can see
the expansion of Midtown Manhattan
between the wars and the grid that
lays the city out like a chessboard,
block-by-block, 1939.

DC-4 beim Flug über New York. Aus die-
ser Perspektive kann man sehen, wie sich
Midtown Manhattan in den Zwischen-
kriegsjahren ausgedehnt hat und wie das
Gitternetz die Stadt schachbrettartig in
Blöcke unterteilt, 1939.

Le DC-4 survolant New York. Cette
vue aérienne montre l'expansion de
Midtown entre les deux guerres et la
trame orthogonale de la ville, 1939.

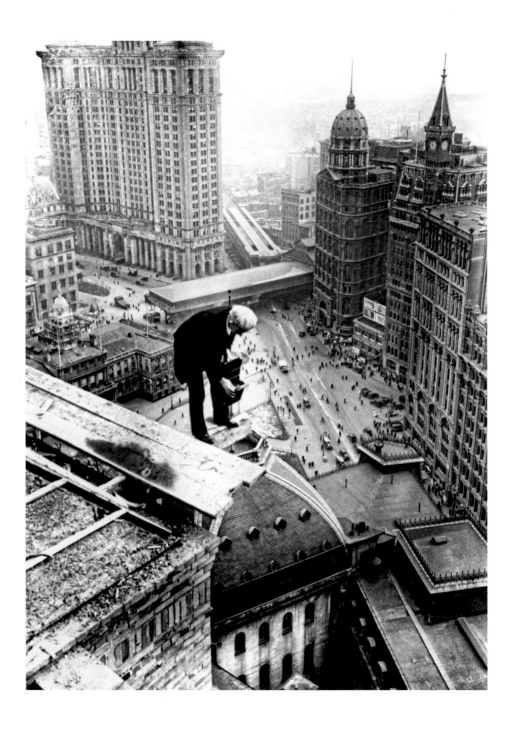

TONY DANZA (1951)

"Alvy, you're incapable of enjoying life, you know that? I mean, you're like New York City. You're just this person. You're like this island unto yourself."

ANNIE HALL, 1977

Anonymous

A brave and formally dressed photographer shooting the city from atop a skyscraper. The city's architecture served as inspiration and subject matter for generations of photographers and artists, mid-1920s.

Ein waghalsiger, förmlich gekleideter Fotograf macht Aufnahmen vom Dach eines Wolkenkratzers aus. Die Architektur der Stadt wurde schnell zu einer Quelle der Inspiration und zum offensichtlichen Motiv für Generationen von Fotografen und Malern, Mitte der 1920er Jahre.

Courageux et bien habillé, un photographe prend des vues de la ville du sommet d'un gratte-ciel. L'architecture de la ville a été un sujet et une source d'inspiration pour des générations de photographes et d'artistes, milieu des années 1920.

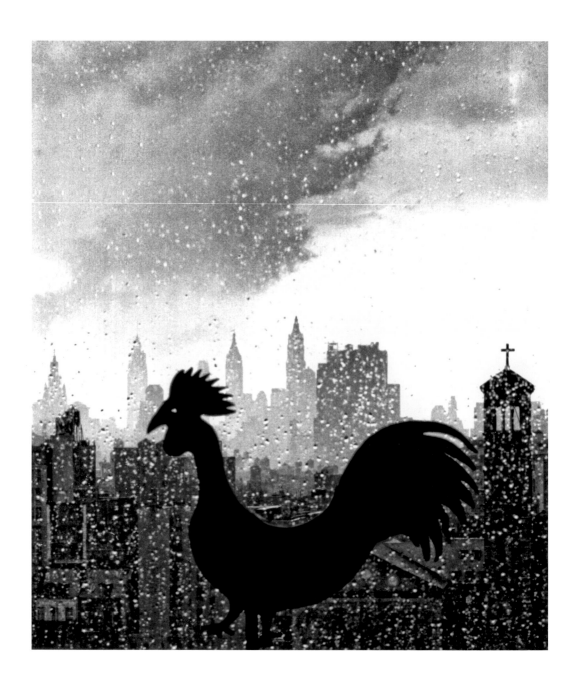

"In the wee small hours of the morning
While the whole wide world is fast asleep
You lie awake and think about the girl
And never ever think of counting sheep.

"When your lonely heart has learned its lesson
You'd be hers if only she would call.
In the wee small hours of the morning,
That's the time you miss her most of all."

"IN THE WEE SMALL HOURS OF THE MORNING," FRANK SINATRA, 1955

André Kertész

Rooster. From his apartment on Fifth Avenue overlooking Washington Square, Kertész photographed various New York scenes and cityscapes for more than 25 years, 1952.

Hahn. Von seinem Apartment an der Fifth Avenue mit Blick auf den Washington Square fotografierte Kertész über 25 Jahre lang viele verschiedene New Yorker Szenen und Stadtlandschaften, 1952.

Coq. De son appartement sur la Cinquième Avenue donnant sur Washington Square, Kertesz photographia de multiples scènes et vues du paysage de New York pendant plus de vingt-cinq ans, 1952.

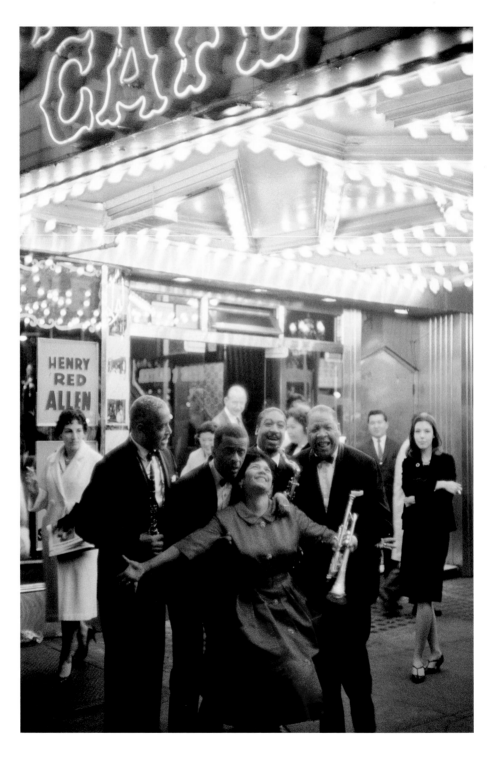

"The Jazz Corner of the World."

PRINTED ON THE COVER OF BIRDLAND'S MENU

William Claxton

Various jazz musicians outside the Metropole Café, the center of traditional jazz in New York, Broadway, 1960.

Verschiedene Jazzmusiker draußen vor dem Metropole Café, dem Zentrum des traditionellen Jazz in New York, Broadway, 1960.

Des musiciens de jazz devant le Metropole Café à Broadway, centre du jazz traditionnel à New York, 1960.

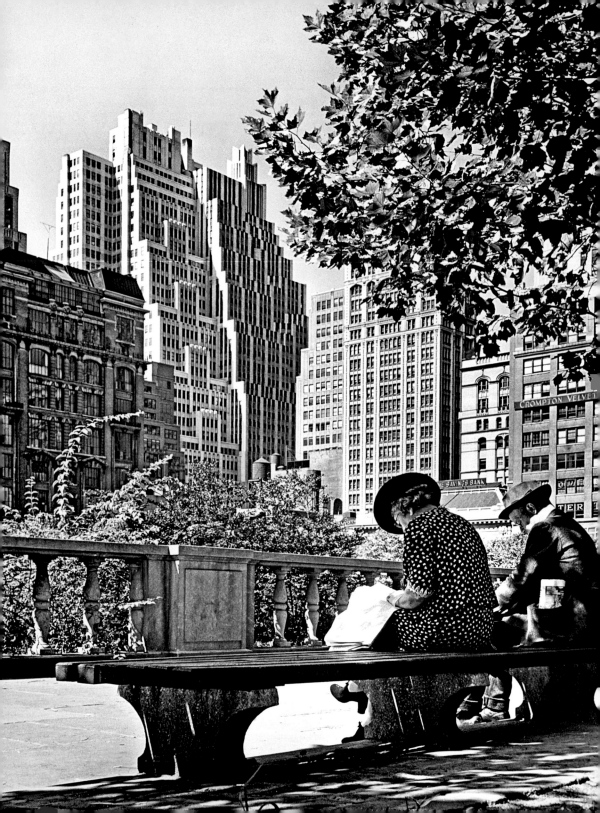

WILLEM DE KOONING (1904)
BARBRA STREISAND (1942)

*"Give my regards to Broadway
Remember me to Herald Square
Tell all the gang at Forty-second Street
That I will soon be there."*

"GIVE MY REGARDS TO BROADWAY," GEORGE M. COHAN

Andreas Feininger

Bryant Park. Right behind the New York Public Library, Bryant Park, formerly known as Reservoir Square, is a much-treasured green space in Midtown along 42nd Street. It was also the site of New York's first World's Fair, the Crystal Palace exhibition of 1852–53, 1940.

Bryant Park. Der hinter der New York Public Library gelegene Park hieß früher Reservoir Square und ist eine beliebte grüne Oase entlang der 42nd Street in Midtown. Dort fand auch die erste Weltausstellung von New York statt, die Crystal-Palace-Ausstellung von 1852–53, 1940.

Bryant Park. Juste derrière la New York Public Library, Bryant Park, anciennement Reservoir Square, est un espace vert particulièrement apprécié, situé le long de la 42e Rue à Midtown. Ce fut également le site de la première Exposition internationale, l'exposition dite du Crystal Palace de 1852–53, 1940.

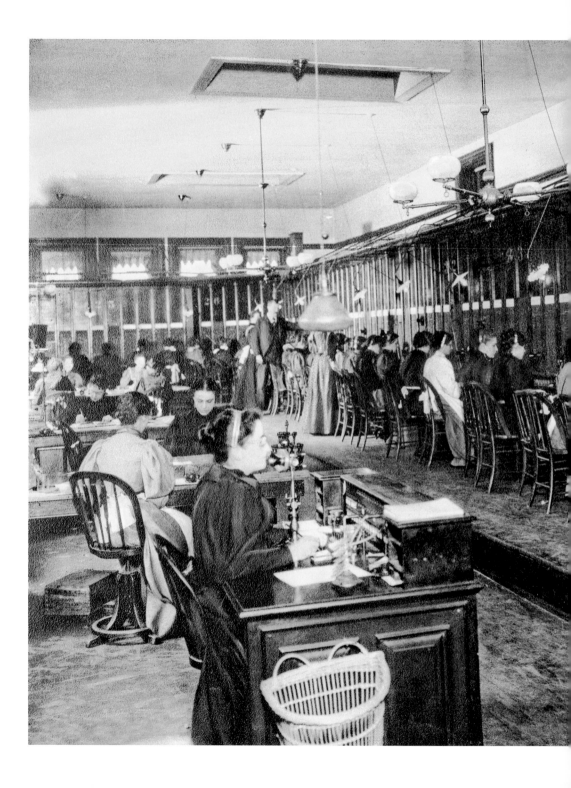

ELLA FITZGERALD (1917)
AL PACINO (1940)

Anonymous

The Telephone Company of New York.
The city was at the forefront of the
telecommunications revolution, 1894.

Die Telefongesellschaft von New York.
Die Stadt war eine Vorreiterin der Revo-
lution der Telekommunikation, 1894.

La Telephone Company of New York.
La ville fut à l'avant-garde de la révolu-
tion de la télécommunication, 1894.

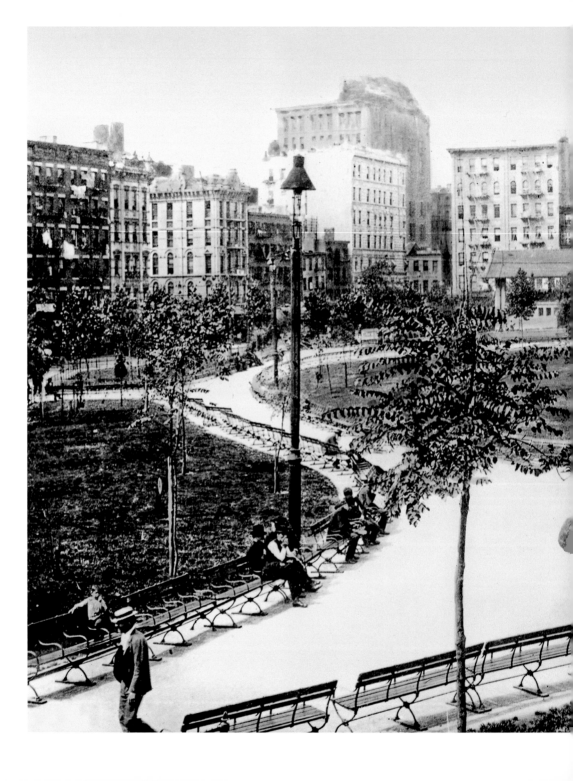

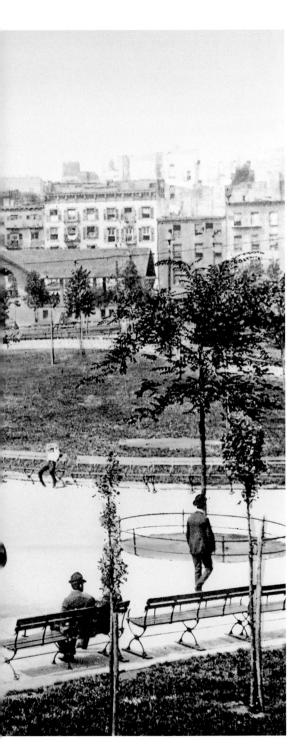

Jacob Riis

Cityscape. Some late 19th century folk are enjoying some downtime in a treasured green space that looks like Union Square, 1880s.

Stadtlandschaft. Ende des 19. Jahr-hunderts genießen einige Leute eine kurze Ruhepause auf einer der wenigen Grünflächen, hier wahrscheinlich der Union Square, 1880er-Jahre.

Paysage urbain. Quelques New-Yorkais, à la fin du XIXe siècle, se détendent dans un espace vert agréable, qui pourrait être Union Square, années 1880.

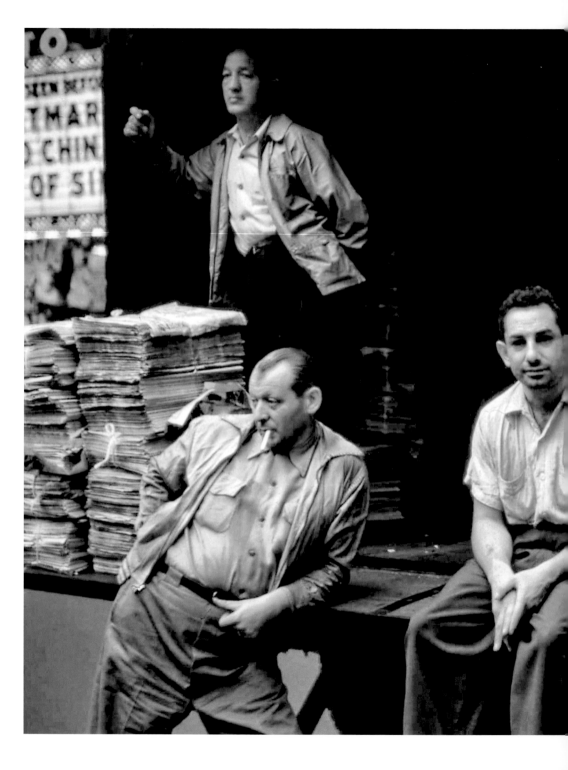

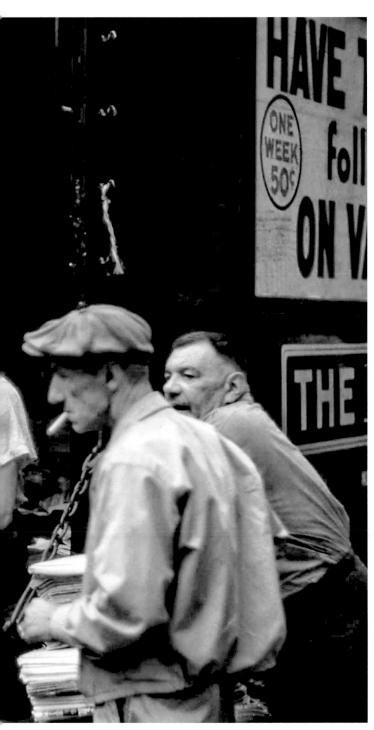

Ruth Orkin

Newspaper deliverymen taking a
breather, late 1940s.

Zeitungsausträger bei einer Verschnauf-
pause, Ende der 1940er Jahre.

Vendeurs de journaux pendant une
pause, fin des années 1940.

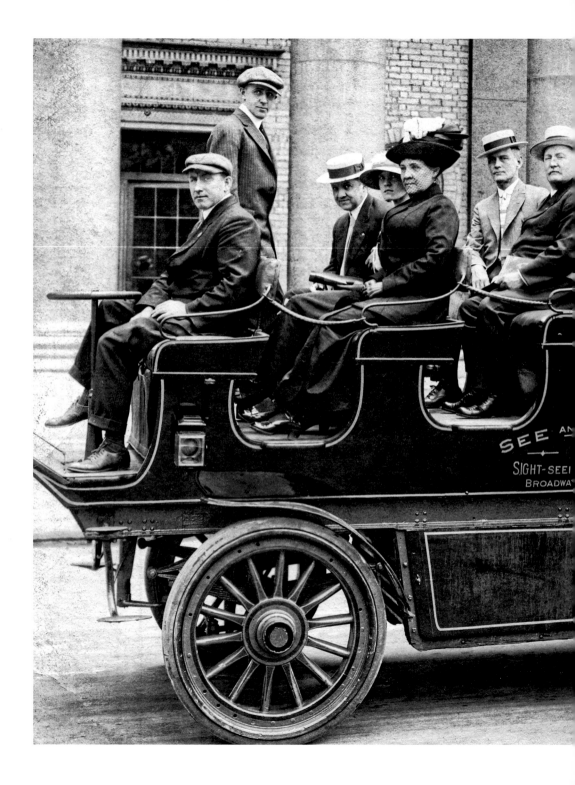

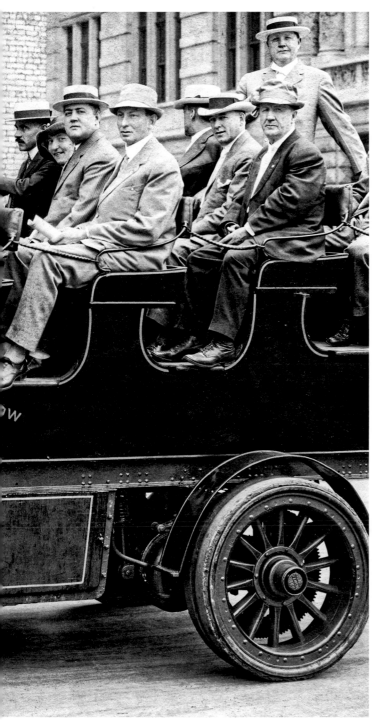

Anonymous

Passengers on an early tour bus, taking in the sights of Manhattan, mid-1920s.

Fahrgäste bei der Stadtbesichtigung in einem der ersten Touristenbusse, Mitte der 1920er-Jahre.

Un des premiers autobus touristiques faisant visiter Manhattan et ses passagers, milieu des années 1920.

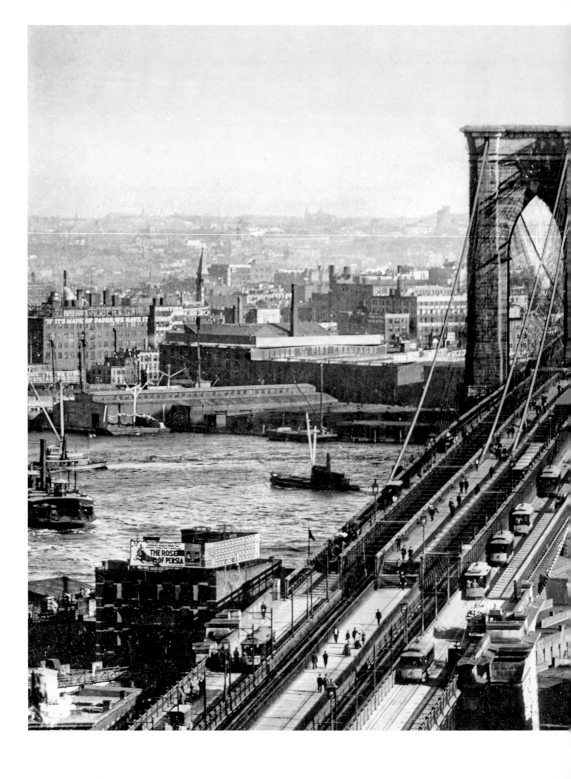

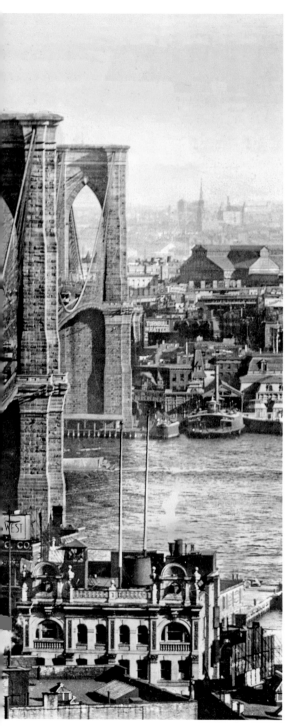

EDWARD KENNEDY "DUKE" ELLINGTON (1899)
BERNIE MADOFF (1938)
JERRY SEINFELD (1954)

Anonymous

A hand-colored glass slide of the
Brooklyn Bridge, taken from a tall
building in Manhattan. One can clearly
see the way traffic flows on either
side of the bridge, with the pedestrian
promenade in the center, 1890s.

Ein handkoloriertes Glasdia der
Brooklyn Bridge, aufgenommen von
einem hohen Gebäude in Manhattan.
Man kann den Verkehrsfluss auf beiden
Seiten der Brücke und die Fußgänger-
promenade in der Mitte klar erkennen,
1890er-Jahre.

Plaque de verre colorée à la main du
pont de Brooklyn prise du haut d'un
grand immeuble de Manhattan. On voit
clairement les flux de la circulation dans
les deux sens et la promenade piéton-
nière en partie centrale, années 1890.

"You fantasize about a man with a Park Avenue apartment and a nice big stock portfolio... For me, it's a fireman with a nice big hose."

SAMANTHA, *SEX AND THE CITY*

Reinhart Wolf

3 Park Avenue was built in 1976 as a mixed-use structure containing a high school and an office building. Behind it is the Empire State Building, c. 1980s.

Das Gebäude 3 Park Avenue wurde 1976 für eine gemischte Nutzung errichtet, es befinden sich eine weiterführende Schule und Büroräume darin. Dahinter ist das Empire State Building zu sehen, 1980er-Jahre.

Le 3 Park Avenue, construit en 1976, est un immeuble mixte contenant un collège et des bureaux. Derrière lui se dresse l'Empire State Building, vers années 1980.

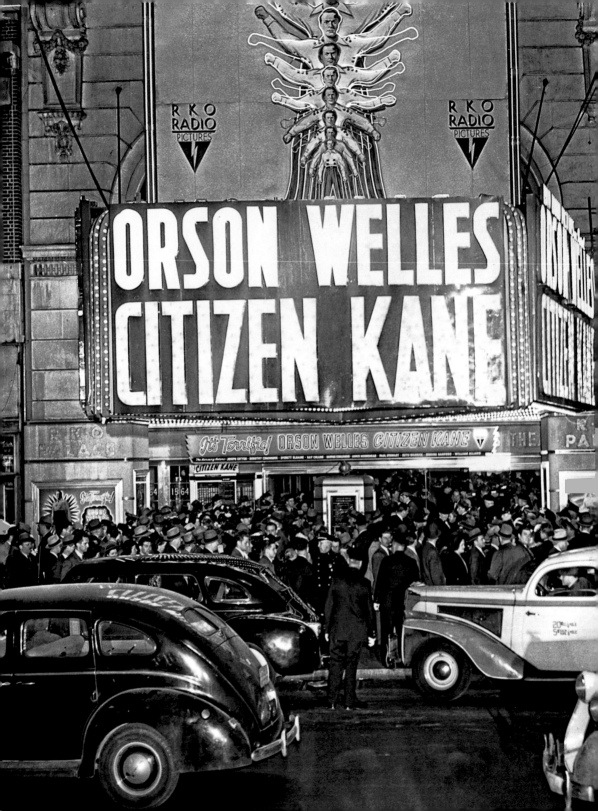

"We've got a really big show!"

TOAST OF THE TOWN, ED SULLIVAN, 1950s

Anonymous

Citizen Kane debuted at the Palace
Theater in Times Square, 1941.

Citizen Kane hatte im Palace Theater am
Times Square Premiere, 1941.

Citizen Kane passa pour la première fois
au Palace Theater à Times Square, 1941.

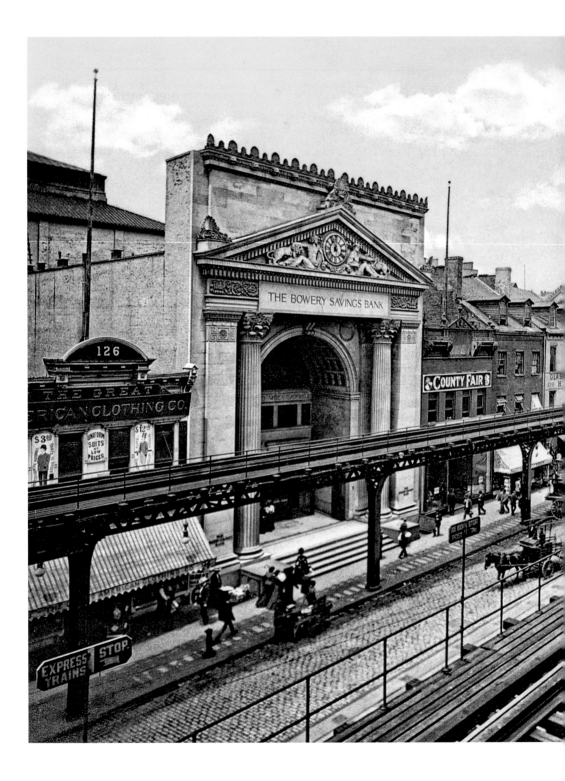

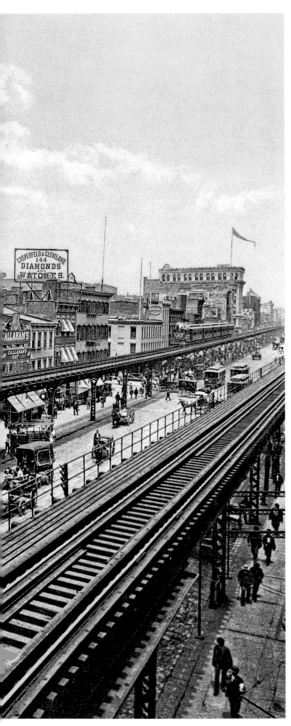

Anonymous

The Bowery and the Third Avenue
elevated railroad. The Bowery is New
York's oldest thoroughfare. In the
earlier part of the 19th century, the
street had been solidly middle class. But
after the Civil War, the area declined,
and it became associated with brothels,
flophouses, and dive bars, 1900.

Die Bowery und die Third-Avenue-
Hochbahn. Die Bowery ist die älteste
Durchgangsstraße von New York. Im
frühen 19. Jahrhundert befand sich die
Straße fest in der Hand der Mittel-
schicht, aber nach dem Bürgerkrieg
verfiel diese Gegend und wurde fortan
mit Bordellen, Absteigen und Spelunken
assoziiert, 1900.

Le Bowery et le train suspendu de la
Troisième Avenue. Le Bowery est la plus
ancienne artère de New York. Au début
du XIXᵉ siècle, la rue était occupée par
la classe moyenne, mais déclina après
la guerre civile, et fut envahie de maisons
closes, d'hôtels borgnes et de bouges de
toutes sortes, 1900.

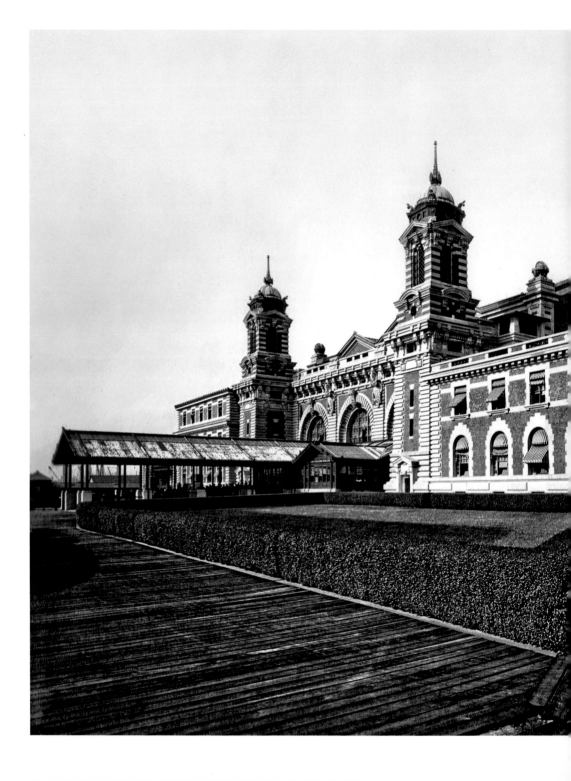

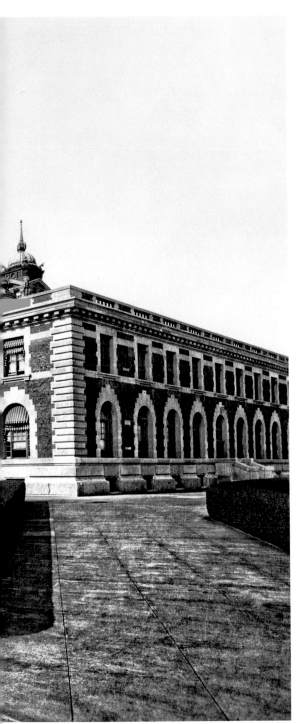

Anonymous

General view of the immigration station on Ellis Island, which opened in 1892 in response to the second wave of mass immigration, mainly from eastern and southern Europe, c. 1902.

Gesamtansicht der zentralen Sammel-stelle für Einwanderer auf Ellis Island. Ellis Island wurde 1892 infolge der zwei-ten großen Welle von Einwanderern, überwiegend aus Ost- und Südeuropa, eröffnet, um 1902.

Vue générale de la gare d'arrivée des immigrants sur Ellis Island. Ellis Island ouvrit ses portes en 1892 pour répondre à la seconde vague d'immigration, principalement venue d'Europe de l'Est et du Sud, vers 1902.

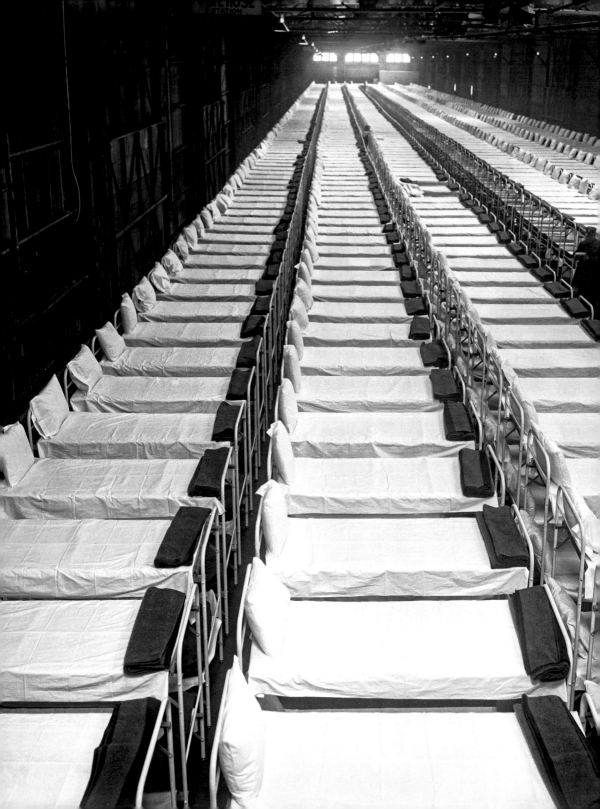

JANE JACOBS (1916)
AUDREY HEPBURN (1929)
KEITH HARING (1958)

"I love bums. Bums in New York are literate bums. Bums in New York could run a grocery chain in Des Moines."

"WHAT I'VE LEARNED," LARRY KING, 2001

Anonymous

A lodging house, 1930.

Eine Unterkunft, 1930.

Abri pour sans-logis, 1930.

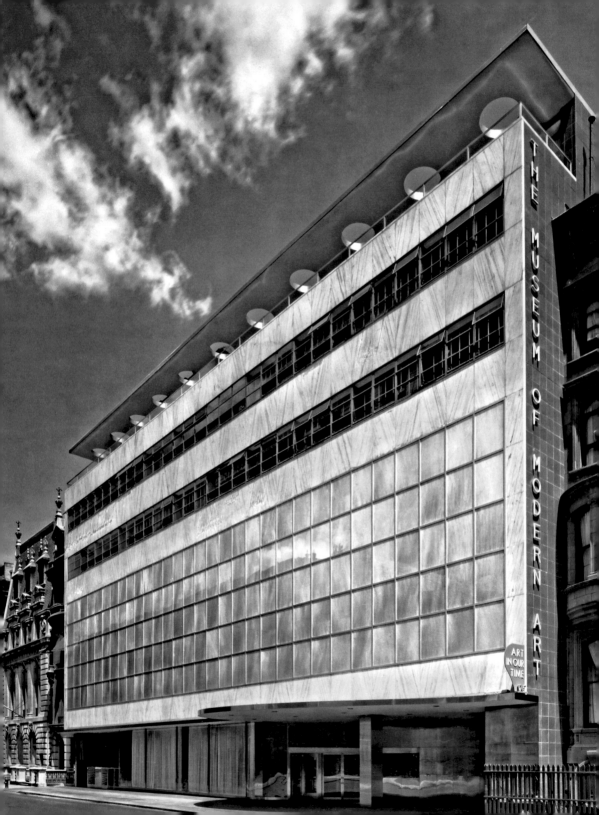

"Nothing in the new building is obtrusive, nothing is cheap. It feels breathless with unspared expense."

JOHN UPDIKE WRITING ABOUT THE NEW MOMA BUILDING, 2004

Anonymous

The Museum of Modern Art. One of the world's most famous and influential museums is on 53rd Street, between Fifth and Sixth Avenues. It was founded in 1929, but it wasn't until ten years later that it moved to its current location. The museum was extensively renovated in recent years, and the new-look MoMA opened its doors in 2004, 1939.

Das Museum of Modern Art. Dieses Museum auf der 53rd Street zwischen der Fifth und Sixth Avenue gehört zu den berühmtesten und einflussreichsten Museen der Welt. Es wurde 1929 gegründet, aber erst zehn Jahre später an seinen aktuellen Standort verlegt. Das Museum wurde kürzlich umfassend renoviert, und das neue MoMA öffnete 2004 seine Türen, 1939.

Le Museum of Modern Art. Un des musées les plus célèbres et les plus influents du monde. Il se trouve 53e Rue, entre la Cinquième et la Sixième Avenue. Il fut fondé en 1929, mais ce n'est que dix ans plus tard qu'il s'installa à son adresse actuelle. Entièrement rénové, un MoMA new-look a rouvert ses portes en 2004, 1939.

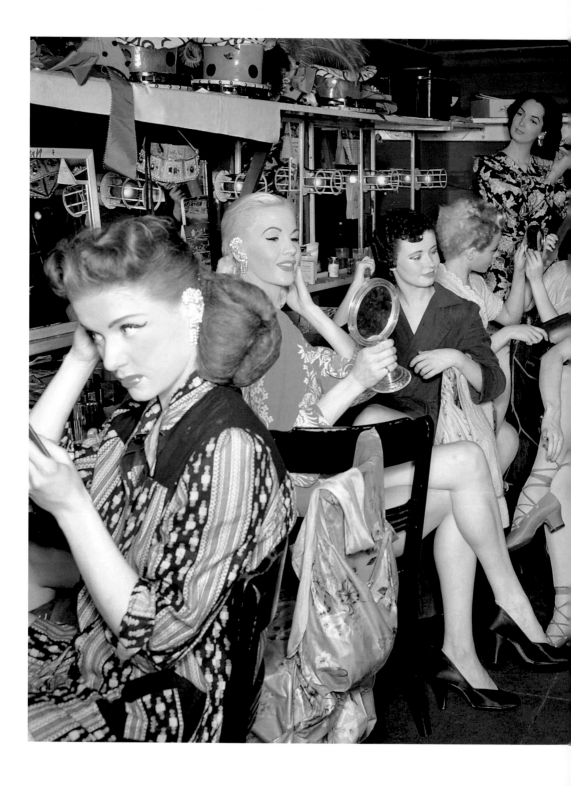

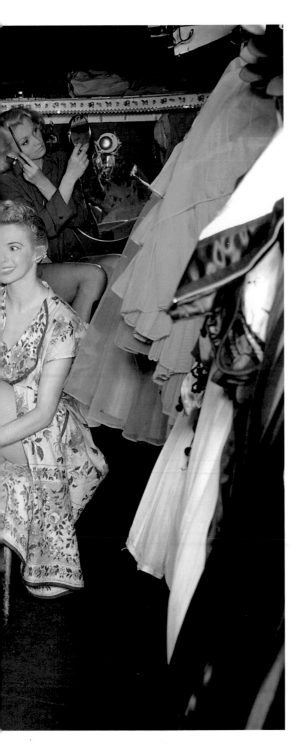

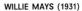

Anonymous

Backstage at the Latin Quarter nightclub, at Broadway and 47th Street, near Times Square. It was opened by Lou Walters, the father of the famous American television journalist Barbara Walters, 1952.

Hinter den Kulissen des Nachtclubs Latin Quarter an Broadway und 47th Street, direkt am Times Square. Der Club wurde von Lou Walters eröffnet, dem Vater der berühmten amerikanischen Fernsehjournalistin Barbara Walters, 1952.

Dans les coulisses de la boîte de nuit le Latin Quarter – Broadway et 47e Rue – près de Times Square. Il fut ouvert par Lou Walters, père de la fameuse journaliste de télévision Barbara Walters, 1952.

Weegee

Metropolitan Opera, Opening Night.
Society ladies, Mrs. George Washington
Kavenaugh and Lady Decies, New York
celebrities of the day, are happy to be
posing for a pack of press photographers.
Their white fur coats, signifying money,
contrast with the dark suits and clothes
of the ordinary folk, 1943.

Metropolitan Opera, Eröffnungsabend.
Damen der Gesellschaft, die Frau von
George Washington Kavenaugh und
Lady Decies, damals New Yorker
Prominente, posieren nur allzu gern für
die Pressefotografen. Ihre weißen Pelz-
mäntel, ein Symbol für Reichtum, bilden
einen Gegensatz zur dunklen Kleidung
der kleinen Leute, 1943.

Metropolitan Opera, nuit de première.
Les dames de la haute société comme
Mrs. George Washington Kavenaugh et
Lady Decies, les célébrités new-yorkaises
du moment, sont heureuses de poser
pour un groupe de photographes de
presse. Leurs manteaux de fourrure
blanche, symboles de la richesse,
contrastent avec les costumes et vête-
ments noirs de la foule ordinaire, 1943.

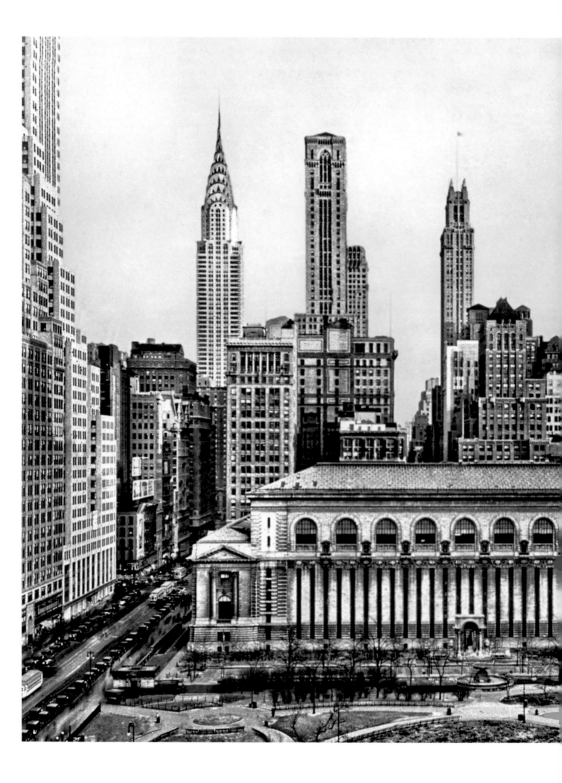

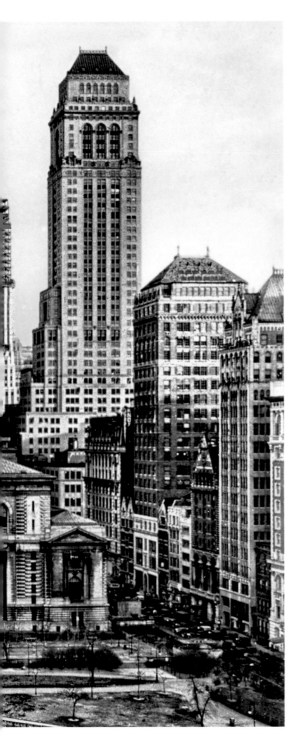

Anonymous

Bryant Park and the main branch of the New York Public Library, looking east. The library is between 40th and 42nd Streets on Fifth Avenue, and opened in 1911. Construction on the Empire State Building, the second tall skyscraper from the right, is making steady progress, early 1930s.

Bryant Park und die Hauptstelle der New York Public Library, Ostseite. Die Bibliothek befindet sich zwischen der 40th und 42nd Street an der Fifth Avenue und öffnete 1911 ihre Tore. Die Bauarbeiten am Empire State Building, dem zweiten hohen Wolkenkratzer von rechts, schreiten schnell voran, Anfang der 1930er-Jahre.

Bryant Park et le siège de la New York Public Library, côté est. La bibliothèque se trouve sur la Cinquième Avenue entre la 40e et la 42e Rue. Elle ouvrit en 1911. Le gratte-ciel, à droite, est l'Empire State Building en plein chantier, début des années 1930.

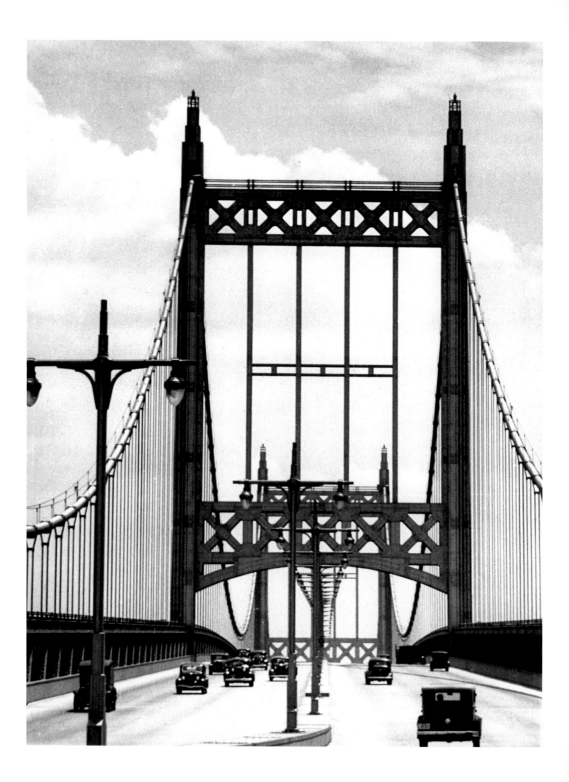

GORDON BUNSHAFT (1909)
BILLY JOEL (1949)

"It has long been a cherished ambition of mine to weave together the loose strands and frayed edges of New York's metropolitan arterial tapestry."

ROBERT MOSES

Anonymous

The Triborough Bridge. It comprises three interconnecting bridges that link the three boroughs of Manhattan, the Bronx, and Queens, and it opened to traffic in 1936, 1937.

Die Triborough Bridge. Ein Komplex aus drei Brücken verbindet die drei Stadtbezirke Manhattan, die Bronx und Queens miteinander. Die Triborough Bridge wurde 1936 für den Verkehr freigegeben, 1937.

Le pont Triborough. Ouvert à la circulation en 1936, il se compose de trois ponts interconnectés qui relient Manhattan, le Bronx et le Queens, 1937.

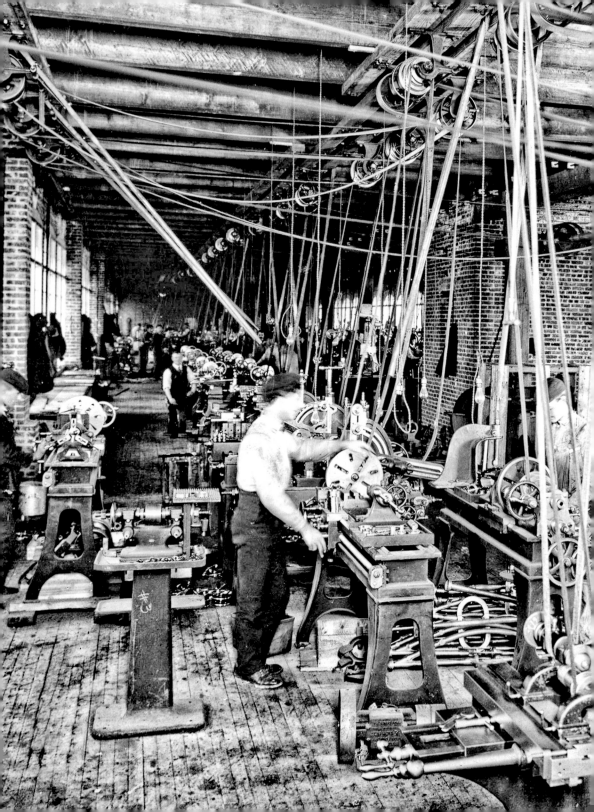

"New York looks as ever: stiff, machine-made, and against nature. It is so mechanical, there is not the sense of death."

D. H. LAWRENCE, 1924

Anonymous

Here, men are working hard in a large loft, engaged in what looks like a complicated manufacturing process of some kind. Note the complete lack of basic safety facilities, late 19th century.

Hier sieht man einen anscheinend etwas komplizierteren Fertigungsprozess in einer größeren Fabriketage. Selbst einfachste Sicherheitsvorkehrungen für die Arbeiter fehlen völlig, Ende des 19. Jahrhunderts.

Ici, des hommes travaillent dans un loft plus grand, affairés à un processus de fabrication complexe. Noter le manque complet d'installations de sécurité de base, vers la fin du XIXe siècle.

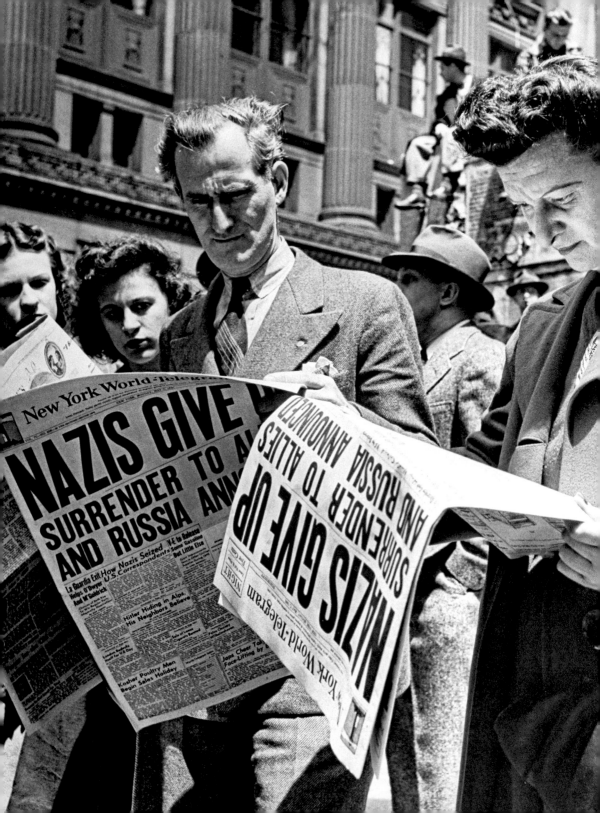

"There are certain sections of New York, major, that I wouldn't advise you to try to invade."

HUMPHREY BOGART, *CASABLANCA*, 1942

Andreas Feininger

New Yorkers engrossed by the dramatic front-page news of the Nazi surrender, 1945.

New Yorker sind ganz vertieft in die dramatische Titelseite über die Kapitulation der Nazis, 1945.

Des New-Yorkais accaparés par la lecture des titres de journaux annonçant la reddition nazie, 1945.

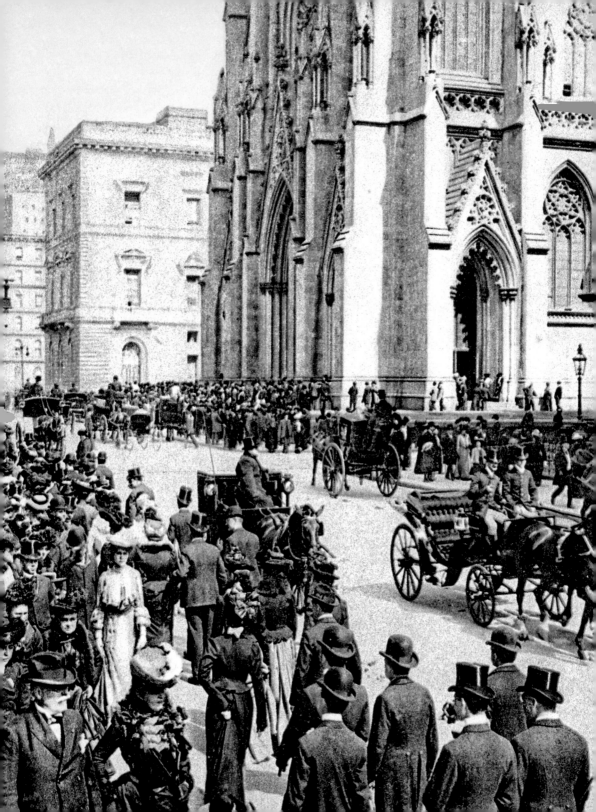

JULIUS ROSENBERG (1918)
LAWRENCE PETER "YOGI" BERRA (1925)
FRANK STELLA (1936)
GEORGE CARLIN (1937)

"An Imposing Ceremonial. Blessing of the New Roman Catholic Cathedral. An Immense Attendance of the Clergy."

THE NEW YORK TIMES, 1879

Julius Wilcox

Walking down Fifth Avenue at the turn of the 20th century, with St. Patrick's Cathedral dominating the scene, 1902.

Die Fifth Avenue mit der unübersehbaren St. Patrick's Cathedral zu Beginn des 20. Jahrhunderts, 1902.

Promenade sur la Cinquième Avenue au tournant du XXe siècle, sous le regard de la cathédrale Saint-Patrick, 1902.

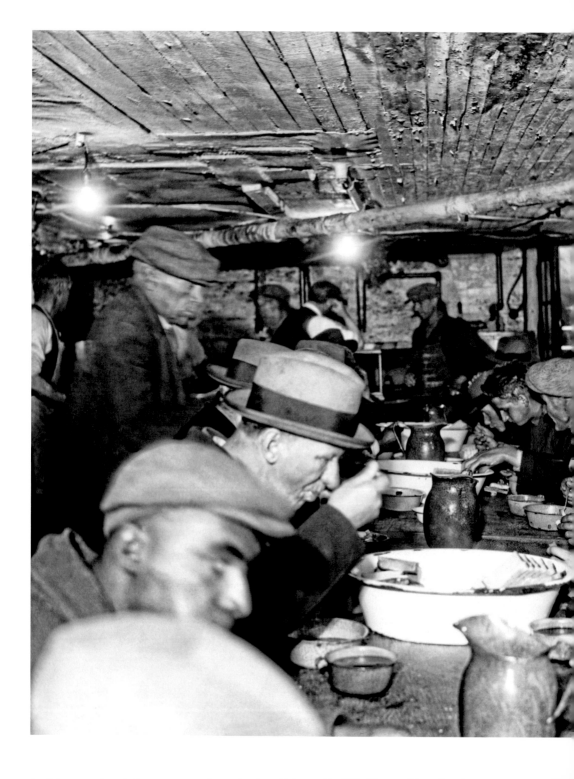

HARVEY KEITEL (1939)

Underwood & Underwood

A Christmas Day meal at a soup
kitchen. New York has always been a
city of extremes: fabulously wealthy
people and the destitute, early 1900s.

Ein Weihnachtsessen in einer Volksküche. New York war schon immer eine
Stadt der Extreme, mit unglaublichem
Reichtum neben Armut und Elend,
Anfang des 20. Jahrhunderts.

Jour de Noël dans une soupe populaire.
New York a toujours été une ville
d'extrêmes, rassemblant des gens fabuleusement riches et des exclus, début
des années 1900.

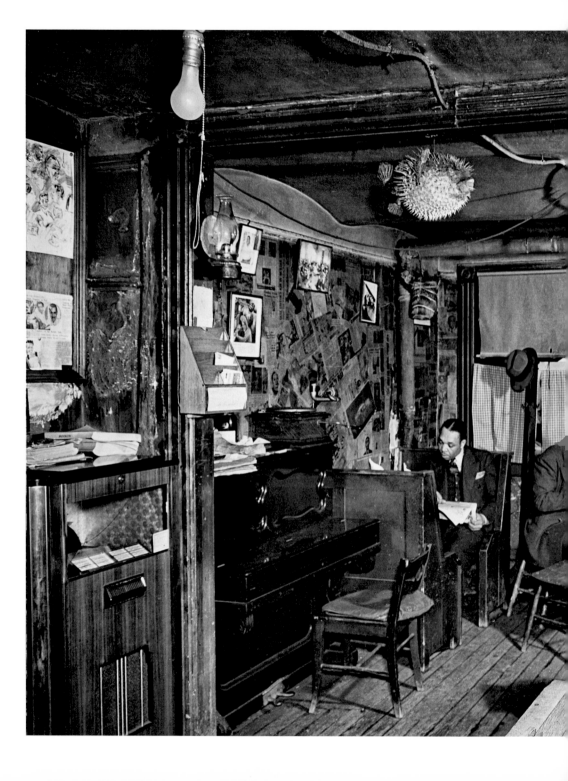

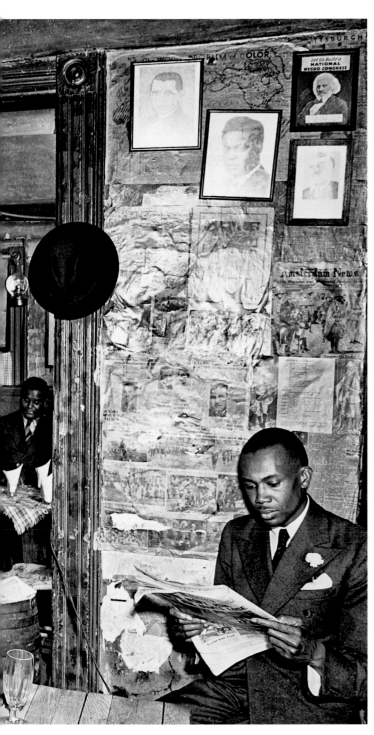

Harold Corsini

A Harlem restaurant, 1935.

Ein Restaurant in Harlem, 1935.

Un restaurant à Harlem, 1935.

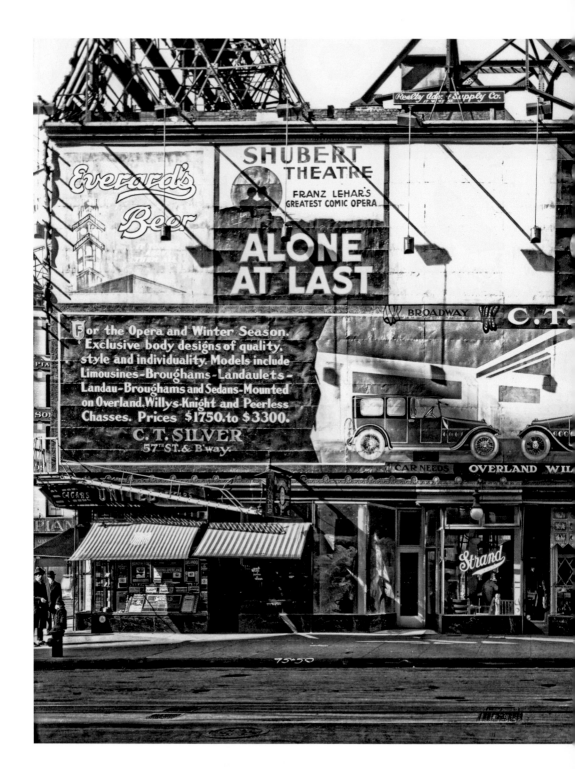

RICHARD AVEDON (1923)
JASPER JOHNS, JR. (1930)

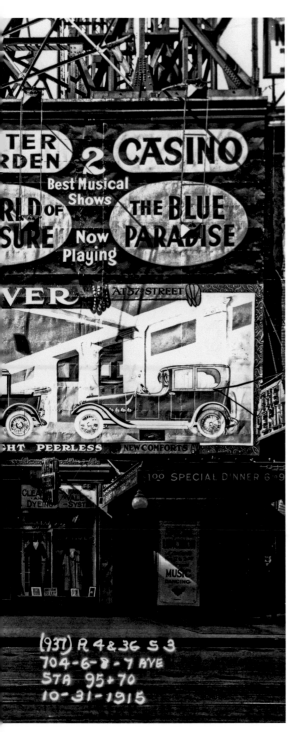

Anonymous

The street, advertising billboards for beer and the theater adorning the side of the building, and, above that, the tracks for the above-ground train, 1915.

Die Straße, Werbeplakate für Bier und das Theater an einer Hauswand, darüber die Gleise der Hochbahn, 1915.

Dans la rue. Façades recouvertes d'affiches publicitaires pour de la bière et pour le cinéma à l'angle de l'immeuble. Au-dessus, on devine les voies du train suspendu, 1915.

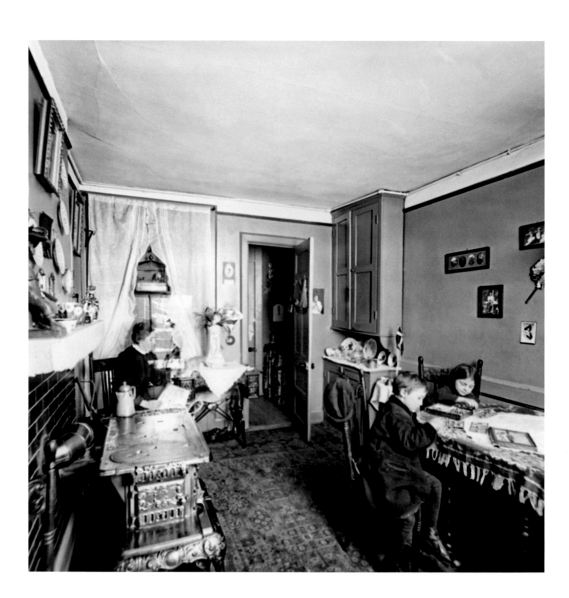

"The death of a child in a tenement was registered at the Bureau of Vital Statistics as 'plainly due to suffocation in the foul air of an unventilated apartment.'"

HOW THE OTHER HALF LIVES, JACOB RIIS, 1890

Jacob Riis

An interior of a tenement apartment on the Lower East Side. This room serves as the kitchen, the living room, and possibly the sleeping quarters as well, 1880s.

Eine Mietwohnung auf der Lower East Side. Das Zimmer ist sowohl Küche als auch Wohnzimmer und wahrscheinlich auch Schlafzimmer, 1880er-Jahre.

Intérieur d'un appartement d'une maison de rapport, dans le Lower East Side. Cette pièce faisait office de cuisine, de séjour et sans doute de chambre, années 1880.

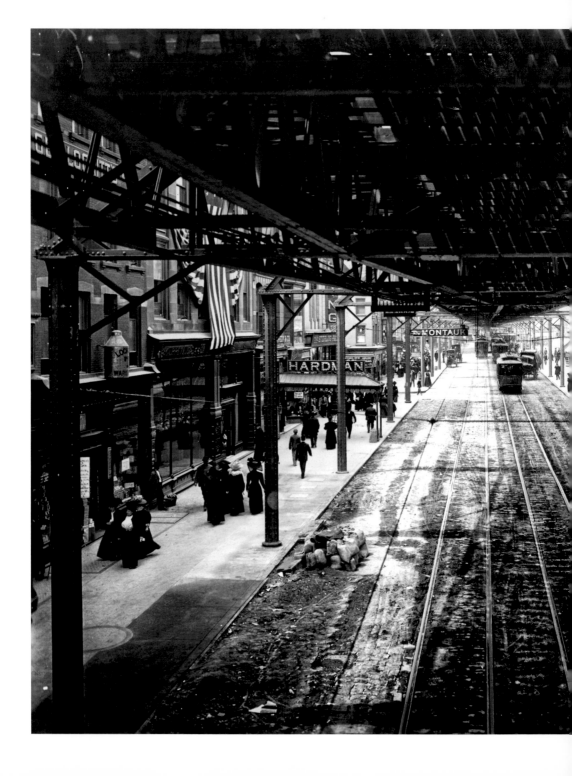

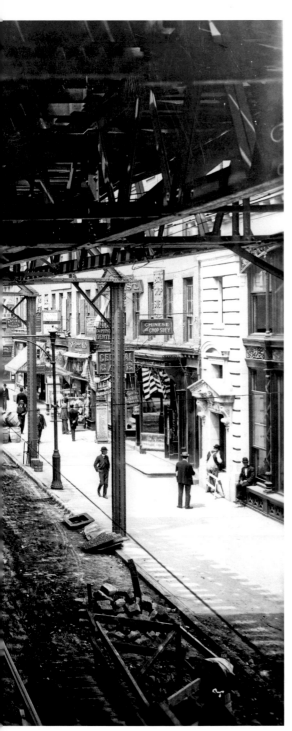

Anonymous

Fulton Street. In addition to the elevated
railroad, there are trolley cars running
beneath and a horse-drawn car, c. 1908.

Fulton Street. Hier sieht man nicht
nur die Hochbahn, sondern auch die
Straßenbahn und eine Pferdekutsche
darunter, um 1908.

Fulton Street. En dehors du train
surélevé, on aperçoit des tramways
et une voiture à cheval sous la voie
suspendue, vers 1908.

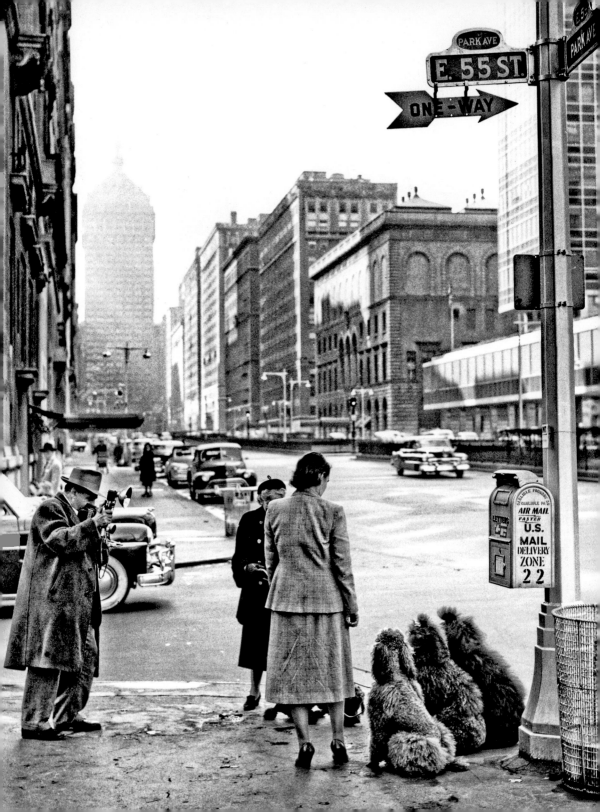

"I hover around the neighborhood, knowing something is gonna happen. I don't know what, but I'm all ready with my camera, just in case."

WEEGEE, 1945

Weegee

Photographing three well-groomed dogs on Park Avenue and 55th Street, c. 1945.

Aufnahme von drei adretten Hunden an der Ecke Park Avenue und 55th Street, um 1945.

Trois chiens toilettés avec soin à l'angle de Park Avenue et de la 55e Rue, vers 1945.

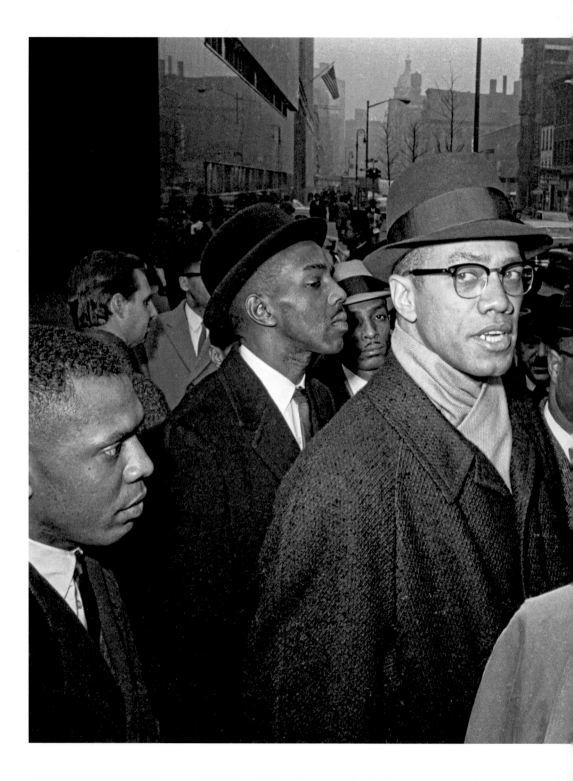

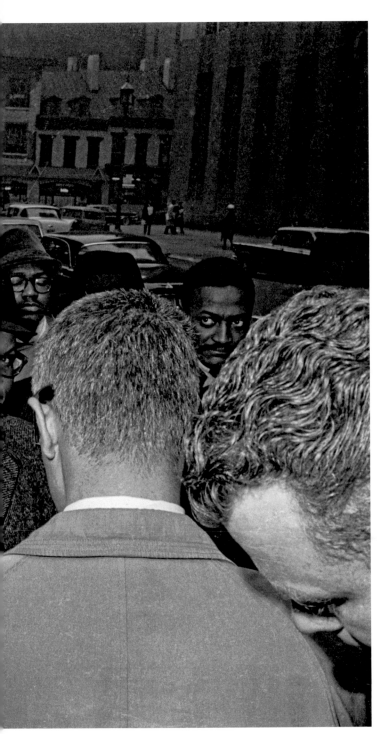

MALCOLM X (1925)
GRACE JONES (1948)
JOEY RAMONE (1951)

Anonymous

Malcolm X and Nation of Islam
followers photographed on the streets
of New York in 1963. In 1964, Malcolm
X left the Nation of Islam following
a dispute with his mentor and leader,
Elijah Muhammad. The rift was to have
tragic consequences when Malcolm X
was assassinated in 1965.

Malcolm X und Anhänger der Nation of
Islam, fotografiert auf den Straßen von
New York 1963. 1964 verließ Malcolm
X nach Auseinandersetzungen mit
seinem Mentor und geistigen Anführer
Elijah Muhammad die Nation of Islam.
Diese Abspaltung hatte tragische Folgen:
1965 wurde Malcolm X ermordet.

Malcolm X et ses partisans de la Nation
d'Islam photographiés dans une rue de
New York en 1963. En 1964, Malcolm
X quitta la Nation of Islam après un
conflit avec son mentor et leader, Elijah
Muhammad. L'incident devait avoir
des conséquences tragiques puisque
Malcolm X fut assassiné en 1965.

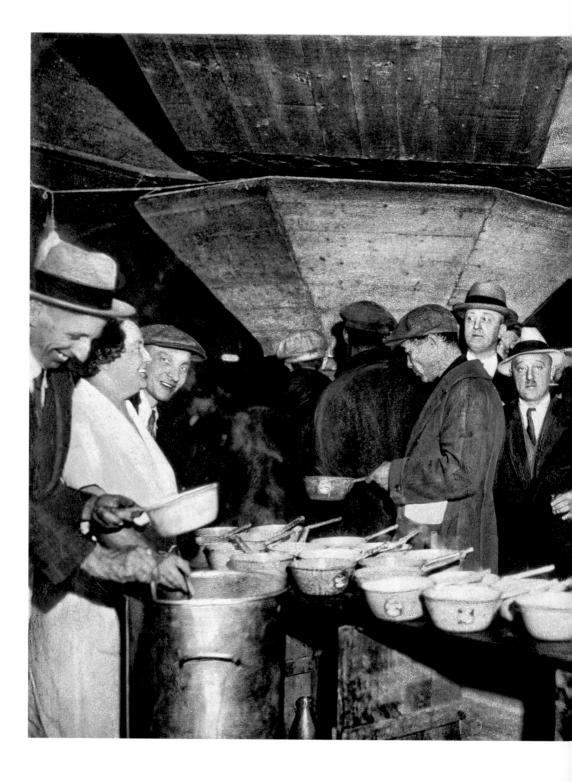

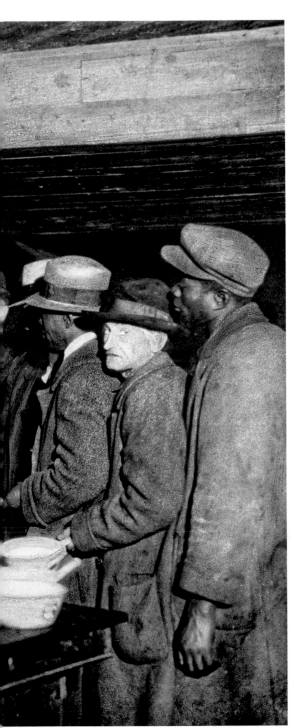

**"BUSTA RHYMES" TREVOR
TAHIEM SMITH, JR. (1972)**

Anonymous

A soup kitchen. The crash hit New Yorkers hard, pushing the unemployment rate up to 25 percent by 1932. There had been downturns before, but this was a Great Depression that engulfed not just New York, but the whole Western world, 1931.

Eine Volksküche. Der Crash war ein harter Schlag für die New Yorker. 1932 lag die Arbeitslosenrate bei 25 Prozent. Zwar hatte es auch früher schon schlechte Zeiten gegeben, aber unter dieser Wirtschaftskrise litt nicht nur New York, sondern die gesamte westliche Welt, 1931.

Une soupe populaire. Le crash frappa très fort New York, faisant monter le taux de chômage à 25 %. Des crises s'étaient produites auparavant, mais cette Grande Dépression allait frapper non seulement New York, mais la totalité du monde occidental, 1931.

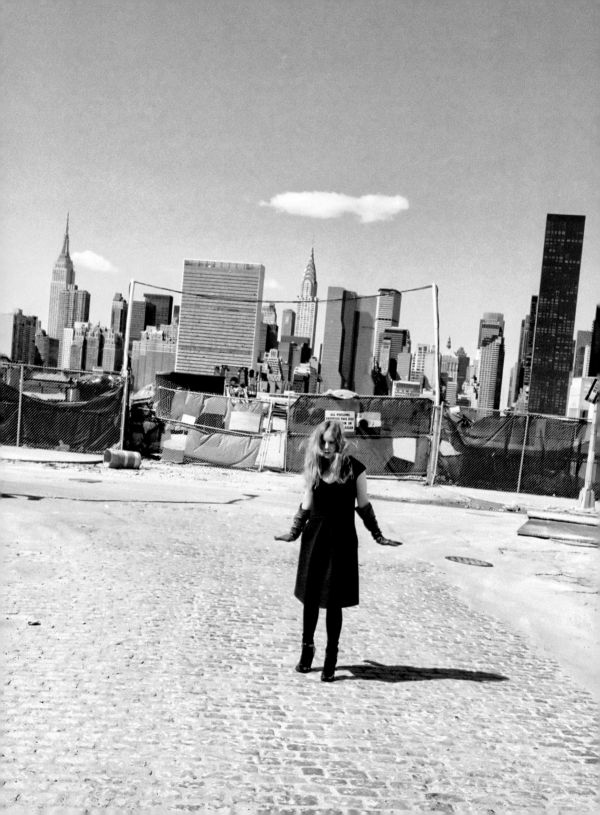

"THE NOTORIOUS B.I.G." CHRISTOPHER
GEORGE LATORE WALLACE (1972)

*Miranda Hobbes: "Why do I think
living in Manhattan is so fantastic?"
Carrie Bradshaw: "Because it is."*

SEX AND THE CITY

Juergen Teller

Jennifer Jason Leigh, a fashion shot for the New York designer Marc Jacobs, 2006.

Jennifer Jason Leigh, eine Modeaufnahme für den New Yorker Designer Marc Jacobs, 2006.

Jennifer Jason Leigh, une prise de vue de mode pour le styliste new-yorkais Marc Jacobs, 2006.

NAOMI CAMPBELL (1970)

Gail Albert Halaban

Central Park Wind, 2005.

Wind am Central Park, 2005.

Vent à Central Park, 2005.

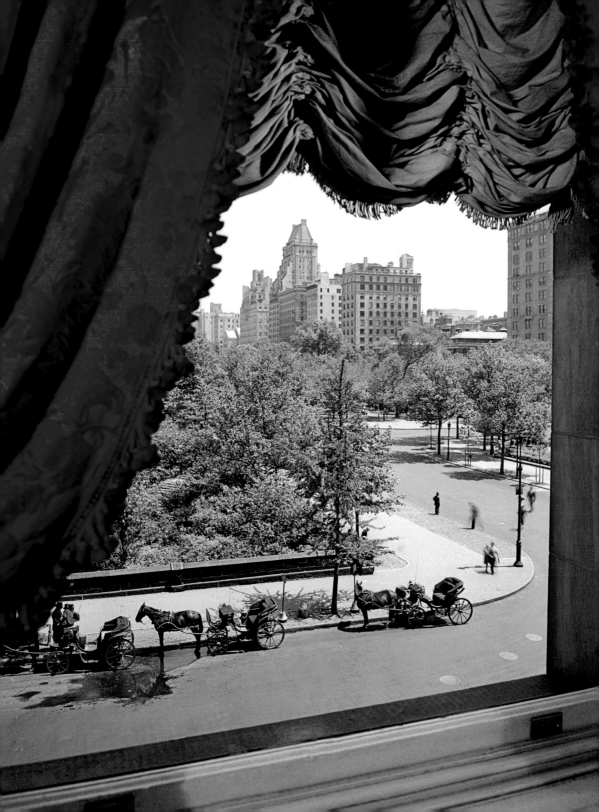

*'And I always heard people
in New York never get to
know their neighbors.'*

BREAKFAST AT TIFFANY'S, 1961

Dmitri Kessel

View from inside the Plaza Hotel.
The hotel, on Fifth Avenue and Central
Park South, opened in 1907, and this
Beaux-Arts marvel is a National Historic
Landmark. It has been featured in numer-
ous movies, from *Barefoot in the Park* to
Crocodile Dundee. Tony Soprano moves
in there when his wife, Carmela, kicks
him out of their home in *The Sopranos*,
1946.

Blick aus dem Plaza Hotel. Das Hotel
im Beaux-Arts-Stil an Fifth Avenue und
Central Park South wurde 1907 eröffnet
und ist ein nationales Baudenkmal. Es
kommt in mehreren Kinofilmen von
Barfuß im Park bis zu *Crocodile Dundee*
vor. Tony Soprano zieht in dieses
Hotel, als ihn seine Frau Carmela in *Die
Sopranos* hinauswirft, 1946.

Vue prise du Plaza Hotel. L'hôtel situé
sur la Cinquième Avenue et Central Park
South ouvrit ses portes en 1907. Son
architecture Beaux-Arts en fait un
monument historique. Il a servi de
décor à de nombreux films, de *Pieds nus
dans le parc* à *Crocodile Dundee*. Tony
Soprano s'y installe lorsque son épouse,
Carmela, le chasse de leur maison dans
Les Soprano, 1946.

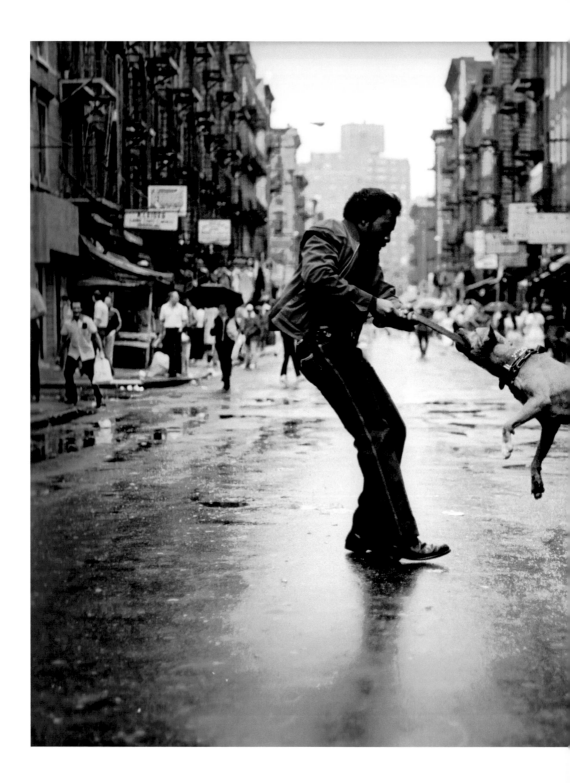

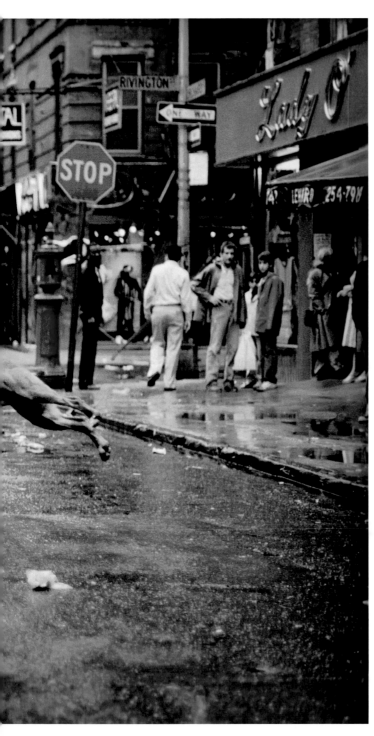

BOB DYLAN (1941)

Jamel Shabazz

Man and Dog on the Lower East Side.
The neighborhood that played such
a key role in the American immigrant
experience throughout the 19th and
early-20th centuries has been gentrified
in the last 15 years, 1980.

*Mann und Hund auf der Lower East
Side.* Die Bevölkerungsstruktur des
Viertels, das im 19. und frühen 20. Jahr-
hundert eine so große Rolle für die
Einwanderer gespielt hatte, wurde in
den letzten 15 Jahren durch Sanierun-
gen komplett umgewandelt, 1980.

*Un homme et un chien dans le Lower
East Side.* Ce quartier, qui avait joué
un rôle clé à l'arrivée des immigrants
tout au long du XIXe siècle et au début
du XXe s'est embourgeoisé pendant ces
quinze dernières années, 1980.

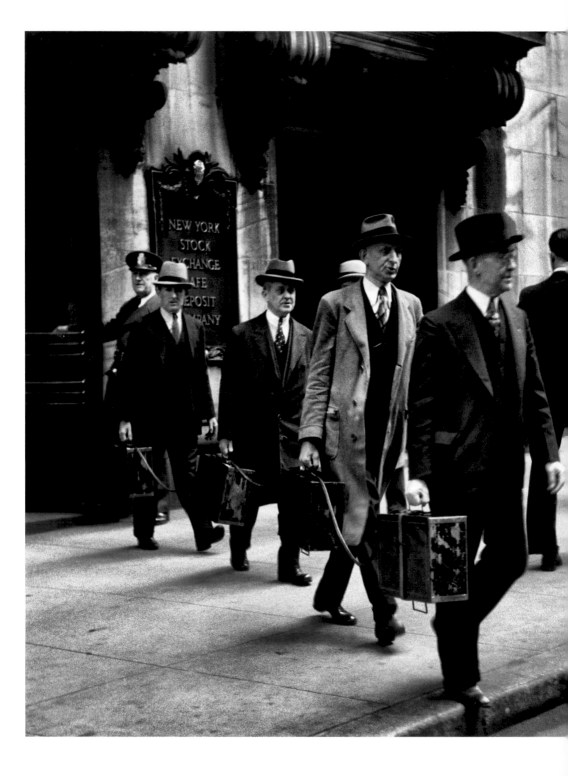

Carl Mydans

Chain Gang. Four Wall Street workers going about their business, 1937.

Gänsemarsch. Vier Männer marschieren hintereinander aus der New Yorker Börse heraus, 1937.

Les enchaînés. Quatre très sérieux personnages quittent la Bourse de New York, 1937.

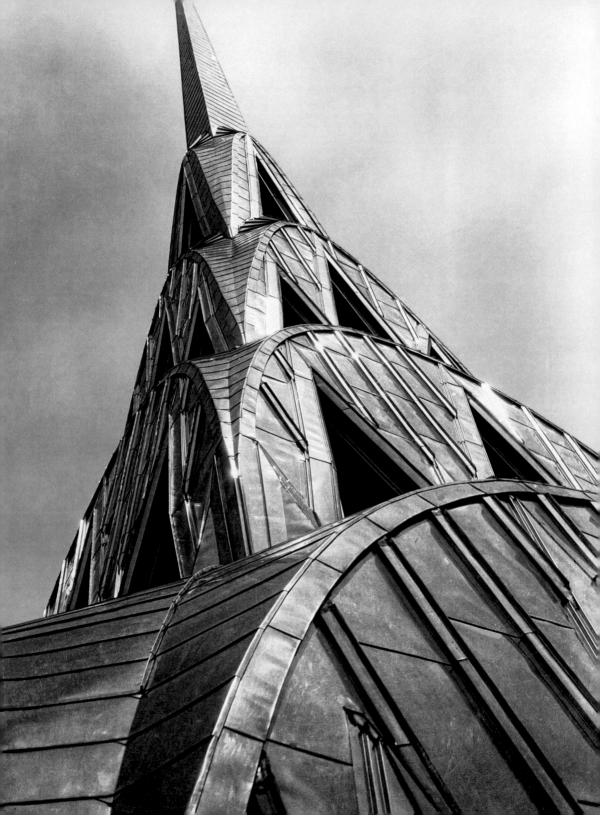

AL JOLSON (1886)
DOROTHEA LANGE (1895)
MILES DAVIS (1926)

"Art Deco in France found its American equivalent in the design of the New York skyscrapers of the 1920s. The Chrysler Building... was one of the most accomplished essays in the style."

THE WORLD ATLAS OF ARCHITECTURE, JOHN JULIUS NORWICH, 1994

Margaret Bourke-White

A close-up of the Chrysler Building, a homage to the automobile. It is an Art Deco masterpiece, and a building that virtually all architects revere. A distinctive feature is its terraced crown built of stainless steel, 1931.

Das Chrysler Building – eine Hommage an das Automobil – aus nächster Nähe. Das Art-déco-Meisterwerk wird von nahezu allen Architekten der Welt verehrt. Eines seiner Kennzeichen ist die abgestufte Bekrönung aus Edelstahl, 1931.

Gros plan du Chrysler Building, hommage à l'automobile. C'est un chef-d'œuvre Art déco que tous les architectes révèrent. L'un de ses éléments caractéristiques est son couronnement à retraits en acier inoxydable, 1931.

CORNELIUS VANDERBILT (1794)
HENRY A. KISSINGER (1923)

Dude walking out of Penn Station: "You know what's great about going out in New York City? You can get completely bombed and it's no big deal, because you'll probably never see those people again, you know?"

OVERHEARDINNEWYORK.COM, 2008

Ralph Gibson

Water tower shadow. Water towers are one of New York's most distinctive and prevalent landmarks, littering the skyline, 1989.

Schatten eines Wasserturms. Die vielen Wassertürme in der Skyline von New York gehören zu den markantesten Wahrzeichen der Stadt, 1989.

Ombre portée d'un réservoir d'eau. Ces réservoirs sont des éléments architecturaux caractéristiques qui ponctuent le panorama urbain new-yorkais, 1989.

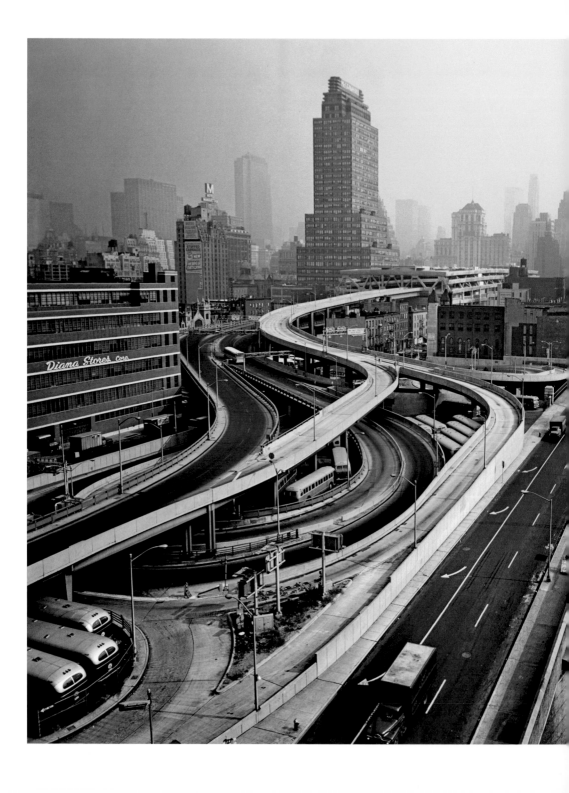

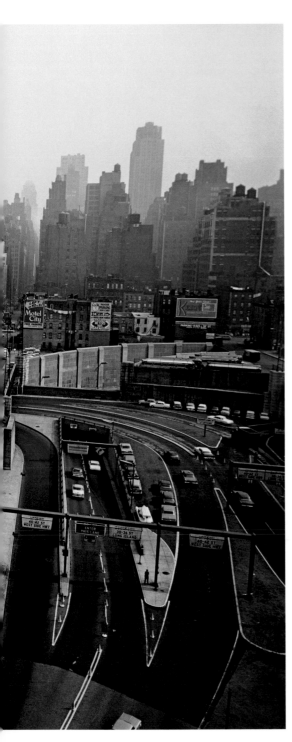

RUDY GIULIANI (1944)

Evelyn Hofer

Arteries. A series of highways flowing through the heart of Manhattan's West Side, 1964.

Schlagadern. Eine Reihe von Stadtautobahnen, die mitten durch die West Side Manhattans verlaufen, 1964.

Artères. Un réseau de voies express suspendues traverse le cœur du West Side de Manhattan, 1964.

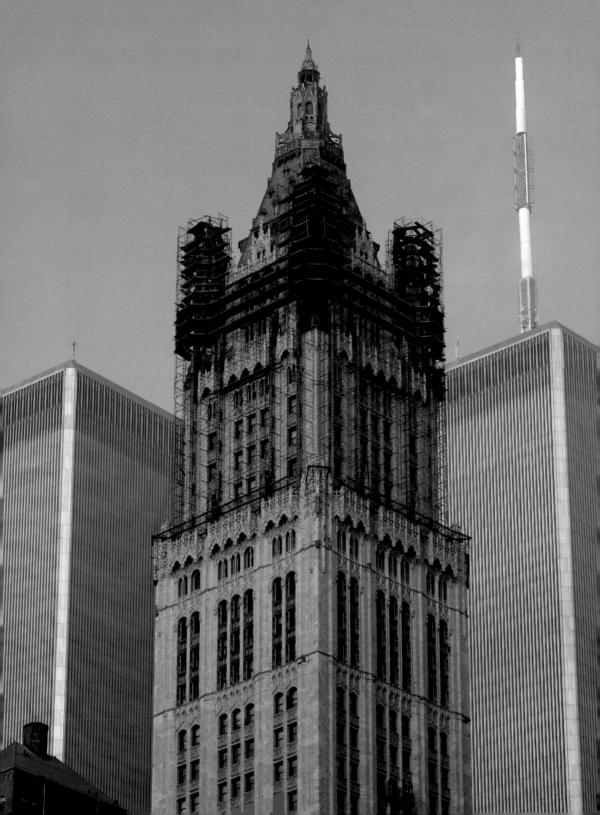

"Cathedral of Commerce."

A CLERGYMAN DESCRIBING THE WOOLWORTH BUILDING, c. 1913

Reinhart Wolf

The Woolworth Building on 233 Broadway was built in 1913 for Frank W. Woolworth by Cass Gilbert. It is 60 stories, 792 feet high, but is dwarfed here by the sorely missed World Trade Center, c 1980s.

Das Woolworth Building, 233 Broadway, wurde 1913 von Cass Gilbert für Frank W. Woolworth erbaut. Es hat 60 Stockwerke und ist 241 m hoch. Hier erscheint es klein im Vergleich zu den heute schmerzlich vermissten Türmen des World Trade Centers, um 1980.

233 Broadway, le Woolworth Building a été construit par Cass Gilbert pour Frank W. Woolworth en 1913. Ses 60 niveaux et ses 241 mètres de haut furent longtemps minimisés par le tristement disparu World Trade Center, années 1980.

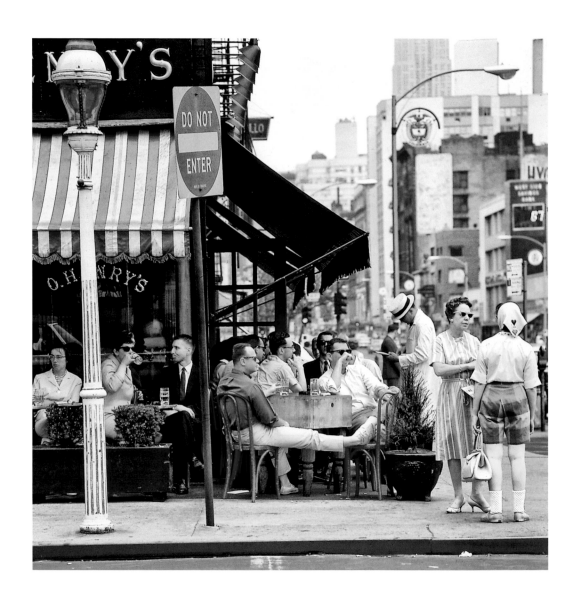

"I swung onto my old guitar
Grabbed hold of a subway car
And after a rocking, reeling, rolling ride
I landed up on the downtown side
Greenwich Village."

TALKIN' NEW YORK, BOB DYLAN, 1962

Anonymous

O. Henry's, on the corner of Sixth Avenue and Fourth Street, in the heart of Greenwich Village. Of all New York neighborhoods, the Village has a particularly European ambience, being neither car- nor grid-friendly, 1964.

O. Henry's an der Ecke Sixth Avenue und Fourth Street im Herzen von Greenwich Village. Von allen Vierteln in New York erinnert das Village mit seiner Aversion gegen Autos und schachbrettartig konzipierte Straßen am meisten an Europa, 1964.

O. Henry's, à l'angle de la Sixième Avenue et de la 4ᵉ Rue, au cœur de Greenwich Village. De tous les quartiers de New York, le Village, qui a échappé à la trame new-yorkaise et aux voitures, possède une ambiance européenne particulière, 1964.

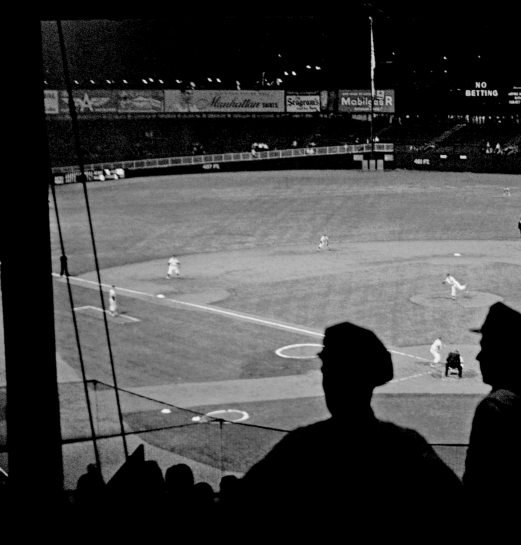

MAY 31

Marvin Newman

Following the action high and above, at Yankee Stadium, the Bronx. The team is known as the Bronx Bombers, 1955.

Blick auf ein Spiel im Yankee Stadion in der Bronx. Die Mannschaft wurde auch „Bronx Bombers" genannt, 1955.

En observation du haut du Yankee Stadium, dans le Bronx. L'équipe locale était celle des Bronx Bombers, 1955.

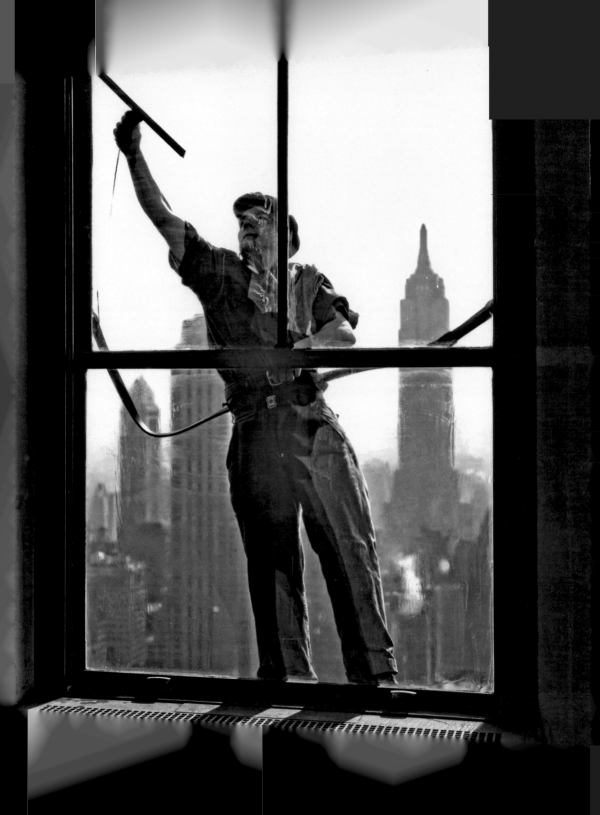

"Outside America, New York is America, and its skyscraper a symbol of the spirit of America."

THOMAS ADAMS, 1931

Wendell Scott MacRae

A window washer at the Rockefeller Center tied to what looks like a fairly flimsy cable. The Empire State Building behind him would suggest that the man is cleaning the windows of the RCA Building. Designed by Raymond Hood, it became the home of the television station NBC. In 1988, it was renamed the GE (General Electric) Building, 1936.

Ein Fensterputzer am Rockefeller Center, gesichert durch ein nicht sehr vertrauenswürdig aussehendes Seil. Das Empire State Building dahinter lässt vermuten, dass der Mann die Scheiben des RCA Building putzt. Das von Raymond Hood entworfene Gebäude war später der Sitz des Fernsehsenders NBC. 1988 wurde es in GE (General Electric) Building umbenannt, 1936.

Un laveur de vitres au Rockefeller Center, attaché à un câble qui semble bien léger. La présence de l'Empire State Building derrière lui suggère qu'il nettoie les vitres du RCA Building. Conçu par Raymond Hood, il devint le siège de la chaîne de télévision NBC. En 1988, il fut renommé GE (General Electric) Building, 1936.

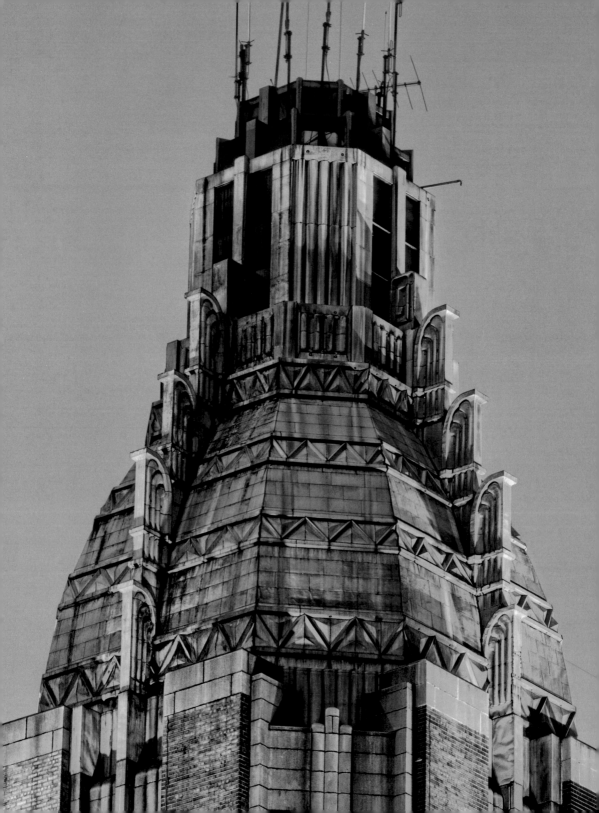

"Don't you know the crime rate is going up, up, up, up, up!
To live in this town you must be tough, tough, tough, tough, tough!
You got rats on the West Side
Bed bugs uptown
What a mess this town's in tatters I've been shattered
My brain's been battered — splattered — all over Manhattan."

"SHATTERED," THE ROLLING STONES, 1978

Reinhart Wolf

The top of the Waldorf-Astoria Hotel, at 301 Park Avenue, between 49th and 50th Streets, 1979.

Die Spitze des Hotels Waldorf-Astoria in der Park Avenue 301, zwischen der 49th und 50th Street, 1979.

Le sommet du Waldor Astoria Hotel, 301 Park Avenue, entre la 49e et la 50e Rue, 1979.

TONY CURTIS (1925)
ALLEN GINSBERG (1926)
DONALD JUDD (1928)

Joel Meyerowitz

New York Fashion, 1974.

New Yorker Mode, 1974.

Mode new-yorkaise, 1974.

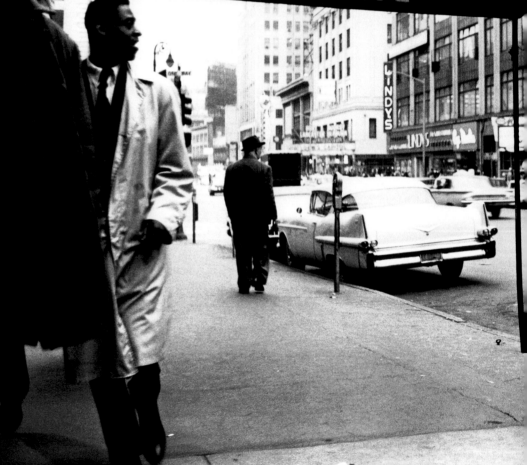

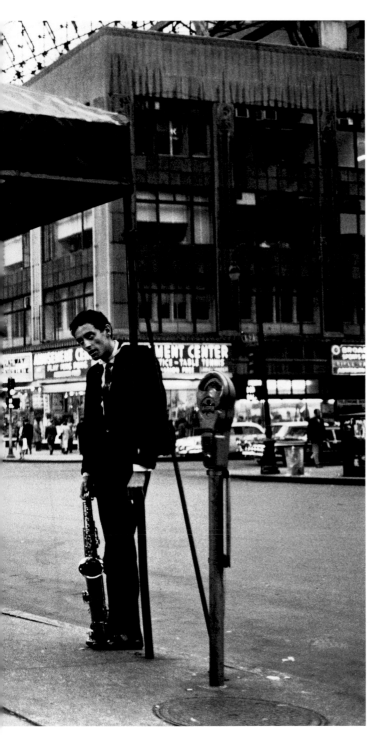

William Claxton

*Outside Birdland at Four o'Clock in
the Morning*, 1960.

*Vor dem Birdland um vier Uhr
früh*, 1960.

*Devant le Birdland à quatre heures
du matin*, 1960.

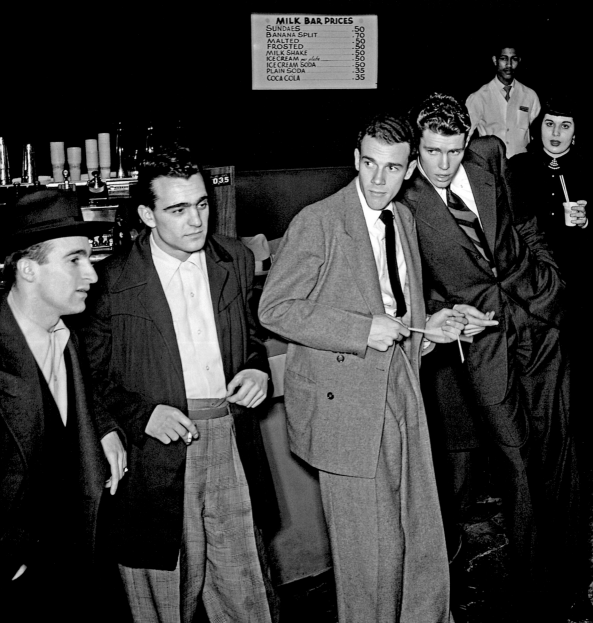

MILK BAR PRICES

SUNDAES	.50
BANANA SPLIT	.70
MALTED	.50
FROSTED	.50
MILK SHAKE	.50
ICE CREAM per plate	.50
ICE CREAM SODA	.50
PLAIN SODA	.35
COCA COLA	.35

SPALDING GRAY (1941)
LAURIE ANDERSON (1947)

"Coltrane, particularly from 1961 to 1964,
sounds like the thing we know as modern jazz."

COLTRANE: THE STORY OF A SOUND, BEN RATLIFF, 1961

Anonymous

Bop City nightclub was on 52nd Street and featured some of the hippest cats of the day, including Miles Davis and Charlie Parker—as well as some sharply dressed patrons, 1950.

Der Nachtclub Bop City war in der 52nd Street; dort traten die angesagten Leute dieser Zeit auf, zum Beispiel Miles Davis und Charlie Parker. In Schale geworfene Gäste kamen auch, 1950.

Le night-club Bop City sur la 52e Rue présentait les stars les plus en vue du moment dont Miles Davis et Charlie Parker. Les clients impeccablement habillés faisaient aussi partie du spectacle, 1950.

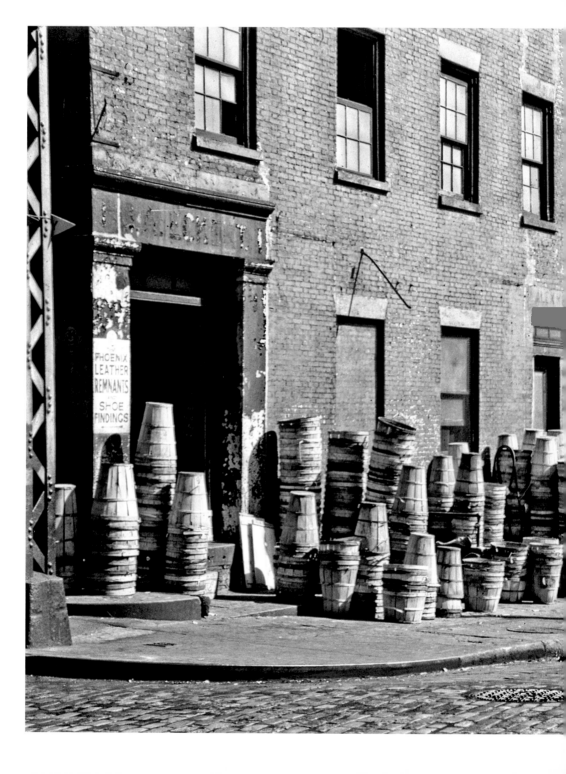

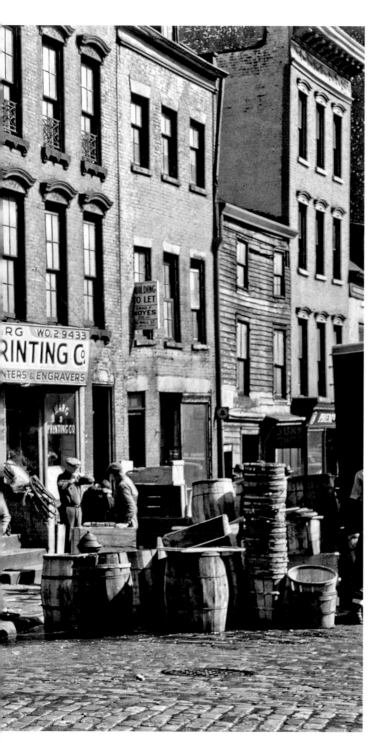

Charles Cushman

Pearl Street, one of Manhattan's
oldest streets, 1942.

Pearl Street, eine der ältesten Straßen
von Manhattan, 1942.

Pearl Street, l'une des plus anciennes
rues de Manhattan, 1942.

*"The buildings are shimmering verticality,
a gossamer veil, a festive scene-prop
hanging there against the black sky to
dazzle, entertain, amaze."*

"THE DISAPPEARING CITY," FRANK LLOYD WRIGHT, 1932

Wendell Scott MacRae

The Mundane and the Magnificent. The Empire State Building photographed from the unusual vantage point of a toilet, 1930s.

Das Banale und das Großartige. Das Empire State Building von dem ungewöhnlichen Aussichtspunkt einer Toilette aus fotografiert, 1930er-Jahre.

Le trivial et la splendeur. L'Empire State Building photographié d'un point de vue inhabituel, années 1930.

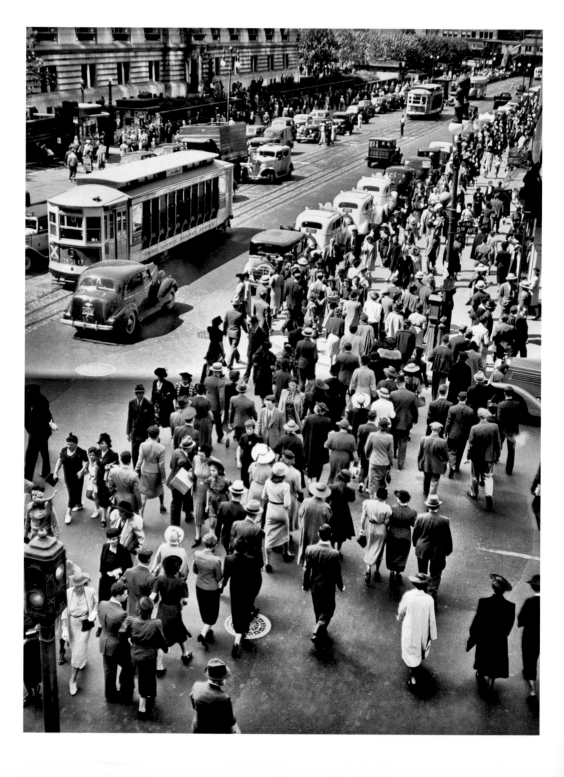

JERRY STILLER (1927)
JOAN RIVERS (1933)

*"East side, West side,
All around the town,
The tots sang 'Ring-around-Rosie,'
'London Bridge is Falling Down.'
Boys and girls together,
Me and Mamie O'Rourke,
Tripped the light fantastic,
On the sidewalks of New York."*

"THE SIDEWALKS OF NEW YORK," CHARLES B. LAWLOR AND JAMES W. BLAKE, 1894

Berenice Abbott

Tempo of the City. Fifth Avenue and 42nd Street, photographed from above, demonstrating New York's bustle, crowds, and manic energy, 1937.

Tempo der Stadt. Fifth Avenue und 42nd Street, fotografiert von oben. Die Aufnahme bringt die Hektik, Betriebsamkeit und frenetische Energie von New York zum Ausdruck, 1937.

Le tempo de la ville. La Cinquième Avenue et la 42e Rue photographiées du haut d'un immeuble pour saisir la foule new-yorkaise dans son inlassable énergie, 1937.

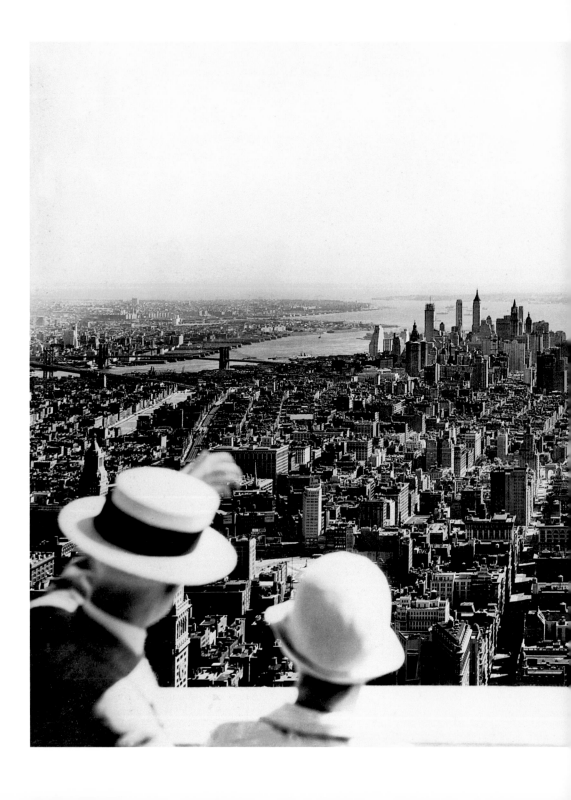

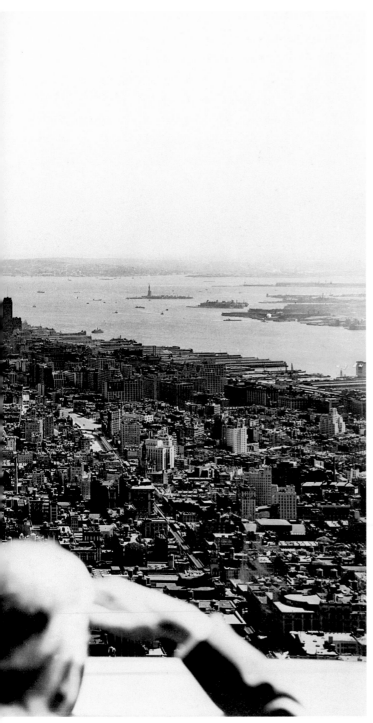

Samuel H. Gottscho

*The Opening Day of the Empire State
Building.* The observatory deck near
the top of the tower offers stunning
360-degree views of Manhattan.
Here, awestruck visitors are gazing
at Downtown, 1931.

*Der Tag der Eröffnung des Empire
State Building.* Die Aussichtsplattform
knapp unter der Turmspitze bietet eine
atemberaubende Rundumsicht auf Man-
hattan. Hier schauen die Touristen voller
Ehrfurcht in Richtung Downtown, 1931.

*Jour d'inauguration à l'Empire State
Building.* La plate-forme d'observation
près du sommet de la tour offre une
étonnante vision à 360° de Manhattan.
Ici, un public émerveillé observe le
Downtown, 1931.

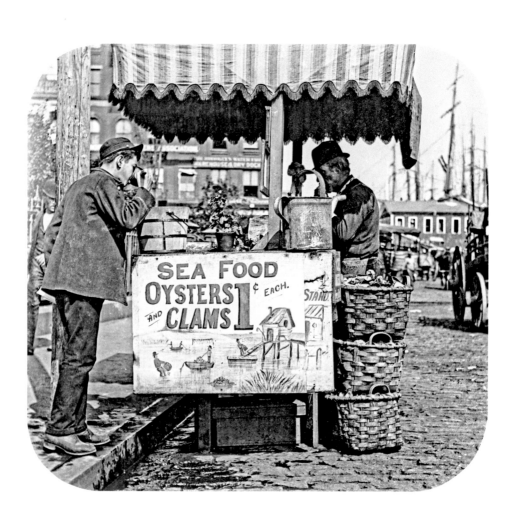

"Jimmie's occupation for a long time was to stand on street corners and watch the world go by, dreaming blood-red dreams at the passing of pretty women."

MAGGIE: A GIRL OF THE STREETS, STEPHEN CRANE, 1893

Anonymous

The oyster stand. In terms of variety and value, New York has the best street food in the world, 1898.

Austernstand. Die Imbissstände von New York gehören in puncto Vielfalt und Qualität zu den besten der Welt, 1898.

Stand d'huîtres. En termes de prix et de variété, la rue de New York offre la meilleure nourriture du monde, 1898.

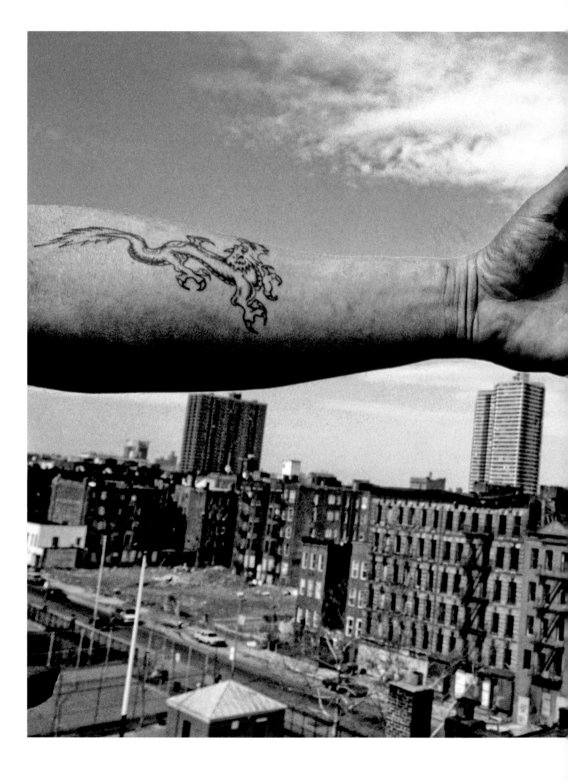

Joseph Rodriguez

Spanish Harlem. The area is one of the
few neighborhoods in Manhattan that
has remained more or less faithful to
its community and has, so far, resisted
gentrification, 1987.

Spanish Harlem. Das Gebiet ist eines
der wenigen Viertel in Manhattan, das
seiner Bevölkerung mehr oder weniger
treu geblieben ist und sich einer Gentri-
fizierung bisher verwehrt hat, 1987.

Spanish Harlem. Cette zone est l'un
des rares quartiers de Manhattan à
être restée plus ou moins fidèle à sa
communauté et à résister jusqu'ici à
l'embourgeoisement, 1987.

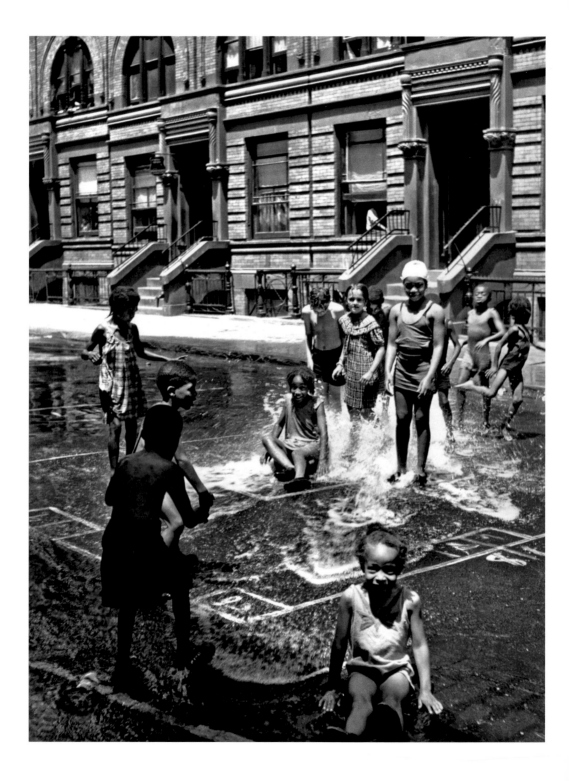

"New York is really the only cosmopolitan American city. It's the only true city in America, in the sense that it's an international crossroads for more than one thing, more than one business, more than one activity."

NEW YORK: A DOCUMENTARY FILM, CALEB CARR, 1999

Alexander Alland

A fire hydrant on 105th Street cools off these Harlem children during a stifling summer day, 1938.

Ein Hydrant auf der 105th Street verschafft diesen Kindern in Harlem an einem drückend heißen Sommertag eine willkommene Abkühlung, 1938.

Des enfants de Harlem se rafraîchissent à une bouche à incendie de la 105ᵉ Rue pendant un jour d'été étouffant, 1938.

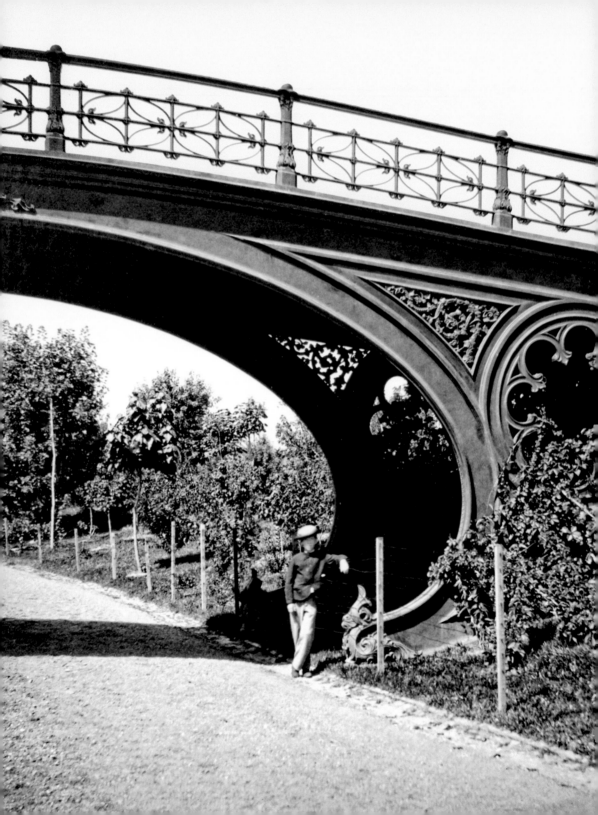

CHRISTO (1935)
MARY-KATE OLSEN AND ASHLEY OLSEN (1986)

"Some people say, 'New York's a great place to visit, but I wouldn't want to live there.' I say that about other places."

ROBERT DE NIRO, DECEMBER 2002

Victor Prevost

Central Park. Construction on the park started in 1857, with sections opening to the public by 1859. By 1865, seven million people per year were enjoying this man-made nature reserve in the heart of the city. This photograph was taken near Lion Bridge on Equestrian Road, 1862.

Central Park. Der Bau des Parks begann 1857; ab 1859 waren Teilbereiche für die Öffentlichkeit zugänglich. Nach 1865 besuchten sieben Millionen Menschen pro Jahr diese von Menschenhand gemachte Naturoase mitten in der Stadt. Dieses Foto wurde an der Lion Bridge in der Equestrian Road aufgenommen, 1862.

Central Park. La construction du parc débuta en 1857, certaines sections s'ouvrant au public dès 1859. En 1865, sept millions de personnes avaient déjà fréquenté cette réserve naturelle artificielle en plein cœur de la ville. Vue prise près du pont du Lion, Equestrian Road, 1862.

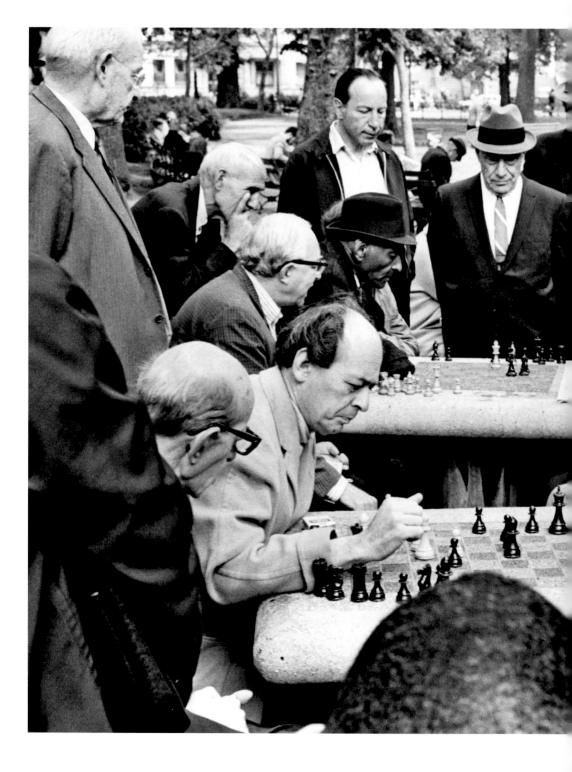

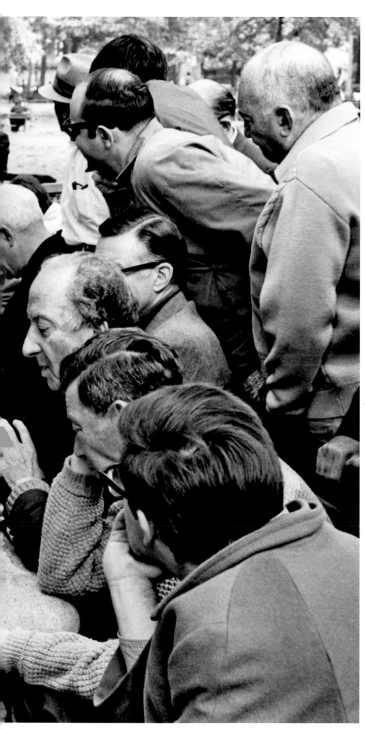

JUNE 14

DONALD TRUMP (1946)

James Jowers

Chess players at Washington Square Park. These days, though the chess players, street performers, and pot dealers (often undercover cops) remain, the New York University (NYU) campus overwhelms the square and its surrounding streets, 1969.

Schachspieler im Washington Square Park. Obwohl es die Schachspieler, Straßenkünstler und Grasdealer (häufig verdeckt ermittelnde Polizisten) auch noch gibt, dominiert nun der Campus der New York University (NYU) den Platz und die Straßen in der Umgebung, 1969.

Joueurs d'échecs à Washington Square Park. Aujourd'hui, si les joueurs d'échecs, les artistes de rue et les dealers de drogues (souvent des policiers en civil) sont toujours là, le campus de l'université de New York domine le square et les rues avoisinantes, 1969.

SAUL STEINBERG (1914)
MARIO CUOMO (1932)

Weegee

President Franklin D. Roosevelt on
Broadway and 49th Street. The presi-
dent, wearing glasses and sitting in the
backseat, acknowledges the presence
of the photographer, as does the police-
man on the motorbike, 1944.

Präsident Franklin D. Roosevelt,
Broadway und 49th Street. Der Präsi-
dent auf dem Rücksitz und mit Brille
ist sich der Gegenwart des Fotografen
bewusst, wie auch der Polizist auf dem
Motorrad, 1944.

Le président Franklin D. Roosevelt sur
Broadway et 49e Rue. Le président,
portant des lunettes est assis à l'arrière.
Il regarde le photographe, de même que
le motard de la police, 1944.

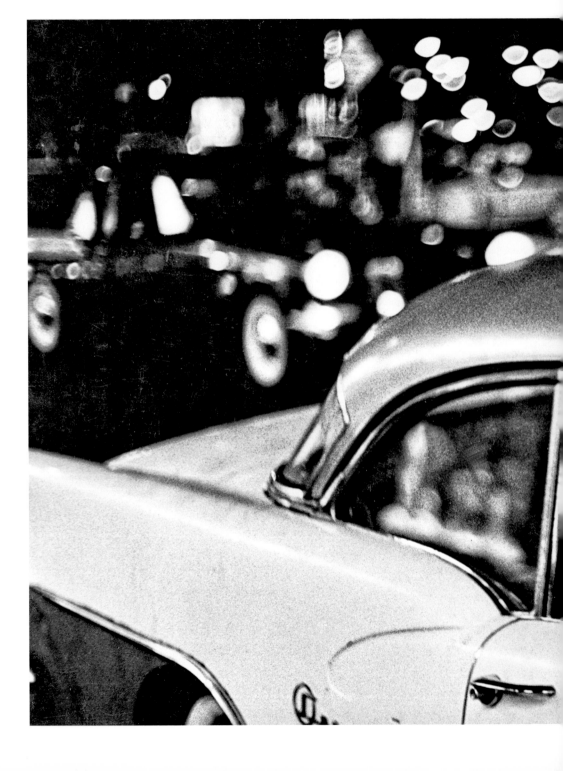

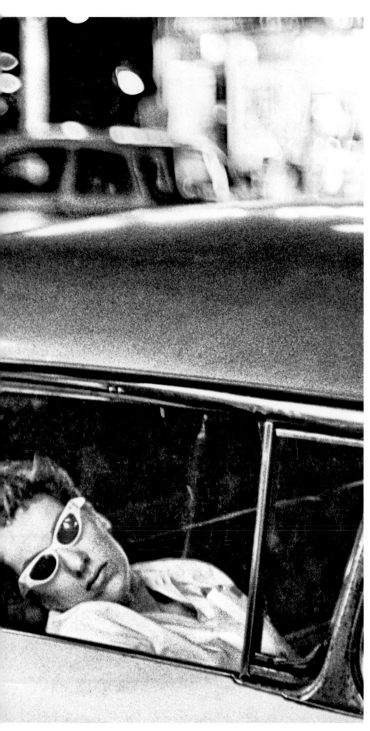

Larry Fink

Cat's Eyes. New York attitude from
the lady in the fancy sunglasses worn
at night, self-conscious yet seemingly
indifferent, 1961.

Katzenaugen. Eine New Yorkerin,
die ihre elegante Sonnenbrille bei
Nacht trägt – unsicher, doch scheinbar
gleichgültig, 1961.

Yeux félins. Attitude typiquement new-
yorkaise de la jeune femme aux lunettes
de soleil portées de nuit, affectée mais
apparemment indifférente, 1961.

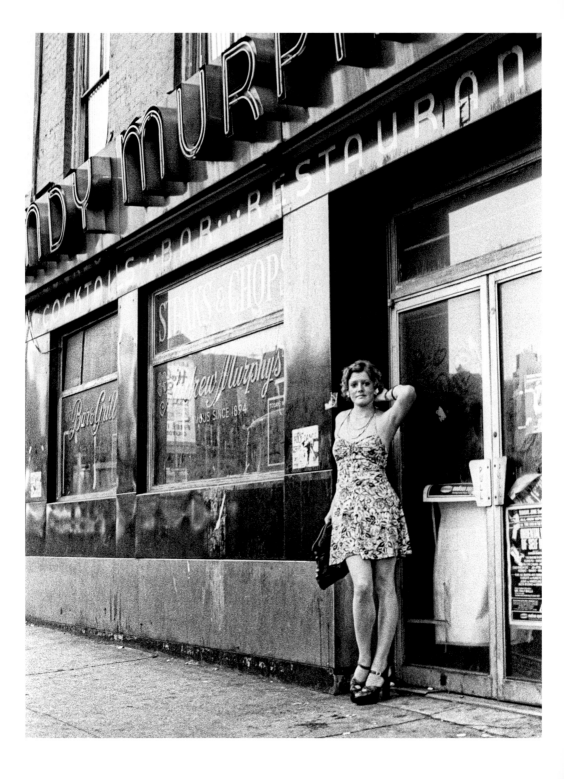

"All the animals come out at night — whores, skunk pussies, buggers, queens, fairies, dopers, junkies, sick, venal. Someday a real rain will come and wash all this scum off the streets."

***TAXI DRIVER*, 1976**

Allan Tannenbaum

Times Square hooker. Since the late 19th century, the area had been associated with vice. Noted for its cafés, hotels, theaters, and restaurants, it was also the place where people came to get laid, 1974.

Prostituierte am Times Square. Seit dem Ende des 19. Jahrhunderts hatte das Gebiet immer als anrüchig gegolten. Hier gab es nicht nur Cafés, Hotels, Theater und Restaurants, sondern es blühte auch das Geschäft mit käuflichem Sex, 1974.

Prostituée à Times Square. Depuis la fin du XIXe siècle, le quartier a toujours été associé à la dépravation. Les gens y venaient non seulement pour les cafés, les hôtels, les théâtres et les restaurants, mais aussi pour le sexe, 1974.

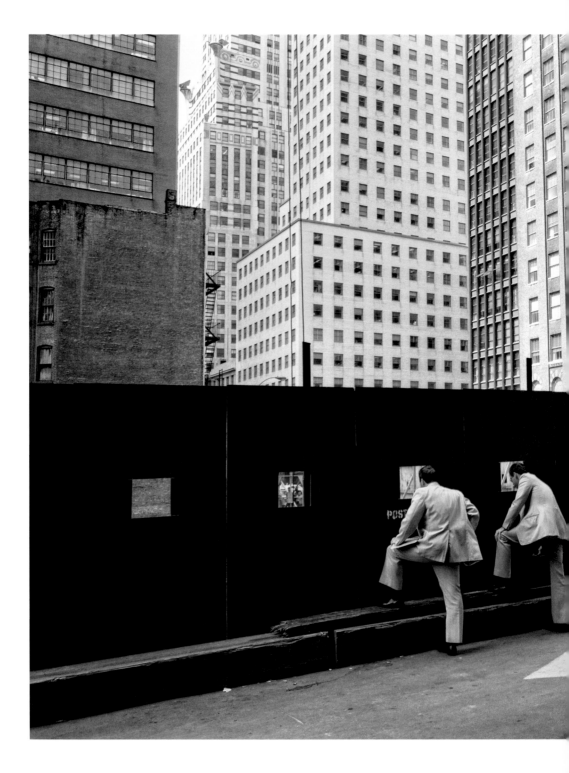

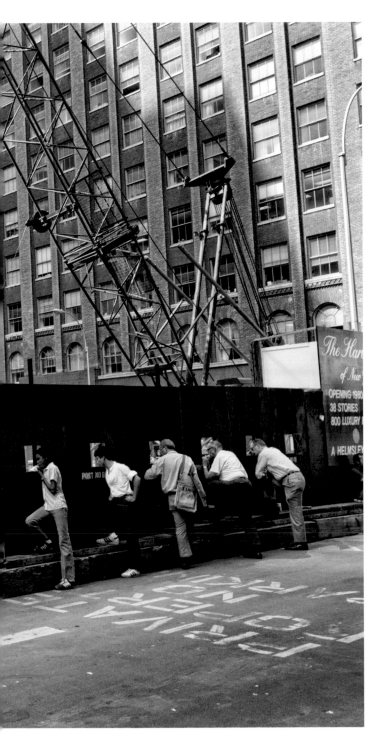

Mitch Epstein

Midtown. There is always major
construction going on in this part
of town, 1979.

Midtown. In Manhattan wird eigentlich
pausenlos gebaut, 1979.

Midtown. Il y a toujours un chantier
quelque part à Manhattan, 1979.

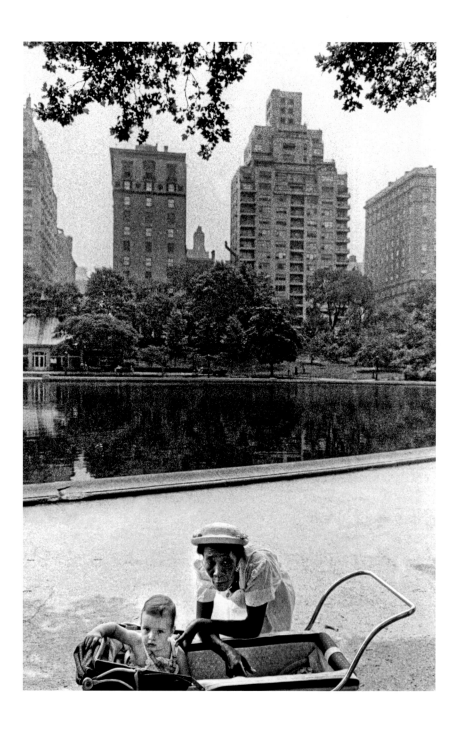

"Integration seems an impossibly romantic notion now. Even to propose it as the solution to the racial morass raises derisive hoots in the black community and patronizing smiles and shrugs from whites."

JOE KLEIN, 1989

Bruce Davidson

Central Park. A nanny and her charge photographed by the lake in Central Park. Some of the most desirable residences in the city overlook Central Park: Fifth Avenue on the East Side and Central Park West on the West Side, 1960.

Central Park. Ein Kindermädchen mit seinem Schützling, aufgenommen am See im Central Park. Einige der begehrtesten Wohnhäuser der Stadt haben Blick auf den Central Park: an der Fifth Avenue auf der East Side und Central Park West auf der West Side, 1960.

Central Park. Une nounou et son enfant photographiés près du lac de Central Park. Certains des appartements les plus recherchés de la ville donnent sur Central Park : Cinquième Avenue dans le East Side et Central Park West dans le West Side, 1960.

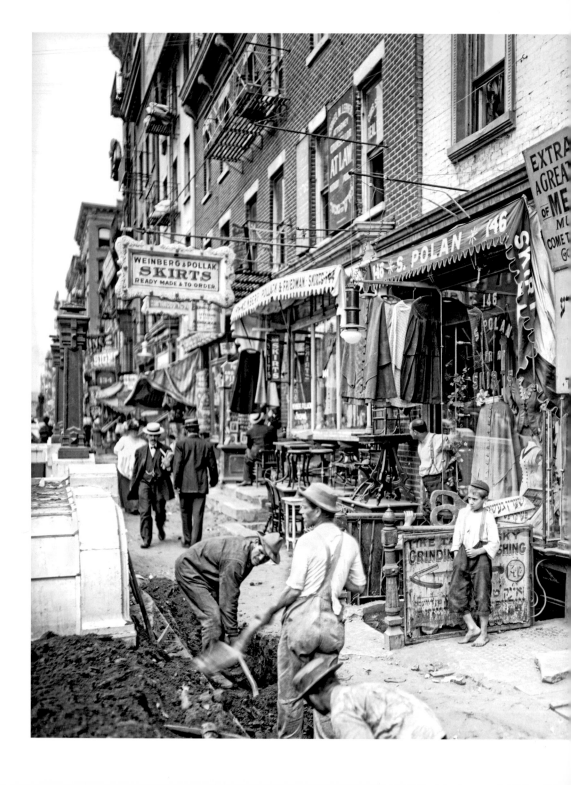

MARTIN LANDAU (1931)
DANNY AIELLO (1933)

Eugene de Salignac

Delancey Street on the Lower
East Side, 1907.

Delancey Street auf der Lower
East Side, 1907.

Delancey Street dans le Lower
East Side, 1907.

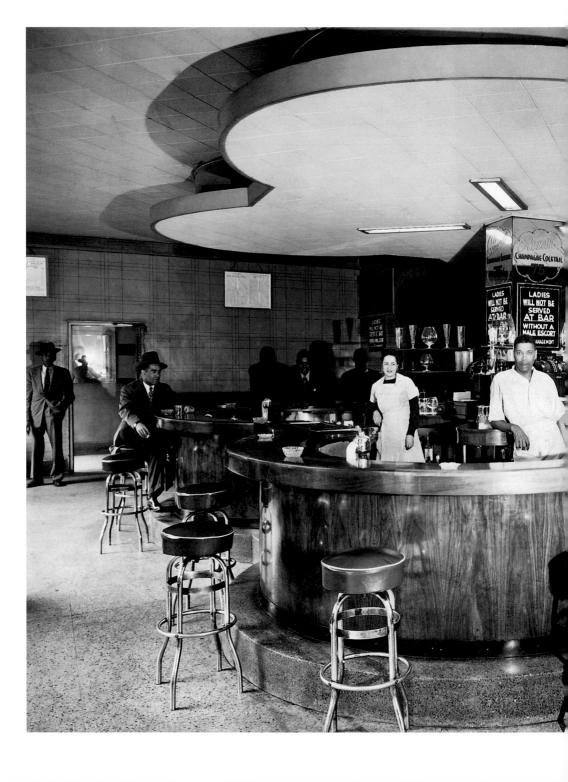

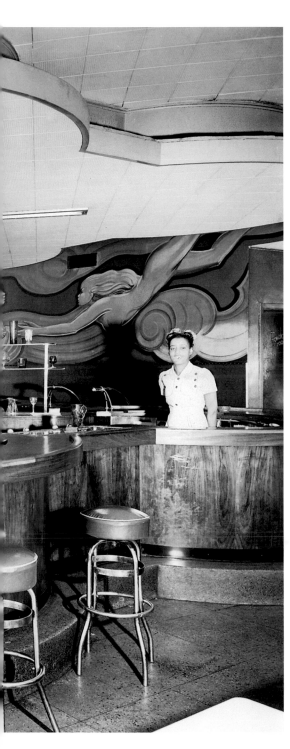

Anonymous

Small's Paradise Harlem Nightclub.
Opened in 1925, during Prohibition, it
was one of the first clubs in Harlem to
have an open-door policy for all races.
One waiter who worked there in the
early 1940s was Malcolm Little, aka
Malcolm X, 1945.

Small's Paradise Harlem Nightclub. Dieser
Klub, der zu den ersten in Harlem ohne
ethnische Zutrittsbeschränkung gehörte,
wurde 1925 während der Prohibition
eröffnet. Einer der Kellner, der Anfang der
1940er-Jahre dort arbeitete, war Malcolm
Little, alias Malcolm X, 1945.

Night-club «Small's Paradise» à Harlem.
Créé en 1925 pendant la prohibition, ce
fut l'un des premiers night-clubs d'Harlem
à s'ouvrir à toutes les races. L'un de ses
serveurs, au début des années 1940, était
Malcom Little, futur Malcolm X, 1945.

MERYL STREEP (1949)
CYNDI LAUPER (1953)

Anonymous

World's Fair. These ladies are in the food zone, where exhibitors included Coca-Cola, Heinz, and meat producer Swift, 1939.

Weltausstellung. Diese Damen befinden sich im Lebensmittelbereich, in dem Aussteller wie Coca-Cola, Heinz und Fleischproduzent Swift vertreten waren, 1939.

Exposition universelle. Ces femmes se trouvent dans le secteur de l'alimentation, occupée par des exposants comme Coca-Cola, Heinz et Swift qui était spécialisé dans les produits à base de viande, 1939.

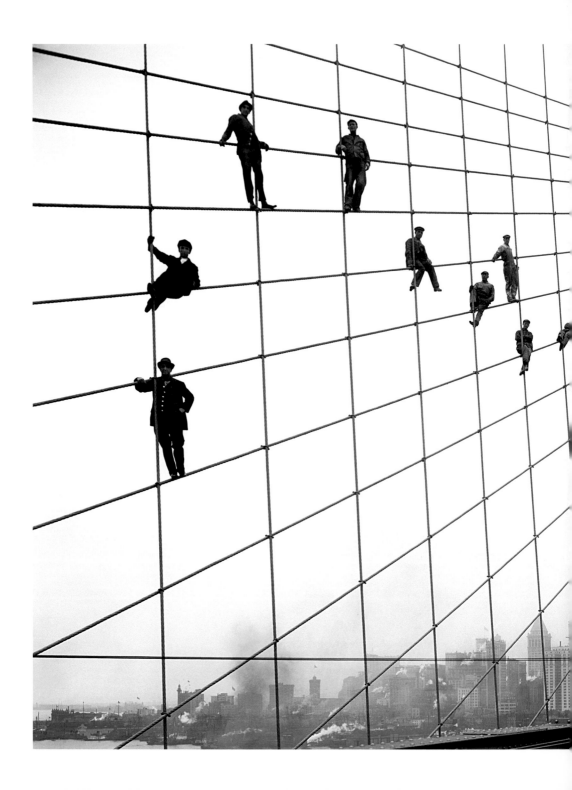

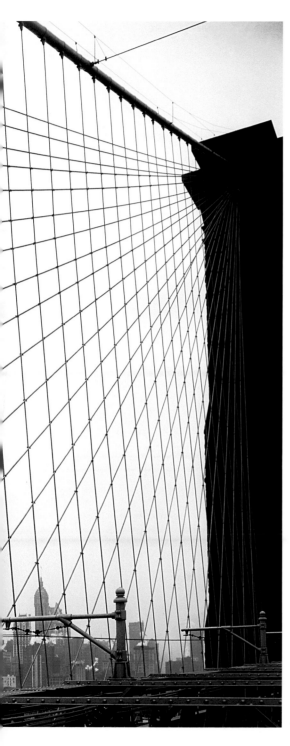

Eugene de Salignac

Brooklyn Bridge painters, 1914.

Anstreicher auf der Brooklyn Bridge, 1914.

Peintres du pont de Brooklyn, 1914.

"There are many many crazy things
That will keep me loving you
And with your permission
May I list a few
The way you wear your hat
The way you sip your tea
The memory of all that
No, no, they can't take that away from me."

"THEY CAN'T TAKE THAT AWAY FROM ME," *SHALL WE DANCE*, 1937

André Kertész

Lost Cloud. A compelling contrast between the imposing Rockefeller Center and the innocent cloud drifting into a hostile space. The photographer was a recent European exile, intimidated by New York, which gives the image an extra dimension, 1937.

Einsame Wolke. Ein faszinierender Gegensatz zwischen dem imposanten Rockefeller Center und einer unschuldigen Wolke, die in feindliches Gebiet hineintreibt. Der Fotograf war erst kurz zuvor aus Europa ins amerikanische Exil gekommen; New York schüchterte ihn ein, was dem Foto eine zusätzliche Dimension verleiht, 1937.

Nuage égaré. Contraste surprenant entre l'imposant Rockefeller Center et l'innocent petit nuage se glissant dans cet espace hostile. Le photographe était un immigré européen récent, encore intimidé par New York, ce qui confère à cette image une dimension supplémentaire, 1937.

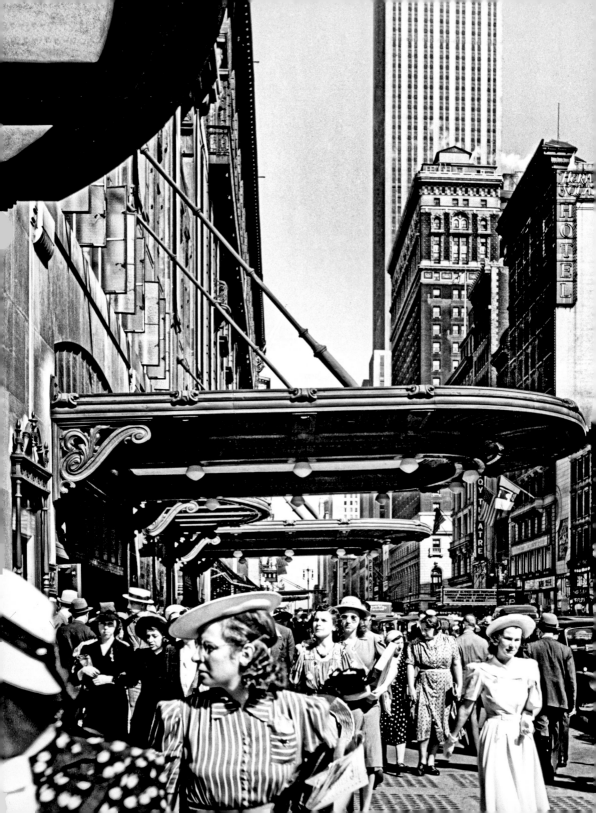

"Normally, it takes years to work your way up to the 27th floor. But it only takes 30 seconds to be out on the street again."

THE APARTMENT, 1960

Andreas Feininger

West 34th Street. One of Manhattan's busiest crosstown streets; the Empire State Building, Penn Station, and Macy's department store are all on 34th Street, c. 1941.

West 34th Street. Eine der geschäftigsten, durch die ganze Insel verlaufenden Straßen von Manhattan. Sowohl das Empire State Building als auch die Penn Station und das Kaufhaus Macy's liegen an der 34th Street, um 1941.

34e Rue ouest. L'une des rues transversales les plus animées de Manhattan, bordée par l'Empire State Building, Penn Station et le grand magasin Macy's, vers 1941.

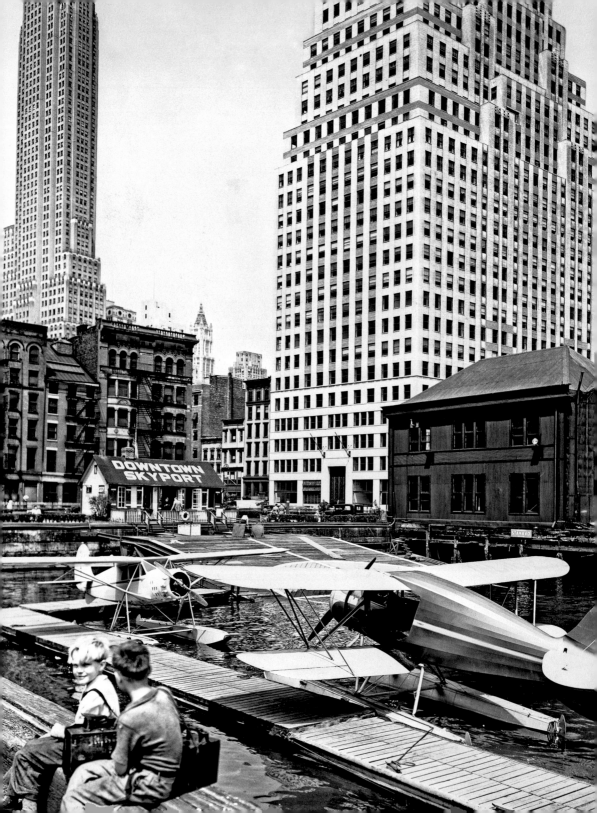

"Old New York is fast disappearing. At almost any point on Manhattan Island the sweep of one's vision can take in dramatic contrasts of the old and the new and the old foreshadowing of the future."

BERENICE ABBOTT, 1931

Berenice Abbott

The sky port at Pier 11 on South Street, on the southern tip of Manhattan near the financial district, 1936.

Der Sky Port (für Wasserflugzeuge) an Pier 11 in der South Street an der Südspitze von Manhattan nahe des Finanzviertels, 1936.

Le «port du ciel» au Pier 11, South Street, à la pointe sud de Manhattan, près du quartier financier, 1936.

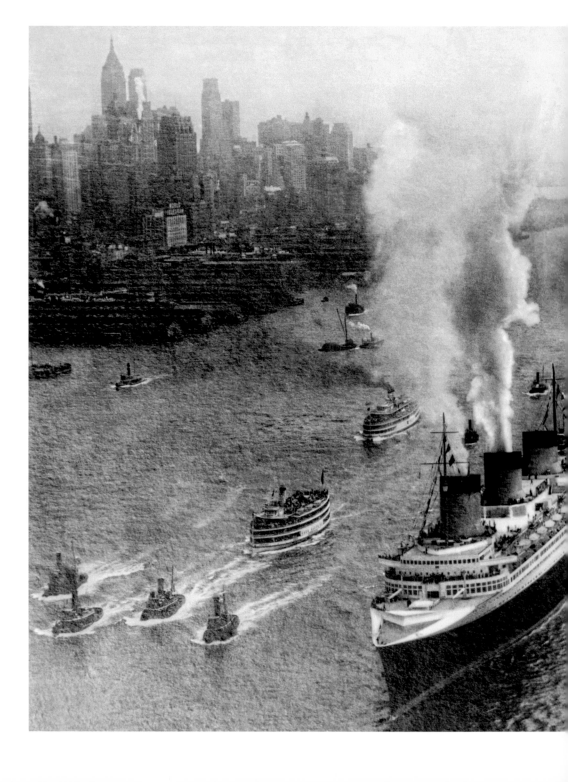

Anonymous

The French passenger liner SS
Normandie, the largest ship of its
time, approaching the New York pier
at the end of her maiden transatlantic
voyage, c. 1934.

Das französische Passagierschiff
Normandie, das größte seiner Zeit,
nähert sich nach seiner Jungfernfahrt
über den Atlantik dem Pier in New
York, um 1934.

Le transatlantique français le
Normandie, le plus grand paquebot
de son époque, à son approche du
port de New York après sa traversée
inaugurale, vers 1934.

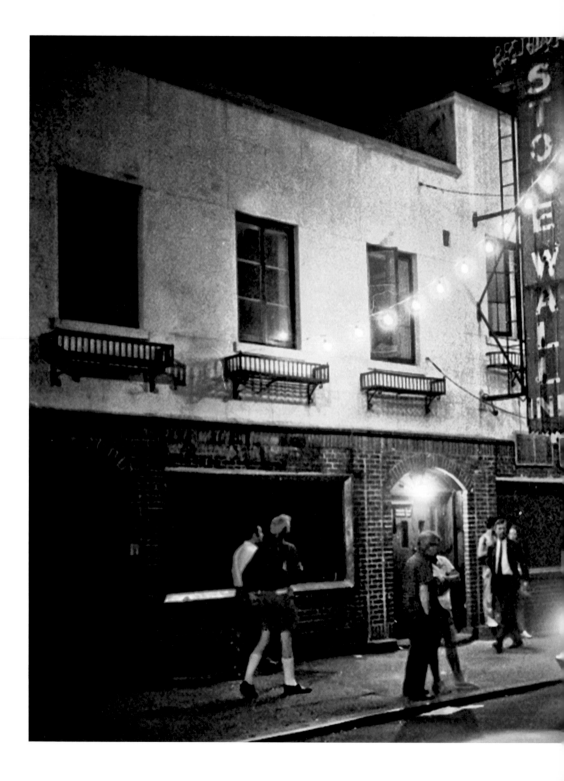

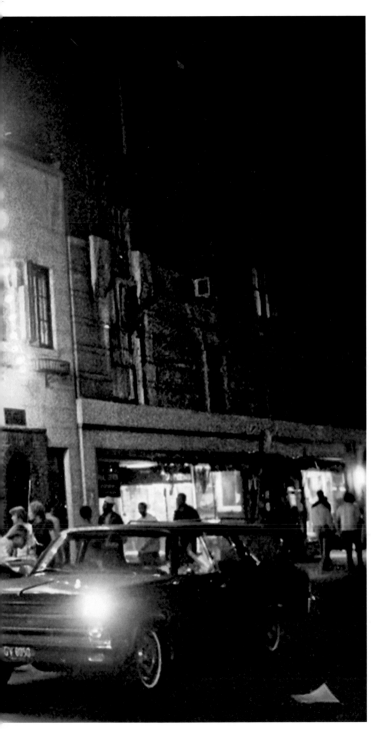

RICHARD RODGERS (1902)
MEL BROOKS (1926)

Larry Morris

The Stonewall Inn, Greenwich Village.
The Stonewall Riots erupted in response
to continual police harassment of the
neighborhood's large gay community.
The riots ushered in the gay rights
movement, 1969.

Das Stonewall Inn in Greenwich Village.
Die Stonewall-Unruhen brachen infolge
der fortgesetzten Polizeischikane gegen
die im Viertel lebenden Schwulen aus
und brachten die Schwulenbewegung
hervor, 1969.

Le Stonewall Inn à Greenwich Village.
Les émeutes du Stonewall éclatèrent
en réaction au harcèlement policier
de l'importante communauté gay du
quartier. Elles conduisirent à l'appa-
rition du Mouvement des droits des
homosexuels, 1969.

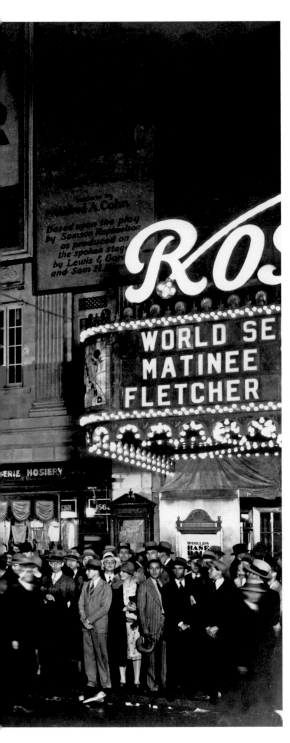

Anonymous

The world's first "talkie," *The Jazz Singer*, based on a Broadway play, makes its debut at the Warner's Theatre. After the movie's release, Warner Bros. company stock shot from $9 to $132 per share, 1927.

Der erste Tonfilm der Welt, *Der Jazzsänger*, basierte auf einem Broadway-Theaterstück und wurde erstmalig im Warner's Theatre gezeigt. Nachdem der Film angelaufen war, stieg der Aktienkurs von Warner Bros. von 9 auf 132 Dollar pro Aktie, 1927.

Le premier film parlant, *Le Chanteur de jazz*, inspiré d'une pièce de Broadway, fit ses débuts au Warner's Theatre. Peu après, le prix de l'action de la Warner Bros. passa de 9 à 132 dollars, 1927.

Frank Paulin

Archetypal New York scene of people
in a public space very much caught in a
private moment, 1956.

Archetypische New Yorker Szene mit
Menschen in der Öffentlichkeit, die
in einem sehr privaten Augenblick
eingefangen wurden, 1956.

Scène archétypale de la rue new-yorkaise:
ensemble et chacun pour soi, 1956.

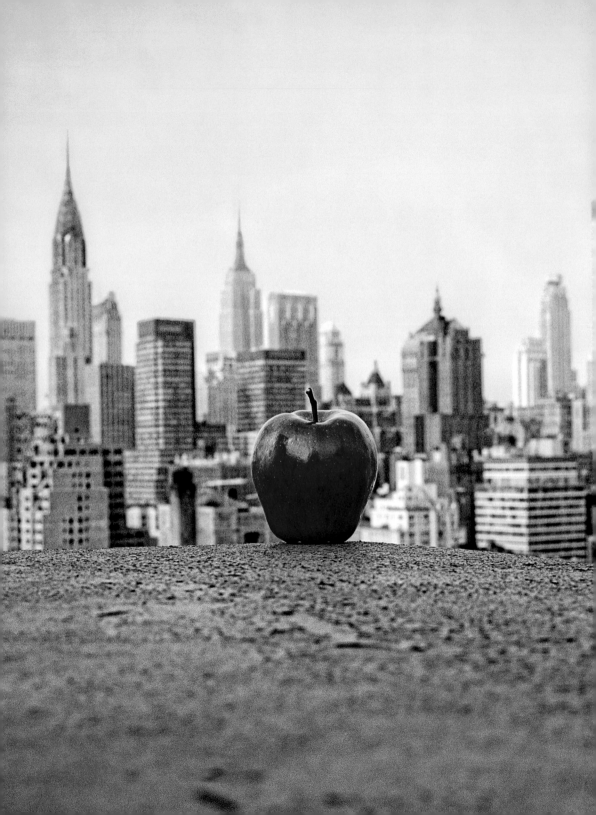

*"New York — the Big, Juicy Apple.
The city that never sleeps with the
same person two nights running…"*

BRIDGET JONES: THE EDGE OF REASON, 2004

William Claxton

Big and Little Apples, 1960.

„Big Apple" und kleines Gegenstück, 1960.

La Grosse Pomme et la petite, 1960.

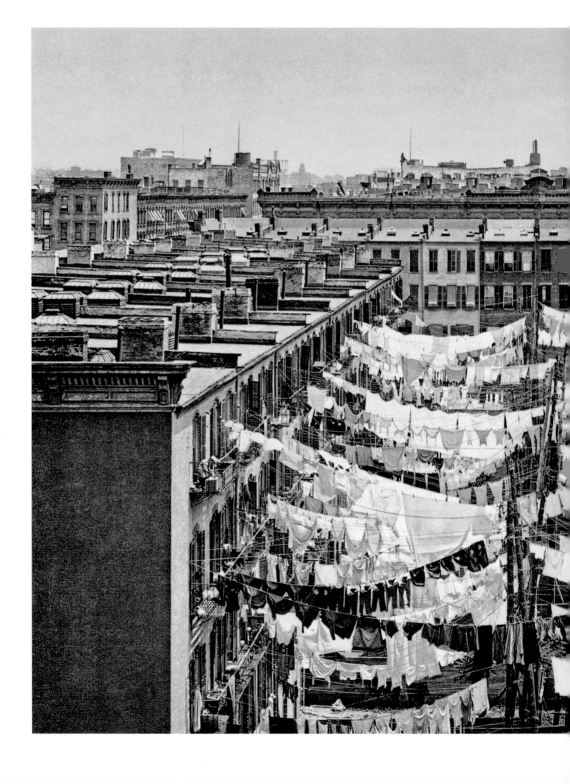

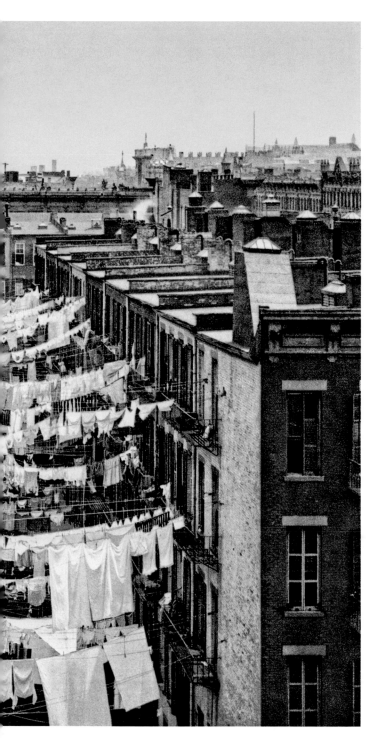

Anonymous

Monday is washday in the city, 1900.

Am Montag ist Waschtag in der Stadt, 1900.

Lundi, jour de lessive, 1900.

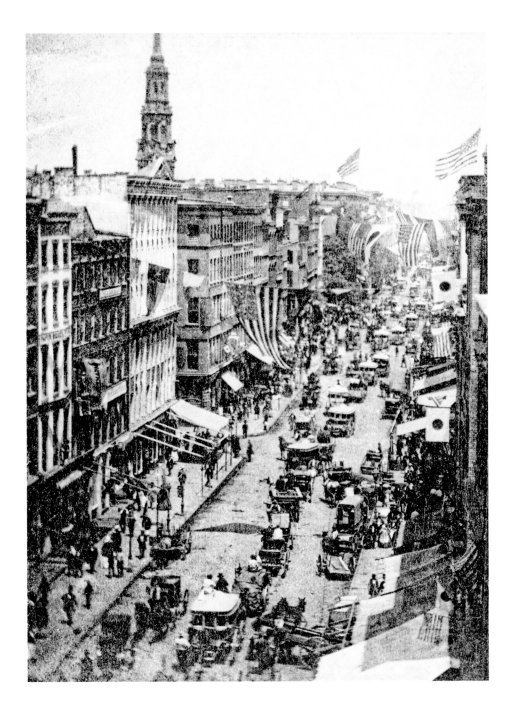

"It is altogether an extraordinary growing, swarming, glittering, pushing, chattering, good-natured, cosmopolitan place..."

HENRY JAMES, 1883

Anonymous

Broadway. Early traffic congestion on the streets of New York. By 1860, the city's population hovered around 800,000, and by the end of that decade, the first El (elevated) train was running, easing traffic somewhat, 1860.

Broadway. Früher Verkehrsstau auf den Straßen von New York. 1860 lag die Einwohnerzahl der Stadt bei etwa 800 000; gegen Ende dieses Jahrzehnts hatte die erste Hochbahn (El, für elevated) den Betrieb aufgenommen, was die Verkehrssituation etwas verbesserte, 1860.

Broadway. Premiers embouteillages dans les rues de New York. En 1860, la population de la rue oscillait autour de 800 000 habitants, et, vers la fin de la décennie, circulait le premier train suspendu (El, pour elevated), soulageant un peu la circulation, 1860.

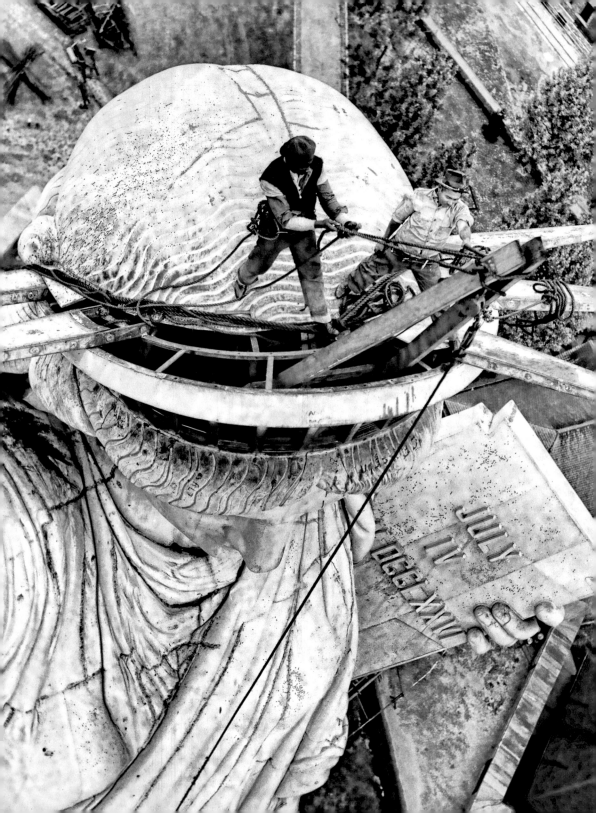

"The Statue of Liberty — a big girl who is obviously going to have a baby. The birth of a nation, I suppose."

EGO 3, JAMES AGATE, 1937

Anonymous

Workman renovating the Statue of Liberty for the 1939 World's Fair. The photograph was taken from the lady's torch, 1938.

Arbeiter renovieren die Freiheitsstatue für die Weltausstellung von 1939. Das Foto wurde von der Fackel der Statue aus aufgenommen, 1938.

Ouvrier travaillant à la rénovation de la statue de la Liberté pour l'Exposition universelle de 1939. La photo a été prise de la fameuse torche, 1938.

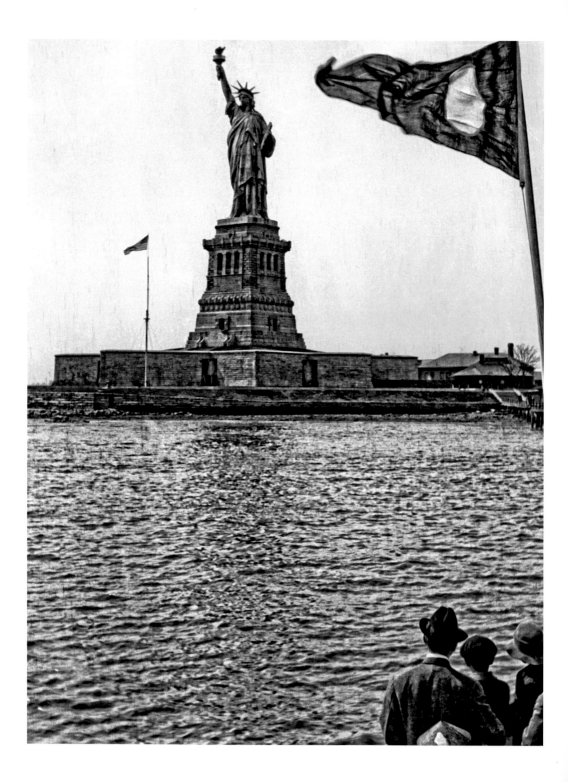

"We will not forget that liberty here made her home; nor shall her chosen altar be neglected."

PRESIDENT GROVER CLEVELAND, 1886

Charles Zoller

Looking at the Statue of Liberty from
a boat, 1913.

Ansicht der Freiheitsstatue von einem
Boot aus, 1913.

En regardant la Statue de la Liberté
du pont d'un bateau, 1913.

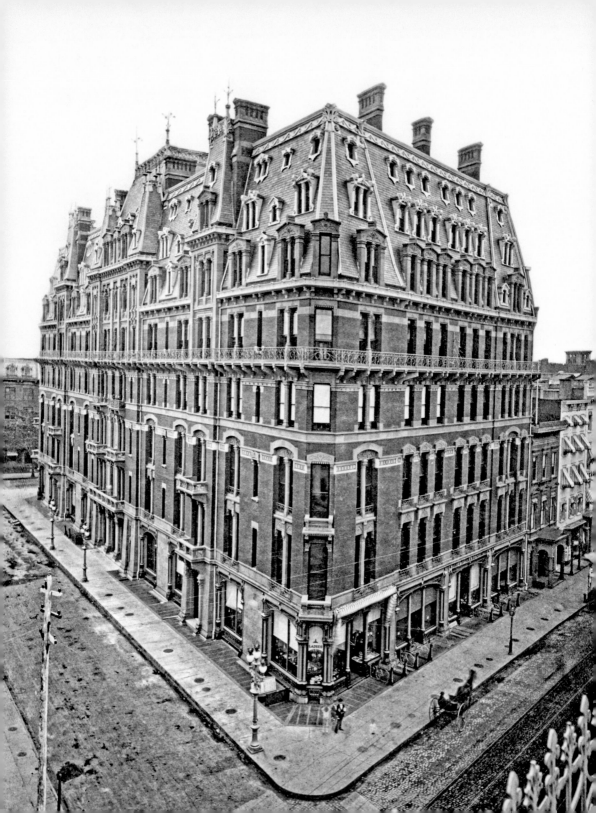

SYLVESTER STALLONE (1946)
"50 CENT" CURTIS JACKSON III (1975)

"There's no room for amateurs,
even in crossing the streets."

GEORGE SEGAL, 1972

Anonymous

The exterior of a fancy
apartment building, c. 1872.

Außenfassade eines luxuriösen
Apartmenthauses, um 1872.

La façade d'un luxueux immeuble
d'appartements, vers 1872.

"New York pizza is a phrase synonymous with pizza greatness, yet for years New Yorkers could find the genuine article in only a few isolated spots."

THE NEW YORK TIMES, 1998

Greg Miller

A pizza stand in Brooklyn. One of New York's most heated debates is about where the best pizza is sold in the city. New York's style of pizza is large slices with a thin crust that are folded and then rapidly consumed, 2002.

Eine Pizzabude in Brooklyn. Wo in New York es die beste Pizza gibt, ist Gegenstand hitziger Debatten. Die New Yorker Variante einer Pizza besteht aus großen Stücken mit dünnem Teig, die zusammengeklappt und schnell verspeist werden, 2002.

Un stand de pizzas à Brooklyn. Qui vend la meilleure pizza est un des débats permanents et des plus enflammés parmi les New-Yorkais. La pizza locale est à pâte fine. Elle se découpe en grandes portions, vite roulées et rapidement consommées, 2002.

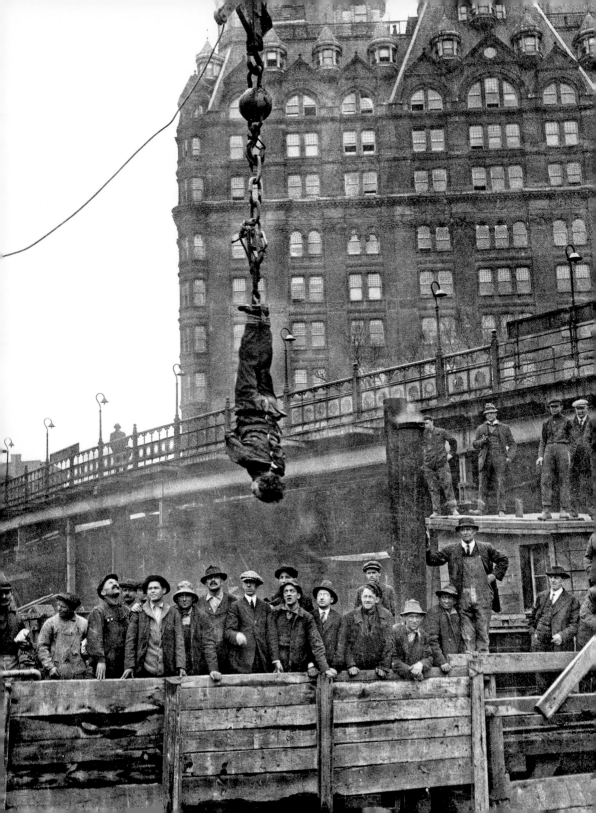

JOHN D. ROCKEFELLER (1839)
PHILIP JOHNSON (1906)
NELSON A. ROCKEFELLER (1908)

*"I think that in a year I may
retire. I cannot take my
money with me when I die
and I wish to enjoy it, with
my family, while I live."*

HOUDINI, 1904

Anonymous

Harry Houdini up to his usual tricks in front of a curious crowd of onlookers. Houdini perfected his act in Coney Island, sometimes performing up to 20 times a day, 1916.

Harry Houdini bei seinen üblichen Zaubertricks vor einer neugierigen Zuschauermenge. Houdini perfektionierte seine Kunststücke in Coney Island, wo er manchmal bis zu 20-mal am Tag auftrat, 1916.

Harry Houdini dans l'un de ses tours habituels devant une foule de curieux. Il perfectionnait ses numéros à Coney Island, les exécutant jusqu'à vingt fois par jour, 1916.

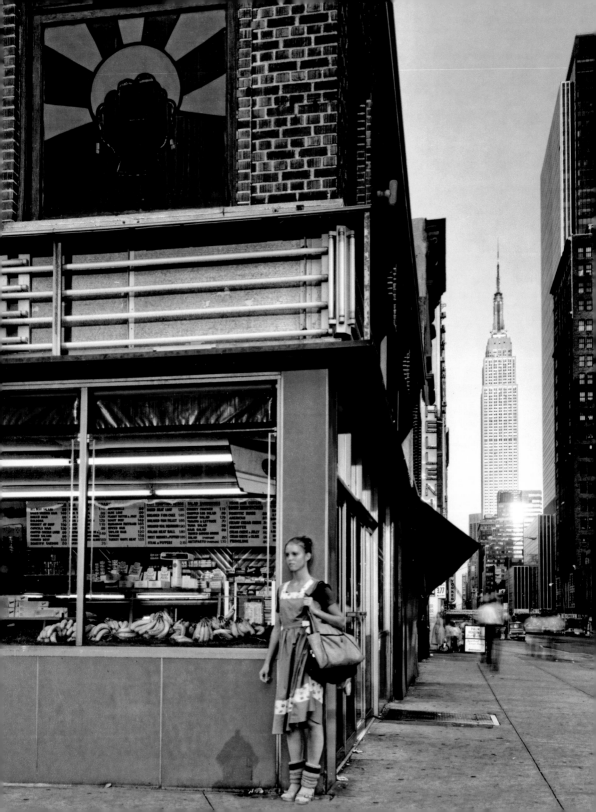

MICHAEL GRAVES (1934)

"Oooo baby, I hear how you spend nighttime
Wrapped like candy in a blue, blue neon glow
Fade away and radiate
Oooo baby, watchful lines
Vibrate soft in brainwave time
Silver pictures move so slow
Golden tubes faintly glow."

"FADE AWAY AND RADIATE," BLONDIE, 1978

Joel Meyerowitz

Empire State Building, 1978.

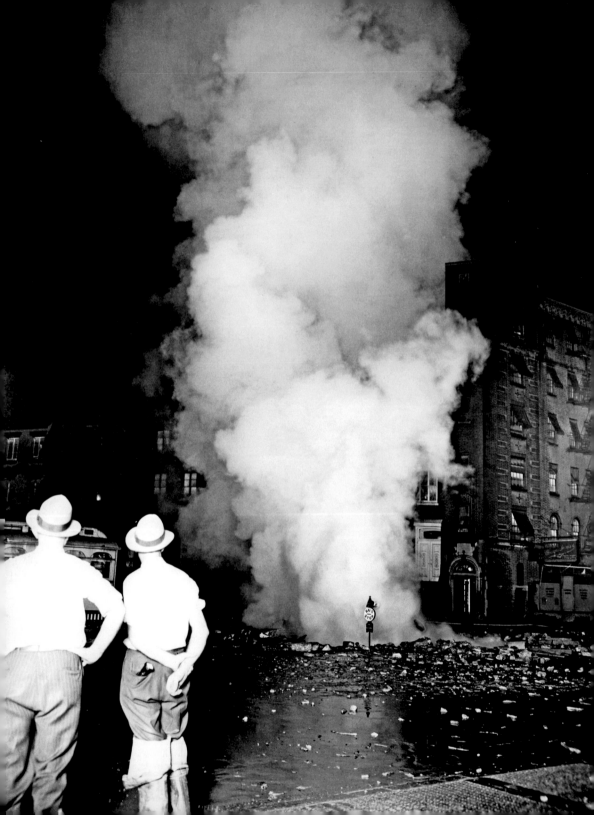

*"Everybody ought to have a
lower East Side in their life."*

IRVING BERLIN, 1962

Weegee

Break for Broadway. It's not clear
whether this fire was on Broadway,
but the title suggests that the fire is
so dramatic and visual that it's akin
to a Broadway show that can't
be missed, 1940.

Auf zum Broadway. Es ist nicht klar, ob
dieser Brand tatsächlich auf dem Broad-
way wütete. Der Titel lässt allerdings
vermuten, dass das dramatische, weithin
sichtbare Feuer mit einem Broadway-
Stück mithalten konnte, das man auf
keinen Fall verpassen durfte, 1940.

Bon pour Broadway. Il n'est pas sûr que
cet incendie se soit déroulé à Broadway,
mais le titre suggère que le feu était si
spectaculaire qu'il évoquait un spectacle
de Broadway à ne pas manquer, 1940.

Arlene Gottfried

An urban sunbather, 1990s.

Ein Sonnenanbeter in der Stadt,
1990er-Jahre.

Bain de soleil urbain, années 1990.

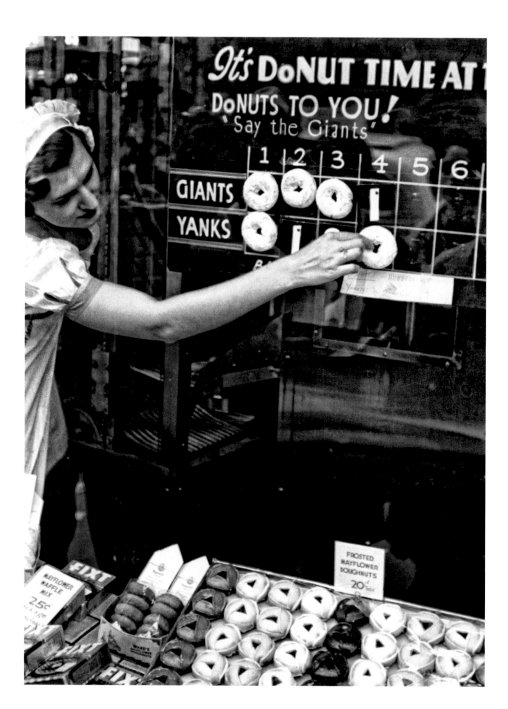

"I'm a New York City girl. It's a little too quiet around here for me."

FLASH GORDON, 1980

Hanns Hubmann

The score of a baseball game being marked up with doughnuts. This is during the World Series between the great city rivals, the New York Giants and the New York Yankees, 1936.

Der Punktestand eines Baseballspiels, markiert mit Doughnuts. Diese Aufnahme entstand während des Finalspiels der großen Rivalen New York Giants und New York Yankees, 1936.

Le score d'un match de baseball est affiché à l'aide de donuts pendant les World Series entre les deux grands rivaux, les New York Giants et les New York Yankees, 1936.

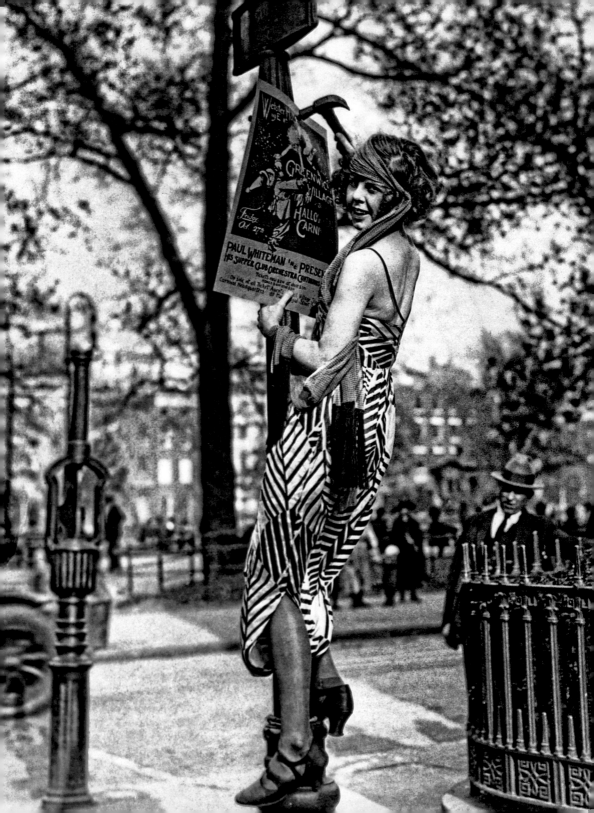

"To him, no matter what the season was, this was still a town that existed in black and white and pulsated to the great tunes of George Gershwin."

MANHATTAN, WOODY ALLEN, 1979

Anonymous

A Greenwich Village woman, dressed in the flapper style of the Roaring Twenties, hanging up a poster. The Village was the neighborhood of choice for New York's radicals, bohemians, gay people, and artists, mid-1920s.

Eine Frau aus Greenwich Village, gekleidet im modischen Stil der „wilden Zwanziger", beim Aufhängen eines Plakats. Das Village war das Viertel der Wahl für Radikale, Bohemiens, Homosexuelle und Künstler in New York, Mitte der 1920er-Jahre.

Dans Greenwich Village, une femme à la mode des années folles pose une affiche. Le Village était le quartier élu par les radicaux, la bohème, les homosexuels et les artistes, milieu des années 1920.

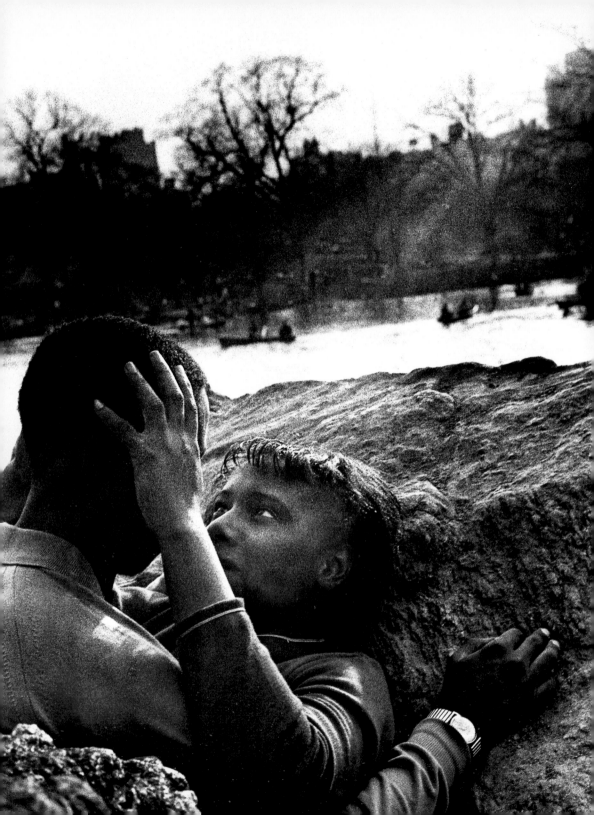

"Mi gente ¡Ustedes!
lo más grande de este mundo
siempre me hacen sentir
un orgullo profundo.
Los llamé ¡vengan conmigo!
no me preguntaron dónde
orgullo tengo de ustedes
mi gente siempre responde."

"MI GENTE," HECTOR LAVOE, 1975

Ralph Gibson

Lovers in Central Park, 1967.

Liebespaar im Central Park, 1967.

Amoureux dans Central Park, 1967.

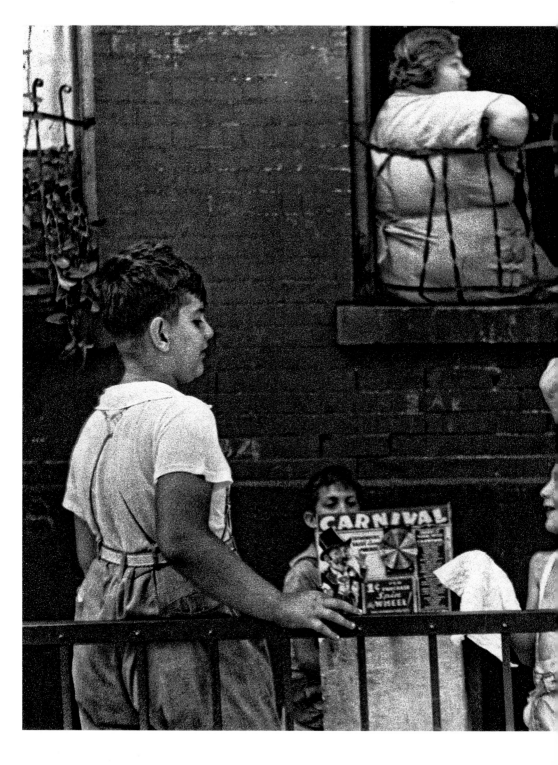

Walker Evans

Street-side Games. Evans would obsessively photograph ordinary blocks in the city, trying to capture every facet of life, 1938.

Spiele am Straßenrand. Evans fotografierte mit Feuereifer die normalen Häuserblocks der Stadt und versuchte, jede Facette des Lebens einzufangen, 1938.

Jeux de rue. Evans photographia de manière obsessive la vie dans les «blocs» de la cité, essayant d'en capter toutes les facettes, 1938.

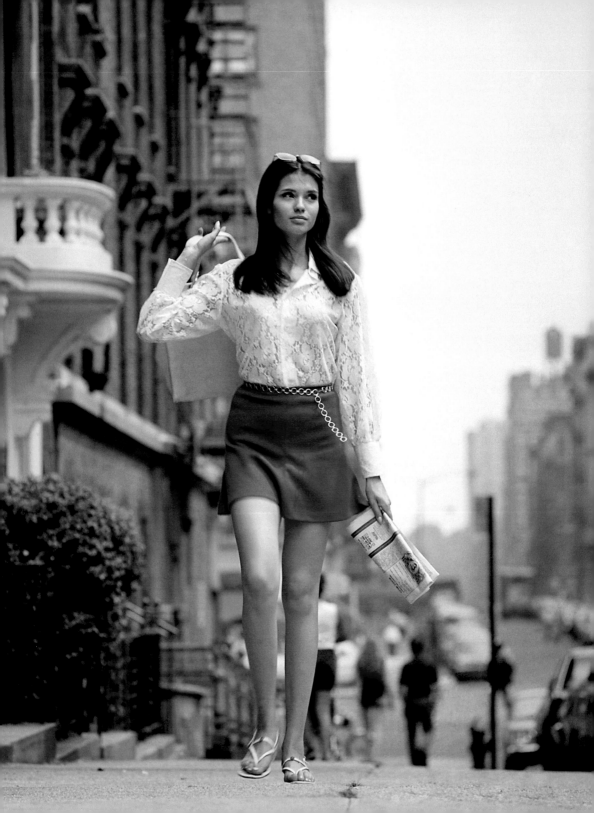

"Woke up, it was a Chelsea morning, and the first thing that I heard
Was a song outside my window, and the traffic wrote the words."

"CHELSEA MORNING," JONI MITCHELL, 1969

Vernon Merritt

New York street fashion at its finest, 1969.

New Yorker Mode von ihrer
besten Seite, 1969.

La mode new-yorkaise parfaitement
incarnée, 1969.

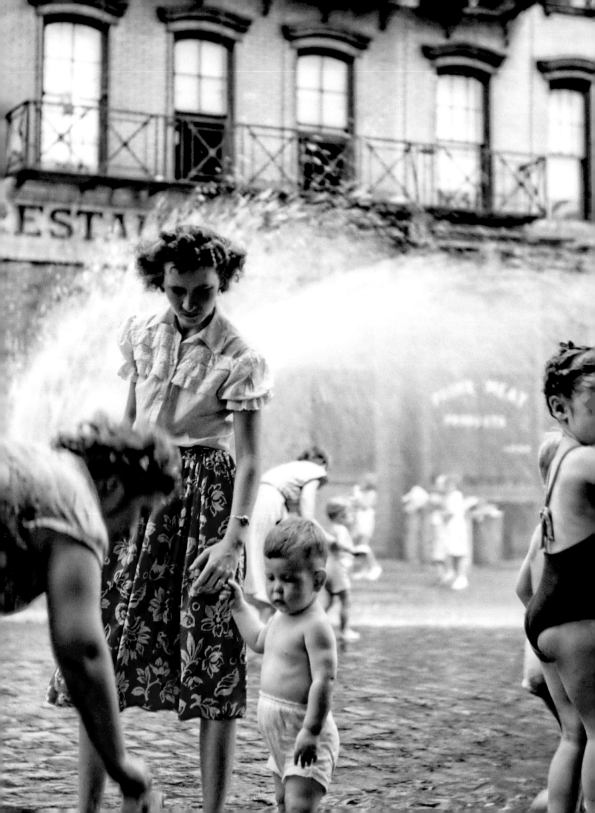

*"Yeah, it's allowed!
This is New York!"*

NIGHT ON EARTH, 1991

Ruth Orkin

A classic New York street scene of children keeping cool in the summer heat with water from a fire hydrant. New York's first fire hydrant was installed in 1808, at the corner of William and Liberty Streets, early 1950s.

Eine klassische New Yorker Straßenszene mit Kindern, die sich in der Hitze des Sommers im Wasser aus einem Hydranten abkühlen. New Yorks erster Hydrant wurde 1808 an der Ecke William und Liberty Street installiert, Anfang der 1950er-Jahre.

Scène classique de la rue new-yorkaise : des enfants tentent de se rafraîchir dans la chaleur de l'été grâce à l'eau d'une bouche d'incendie. Les premières bouches d'incendie de New York furent installées en 1808, à l'angle des rues William et Liberty, début des années 1950.

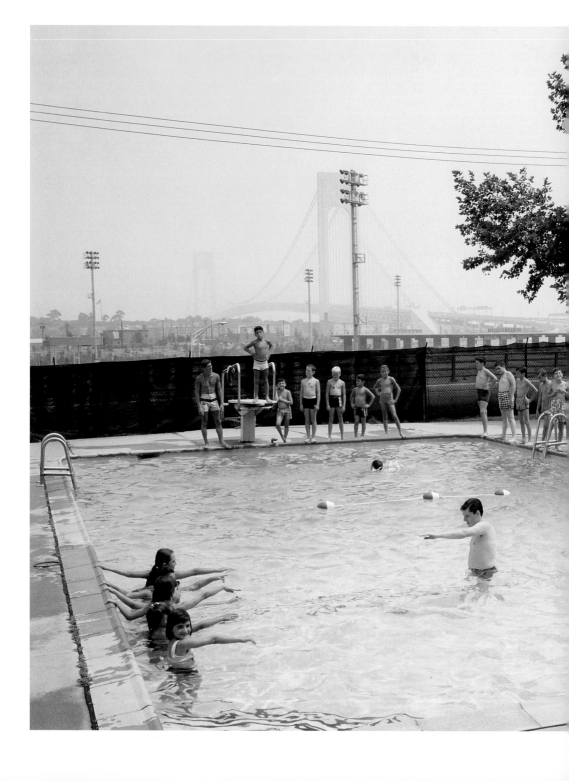

Anonymous

Swim lessons at St. John Villa Academy
in Staten Island. The Verrazano-Narrows
Bridge can be seen in the distance,
mid-1960s.

Schwimmunterricht in der St. John Villa
Academy auf Staten Island. Im Hinter-
grund sieht man die Verrazano Narrows
Bridge, Mitte der 1960er-Jahre.

Leçons de natation à la St. John Villa
Academy à Staten Island. On aperçoit
dans le lointain le pont Verrazano-Nar-
rows, milieu des années 1960.

"The great big city's a wondrous joy
Just made for a girl and boy
We'll turn Manhattan
Into an isle of joy."

"MANHATTAN," 1925

Morris Engel

A New York boy captivated by the
world of comic books, 1946.

Ein Junge aus New York ist ganz in der
Welt der Comics versunken, 1946.

Petit New-Yorkais passionné par l'uni-
vers des bandes dessinées, 1946.

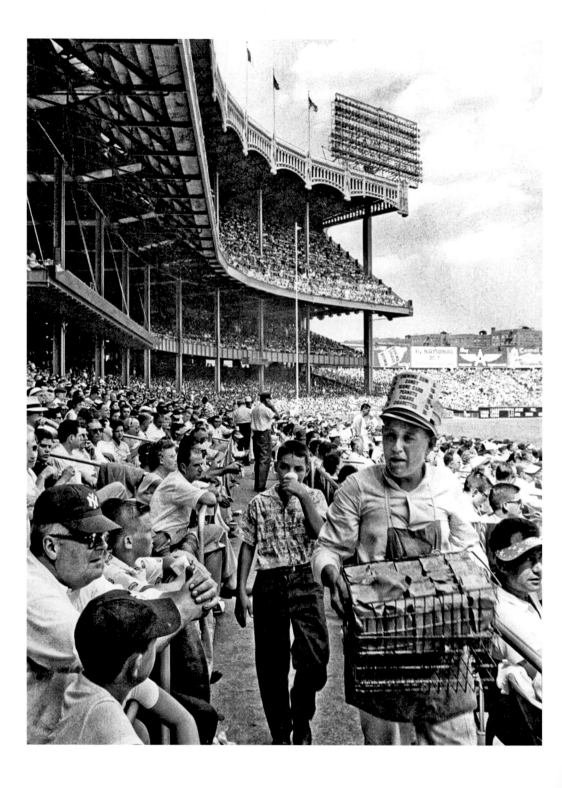

"Take me out to the ball game,
Take me out with the crowd;
Buy me some peanuts and Cracker Jack,
I don't care if I never get back."

"TAKE ME OUT TO THE BALL GAME," 1908

Arnold Newman

A vendor looking for business at Yankee Stadium. That season, the Yankees, featuring playing legends such as Mickey Mantle and Yogi Berra, beat their fierce rivals, the Brooklyn Dodgers, in the World Series, 1956.

Ein Bauchladenverkäufer im Yankee Stadion. In dieser Saison schlugen die Yankees mit ihren legendären Spielern Mickey Mantle und Yogi Berra ihre er-bitterten Rivalen, die Brooklyn Dodgers, in der World Series, 1956.

Un marchand ambulant fait l'article au Yankee Stadium. Cette même saison, les Yankees et leurs joueurs légendaires, tels que Mickey Mantle et Yogi Berra, batti-rent leurs fougueux rivaux, les Brooklyn Dodgers, aux World Series, 1956.

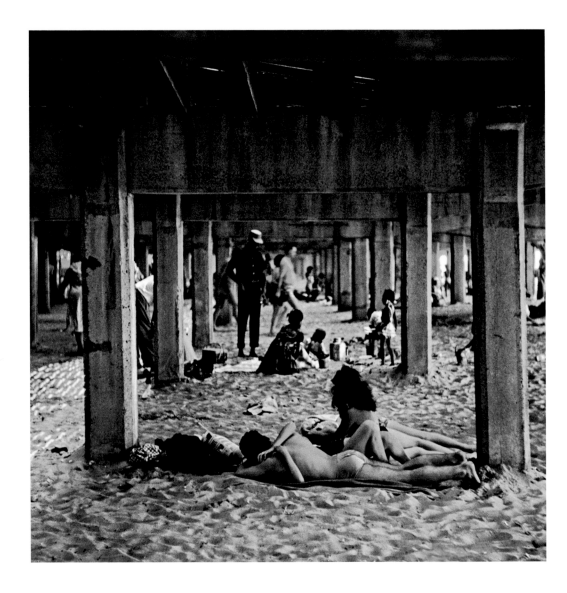

GARRY TRUDEAU (1948)

"Well, my mother was born out in Coney Island
Raised on the L.E.S. Manhattan Island
My dad came out from Detroit and they had me
And back on through Ellis Island goes through the family tree"

"DO IT," THE BEASTIE BOYS, 1994

Marvin Newman

Young lovers embrace as the shadows of the sun find their way through the gaps of the wooden boardwalk, Coney Island, 1954.

Ein junges Paar umarmt sich unter der Promenade, durch deren Holzbretter das Sonnenlicht einfällt, Coney Island, 1954.

Deux jeunes gens s'embrassent. Le soleil se glisse entre les planches de la promenade de Coney Island, 1954.

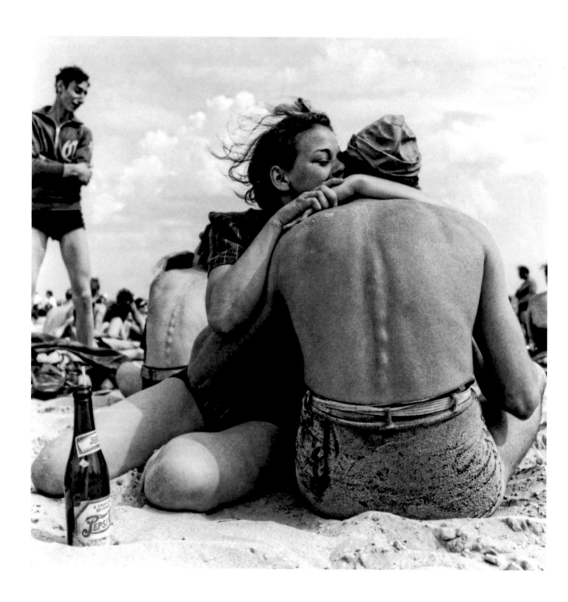

EDWARD HOPPER (1882)
JOHN LEGUIZAMO (1964)

"Roses are red... violets are blue.
I can't go to Coney Island...
And you can't too! Ha, Ha, Ha..."

LITTLE FUGITIVE, 1953

Morris Engel

Coney Island, 1938.

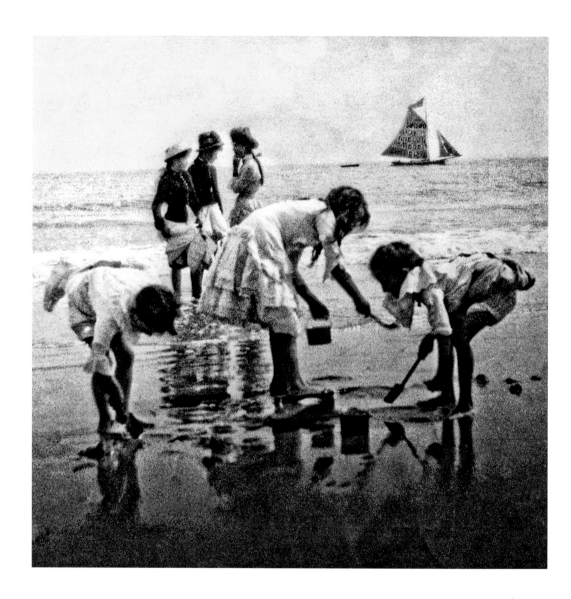

"The astonishing sight of Coney Island, this famous island, heap of abandoned earth four years ago, and today the spacious area of repose, refuse, and recreation for a hundred thousand New Yorkers who attend joyful beaches daily."

JOSÉ JULIÁN MARTÍ PÉREZ, 1883

George Bradford Brainerd

Coney Island, Brooklyn. Formerly a remote beach on the southern tip of Brooklyn, improvements in mass transit, namely the railroad and the steamship, established Coney Island as a vast outdoor leisure center, 1877.

Coney Island, Brooklyn. Der früher als abgelegen geltende Strand an der Südspitze von Brooklyn verwandelte sich durch die Verbesserung des öffentlichen Nahverkehrs, insbesondere mit Zügen und Dampfschiffen, in einen riesigen Freizeitpark unter freiem Himmel, 1877.

Coney Island, Brooklyn. Grâce à l'amélioration des transports publics, en particulier du rail et des services de bateaux à vapeur, cette plage lointaine à l'extrémité sud de Brooklyn se transforma en un immense centre de loisirs de plein air, 1877.

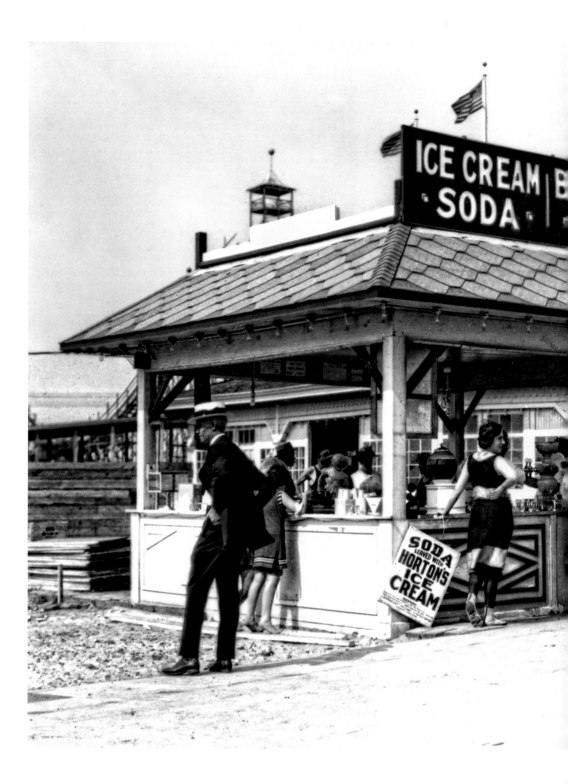

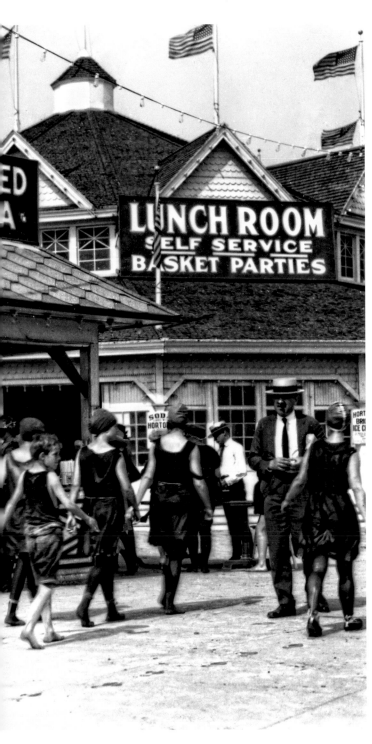

William Hassler

Coney Island. In 1915, the Brooklyn Rapid Transit Service began a subway service between Brooklyn and Manhattan, ushering in Coney Island's peak years. The beach offered fast food, risqué entertainment, state-of-the-art amusement parks, a beach, of course, and many flirting opportunities, 1910–20.

Coney Island. 1915 eröffnete der Brooklyn Rapid Transit Service eine U-Bahn-Strecke zwischen Brooklyn und Manhattan und läutete damit die goldene Ära von Coney Island ein. Dort gab es Fast Food, zwielichtige Vergnügungen, moderne Vergnügungsparks, natürlich einen Badestrand und jede Menge Gelegenheit, miteinander zu flirten, 1910–20.

Coney Island. En 1915, le Brooklyn Rapid Transit Service proposa un service de métro entre Brooklyn et Manhattan, annonçant les grandes années de Coney Island. La plage proposait de la restauration rapide, des spectacles osés, des parcs d'attractions dernier cri, des bains de mer, bien sûr, et de nombreuses opportunités de rencontres amoureuses, 1910–20.

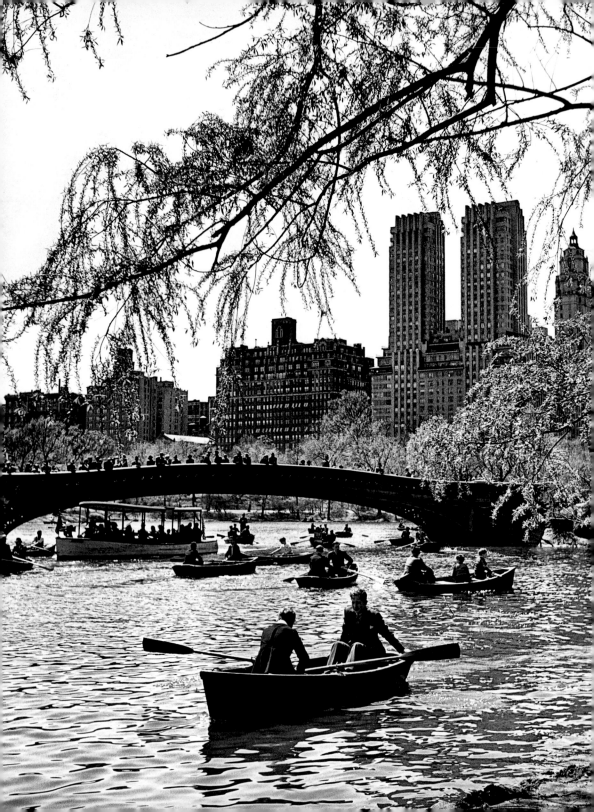

IMAN MOHAMED ABDULMAJID (1955)

"New York is full of people ... with a feeling for the tangential adventure, the risky adventure, the interlude that's not likely to end in any double-ring ceremony."

JOAN DIDION, 1961

Andreas Feininger

Boating in Central Park. People have been rowing on this 22-acre lake since the 19th century. Open from April to October, it offers pure escapism from the frenzy of New York life, 1940.

Bootsfahrt im Central Park. Schon seit dem 19. Jahrhundert rudern Menschen auf diesem neun Hektar großen See, um der Hektik des Großstadtlebens zu entfliehen. Er ist von April bis Oktober geöffnet, 1940.

Canotage à Central Park. Les New-Yorkais font du bateau sur ce lac de neuf hectares depuis le XIXe siècle. Ouvert d'avril à octobre, il offre une échappée à la frénésie de la vie new-yorkaise, 1940.

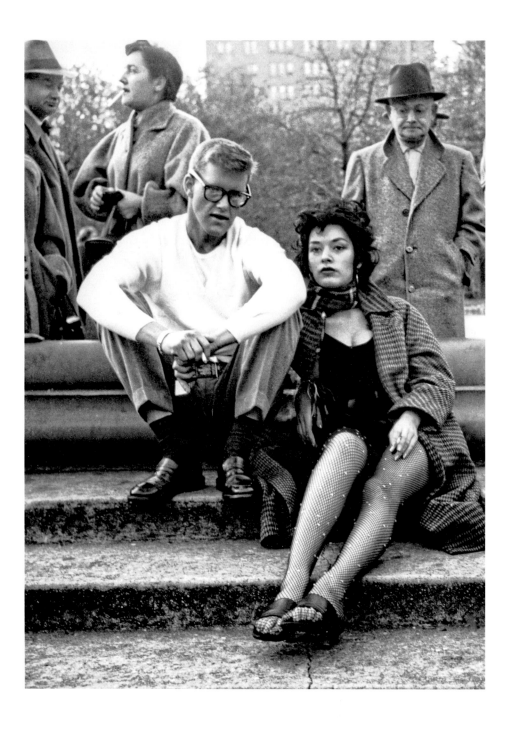

"How many roads must a man walk down
Before you call him a man?
How many seas must a white dove sail
Before she sleeps in the sand?
And how many times must the cannonballs fly
Before they're forever banned?
The answer, my friend, is blowing in the wind,
The answer is blowing in the wind."

"BLOWIN' IN THE WIND," BOB DYLAN, 1963

Weegee

Greenwich Village hipsters sitting on the steps of the fountain in Washington Square Park, 1956.

Coole junge Leute sitzen in Greenwich Village auf den Treppenstufen des Brunnens im Washington Square Park, 1956.

Jeunes gens à la mode dans Greenwich Village, assis sur les marches de la fontaine de Washington Square, 1956.

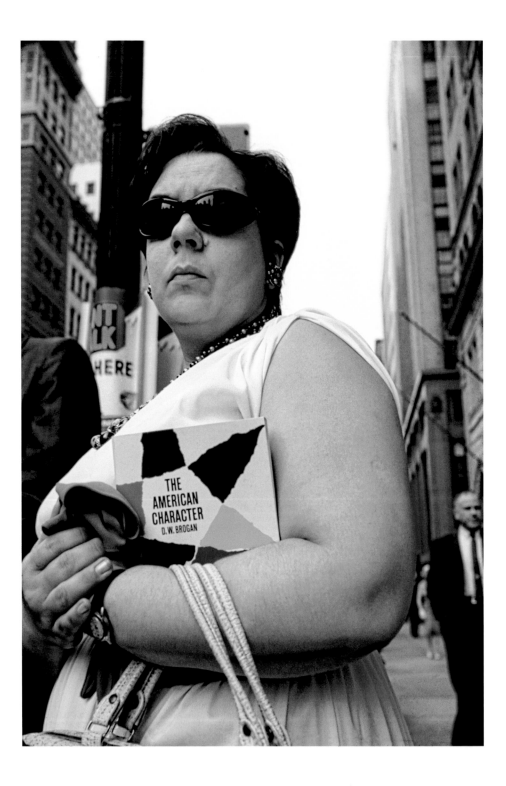

"Only in New York, kids,
only in New York."

CINDY ADAMS, *THE NEW YORK POST*, 1981

Joel Meyerowitz

A New York street portrait, 1963.

Ein Straßenporträt in New York, 1963.

Un portrait de la rue new-yorkaise, 1963.

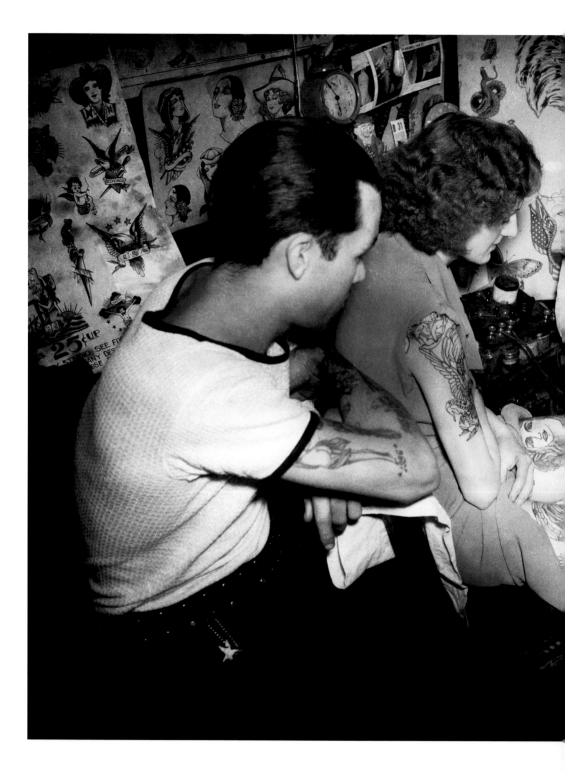

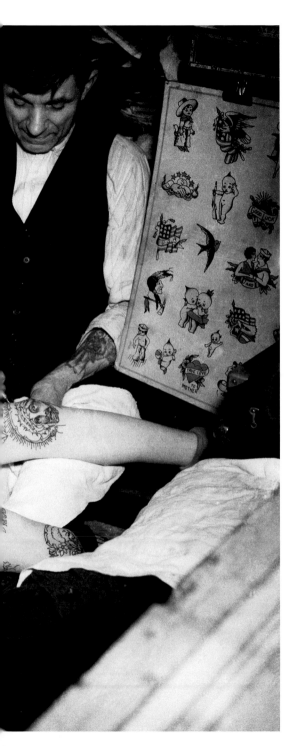

MARCEL DUCHAMP (1887)
JACQUELINE "JACKIE" LEE BOUVIER
KENNEDY ONASSIS (1929)

Anonymous

A tattoo artist on the Bowery, 1938.

Ein Tätowierer auf der Bowery, 1938.

Tatoueur sur le Bowery, 1938.

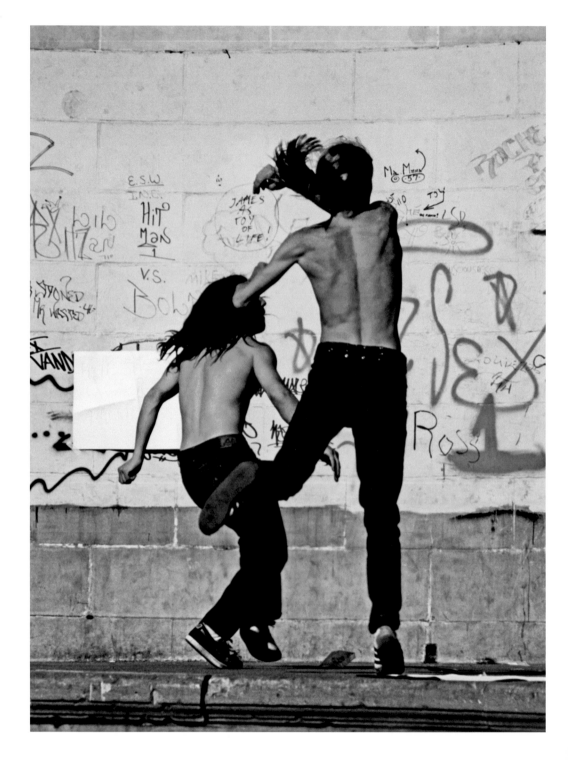

*"We had a bomb scare in the Bronx yesterday,
but it turned out to be a cantaloupe."*

THE TAKING OF PELHAM ONE TWO THREE, 1974

Ernst Haas

Kids playing a street version of hand-
ball, one of New York's most popular
pastimes, 1974.

Kinder spielen eine Straßenvariante von
Handball – eine der beliebtesten Freizeit-
beschäftigungen in New York, 1974.

Jeunes jouant à une version de rue du
handball, l'un des passe-temps favoris
des New-Yorkais, 1974.

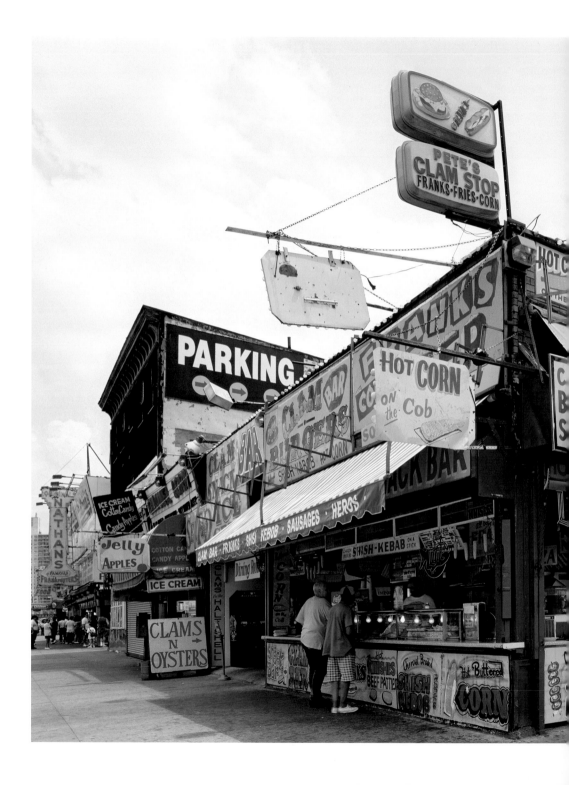

Carol M. Highsmith

Coney Island is as famous for its fast food, as it is for its boardwalk and roller coaster, c. 1990.

Coney Island ist für sein Fast Food ebenso berühmt wie für seine Strandpromenade und die Achterbahnen, c. 1990.

Coney Island doit autant sa notoriété à ses fast-foods qu'à sa promenade et ses montagnes russes, vers 1990.

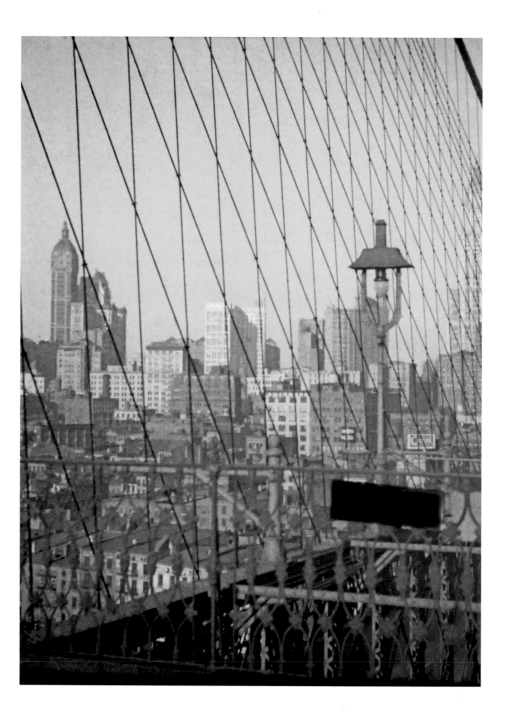

'All about was the night, pulsating with the thoughts of pleasure and exhilaration — the curious enthusiasm of a great city bent upon finding joy in a thousand different ways.'

SISTER CARRIE, THEODORE DREISER, 1900

Charles Zoller

Downtown Manhattan glimpsed through the steel cables of the Brooklyn Bridge. The impetus behind the building of the bridge was the East River freezing over in 1867, which halted trade between Manhattan and Brooklyn for several weeks. Construction started in 1870 and was completed in 1883, 1915.

Blick auf Downtown Manhattan durch die Stahlseile der Brooklyn Bridge. Der Plan zum Brückenbau entstand, als 1867 der East River zufror und der Handel zwischen Manhattan und Brooklyn für mehrere Wochen zum Erliegen kam. Die Bauarbeiten begannen 1870 und dauerten bis 1883, 1915.

Le Downtown Manhattan vu à travers les câbles du pont de Brooklyn. La raison majeure de la construction du pont fut le gel de l'East River en 1867 qui bloqua tout échange entre Manhattan et Brooklyn pendant plusieurs semaines. Le chantier débuta en 1879, et s'acheva en 1883, 1915.

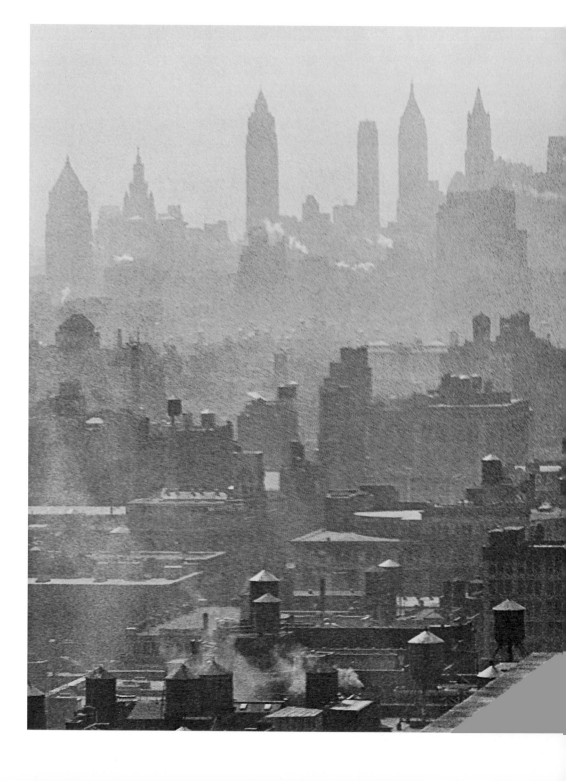

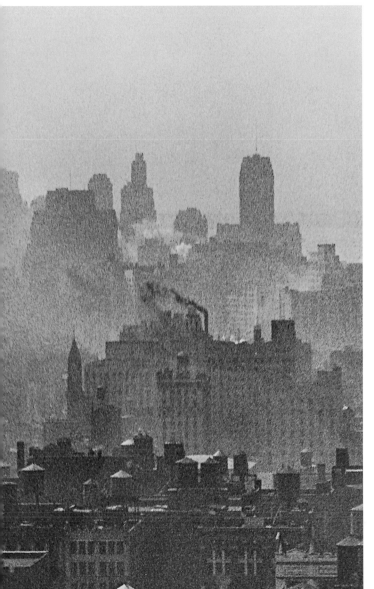

HERMAN MELVILLE (1819)
DOM DELUISE (1933)
"CHUCK D" CARLTON DOUGLAS
RIDENHOUR (1960)

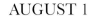

Paul Woolf

City Symphony. The skyline of the city looking hazy, but strangely alluring, 1935.

Städtische Sinfonie. Die Skyline der Stadt sieht dunstig aus, übt jedoch einen seltsamen Reiz aus, 1935.

Symphonie urbaine. Panorama de la ville, à la fois brumeux et étonnament présent, 1935.

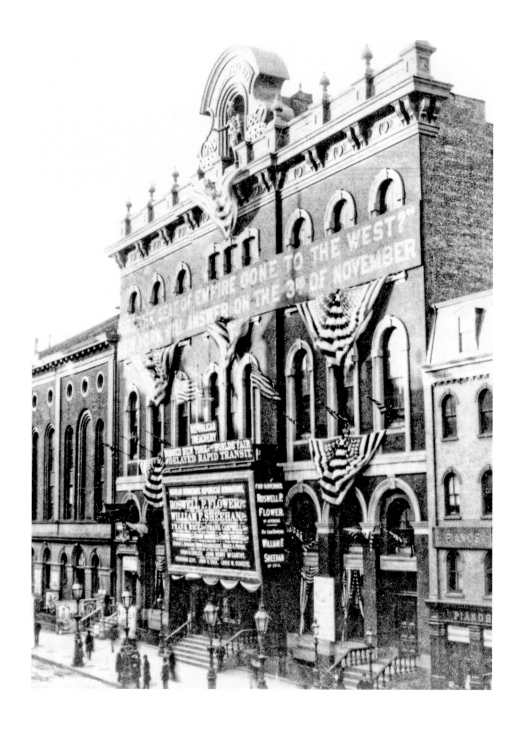

*"Manna-hata, the handsomest
and most pleasant country that
man can behold."*

HENRY HUDSON, 1893

Anonymous

Tammany Hall. Founded as the
Tammany Society, in 1789, this powerful
organization controlled all aspects of the
city's political and economic life, from
electing its mayors to distributing food
baskets. It was run by "bosses," some
of whom came to represent municipal
corruption at its worst, 1880s.

Tammany Hall. Die 1789 als Tammany
Society gegründete mächtige Organisa-
tion kontrollierte alle Aspekte des poli-
tischen und wirtschaftlichen Lebens der
Stadt, von der Wahl ihrer Bürgermeister
bis hin zur Verteilung von Lebensmitteln.
Einige ihrer „Bosse" verkörperten die
städtische Korruption in ihrer schlimms-
ten Ausprägung, 1880er-Jahre.

Tammany Hall. La Tammany Society
fondée en 1789 était une puissante
organisation qui contrôlait tous les
aspects de la vie politique et économi-
que de la cité, de l'élection des maires
à la distribution de paniers de vivres.
Elle était dirigée par des «bosses», dont
certains finirent par incarner le pire de la
corruption municipale, années 1880.

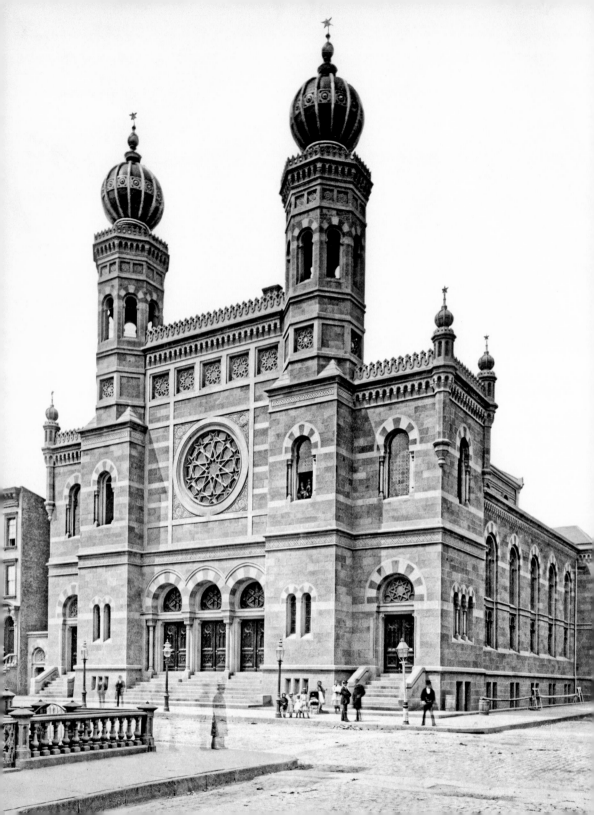

"If you're from New York and you're Catholic, you're still Jewish."

LENNY BRUCE

Anonymous

Central Synagogue. Located on Lexington Avenue and 55th Street, this reform synagogue in the Moorish style was built in 1872, c. 1872.

Zentralsynagoge. Diese Reformsynagoge in maurischem Stil an der Lexington Avenue und 55th Street wurde 1872 erbaut, um 1872.

Central Synagogue. Située sur Lexington Avenue et la 55e Rue, cette synagogue réformée de style mauresque fut édifiée en 1872, vers 1872.

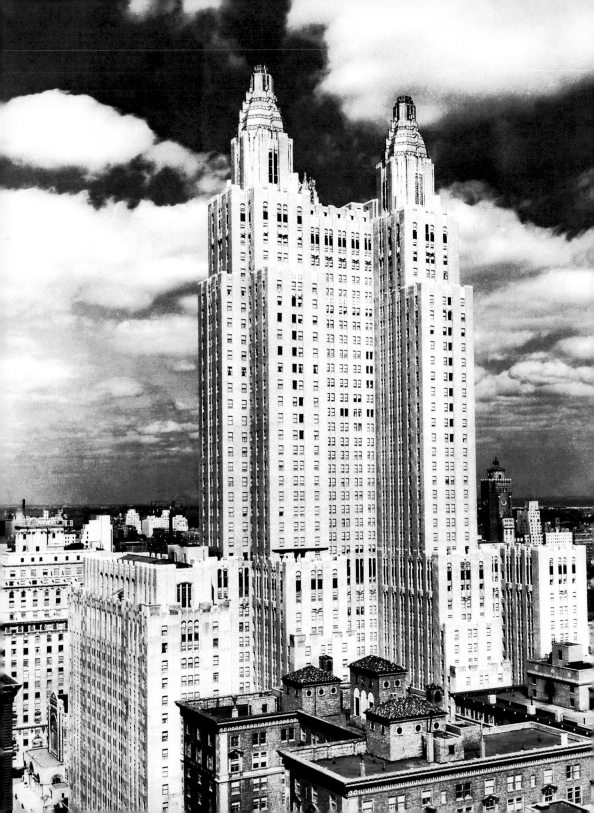

"Home from Guatemala, back at the Waldorf.
This arrival in the wild country of the soul,
All approaches gone, being completely there."

ARRIVAL AT THE WALDORF, WALLACE STEVENS, 1942

Anonymous

The Waldorf Astoria. The hotel occupies an entire city block, between Park Avenue and Lexington Avenue and 49th Street and 50th Street, just a bit north of Grand Central Terminal. The Waldorf Towers is between the 27th and 42nd stories, offering its own discreet entrance and luxury suites, including the Presidential Suite, apartments, and one- to six-bedroom permanent residences, 1942.

Das Waldorf Astoria. Das Hotel erstreckt sich über einen ganzen Häuserblock zwischen der Park Avenue und der Lexington Avenue und der 49th und 50th Street, etwas nördlich vom Grand Central Terminal. Zwischen dem 27. und 42. Stockwerk liegen die Waldorf Towers mit ihrem eigenen unauffälligen Eingang, Luxussuiten wie der Präsidentensuite, Apartments und Wohnungen mit bis zu sechs Schlafzimmern, 1942.

Le Waldorf Astoria. L'hôtel occupe un bloc entier entre Park Avenue et Lexington Avenue et la 49e et la 50e Rue, un peu au nord de Grand Central Terminal. Dotées de leur propre entrée discrète, les tours Waldorf, entre les 27e et 42e étages, comprenaient des suites de luxe, dont la Presidential Suite, et des appartements de résidence permanente de deux à six pièces, 1942.

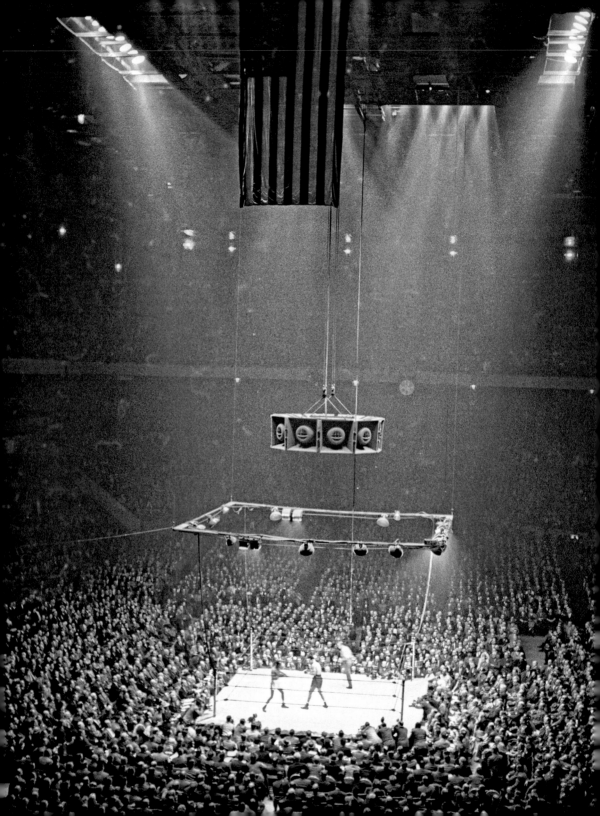

"The third (Madison Square Garden) is the one still in use, the dingy box on New York's Eighth Avenue — the one the architects forgot to provide with ticket windows and the one that has outgrown the requirements of present-day sports."

SPORTS ILLUSTRATED, 1967

Andreas Feiniger

Joe Louis vs. Joe Walcott at Madison Square Garden, the most famous boxing arena in the world. For the record, Walcott dominated the fight. But Louis was declared the winner after 15 grueling rounds, 1947.

Joe Louis gegen Joe Walcott im Madison Square Garden, der berühmtesten Boxarena der Welt. Walcott dominierte zwar den Kampf, aber Louis wurde nach 15 zermürbenden Runden zum Sieger erklärt, 1947.

Joe Louis contre Joe Walcott au Madison Square Garden, le plus célèbre ring de boxe du monde. Pour mémoire, Walcott domina le combat, mais Louis fut déclaré vainqueur après quinze rounds épuisants, 1947.

LUCILLE BALL (1911)
ANDY WARHOL (1928)

Anonymous

Shooting *West Side Story* on location.
One of the great New York movies,
loosely based on *Romeo and Juliet*,
the film pushed Latino culture into the
American mainstream, 1961.

Dreharbeiten zu *West Side Story* am
Originalschauplatz. Dieser Film, der zu
den großen New-York-Filmen gehört
und frei auf *Romeo und Julia* basiert,
machte die Latinokultur zu einem Teil
des amerikanischen Mainstreams, 1961.

Tournage de *West Side Story* en décor
naturel. Ce film, l'un des grands classiques
new-yorkais, inspiré de *Roméo et Juliette*,
ouvrit les portes de la culture populaire
américaine aux influences latino, 1961.

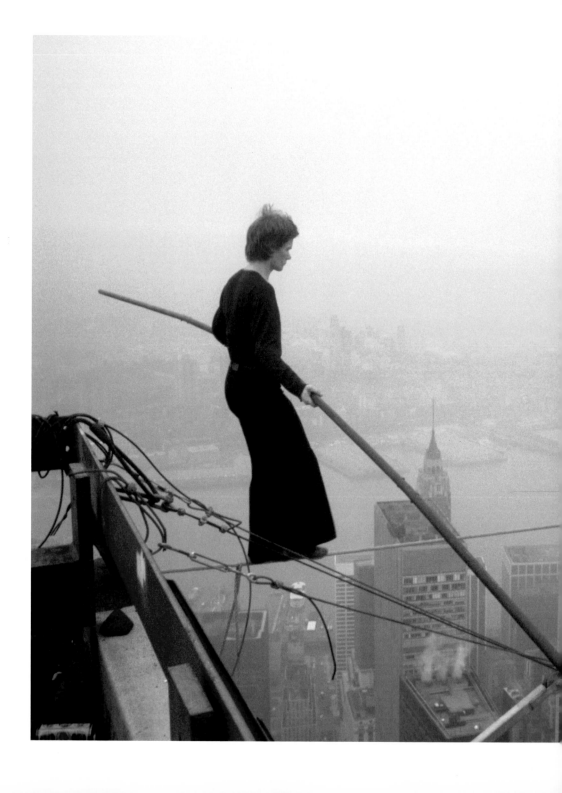

Jean Luis Blondeau

Philippe Petit during his daring high-wire walk between the Twin Towers at the World Trade Center. The 45-minute walk took six years of planning and was called "The Artistic Crime of the Century," by *Time* magazine, 1974.

Philippe Petit bei seinem wagemutigen Hochseilakt zwischen den Zwillingstürmen des World Trade Center. Vor dem 45-minütigen Kunststück lagen sechs Jahre der Planung. Es wurde von der Zeitschrift *Time* „das künstlerische Verbrechen des Jahrhunderts" genannt, 1974.

Philippe Petit au cours de son audacieuse traversée du vide entre les tours jumelles du World Trade Center. Cet exploit, qui dura quarante-cinq minutes, demanda six années de préparation et fut appelé «Le Crime artistique du siècle» par le magazine *Time,* 1974.

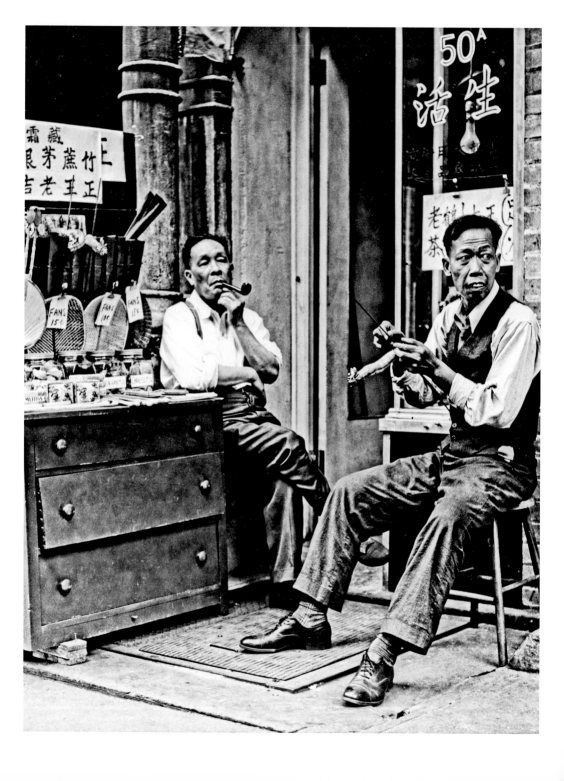

"Pell and Mott Street streets forms New York's Chinatown, of which it has always been the nerve center and the scene of much of the turbulent life of the quarter."

THE GANGS OF NEW YORK, HERBERT ASHBURY, 1928

Alexander Alland

Chinatown merchants. Chinatown was a mix of Chinese from Taiwan and Mainland China. More recently, it is home to Burmese, Vietnamese, and Filipinos. It is a commercial and residential area and a major tourist attraction, 1940.

Händler in Chinatown. In Chinatown lebte eine bunte Mischung von Chinesen aus Taiwan sowie vom chinesischen Festland und später auch Birmanen, Vietnamesen und Filipinos. Das Viertel ist ein Geschäfts- und Wohngebiet und eine wichtige Touristenattraktion, 1940.

Commerçants de Chinatown. Chinatown mélangeait les Chinois de Taiwan et ceux du continent. Plus récemment, le quartier a accueilli des Birmans, des Vietnamiens et des Philippins. Zone commerçante et résidentielle, c'est aussi une importante attraction touristique, 1940.

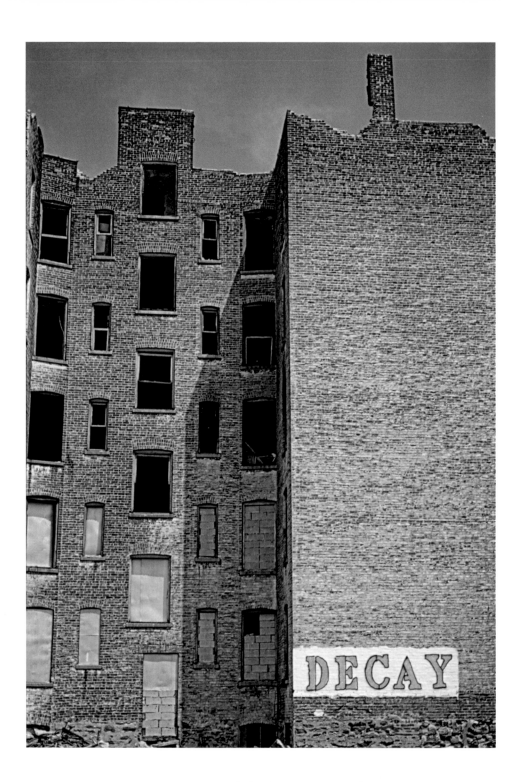

MICHAEL KORS (1959)
KURTIS BLOW (1959)

*"Ladies and Gentlemen,
the Bronx is burning."*

HOWARD COSELL, 1973

Harvey Stein

South Bronx. With its abandoned buildings, lots overgrown with weeds, and shells of burnt-out cars, the area became an American symbol for urban blight. The South Bronx, however, also became synonymous with the birth of hip-hop, 1980.

South Bronx. Mit seinen verlassenen Gebäuden, verwilderten Brachflächen und ausgebrannten Autowracks wurde das Gebiet zum amerikanischen Symbol für Not und Elend in der Großstadt. Die South Bronx ist allerdings auch die Wiege des Hip-Hop, 1980.

South Bronx. Par ses immeubles abandonnés, ses terrains vagues envahis de mauvaises herbes et de carcasses de voitures calcinées, le quartier est devenu le symbole américain de la dégradation urbaine. Dans le même temps, le South Bronx fut aussi le lieu de naissance du hip-hop, 1980.

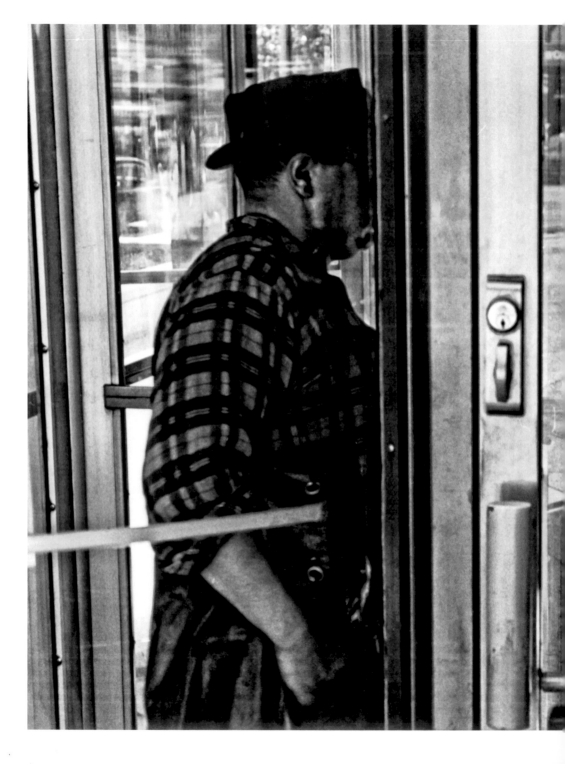

Lee Friedlander

An everyday moment that simply and effectively conveys something of the anonymity of big city life, 1963.

Ein alltäglicher Moment, der auf einfache und doch wirkungsvolle Art etwas über die Anonymität der Großstadt verrät, 1963.

Un instant de la vie quotidienne qui exprime simplement, mais efficacement, une part de cet anonymat ressenti dans la grande ville, 1963.

"Some ball yard!"

BABE RUTH

Fans listening to a New York Yankees game on the radio. The team finished second in the American League that year, 1924.

Fans verfolgen ein Spiel der New York Yankees im Radio. Die Mannschaft wurde in diesem Jahr Vizemeister der American League, 1924.

Amateurs suivant une match des New York Yankees à la radio. L'équipe sera seconde de l'American League la même année, 1924.

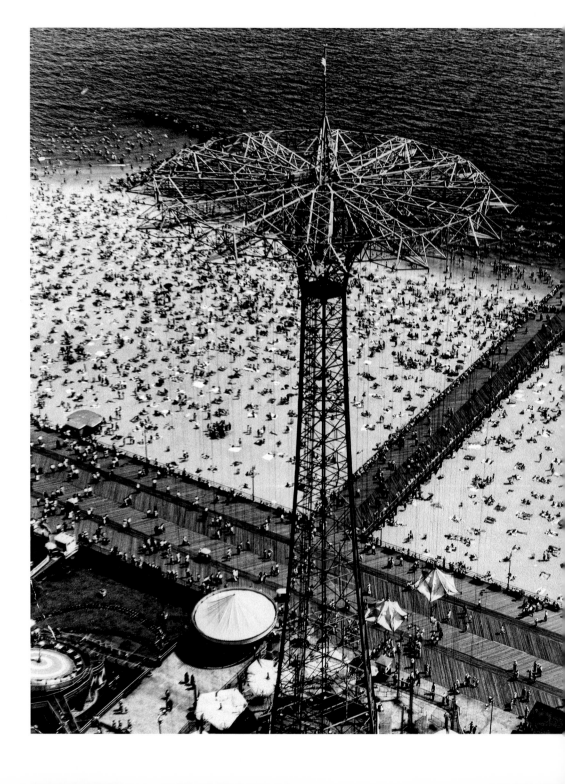

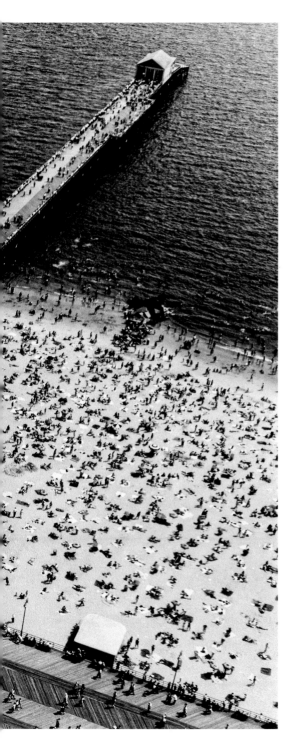

Margaret Bourke-White

Aeriel shot of the crowded beach at
Coney Island and the famous parachute
drop tower, 1951.

Luftbildaufnahme des gut besuchten
Strandes und des berühmten Fallschirm-
Sprungturms auf Coney Island, 1951.

Vue aérienne de la plage bondée de
Coney Island et de la fameuse tour du
saut en parachute, 1951.

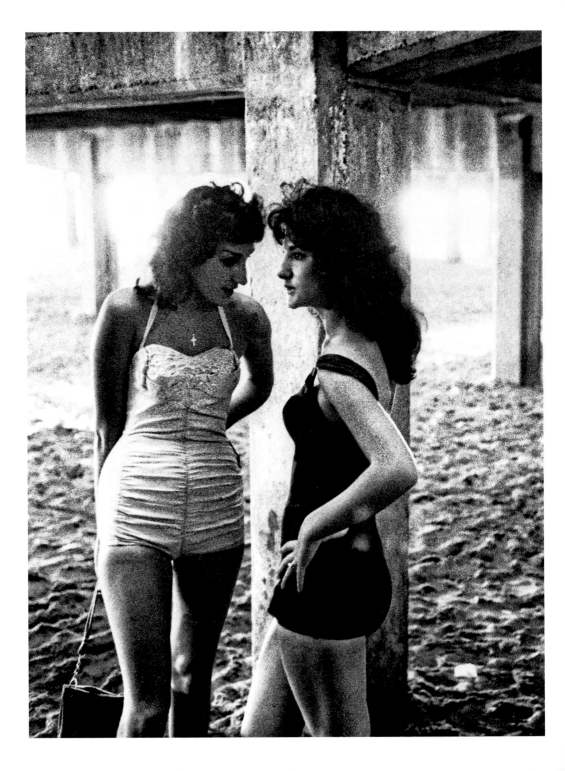

"I would love to be the poet laureate of Coney Island."

THORNTON WILDER, 1955

Steve Schapiro

Under the boardwalk in Coney Island offered some degree of privacy from the crowds. It's where many teenagers growing up in New York in the 1940s and 1950s had their first drink and "encounter" with a member of the opposite sex. The scene was immortalized in the Drifters song *Under the Boardwalk*, recorded in 1964, 1959.

Unter der Fußgängerpromenade in Coney Island konnte man sich den Menschenmengen etwas entziehen. Dort machten viele Teenager, die in den 1940er- und 1950er-Jahren in New York aufwuchsen, erstmalig Bekanntschaft mit Alkohol und dem anderen Geschlecht. Die Szene wurde in dem Song *Under the Boardwalk* von den Drifters verewigt, aufgenommen im Jahr 1964, 1959.

L'espace sous la promenade de Coney Island permettait un certain degré d'intimité. C'est ici que de nombreux adolescents new-yorkais des années 1940 et 1950 prirent leurs premières boissons alcoolisées et «rencontrèrent» pour la première fois des membres du sexe opposé. La scène fut immortalisée par une chanson des Drifters, *Under the Boardwalk*, en 1964, 1959.

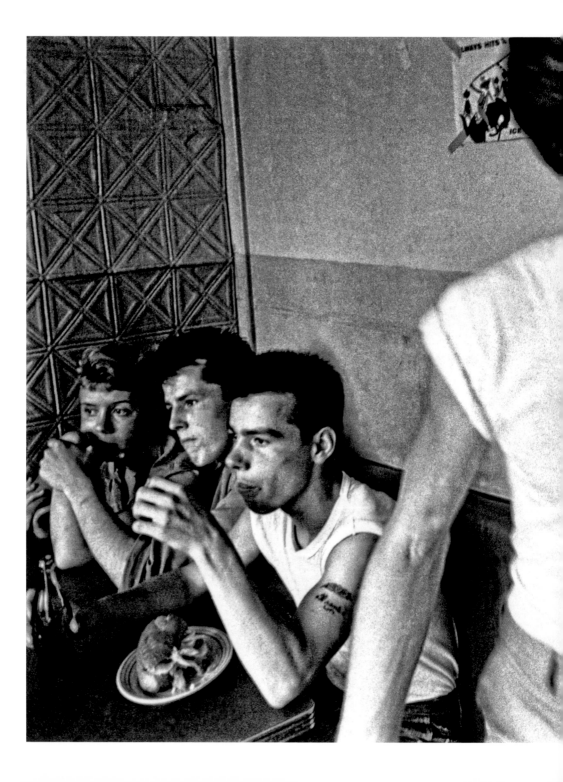

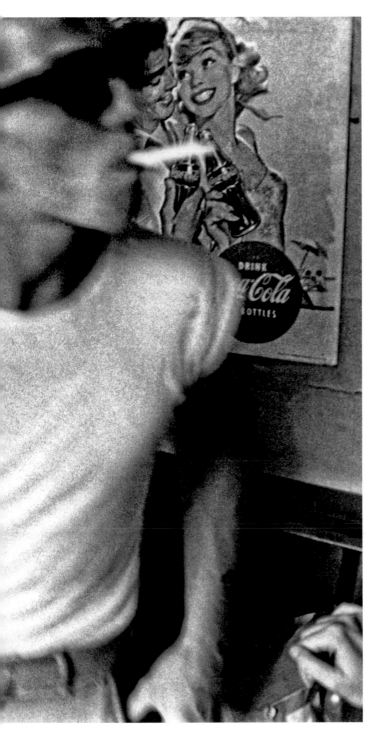

Bruce Davidson

Brooklyn Gang, 1959.

Gang in Brooklyn, 1959.

Gang de Brooklyn, 1959.

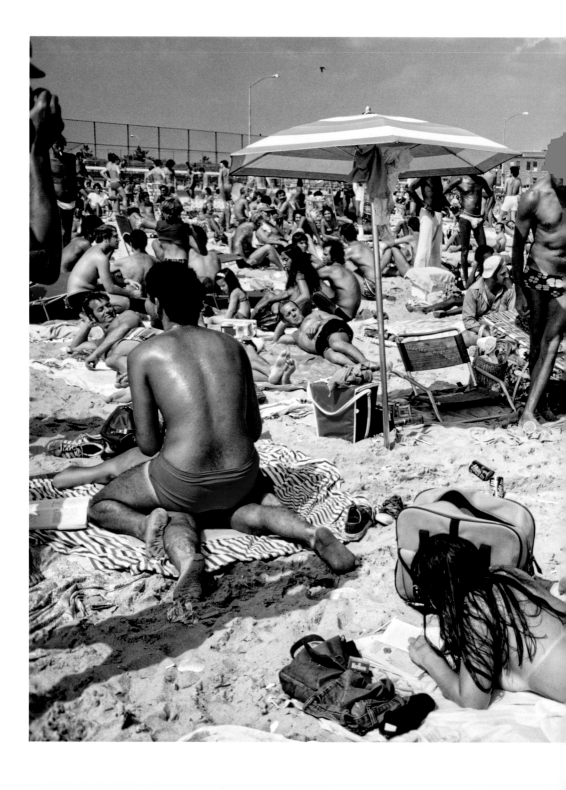

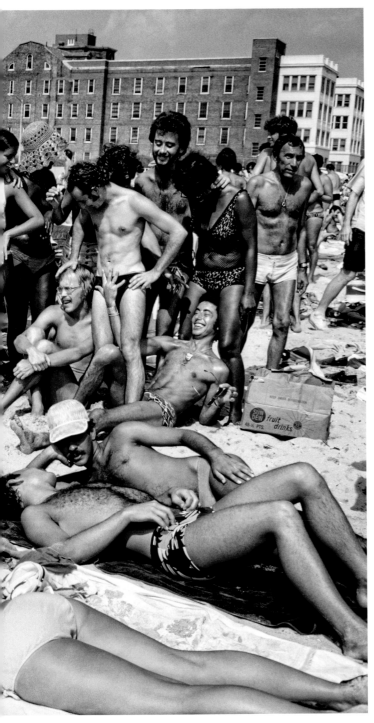

Mitch Epstein

Jacob Riis Park, Queens, 1974.

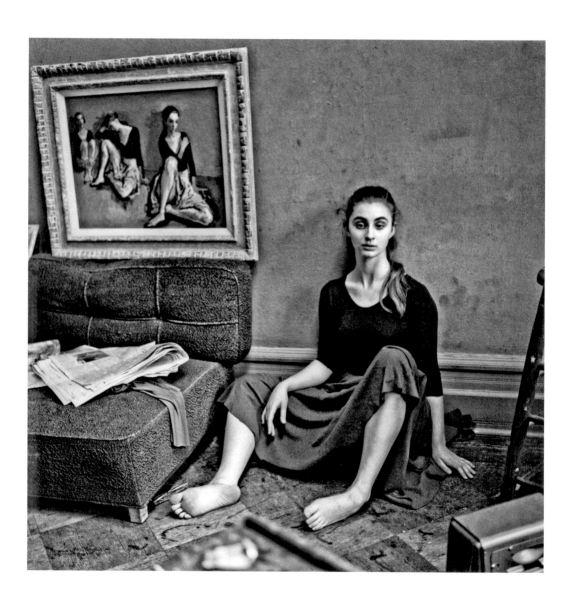

MADONNA (1958)

"It is ridiculous to set a detective story in New York City. New York City is itself a detective story."

AGATHA CHRISTIE, 1956

Larry Fink

A portrait taken at the studio of Russian-American artist Moses Soyer, c. 1957.

Ein Porträt, das im Studio des russisch-amerikanischen Malers Moses Soyer aufgenommen wurde, um 1957.

Portrait pris dans le studio de l'artiste russo-américain Moses Soyer, vers 1957.

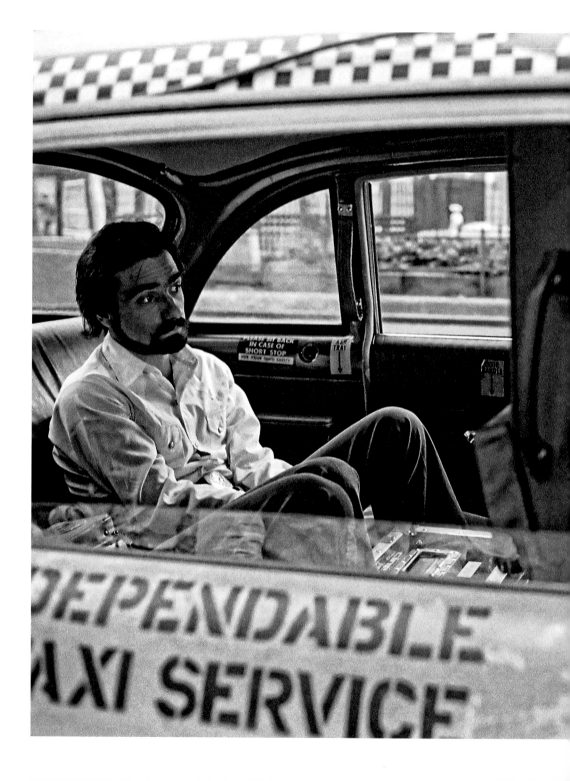

ROBERT DE NIRO (1943)

Steve Schapiro

A film still from the classic 1970s movie
Taxi Driver, featuring Robert De Niro
and the director Martin Scorsese. The
director cast himself in a cameo role,
playing a psychotically jealous husband.
The movie both celebrated and con-
demned the sleaze of the city, 1976.

Ein Standbild aus dem Filmklassiker
Taxi Driver aus den 1970er-Jahren mit
Robert De Niro unter der Regie von
Martin Scorsese. Der Regisseur hatte
einen Gastauftritt und spielte einen
krankhaft eifersüchtigen Ehemann. Mit
dem Film wurde die anrüchige Seite
der Stadt gleichzeitig verherrlicht und
angeprangert, 1976.

Image tirée du grand film classique des
années 1970, *Taxi Driver* de Martin Scor-
sese avec Robert De Niro. Le metteur en
scène s'était donné un petit rôle de mari
psychotique et jaloux. Le film célébrait et
condamnait en même temps le relâche-
ment des mœurs de la ville, 1976.

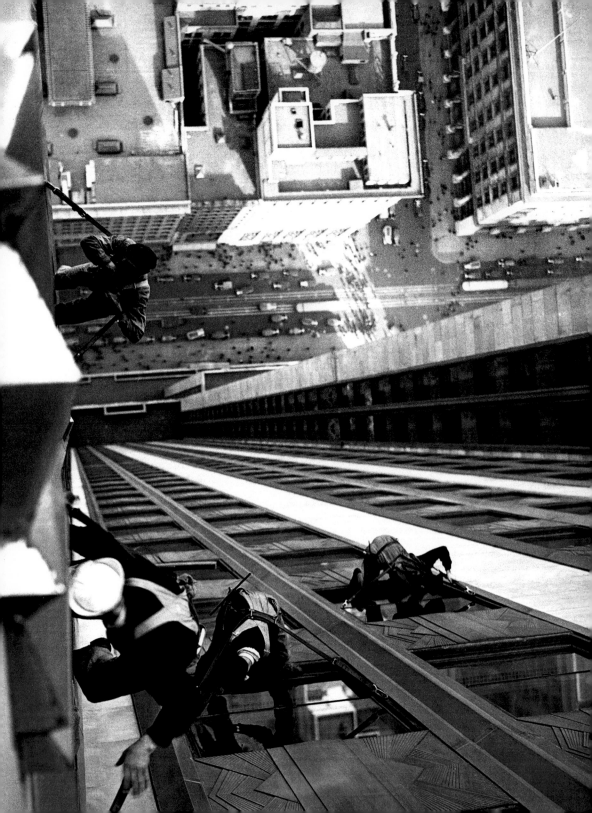

"Up to quite recently Lower New York has been the most old-fashioned city in the world, unique in its gloomy antiquity. The last of the ancient skyscrapers, the Empire State Building, is even now under demolition in C.E. 2106!"

THE SHAPE OF THINGS TO COME, H.G. WELLS, 1933

Anonymous

Washing the windows of the Empire State Building, 1932.

Fensterputzer am Empire State Building, 1932.

Laveurs de vitres de l'Empire State Building, 1932.

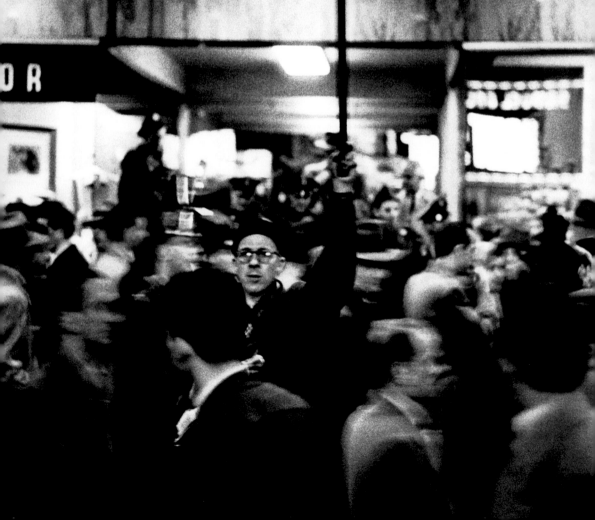

"…A blazing daytime in themselves, a magical universe of lights sparkling and throbbing with the intensity of a flash explosion."

THE TOWN AND THE CITY, JACK KEROUAC, 1950

Ernst Haas

The sign says: "Christ or chaos, choose now." This photo was taken in Times Square. Apart from this visionary or lost soul (depending on your point of view), everyone is in a mad rush, oblivious to the photographer, the man with the sign, and each other, 1952.

Auf dem Schild steht: „Christus oder Chaos, wählen Sie jetzt." Das Foto wurde auf dem Times Square aufgenommen, und außer dieser visionären oder bedauernswerten (je nach Standpunkt) Seele eilen alle anderen hektisch über den Platz, ohne sich um den Fotografen, den Mann mit dem Schild oder die anderen Passanten zu kümmern, 1952.

La pancarte dit «Christ ou chaos, choisis maintenant». Photo prise à Times Square. En dehors de cette âme visionnaire ou égarée (selon le point de vue), chacun semble follement pressé et ignore le photographe, l'homme à la pancarte et les autres, 1952.

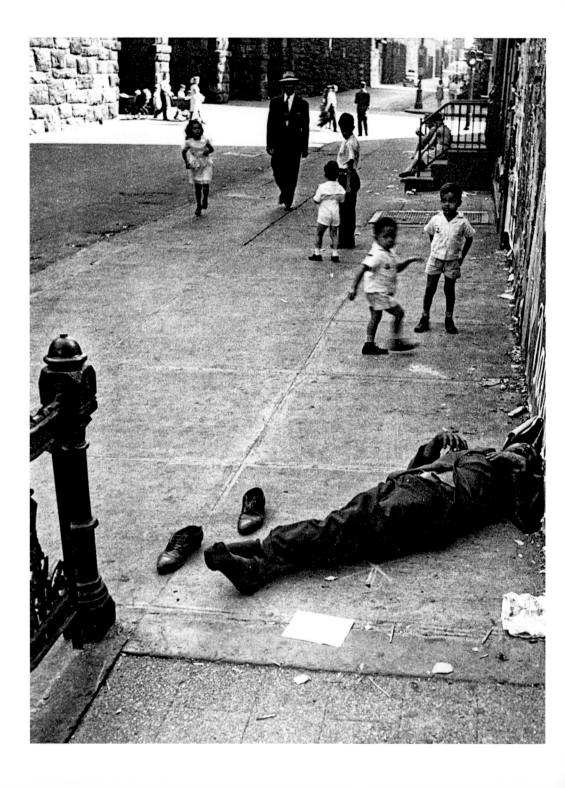

"No love.
No passion.
No pity.
Dead."

THE PAWNBROKER, 1964

John Albok

A prostrate figure probably sleeping off the effects of drinking too much, 1940s.

Der ausgestreckte Mann schläft wahrscheinlich seinen Rausch aus, 1940er-Jahre.

Le personnage couché sommeille tranquillement sur un trottoir, sans doute pour effacer les effets de quelques verres de trop, années 1940.

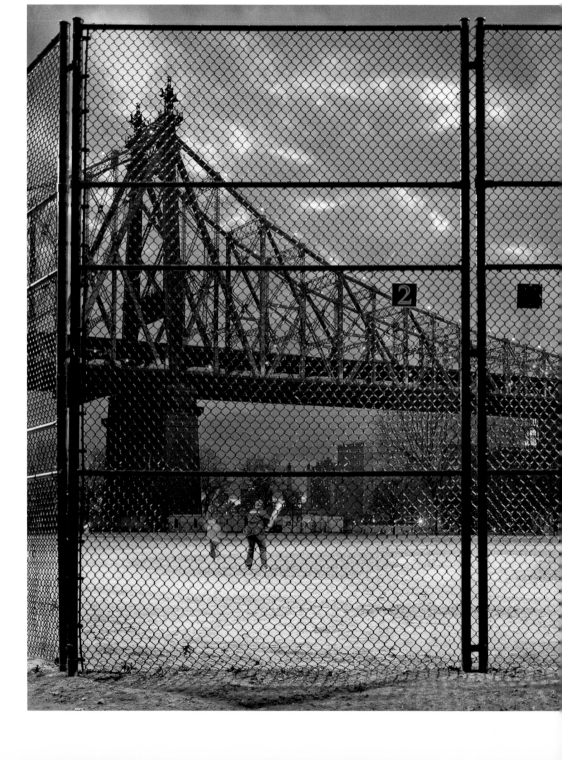

WILLIAM "COUNT" BASIE (1904)

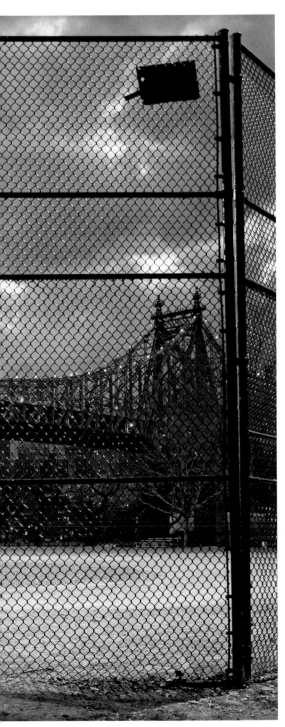

Jonathan Smith

A baseball field near the Queensborough Bridge. The bridge, also known as the 59th Street Bridge, connects Queens and Manhattan and was immortalized in a song by Simon and Garfunkel, 2005.

Ein Baseballfeld in der Nähe der Queensborough Bridge. Die Brücke, die auch 59th Street Bridge genannt wird, verbindet Queens mit Manhattan und wurde von Simon and Garfunkel in einem Lied verewigt, 2005.

Un terrain de baseball près du pont de Queensborough. Le pont également appelé 59th Street Bridge, qui relie le Queens et Manhattan, a été immortalisé par une -chanson de Simon et Garfunkel, 2005.

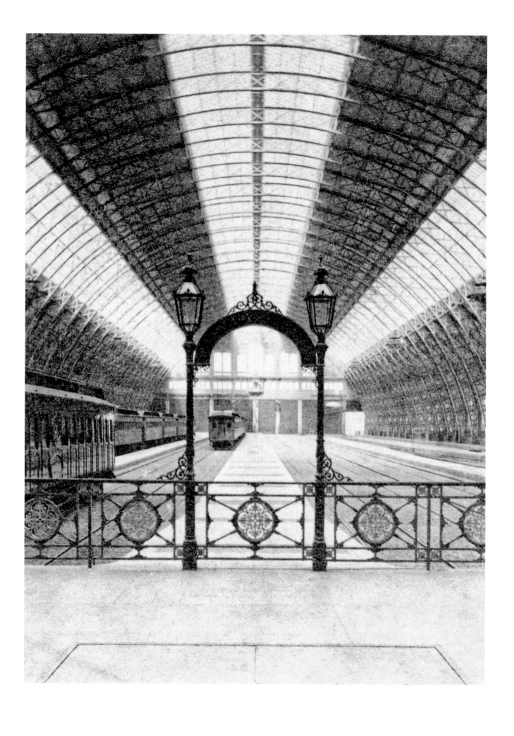

"Grand Central Terminal had arrived and New York City would never be the same again."

WWW.GRANDCENTRALTERMINAL.COM

Anonymous

Grand Central Terminal. This is the earliest version of the world-famous railway station. Commodore Cornelius Vanderbilt, the billionaire who controlled the New York Central and Hudson River Railroads, began construction in 1869. It was completed in 1871, early 1870s.

Grand Central Terminal, die früheste Version des weltberühmten Bahnhofs. Der Milliardär Commodore Cornelius Vanderbilt, dem die New York Central and Hudson River Railroads gehörten, begann 1869 mit den Bauarbeiten. Das Gebäude wurde 1871 fertiggestellt, Anfang der 1870er-Jahre.

Grand Central Terminal. Cette photographie représente la première version de cette gare connue dans le monde entier. Le «Commodore», Cornelius Vanderbilt, milliardaire et directeur du New York Central and Hudson River Railroads, en avait commencé les travaux en 1869. Le bâtiment fut achevé en 1871, début des années 1870.

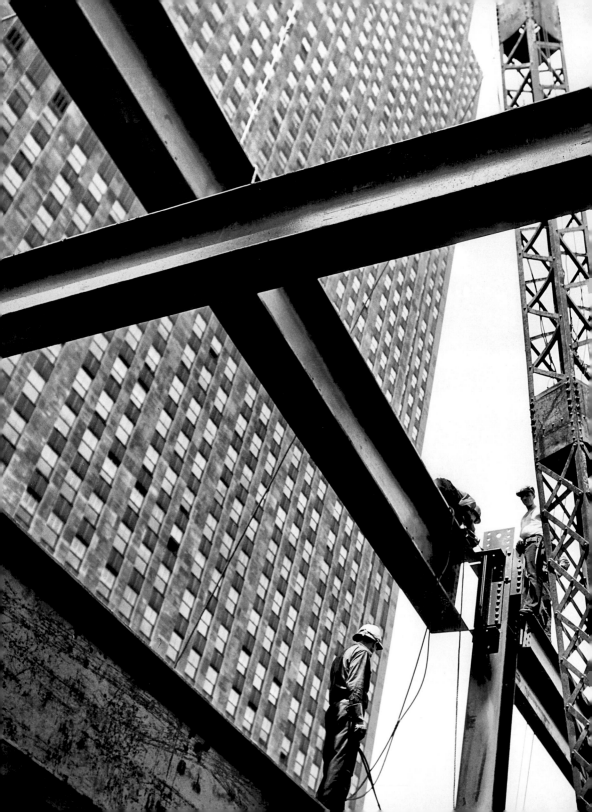

"I believe that love is the greatest thing in the world; that it alone can overcome hate; that right can and will triumph over might."

PLAQUE AT ROCKEFELLER CENTER, 1962

Paul Woolf

Rockefeller Center under construction. The original plan for the site west of Fifth Avenue, between Fifth and Sixth Avenues, was for an opera house. Once the Wall Street crash occurred, it was decided that the sprawling complex would be better as a commercial, shopping, and entertainment center. Construction lasted from 1930 to 1939, 1938.

Bau des Rockefeller Center. An diesem Ort zwischen der Fifth und Sixth Avenue sollte ursprünglich ein Opernhaus errichtet werden. Nach dem Crash an der Wall Street wurde jedoch beschlossen, dass das großflächige Gelände besser als Wirtschafts-, Einkaufs- und Unterhaltungszentrum genutzt werden könnte. Die Bauarbeiten dauerten von 1930 bis 1939, 1938.

La construction du Rockefeller Center. À l'origine, on pensait construire sur ce terrain à l'ouest de la Cinquième Avenue, entre la Cinquième et la Sixième Avenue, un opéra. Après le crash de Wall Street, il fut décidé qu'un complexe commercial de boutiques et de lieux de spectacles serait plus indiqué. La construction dura de 1930 à 1939, 1938.

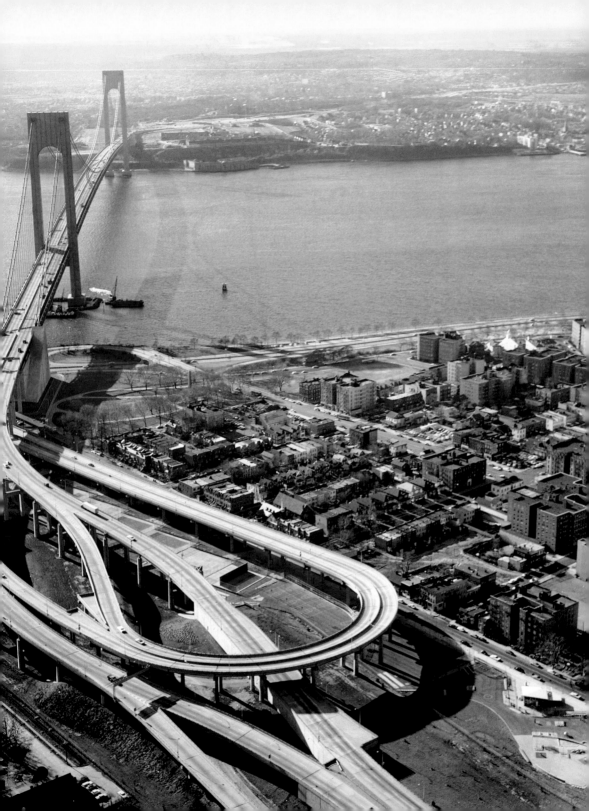

"DON" CARLO GAMBINO (1902)
DAVE CHAPPELLE (1973)

*"I'll take Manhattan, the Bronx,
and Staten Island too…"*

"MANHATTAN," RODGERS & HART, 1925

Charles E. Rotkin

The Verrazano-Narrows Bridge that connects Brooklyn (in the foreground) with Staten Island. It was completed in 1964 and at the time was the world's largest suspension bridge, mid-1960s.

Die Verrazano-Narrows Bridge, die Brooklyn (im Vordergrund) mit Staten Island verbindet. Die Brücke wurde 1964 fertig gestellt und war zu dieser Zeit die größte Hängebrücke der Welt, Mitte der 1960er-Jahre.

Le pont Verrazano-Narrows relie Brooklyn (au premier plan) et Staten Island. Achevé en 1964, il était alors le plus grand pont suspendu au monde, milieu des années 1960.

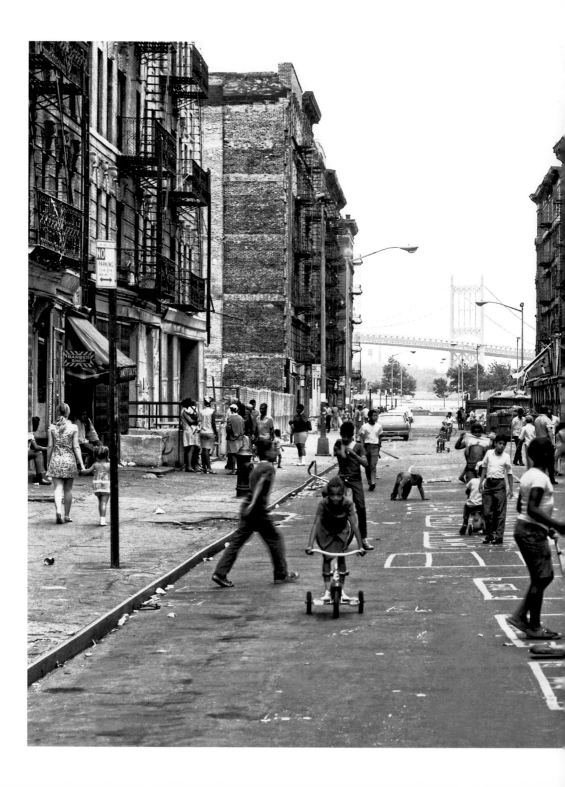

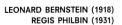

LEONARD BERNSTEIN (1918)
REGIS PHILBIN (1931)

Bruce Davidson

East 110ᵗʰ Street. The Magnum photographer systematically documented this one block in East (Spanish) Harlem, giving a detailed picture of the hardships, but also the vibrancy of ghetto life, 1966.

East 110th Street. Der Magnum-Fotograf dokumentierte systematisch diesen Block in East (Spanish) Harlem und zeichnete ein detailliertes Bild der Nöte und Schwierigkeiten, zeigte aber auch die Lebendigkeit des Gettolebens, 1966.

110ᵉ Rue est. Le photographe de l'agence Magnum a systématiquement documenté ce bloc d'East (Spanish) Harlem pour faire le portrait détaillé des difficultés, mais aussi de l'intensité de la vie du ghetto, 1966.

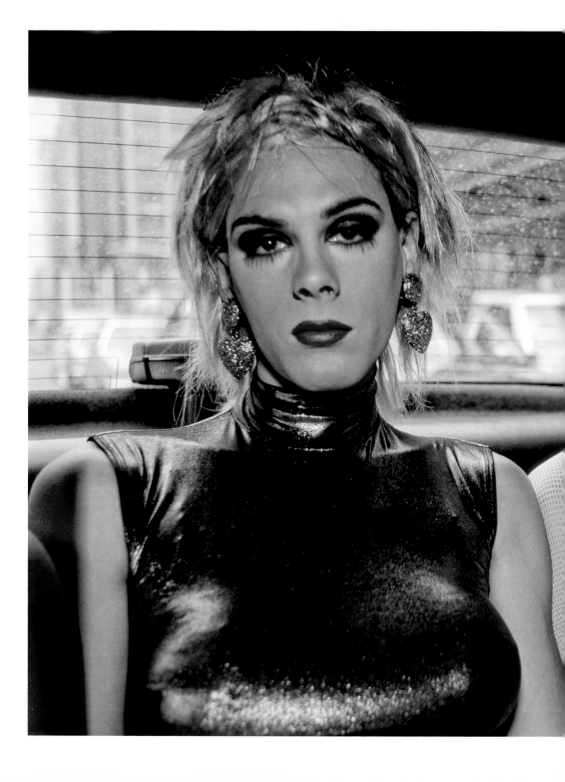

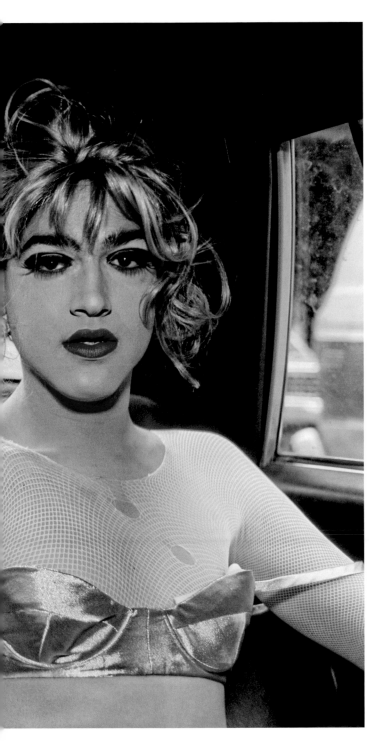

Nan Goldin

Misty and Jimmy Paulette in a Taxi, 1991.

Misty und Jimmy Paulette im Taxi, 1991.

Misty et Jimmy Paulette dans un taxi, 1991.

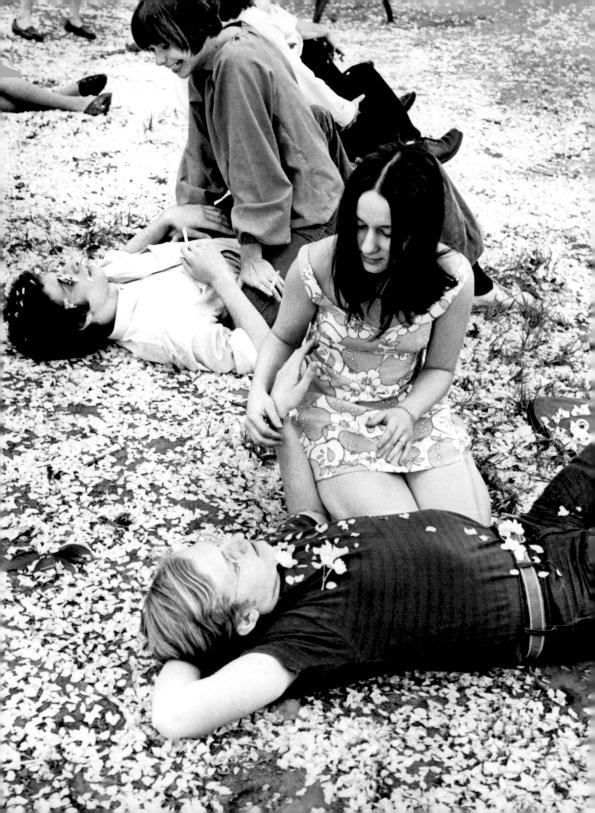

"MAN RAY" EMMANUEL RADNITZKY (1890)
TOM FORD (1961)

"I get the news I need on the weather report.
I can gather all the news I need on the weather report.
Hey, I've got nothing to do today but smile.
Da-n-da-da-n-da-da-n-da-da here I am
The only living boy in New York."

"THE ONLY LIVING BOY IN NEW YORK," SIMON & GARFUNKEL, 1970

James Jowers

Central Park. Just another typical day
in 1960s New York, 1969.

Central Park. Ein ganz normaler Tag in
den 1960er-Jahren in New York, 1969.

Central Park. Journée typique dans le
New York des années 1960, 1969.

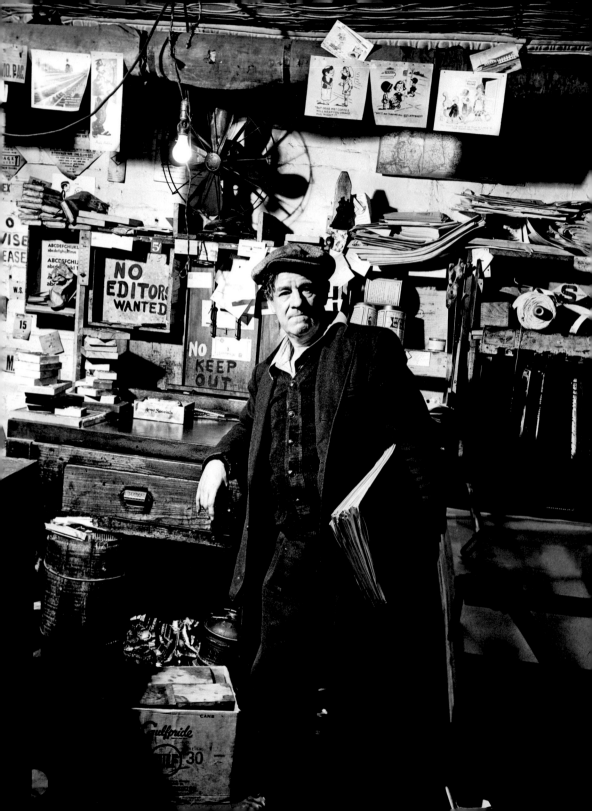

*"This is New York, where
hello means goodbye."*

DEADLINES AT DAWN, 1946

Arnold Eagle

The offices of *Hobo News* on the Bowery. The paper sold on street corners for ten cents and featured cartoons and advice for the down-and-out. Note the sign: "No Editors Wanted," 1939.

Die Büros von *Hobo News* an der Bowery. Die Obdachlosenzeitung wurde für 10 Cent auf der Straße verkauft und enthielt Comics und Tipps für Obdachlose. Man beachte das Schild mit den Worten „Kein Bedarf an Redakteuren", 1939.

Les bureaux *d'Hobo News* sur le Bowery. Le journal vendu dans la rue pour dix cents était rempli de dessins humoristiques et de conseils pour exclus. Noter le panonceau : «On ne cherche pas de rédacteurs», 1939.

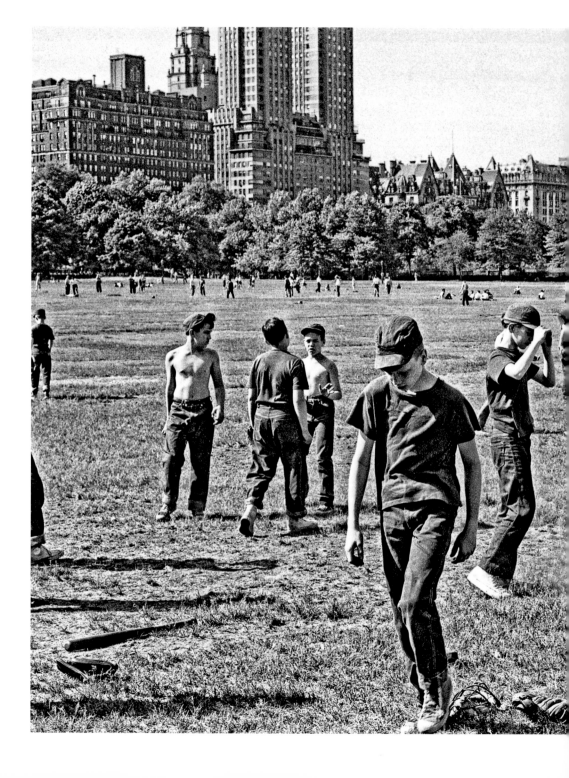

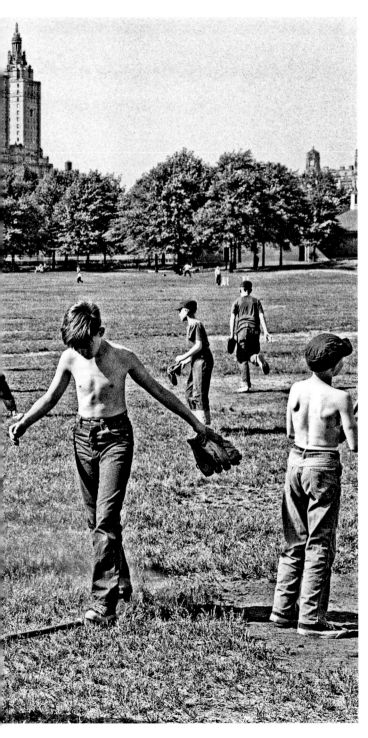

Larry Fink

Baseball in Central Park, 1962.

Baseball im Central Park, 1962.

Baseball à Central Park, 1962.

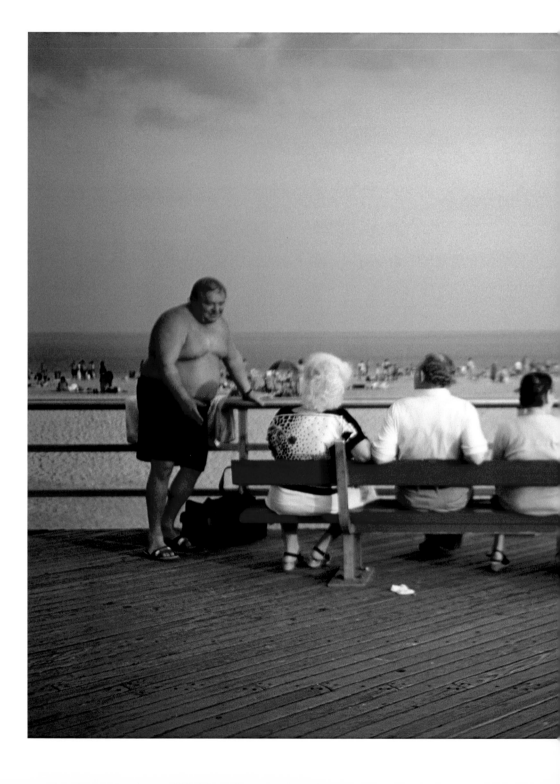

ROWLAND HUSSEY MACY, SR. (1822)

Arlene Gottfried

Brighton Beach. The neighborhood
on the southern tip of Brooklyn, near
Coney Island, has been dubbed Little
Odessa because it is home to hundreds
of thousands of immigrants from the
former Soviet Union. Many are Jews
who came to the United States during
1980s Glasnost, 1990s.

Brighton Beach. Das Viertel an der
Südspitze von Brooklyn in der Nähe von
Coney Island wird „Little Odessa" ge-
nannt, weil dort Hunderttausende Immi-
granten aus der ehemaligen Sowjetunion
leben. Viele von ihnen sind Juden, die zur
Zeit von Glasnost in den 1980er-Jahren
in die USA kamen, 1990er-Jahre.

Brighton Beach. Ce quartier de la pointe
sud de Brooklyn, près de Coney Island,
a été surnommé la Petite Odessa («Little
Odessa»), car elle a accueilli des centai-
nes de milliers de personnes venues de
l'ancienne Union soviétique. Beaucoup
sont des Juifs venus aux États-Unis
pendant la période de la glasnost dans
les années 1980, années 1990.

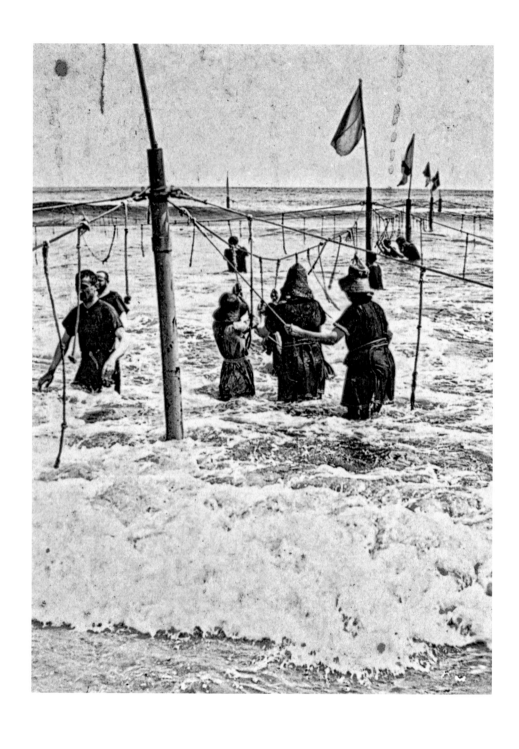

"Rock Rock Rockaway Beach
Rock Rock Rockaway Beach
Rock Rock Rockaway Beach
We can hitch a ride to Rockaway Beach

It's not hard, not far to reach
We can hitch a ride to Rockaway Beach"

ROCKAWAY BEACH, THE RAMONES, 1977

Alfred S. Campbell

Bathing at Rockaway beach. Note how people who cannot swim, the majority in those days, are being aided, c. 1890.

Badende am Rockaway Beach. Man beachte die Schwimmhilfen – Nichtschwimmer waren damals in der Überzahl, um 1890.

Baignade à la plage de Rockaway. Noter comment les baigneurs se font aider, car la majorité des gens ne sait pas encore nager à cette époque, vers 1890.

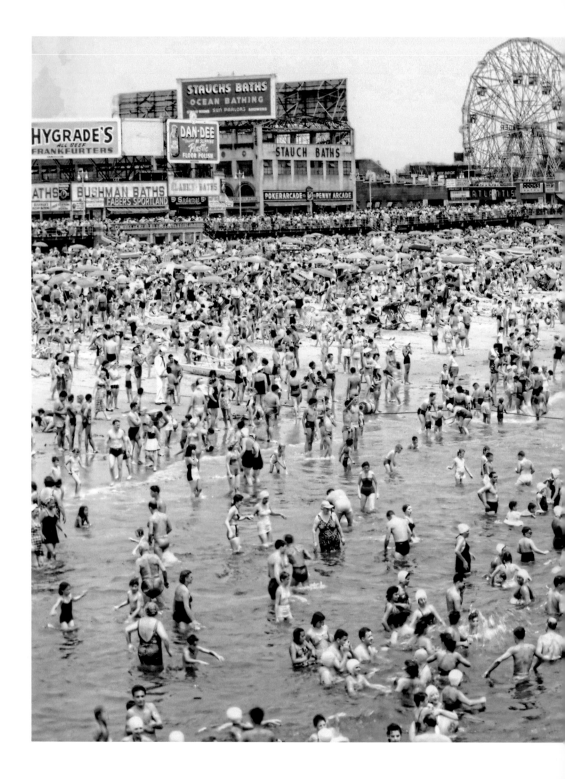

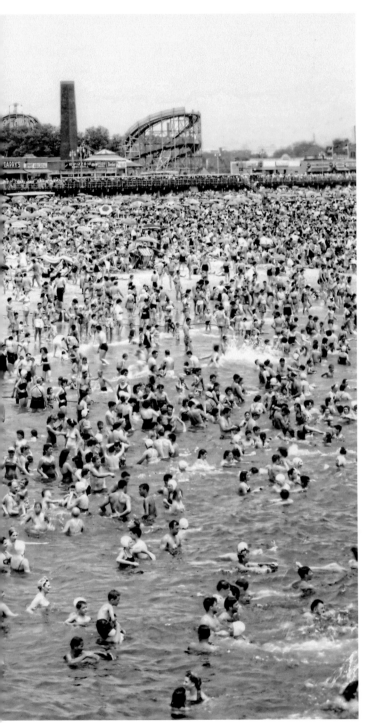

Anonymous

The New York crowds flock to
Coney Island to escape the stifling
summer heat, 1950s.

Heerscharen von New Yorkern flüchten
nach Coney Island, um der drückenden
Sommerhitze zu entgehen, 1950er-Jahre.

La foule des New-Yorkais s'est échappée
à Coney Island pour fuir la canicule,
années 1950.

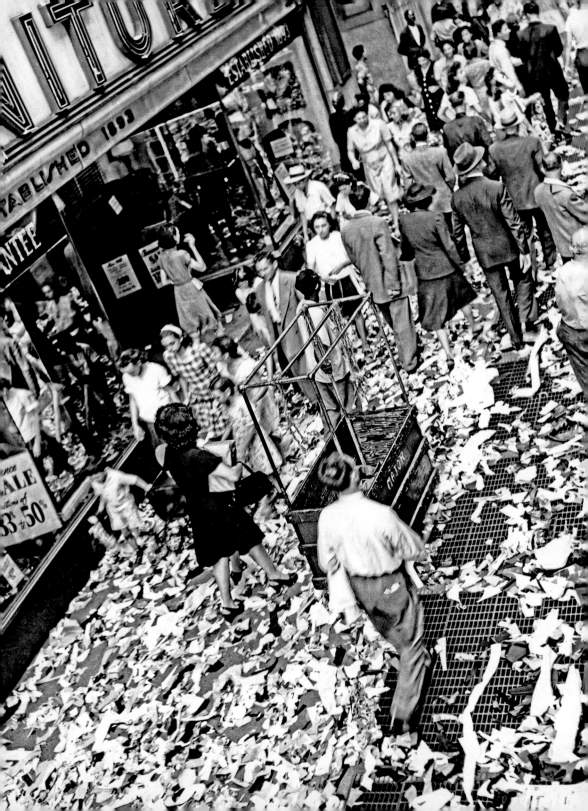

*"Wild Crowds Greet
News In City
While Others Pray"*

NEW YORK TIMES, 1945

Weegee

Garment District. The aftermath of New York celebrating V-J Day (Victory over Japan), which marked the end of World War II, 1945.

Garment District. Nach den Feierlichkeiten anlässlich der Kapitulation Japans, mit der der Zweite Weltkrieg zu Ende ging, 1945.

Quartier de la confection. Lendemain des festivités de la Victoire sur le Japon qui marqua la fin de la Seconde Guerre mondiale, 1945.

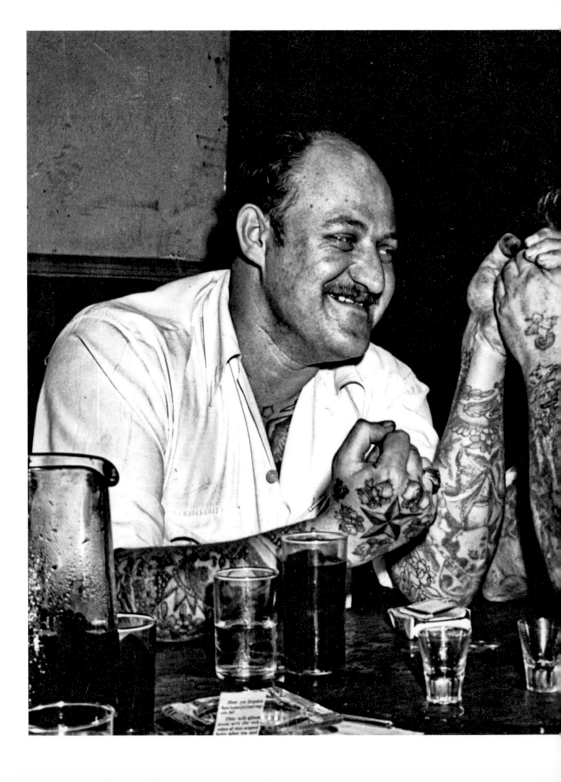

CHARLIE SHEEN (1965)

Erika Stone

Test of Strength at Sammy's on the Bowery. Sammy, the bar's owner, was the unofficial mayor of the Bowery, and his dive bar was the only one on the famous street that had a floor show. Lowlife frequented it, but also fancy uptown people who wanted a rough night out, 1946.

Kräftemessen bei Sammy's auf der Bowery. Sammy, der Besitzer der Bar, war der inoffizielle Bürgermeister der Bowery, und seine Spelunke war die einzige in dieser berühmten Straße mit einer Nachtclubshow. Nicht nur zwielichtige Gestalten besuchten die Kneipe, sondern auch eleganteres Publikum aus Uptown, das einmal weniger fein ausgehen wollte, 1946.

Bras de fer chez Sammy's sur le Bowery. Sammy, le propriétaire du bar, était le maire inofficiel du Bowery, et son bar le seul de cette célèbre rue à présenter des spectacles. La pègre le fréquentait, mais aussi des gens élégants d'Uptown à la recherche de sensations, 1946.

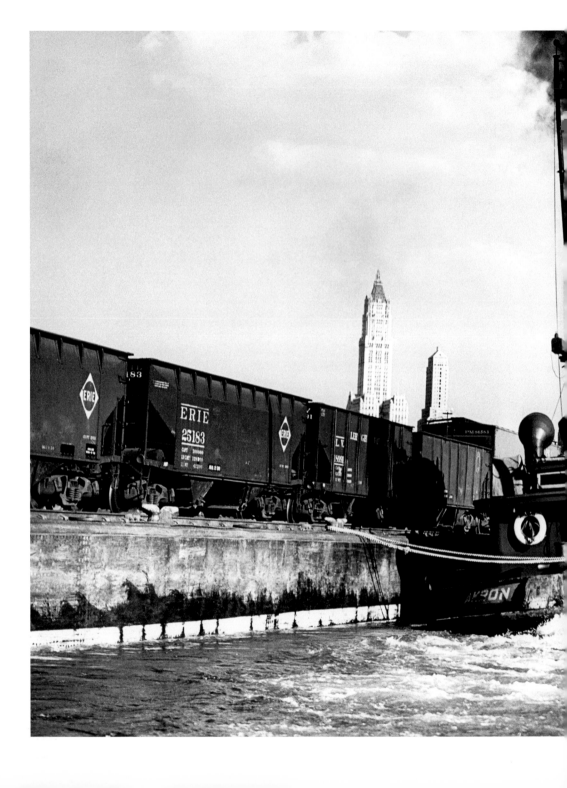

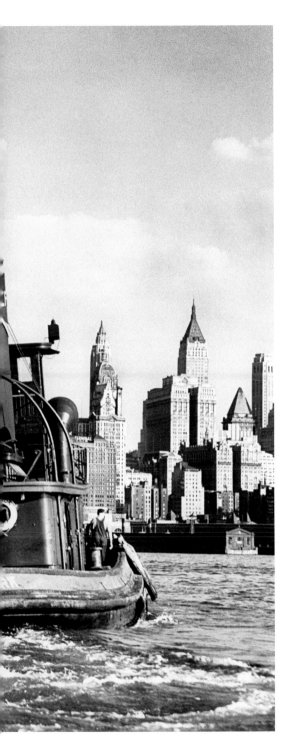

Margaret Bourke-White

A tugboat in Lower Manhattan, 1939.

Schleppschiff in Lower Manhattan, 1939.

Un remorqueur devant le Lower Manhattan, 1939.

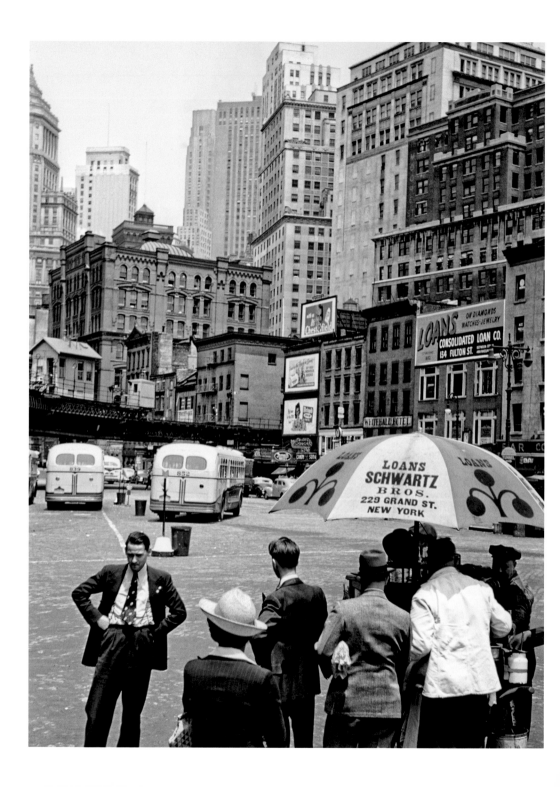

"He looked up at the skyline on the Manhattan shore. 'New York! I've always wanted to see it and now I've seen it. It's true what they say—it's the most wonderful city in the world.'"

A TREE GROWS IN BROOKLYN, BETTY SMITH, 1943

Charles Cushman

South Ferry. Note the pun advertising the services of Loans Schwartz on the vendor's sunshade, 1941.

South Ferry. Man beachte die Werbung für Darlehen von Loans Schwartz auf dem Sonnenschirm des Verkäufers, 1941.

South Ferry. Noter la publicité pour l'etablissement de prêts Loans Schwartz sur le parasol d'un vendeur de rue, 1941.

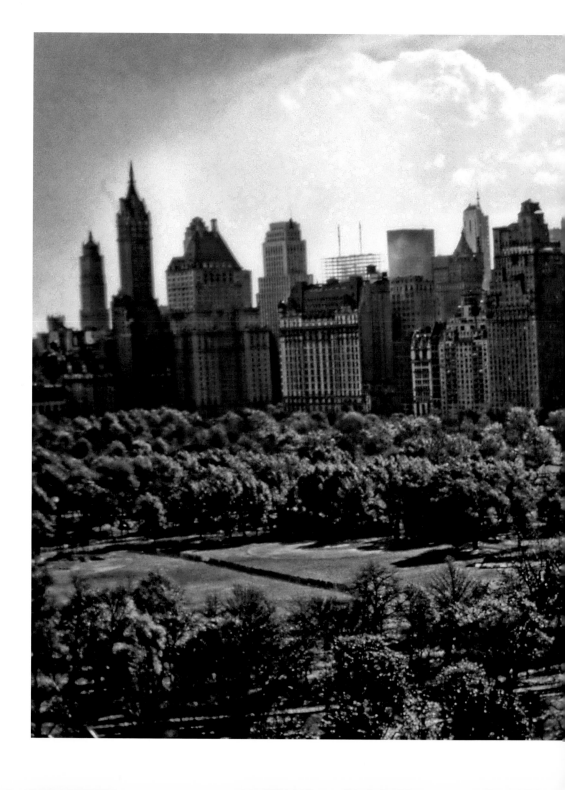

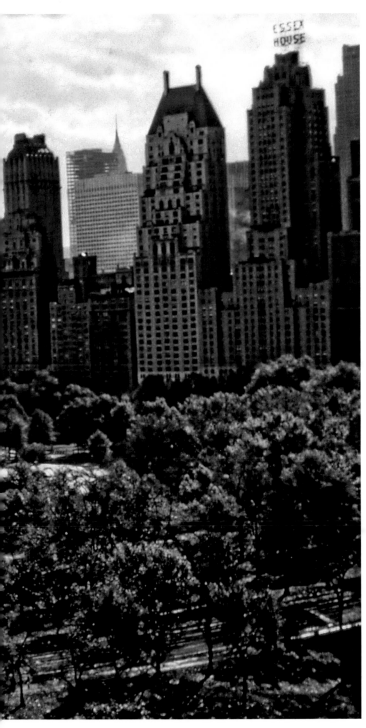

ROSIE PÉREZ (1964)

Ruth Orkin

The photographer was lucky enough to own an apartment overlooking Central Park, and she spent decades shooting the changing seasons and evolving cityscape outside her window. Already by the early 1950s, Manhattan was dense with skyscrapers, and in Midtown, in particular, development was relentless. The open vistas of the park look inviting in these images, 1950s.

Die Fotografin hatte das Glück, ein Apartment mit Blick auf den Central Park zu besitzen. Jahrzehntelang fotografierte sie von ihrem Fenster aus den Wandel der Jahreszeiten und der Stadtlandschaft. Bereits Anfang der 1950er-Jahre gab es eine Unmenge von Wolkenkratzern in New York, und insbesondere in Midtown war die Bautätigkeit gnadenlos. Die offenen Ausblicke auf den Park wirken sehr einladend, 1950er Jahre.

Ruth Orkin avait la chance de posséder un appartement donnant sur Central Park. Pendant des décennies, elle photographia de ses fenêtres le changement des saisons et l'évolution du panorama urbain. Au début des années 1950 déjà, Manhattan se peuplait de gratte-ciel et, dans Midtown en particulier, leur progression ne connaissait pas de répit. Les perspectives sur le parc semblent bien attirantes de ses photos, années 1950.

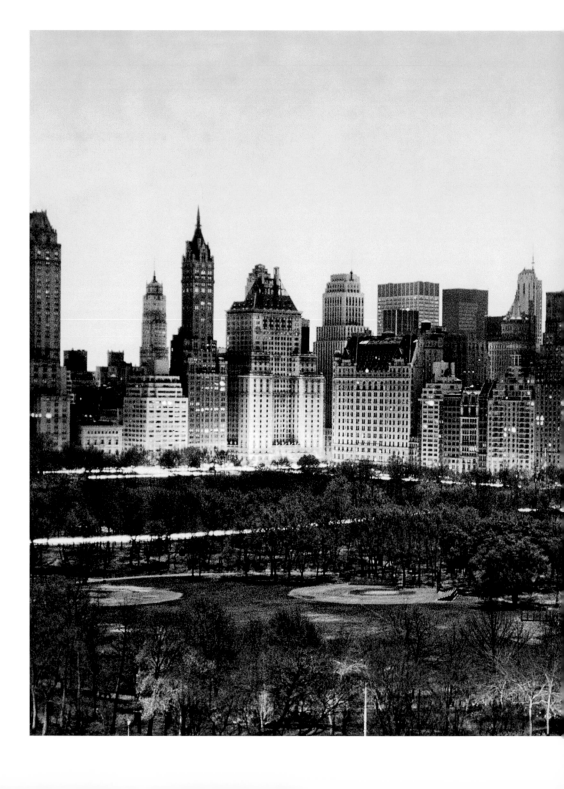

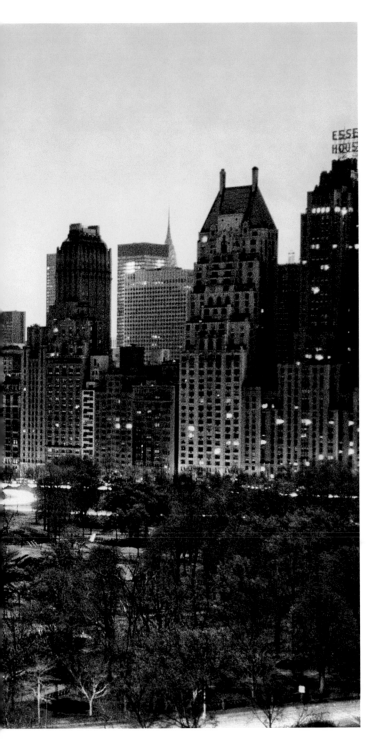

SEPTEMBER 7

THEODORE WALTER "SONNY" ROLLINS (1930)

Ruth Orkin

Another view of Central Park, 1950s.

Eine andere Ansicht des Central Parks, 1950er Jahre.

Une autre vue de Central Park, années 1950.

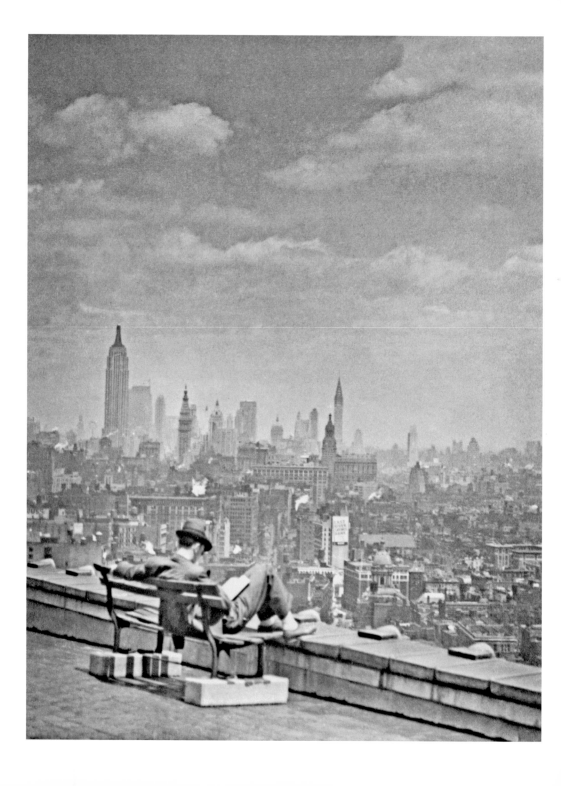

*"People here are funny.
They work so hard at living
they forget how to live."*

MR. DEEDS GOES TO TOWN, 1936

Anonymous

A man and a view, 1936.

Ein Blick auf Manhattan von der
anderen Seite des East River, 1936.

Vue de Manhattan prise de l'autre
rive de l'East River, 1936.

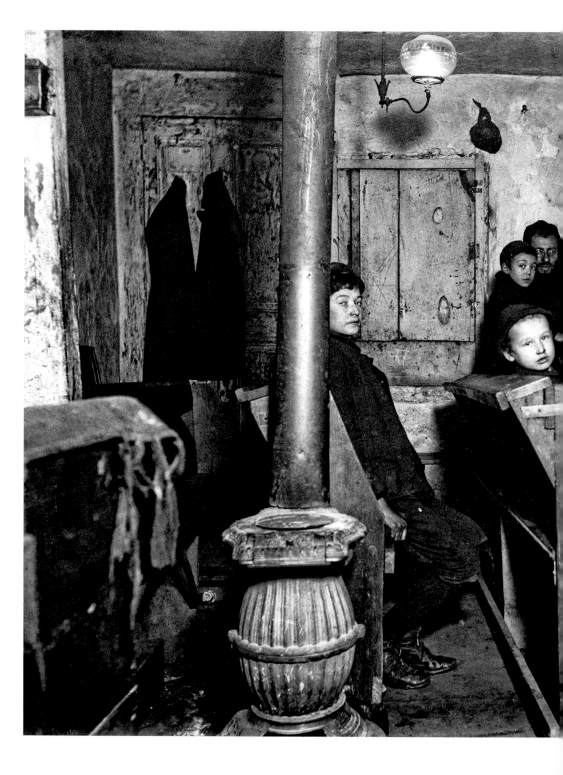

ADAM SANDLER (1966)

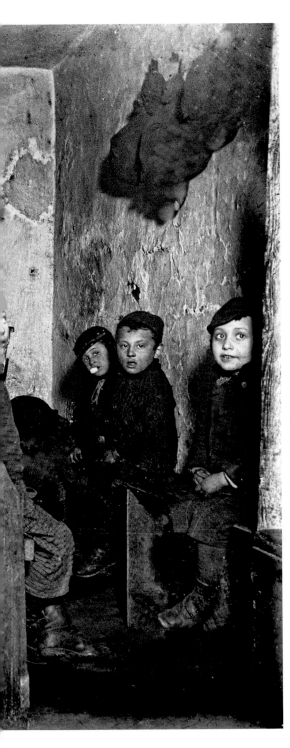

Jacob Riis

Talmud School, Hester Street Tenement.
Hester Street was in the heart of the
Jewish Lower East Side, and these young
boys are Jewish scholars. Roughly two
million Jews came to the United States
between 1881 and 1916, and by 1910
there were 1.2 million Jews living in
New York City, c. 1888–95.

*Talmud School, Hester Street Tenement
(Talmud-Schule, Mietshaus in der Hester
Street).* Hester Street lag im Herzen der
jüdischen Lower East Side; diese Jungen
sind jüdische Talmud-Schüler. Etwa zwei
Millionen Juden kamen zwischen 1881
und 1916 nach New York; 1910 lebten
etwa 1,2 Millionen Juden in New York
City, um 1888–95.

*Talmud School, Hester Street Tenement
(École talmudique, maison de rapport
d'Hester Street).* Hester Street était au
cœur du quartier juif du Lower East
Side, et ces jeunes garçons sont des
élèves de confession israélite. Environ
deux millions de Juifs vinrent s'installer
aux États-Unis entre 1881 et 1916, et
1,2 million d'entre eux vivaient à New
York en 1910, vers 1888–95.

*"Conservation means development
as much as it does protection."*

ATTRIBUTED TO PRESIDENT THEODORE ROOSEVELT

James Jowers

A mother and her child admiring the dinosaur fossils at New York's famous American Museum of Natural History that faces Central Park at 79th Street, 1973.

Eine Mutter und ihr Kind bewundern die Dinosaurierskelette im berühmten New Yorker American Museum of Natural History an der 79th Street gegenüber vom Central Park, 1973.

Une mère et son enfant devant les fossiles de dinosaures du fameux Muséum d'histoire naturelle américain de la 79e Rue, au bord de Central Park, 1973.

BRIAN DE PALMA (1940)
"MOBY" RICHARD MELVILLE HALL (1965)

"Sky of blackness and sorrow (a dream of life)
Sky of love, sky of tears (a dream of life)
Sky of glory and sadness (a dream of life)
Sky of mercy, sky of fear (a dream of life)
Sky of memory and shadow (a dream of life)
Your burnin' wind fills my arms tonight
Sky of longing and emptiness (a dream of life)
Sky of fullness, sky of blessed life (a dream of life)."

"THE RISING," BRUCE SPRINGSTEEN, 2002

Louis Stettner

The Twin Towers and a seagull. The 110-story Twin Towers, designed by Minoru Yamasaki and completed 1972/73. The World Trade Center made the New York skyline even more spectacular, but up close and inside, the towers proved too functional to arouse much affection among New Yorkers, 1979.

Die Zwillingstürme und eine Möwe. Die Türme mit ihren 110 Stockwerken wurden von Minoru Yamasaki entworfen und 1972/73 fertiggestellt. Durch das World Trade Center wirkte die Skyline von New York zwar noch spektakulärer, aber aus nächster Nähe und von innen waren die Türme viel zu funktional, um den New Yorkern ans Herz zu wachsen, 1979.

Les Twin Towers et une mouette. Ces tours de 110 niveaux chacune avaient été conçues par l'architecte Minoru Yamasaki et achevées en 1972/73. Le World Trade Center avait rendu le panorama new-yorkais encore plus spectaculaire, mais le fonctionnalisme extrême de ces gratte-ciel ne provoqua guère d'affection parmi les habitants, 1979.

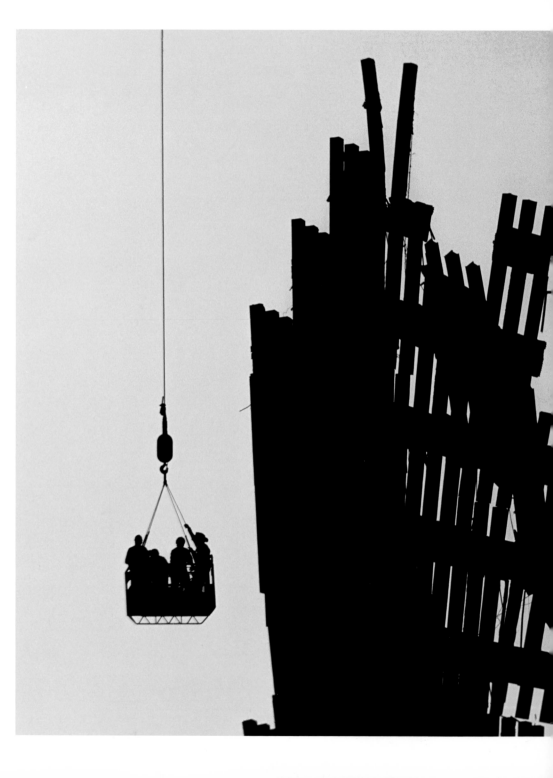

SEPTEMBER 12

NAN GOLDIN (1953)

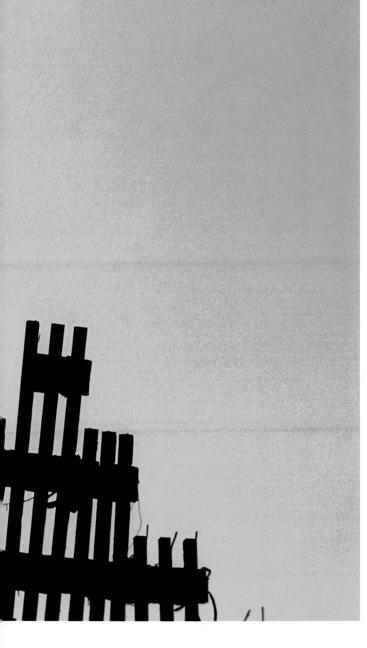

Ron Haviv

Ground Zero. Workers taking down the remains of the World Trade Center on September 19. The rescue and recovery efforts continued for days after the attacks, while the cleanup of Ground Zero took 18 months, 2001.

Ground Zero. Arbeiter reißen am 19. September die Überbleibsel des World Trade Center ab. Die Hilfs- und Rettungsarbeiten nach den Anschlägen dauerten mehrere Tage, die Aufräumarbeiten am Ground Zero 18 Monate, 2001.

Ground Zero. Le 19 septembre, des ouvriers démolissent ce qui reste du World Trade Center. Les opérations de secours et de recherche continuèrent pendant des jours. Le nettoyage du site de Ground Zero dura dix-huit mois, 2001.

"Glass Walled Skyscraper"

ENGINEERING NEWS, RECORD ON LEVER HOUSE, 1952

Julius Shulman

Lever House, a landmark modernist building, was on Park Avenue. Photographed from under the Seagram Building, 1959.

Das Lever House an der Park Avenue, ein markantes Bauwerk der klassischen Moderne, fotografiert von unterhalb des Seagram Building, 1959.

Lever House, un immeuble moderniste historique sur Park Avenue, pris de sous le Seagram Building, 1959.

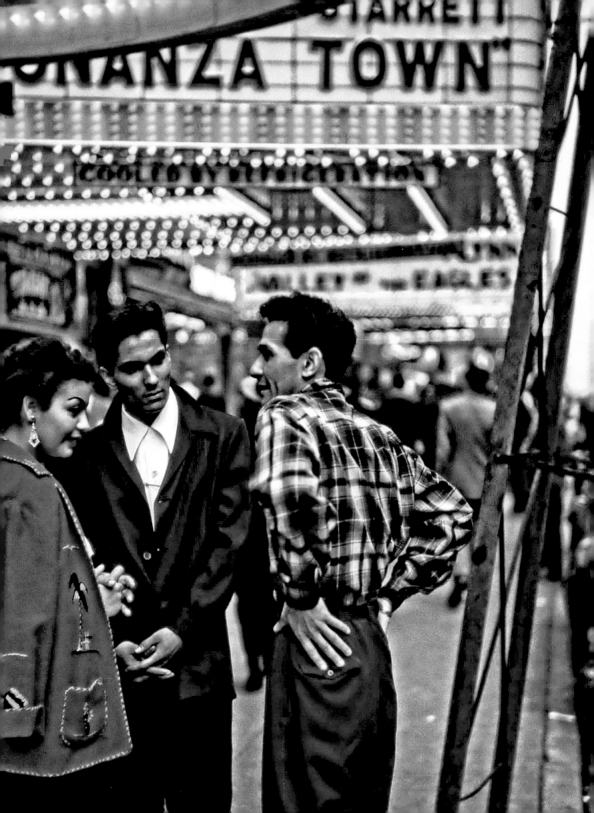

"He talked about the city, what life was like, what the chances were of getting a job."

PUERTO RICAN ARRIVAL IN NEW YORK: NARRATIVES OF THE MIGRATION, 1920–1950, JUAN FLORES, 2005

Ruth Orkin

After World War II, there was a large influx of Puerto Ricans to New York. They settled uptown, in areas such as East Harlem and Washington Heights. Latino culture became an important and vibrant component of the city, early 1950s.

Nach dem Zweiten Weltkrieg wurde New York von Puerto Ricanern überflutet, die sich in East Harlem und Washington Heights in Uptown niederließen. Die Latinokultur war schon bald ein wichtiges und lebendiges Merkmal der Stadt, Anfang der 1950er-Jahre.

Après la Seconde Guerre mondiale, de nombreux Portoricains affluèrent à New York. Ils s'installèrent dans des quartiers comme East Harlem et Washington Heights. La culture latino devint une composante importante et dynamisante de la ville, début des années 1950.

OLIVER STONE (1946)

Ellen von Unwerth

Subway Fashion, 1994.

Mode in der U-Bahn, 1994.

Mode dans le métro, 1994.

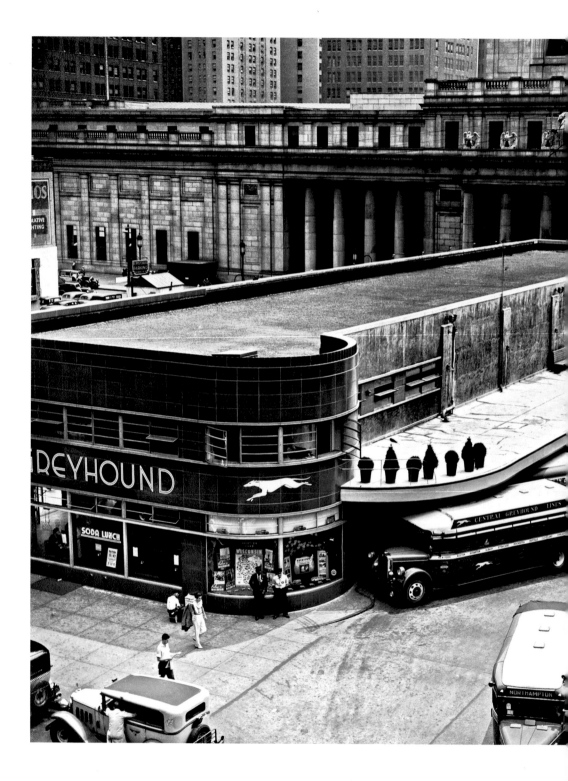

LAUREN BACALL (1924)
PETER FALK (1927)

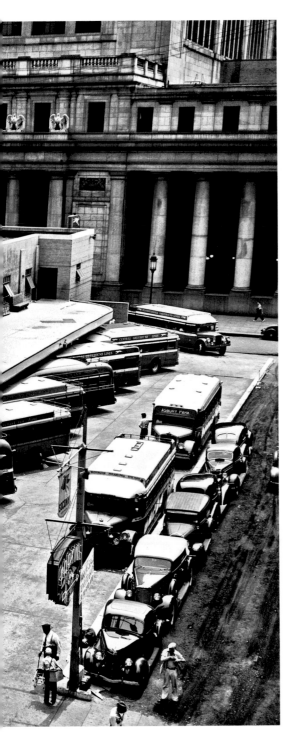

Berenice Abbott

The Greyhound Terminal was on 34th Street, just across from Pennsylvania Station, which can be seen at the back of the photograph. At the time, bus travel was seen as a glamorous alternative to the railroad, 1936.

Das Greyhound Terminal befand sich auf der 34th Street, gegenüber der Pennsylvania Station, die hinten auf dem Foto zu sehen ist. Zu dieser Zeit galt das Busfahren als glamouröse Alternative zur Bahnreise, 1936.

Le terminal des autobus Greyhound se trouvait sur la 34e Rue, juste en face de Pennsylvania Station, que l'on aperçoit à l'arrière. À l'époque les voyages en bus étaient une alternative «glamour» au train, 1936.

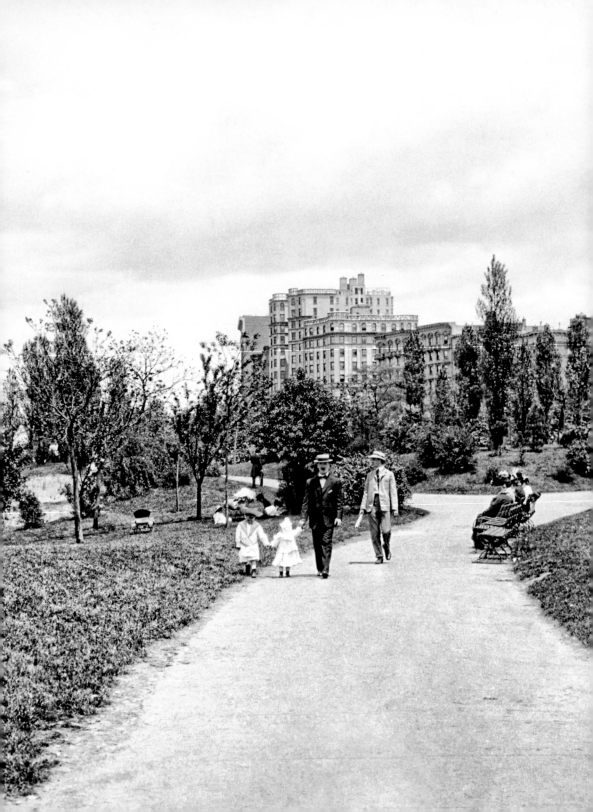

"Advocates suggested that a park would be a less repressive means of reforming the character of the city's working classes."

THE PARK AND THE PEOPLE: A HISTORY OF CENTRAL PARK, ROY ROSENWEIG AND ELIZABETH BLACKMOR, 1998

Frank M. Ingalls

A father takes his children out for a stroll in Central Park, c. 1905.

Ein Vater geht mit seinen Kindern im Central Park spazieren, um 1905.

Un père emmène ses enfants en promenade à Central Park, vers 1905.

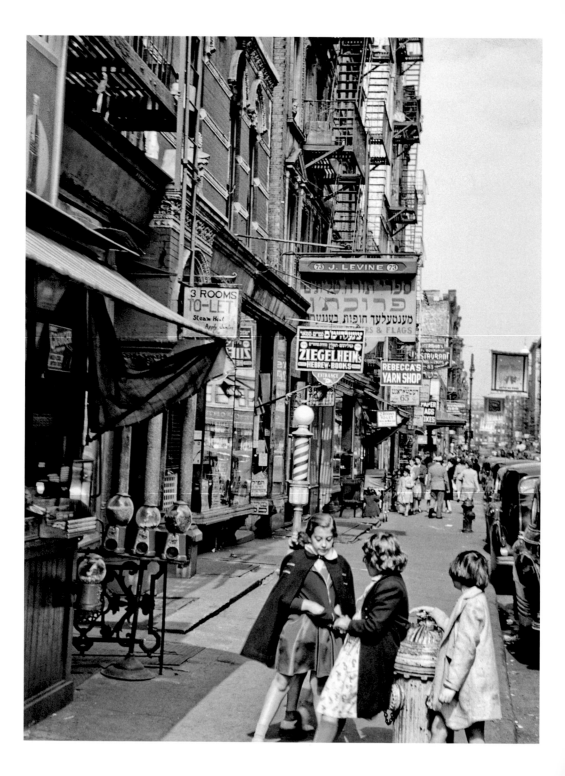

"Autumn in New York
Why does it seem so inviting?
Autumn in New York
It spells the thrill of first-nighting
Glittering crowds and shimmering clouds
In canyons of steel
They're making me feel I'm home."

"AUTUMN IN NEW YORK," *THUMBS UP!*, 1934

Charles Cushman

Lower East Side, 1942.

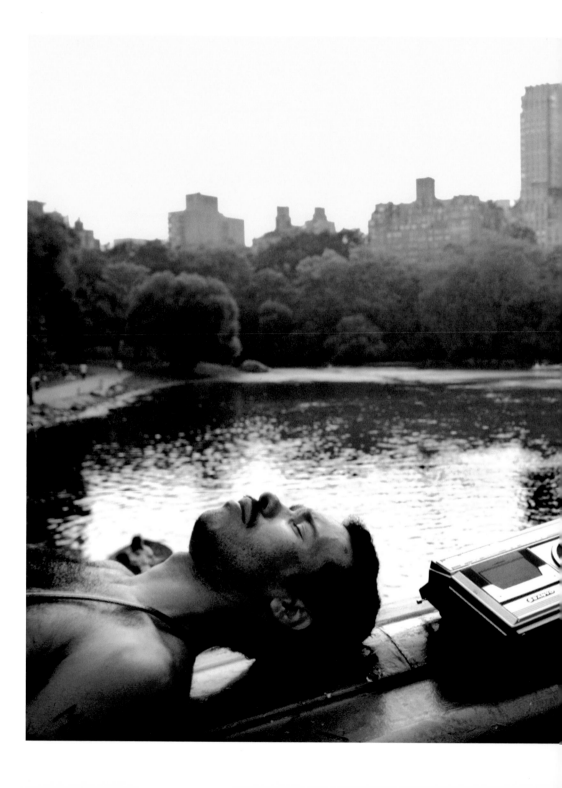

Ferdinando Scianna

Central Park. The park has always
provided respite from the stresses and
turbulence of city life, 1985.

Central Park. Der Park war immer schon
eine Oase der Ruhe inmitten der stressi-
gen, turbulenten Großstadt, 1985.

Central Park. Le parc a toujours été
un lieu où échapper aux tensions et
turbulences de la vie urbaine, 1985.

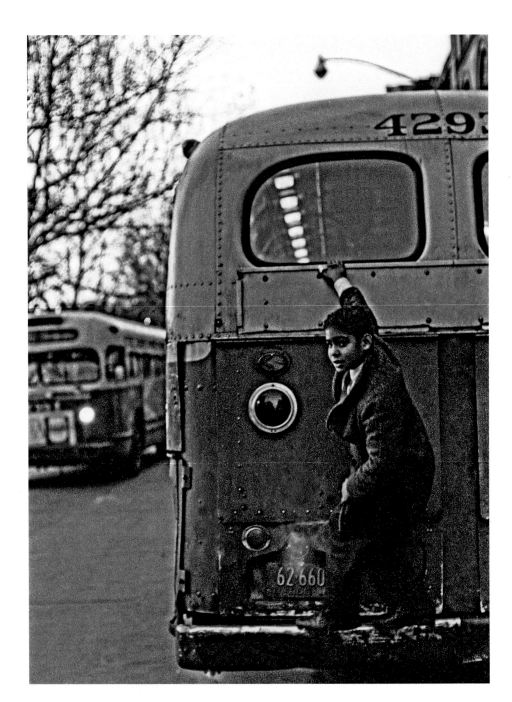

"It comes down to reality
And it's fine with me 'cause I've let it slide
Don't care if it's Chinatown or on Riverside
I don't have any reasons
I've left them all behind
I'm in a New York state of mind."

"NEW YORK STATE OF MIND," BILLY JOEL, 1976

Larry Fink

Free ride along 8ᵗʰ Street, 1965.

Kostenlose Fahrt entlang der
8th Street, 1965.

Trajet gratuit sur la 8ᵉ Rue, 1965.

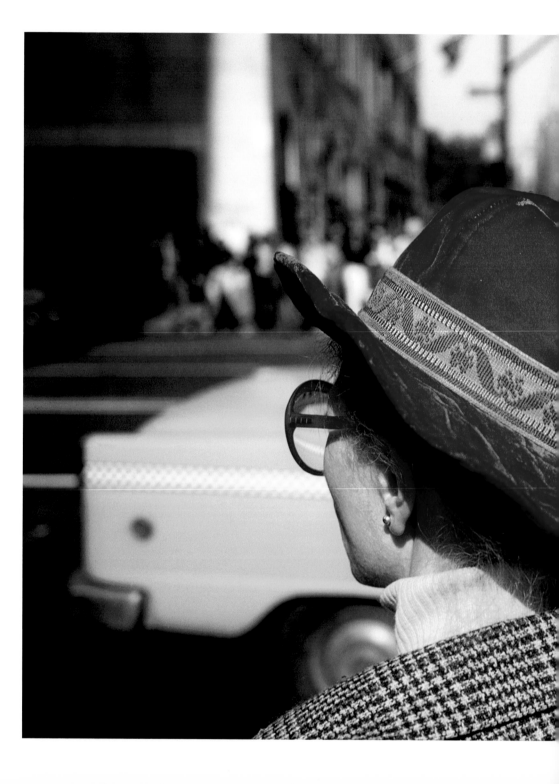

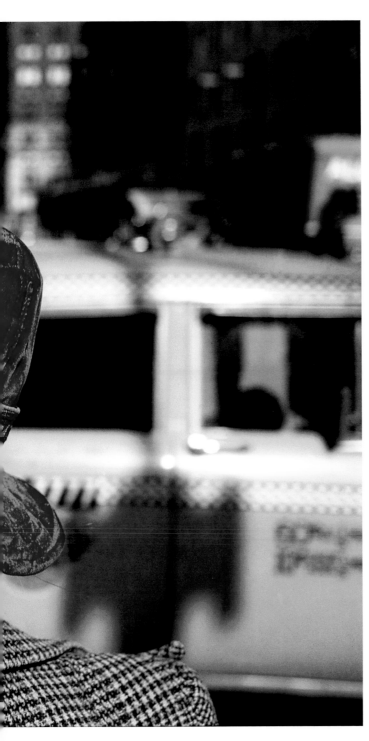

Joel Meyerowitz

A woman in a red hat on
Fifth Avenue, 1974.

Frau mit rotem Hut auf der
Fifth Avenue, 1974.

Femme au chapeau rouge sur la
Cinquième Avenue, 1974.

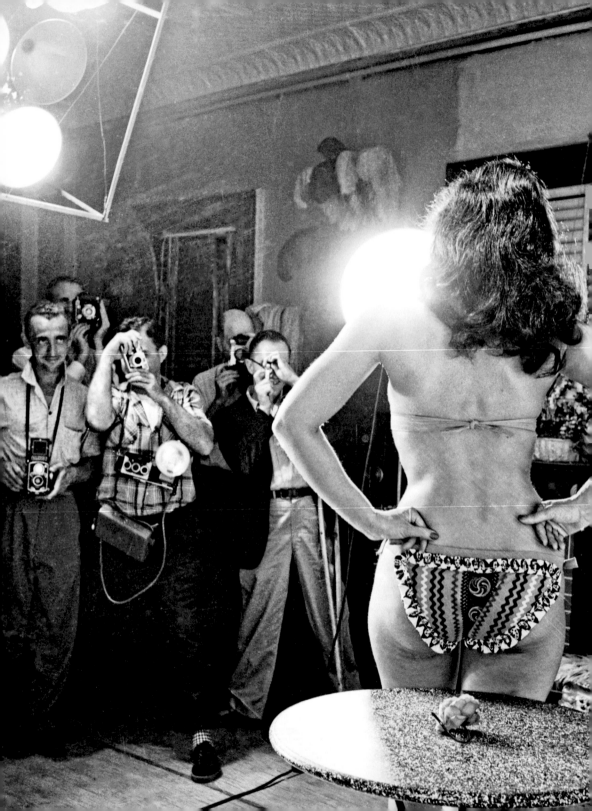

*"Bettie Page is the Queen of Pin-ups.
The model of the century, yet she
remains one of its best kept secrets."*

PLAYBOY MAGAZINE, 1955

Weegee

"Queen of the Pin-ups" Bettie Page photographed at a camera club. At camera clubs, keen amateur photographers could explore their artistic side with like-minded souls. These clubs were also a way of getting around legal restrictions on the taking and production of nude photos. Page was known for her trademark jet-black hair and willingness to cater to a variety of tastes, including bondage, c. 1955.

Die „Königin der Pin-ups", Bettie Page, wird in einem Camera Club fotografiert. In Camera Clubs konnten ambitionierte Amateurfotografen zusammen mit Gleichgesinnten ihre künstlerischen Ideen umsetzen. Außerdem war es so möglich, auf legale Weise die gesetzlichen Restriktionen für Aktfotografie zu umgehen. Page war für ihr pechschwarzes Haar und ihre Bereitschaft bekannt, für jeden Geschmack etwas anzubieten, zum Beispiel auch Bondage, um 1955.

La «Reine des pinup», Bettie Page, posant pour un club de photographes. Dans ces clubs, les photographes amateurs pouvaient mettre en pratique leurs penchants artistiques au milieu de confrères de mêmes aspirations. C'était aussi une façon de détourner une réglementation stricte sur la prise de vue et la production de photos de nus. Page était célèbre pour sa chevelure noire de jais et sa disponibilité à toutes sortes de pratiques, y compris le bondage, vers 1955.

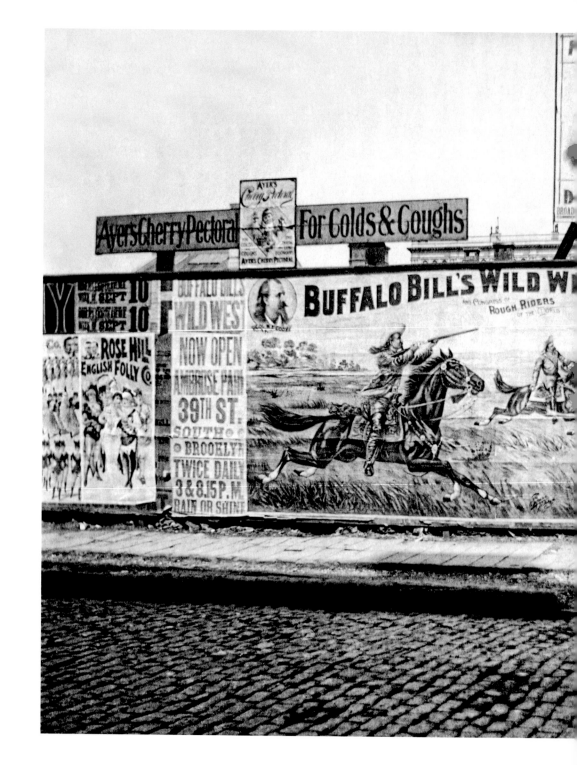

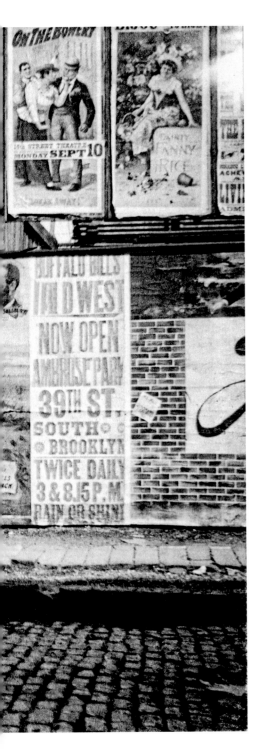

Charles Gilbert Hine

Wall posters advertising the latest must-see shows and cough remedies, 1894.

Wandplakate mit Werbung für die neuesten Shows, die man gesehen haben musste, und für Medikamente gegen Husten, 1894.

Affiches murales annonçant les derniers spectacles, et des médicaments contre la toux, 1894.

F. SCOTT FITZGERALD (1896)
LINDA McCARTNEY (1941)

Elliott Landy

Ornette Coleman and son. Coleman is
a multitalented jazz instrumentalist who
was at the forefront of the 1960s "free
jazz" movement, 1969.

Ornette Coleman und sein Sohn.
Coleman ist ein Jazzmusiker mit vielen
Talenten, der an vorderster Front
der Free-Jazz-Bewegung der 1960er-
Jahre stand, 1969.

Ornette Coleman et son fils. Coleman,
jazzman aux multiples talents, était à
l'avant-garde du mouvement du «free
jazz» dans les années 1960, 1969.

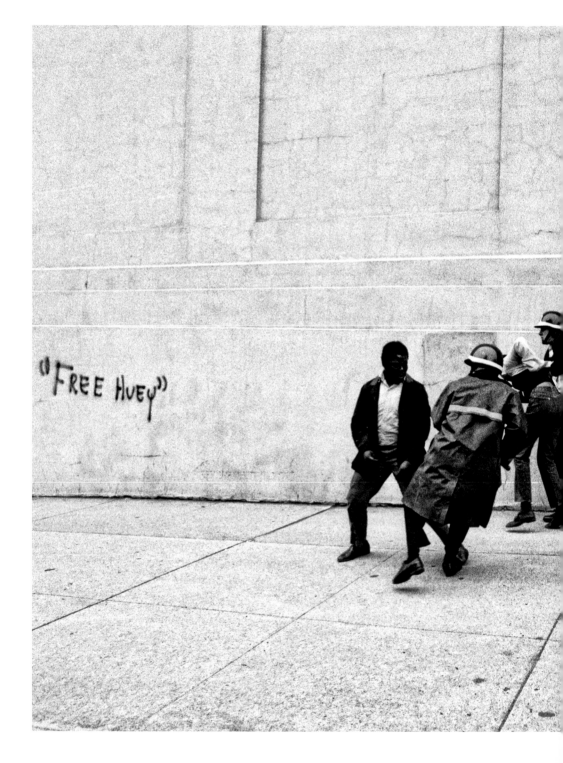

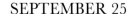

SEPTEMBER 25

Anonymous

Policeman and student clashing. New York also experienced student riots, both at Columbia University and City College. The graffiti in the background, "Free Huey," refers to the incarcerated leader of the Black Panther Party, Huey P. Newton, 1968.

Zusammenprall eines Polizisten mit einem Studenten. Auch in New York gab es Studentenunruhen, und zwar an der Columbia University und am City College. Die Wandkritzelei „Free Huey" im Hintergrund bezieht sich auf den inhaftierten Anführer der Black Panther Party, Huey P. Newton, 1968.

Affrontement entre un policier et un étudiant. New York connut également des soulèvements étudiants à l'université Columbia et au City College. Le graffiti sur le mur «Free Huey» (Libérez Huey) se réfère au leader du Black Panther Party emprisonné, Huey P. Newton, 1968.

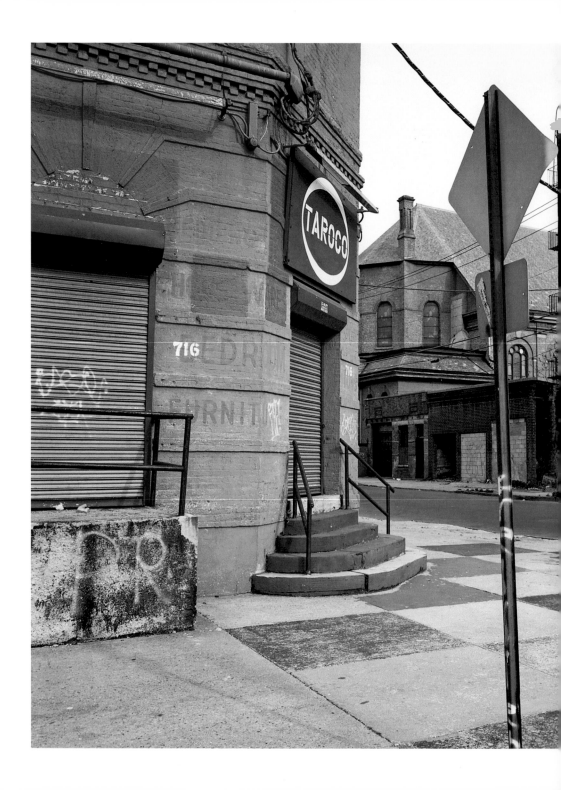

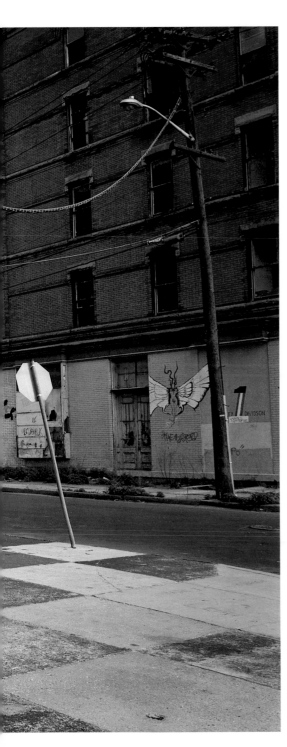

GEORGE GERSHWIN (1898)

Jerry Shore

Red-cornered building with checkered
sidewalk, mid-1980s.

Gebäude mit roter Ecke und Schach-
brett-Bürgersteig, Mitte der 1980er-
Jahre.

Immeuble d'angle rouge et trottoir en
damier, milieu des années 1980.

ED SULLIVAN (1901)

Jeff Jacobson

A tourist documenting one of the world's most famous landmarks. The Staten Island ferry, which leaves from Battery Park, passes the Statue of Liberty and it's a free ride, 2004.

Ein Tourist dokumentiert eines der berühmtesten Wahrzeichen der Welt. Die kostenlose Fähre nach Staten Island, die am Battery Park ablegt, fährt an der Freiheitsstatue vorbei, 2004.

Un touriste photographie l'un des monuments les plus photographiés au monde. Le ferry de Staten Island, qui part de Battery Park, passe devant la Statue de la Liberté. Et c'est gratuit, 2004.

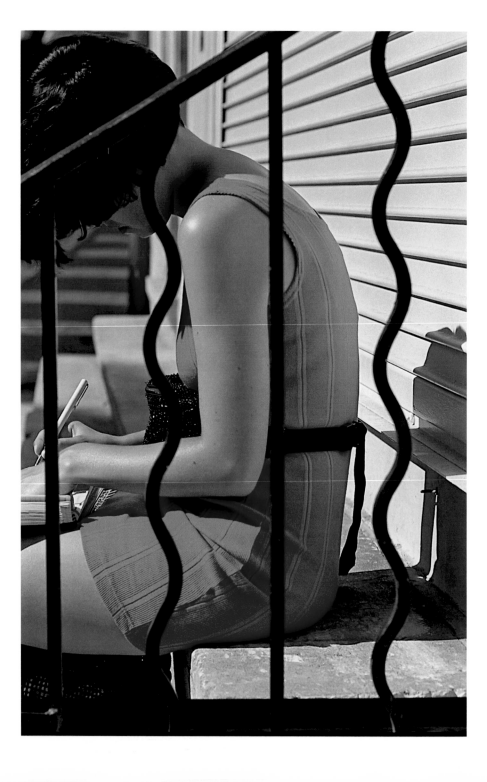

"It's about sex, love, relationships, careers, a time in your life when everything's possible. And it's about friendship because when you're single and in the city, your friends are your family."

DAVID CRANE AND MARTA KAUFMAN, PITCH FOR *FRIENDS*, 1992

Ralph Gibson

A woman in a red dress, 2001.

Frau in rotem Kleid, 2001.

Femme en robe rouge, 2001.

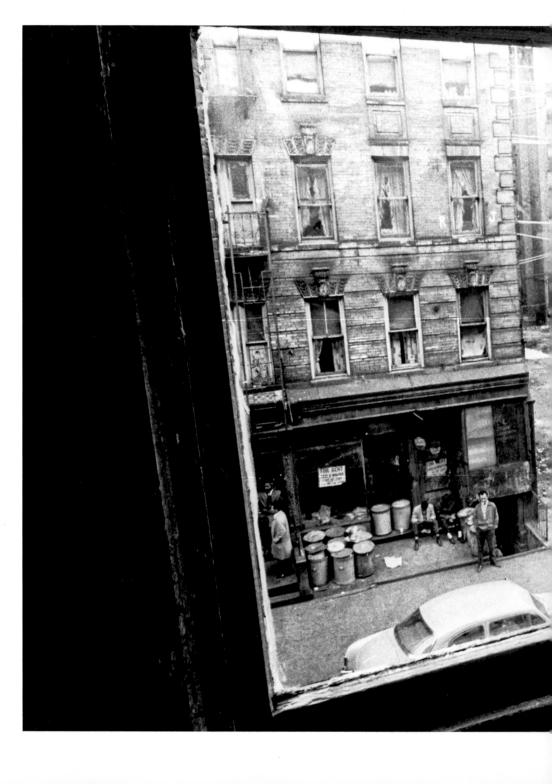

Steve Schapiro

A woman watching the action on the street from her tenement building in East Harlem. East Harlem, also known as El Barrio and Spanish Harlem, is home to large numbers of Puerto Ricans, who mainly settled there after World War II, 1960.

Eine Frau verfolgt vom Fenster ihrer Mietswohnung in East Harlem das Treiben auf der Straße. In East Harlem, das auch El Barrio oder Spanish Harlem genannt wird, leben viele Puerto Ricaner, die sich dort meist nach dem Zweiten Weltkrieg ansiedelten, 1960.

Une femme observe le spectacle de la rue de son appartement de location dans l'East Harlem. Ce quartier, également appelé « El Barrio » ou « Spanish Harlem », accueillit un très grand nombre de Portoricains après la Seconde Guerre mondiale, 1960.

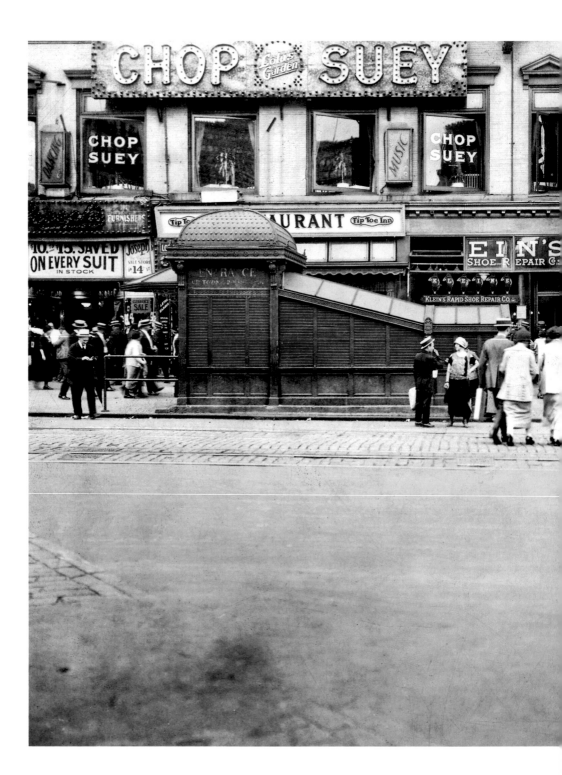

TRUMAN CAPOTE (1924)
FRAN DRESCHER (1957)

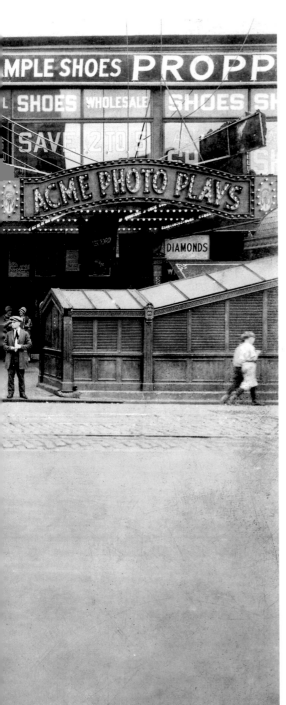

Anonymous

Just outside the subway entrance
on Union Square, 1939.

Vor dem Eingang zur U-Bahn am
Union Square, 1939.

Devant l'entrée du métro à
Union Square, 1939.

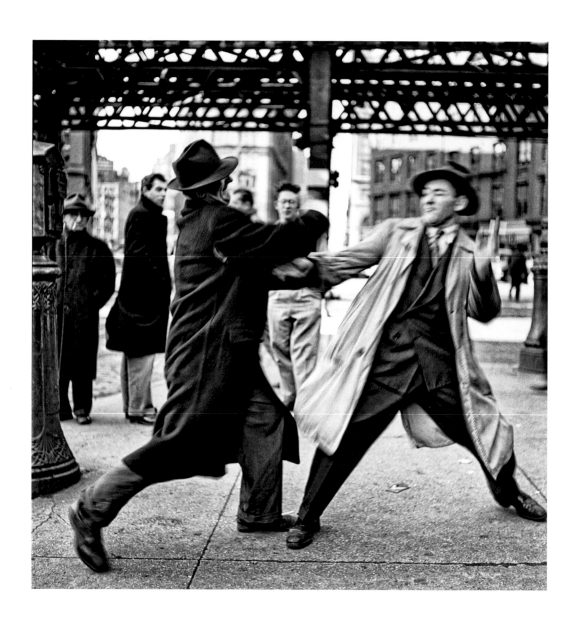

"I want to impress upon you men now, of the terrific responsibility that you have in this ring tonight."

**REFEREE TO JOE LOUIS AND MAX SCHMELING
MOMENTS BEFORE THEIR REMATCH, 2005**

Elliott Erwitt

A street fight New York-style,
reasons unknown, 1950.

Eine Straßenschlägerei à la New York
aus unbekannten Gründen, 1950.

Bagarre de rue, style New York.
Motif inconnu, 1950.

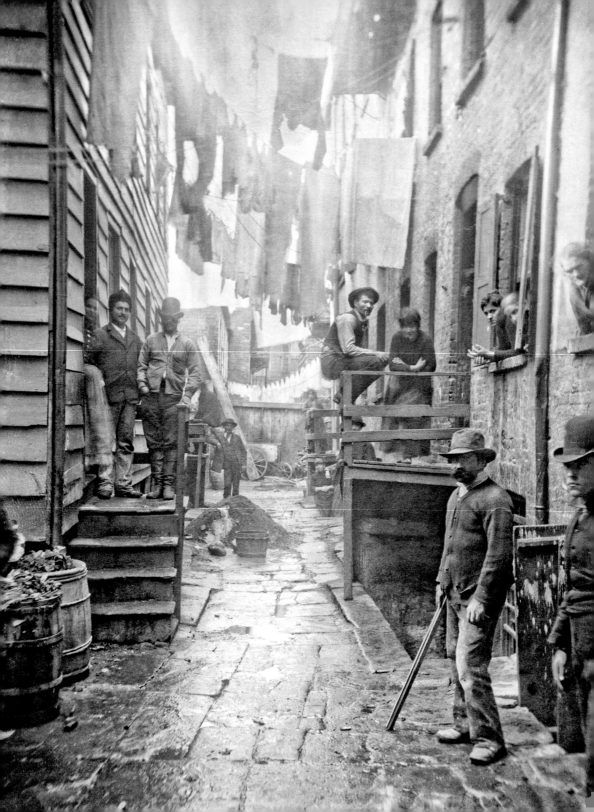

JULIUS HENRY "GROUCHO" MARX (1890)
DONNA KARAN (1948)
ANNIE LEIBOVITZ (1949)

*"The nursery where every species of
vice is conceived and matured; that
it is infested by a class of the most
abandoned and desperate character."*

BOARD OF ASSISTANT ALDERMEN ABOUT FIVE POINTS, 1831

Jacob Riis

Bandit's Roost. Taken on Mulberry Street, these menacing-looking men are supposedly a vicious gang that terrorized Five Points. The blowing laundry, suggesting domestic routine, is somewhat incongruous, c. 1888.

Bandit's Roost (Banditennest). Diese auf der Mulberry Street fotografierten, bedrohlich aussehenden Männer gehörten angeblich zu einer brutalen Bande, die in Five Points ihr Unwesen trieb. Die zum Trocknen aufgehängte Wäsche, die eine gewisse tägliche Routine andeutet, steht etwas im Widerspruch zum Hauptmotiv, um 1888.

Bandit's Roost (Repaire de bandits). Pris dans Mulberry Street, ces hommes d'aspect menaçant appartiendraient à l'un de ces gangs qui terrorisaient Five Points. Le linge suspendu, qui suggère une vie domestique banale, semble presque incongru, vers 1888.

"We will not allow premises to be used for prostitutes or high-risk sexual activites."

MAYOR ED KOCH, 1985

Allan Tannenbaum

The coat-check girl at Plato's Retreat. Located on the Upper West Side in the late 1970s, it was one of the world's most notorious swingers club. Along with Studio 54, it came to represent New York's no-holds-barred hedonism in the 1970s, 1978.

Garderobenfrau im Plato's Retreat, einem Swingerclub auf der Upper West Side, der Ende der 1970er-Jahre einer der berüchtigtsten der Welt war. Neben dem Studio 54 stand er für den grenzenlosen New Yorker Hedonismus der 1970er-Jahre, 1978.

La fille du vestiaire au Plato's Retreat. Situé dans l'Upper West Side, ce fut l'un des plus célèbres clubs du monde pour branchés de la fin des années 1970. Avec le Studio 54, ils symbolisaient l'hédonisme débridé du New York des années 1970, 1978.

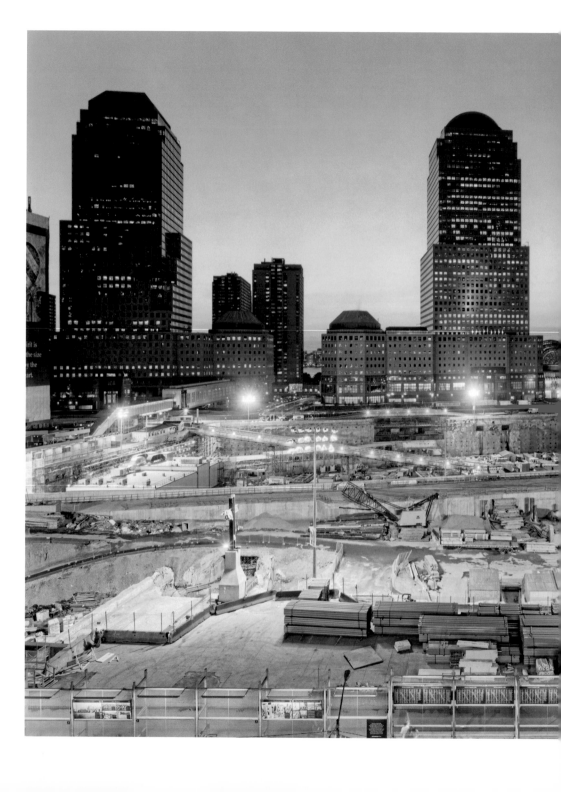

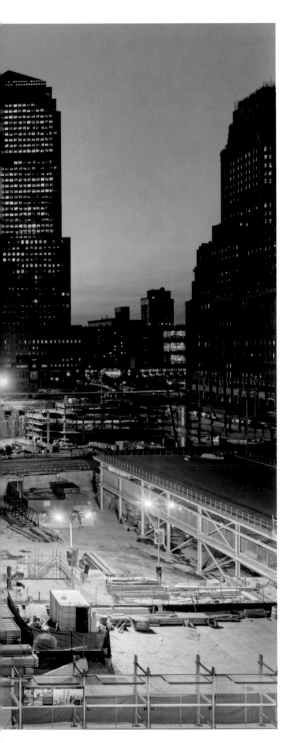

Ferit Kuyas

Ground Zero. Photographed from the roof of the department store Century 21. Ground Zero is now one of the must-see tourist sites in New York, 2003.

Ground Zero, fotografiert vom Dach des Kaufhauses Century 21. Ground Zero ist heute eine der wichtigsten Sehenswürdig-keiten von New York, 2003.

Ground Zero photographié du toit du grand magasin Century 21. Ground Zero est devenu l'un des sites touristiques incontournables de New York. 2003.

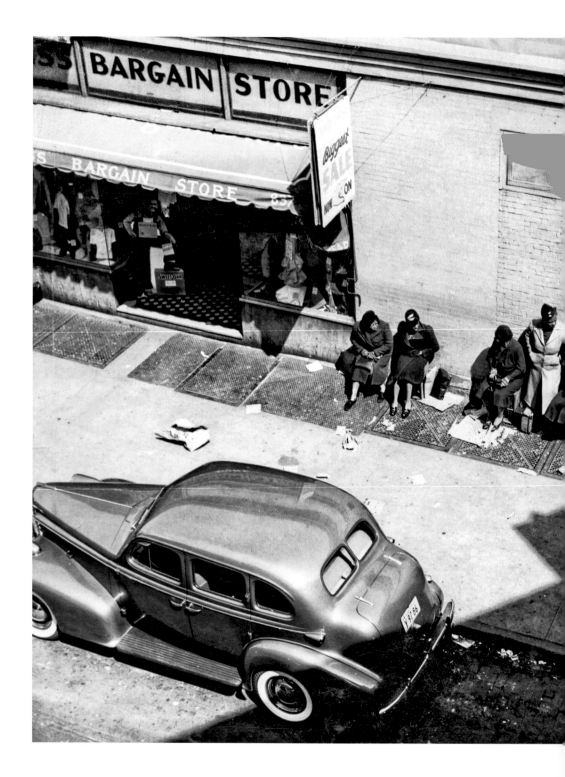

Aubury Pollard

Unemployed women waiting to
be hired, 1939.

Arbeitslose Frauen, die auf eine
Anstellung warten, 1939.

Femmes au chômage attendant
un emploi, 1939.

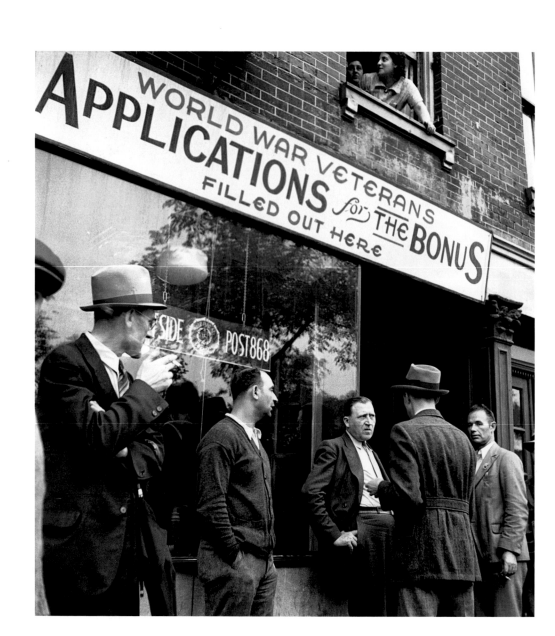

"Don't push me, 'cause I'm close to the edge
I'm trying not to lose my head
It's like a jungle sometimes, it makes me wonder
How I keep from going under."

"THE MESSAGE," GRANDMASTER FLASH, 1982

Dorothea Lange

Some kind of altercation seems to be taking place outside a post office, 1936.

Hier scheint es sich um eine Art Streitgespräch vor einer Postfiliale zu handeln, 1936.

On a l'impression d'une dispute devant un bureau de poste, 1936.

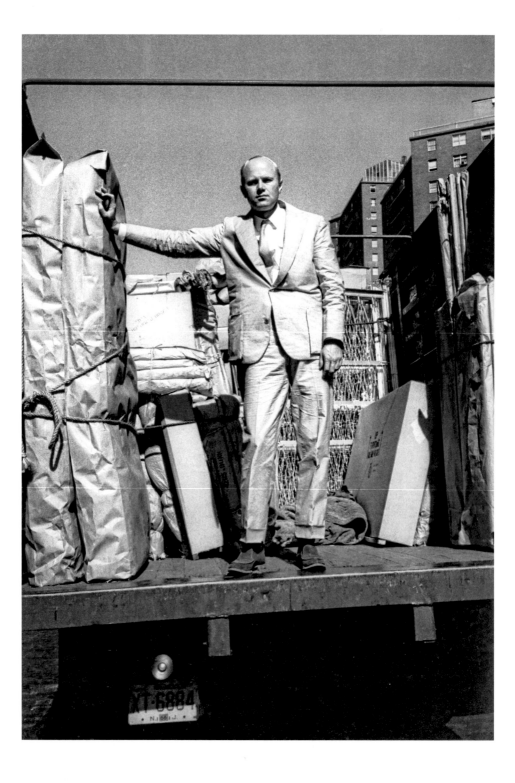

'A hustle here and a hustle there
New York City is the place where they said
Hey, babe, take a walk on the wild side
I said, hey Joe, take a walk on the wild side.'

"WALK ON THE WILD SIDE," LOU REED, 1972

Steve Schapiro

The Pop artist James Rosenquist in a paper suit, photographed on the back of a truck with some of his creations, 1966.

Der Pop-Art-Künstler James Rosenquist in einem Papieranzug, fotografiert auf der Ladefläche eines LKW mit einigen seiner Werke, 1966.

L'artiste pop James Rosenquist en costume de papier, photographié à l'arrière d'un camion, au milieu de quelques-unes de ses créations, 1966.

Lisette Model

Gallagher's People. These gentlemen are dining at Gallagher's, one of New York's most famous steak houses. It's been in business since 1927, and started out as a speakeasy during Prohibition, 1945.

Gallagher's Gäste. Diese Herren essen im Gallagher's, einem der berühmtesten Steakhäuser der Stadt, zu Abend. Das Restaurant wurde 1927 während der Prohibition als „speakeasy" eröffnet, 1945.

Chez Gallagher's. Des gentlemen se restaurent chez Gallagher's, l'un des plus célèbres grills de New York. Ouvert en 1927, le restaurant était un «speakeasy» pendant la Prohibition, 1945.

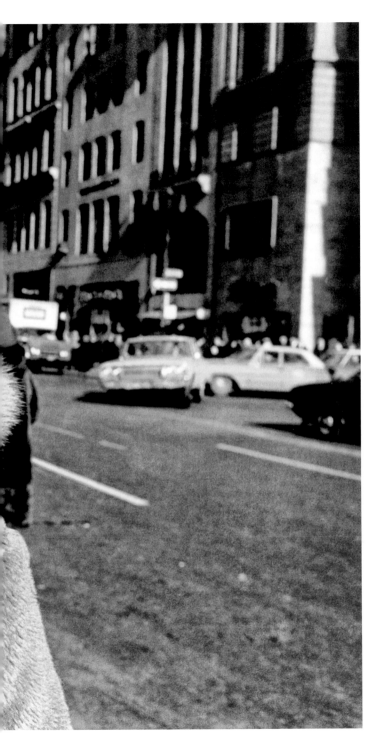

Lee Friedlander

An unusual self-portrait taken on the streets of New York City, 1966.

Ein ungewöhnliches Selbstporträt, aufgenommen auf den Straßen von New York City, 1966.

Autoportait inhabituel pris dans les rues de New York, 1966.

Patrick McMullan

Hosiery, c. 1980.

Strümpfe, um 1980.

Lingerie fine, vers 1980.

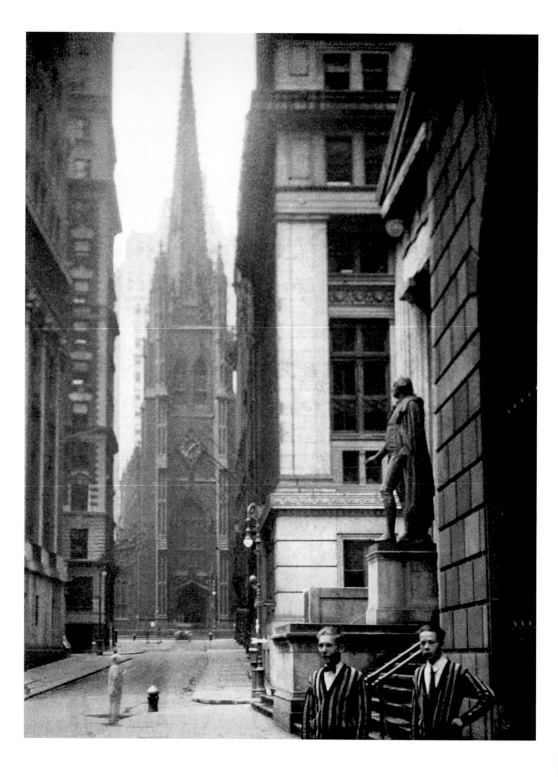

ELEANOR ROOSEVELT (1884)
JEROME ROBBINS (1918)

"Money itself isn't lost or made, it's simply transferred from one perception to another."

WALL STREET, 1987

Charles Zoller

Wall Street and Trinity Church. The church was constructed in the Gothic Revival style in 1830. The men in distinctive blazers in the foreground are Wall Street brokers, c. 1915.

Wall Street und Trinity Church. Die Kirche wurde 1830 im neogotischen Stil erbaut. Die Männer im Vordergrund in ihren typischen Jacketts sind Börsenmakler von der Wall Street, um 1915.

Wall Street et Trinity Church. L'église de style néogothique fut construite en 1830. Les hommes en blazers rayés sont des courtiers de Wall Street, vers 1915.

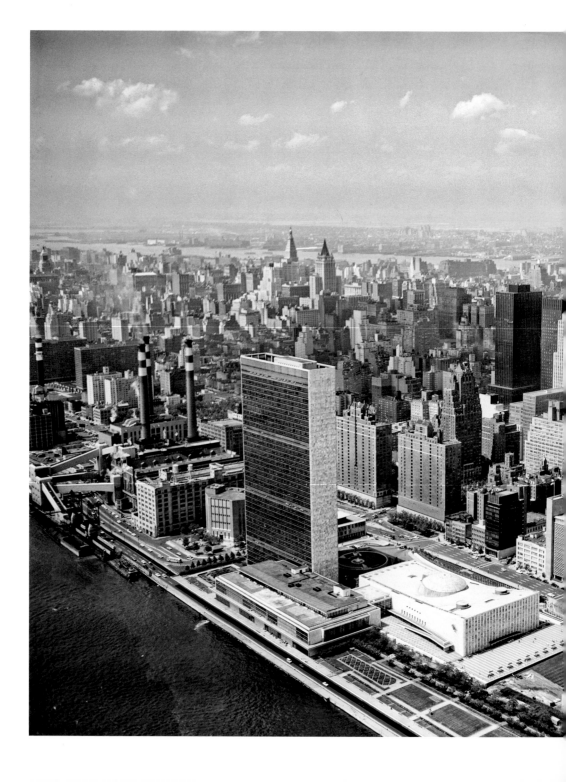

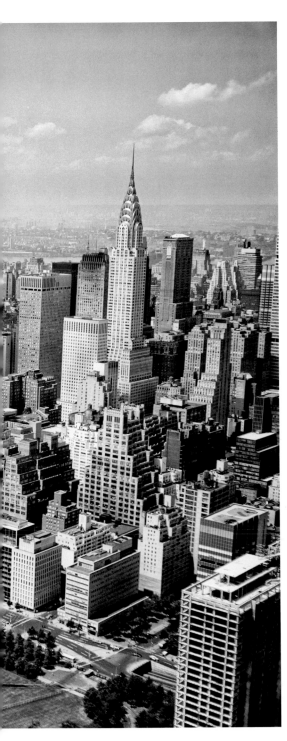

RICHARD MEIER (1934)

Anonymous

The U.N. Headquarters with the skyline
of Midtown Manhattan. The U.N.
complex is dominated by the Secretariat
Building, completed in 1952, mid-1950s.

Der UNO-Komplex mit der Skyline
von Midtown Manhattan. Der UNO-
Komplex wird vom Secretariat Building
überragt, das 1952 fertiggestellt wurde,
Mitte der 1950er-Jahre.

Le complexe des Nations Unies sur
le fond du panorama de Midtown.
L'ensemble est dominé par l'immeuble
du Secrétariat achevé en 1952, milieu
des années 1950.

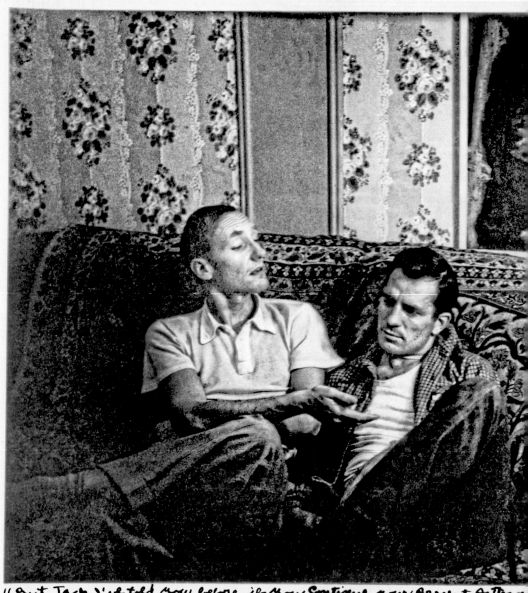

"But Jack I've told you before, if you continue your present pattern
closer round her apron-strings till you're an old man ..." William B.
yapping at the all-American serious Thomas Wolfean youth Jack
to "the most intelligent man in America" for a funny second in the
"Undoubtedly you realize this Buddhist 'Second Religiousness of the Fella
of the West may provoke high-teacup literary critics of the Future to mo
genius than your poor French-Canadian family heart can imagine, take i
September-october 1953.

Allen Ginsberg

William S. Burroughs and Jack Kerouac photographed in Ginsberg's East Village apartment in 1953. Both men were on the cusp of immortality: Kerouac had written the yet-to-be published *On the Road*, while Burroughs' *Naked Lunch* wasn't published until 1959.

William S. Burroughs und Jack Kerouac, fotografiert 1953 in Allen Ginsbergs Apartment im East Village. Beide Männer waren zu diesem Zeitpunkt nur eine Handbreit von der Unsterblichkeit entfernt: Kerouac hatte gerade *Unterwegs* geschrieben, dessen Veröffentlichung noch bevorstand und *Naked Lunch* von Burroughs erschien 1959.

William S. Burroughs et Jack Kerouac photographiés chez Ginsberg dans l'East Village en 1953. Les deux hommes étaient en attente de l'immortalité : Kerouac avait écrit, mais n'avait pas encore publié *Sur la route*, et le *Festin nu* de Burroughs ne fut publié qu'en 1959.

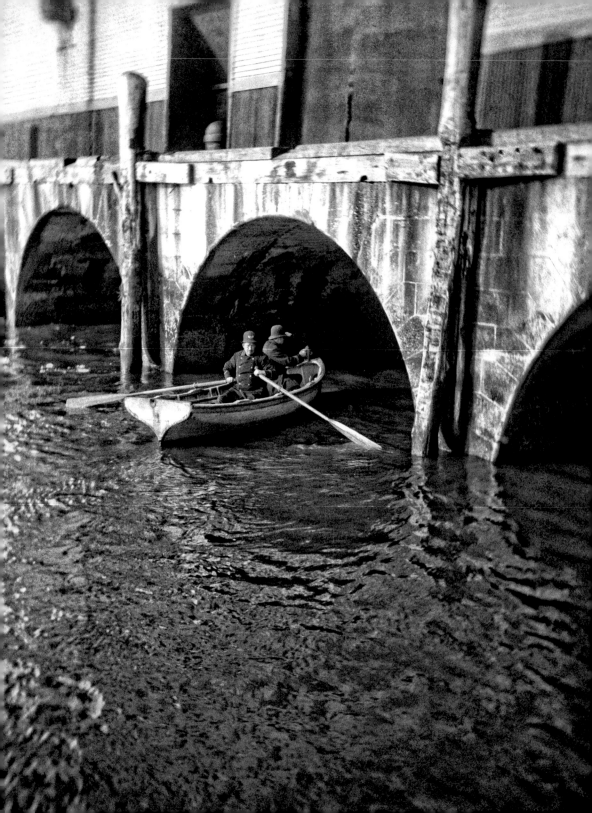

"Hideous tenements which take their name from robbery and murder: all that is loathsome, drooping, and decayed is here."

CHARLES DICKENS, 1842

Jacob Riis

Dock Rats Hunted by Police. This was the colloquial term for smugglers and pirates who traded in stolen or illegal goods around the New York docks, 1889.

Dock Rats, von der Polizei verfolgt. Dockratten war ein umgangssprachlicher Begriff für Schmuggler und Piraten, die in den Docks von New York mit gestohlenen oder illegalen Waren handelten, 1889.

« Dock Rats » chassés par la police. Les «dock rats» (rats des docks) était un terme d'argot désignant les contrebandiers et pirates spécialisés dans les biens volés ou illégaux sur les docks de New York, 1889.

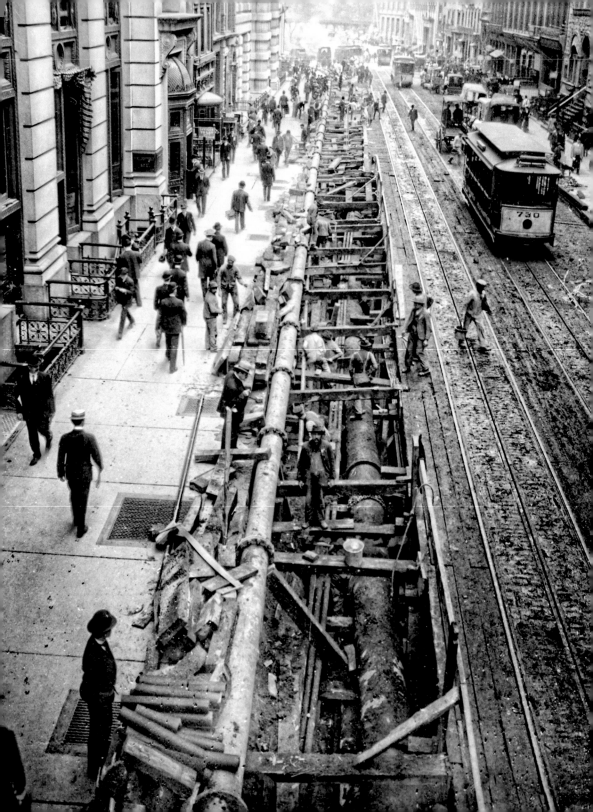

MARIO PUZO (1920)

"The completion of the rapid transit railroad in the boroughs of Manhattan and The Bronx, which is popularly known as the 'Subway,' has demonstrated that underground railroads can be built beneath the congested streets of the city."

INTERBOROUGH RAPID TRANSIT: THE NEW YORK SUBWAY, 1904

Anonymous

Exchange Place, Broadway. These men, predominately Irish and Italian, are building the subway using the "cut and cover" method. This required using mostly picks and shovels to dig out the outline of the subway line under the street. The next stage involved erecting a temporary wooden street surface as they dug below, then building the tunnel, and finally restoring the street above, 1904.

Exchange Place, Broadway. Diese Männer, überwiegend Iren und Italiener, bauen die U-Bahn in der „Cut and Cover"-Methode. Zunächst wurde entlang der U-Bahn-Trasse mit Hacke und Schaufel ein Graben ausgehoben. In der nächsten Phase wurde ein provisorischer Straßenbelag aus Holz konstruiert, während darunter weiter gegraben wurde. Nach dem Tunnelbau wurde die Straße darüber wiederhergestellt, 1904.

Exchange Place, Broadway. Des ouvriers, essentiellement irlandais et italiens, construisirent le métro selon la technique de la tranchée couverte. On utilisait principalement des pioches et des pelles pour creuser le passage de la ligne sous la rue. L'étape suivante consistait à ériger une couverture en bois provisoire qui protégeait les ouvriers continuant à creuser, avant de construire le tunnel et de reconstituer la chaussée, 1904.

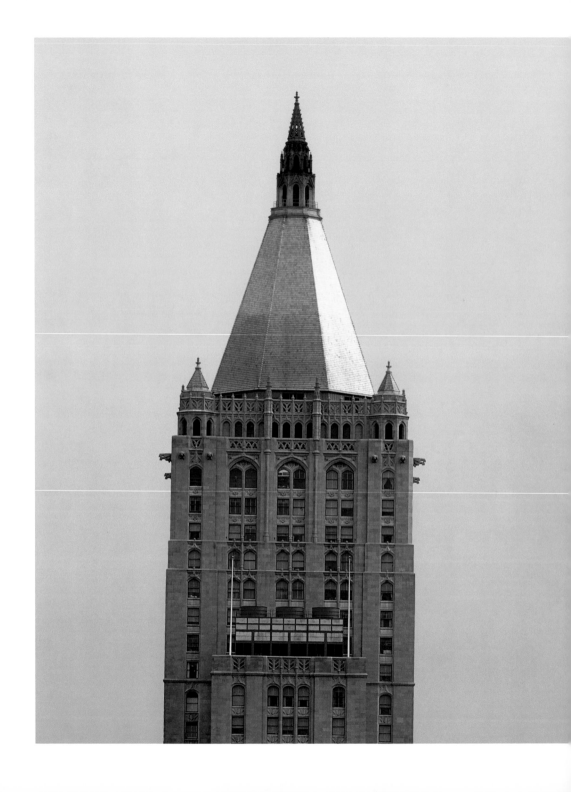

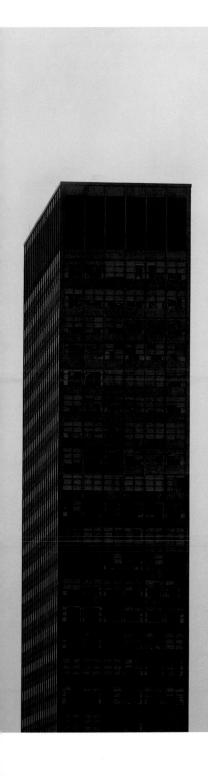

Reinhart Wolf

The New York Life Insurance Company
on 51 Madison Avenue, between 26th
and 27th Street, built in 1928 for New
York Life Insurance Company by Cass
Gilbert, c. 1980s.

Die New York Life Insurance Company,
51 Madison Avenue, zwischen 26th
und 27th Street, wurde 1928 von Cass
Gilbert für die Versicherung gebaut,
1980er-Jahre.

La New York Life Insurance Company,
51 Madison Avenue, entre la 26e et la
27e Rue, a été construit en 1928 pour
cette compagnie d'assurances par Cass
Gilbert, années 1980.

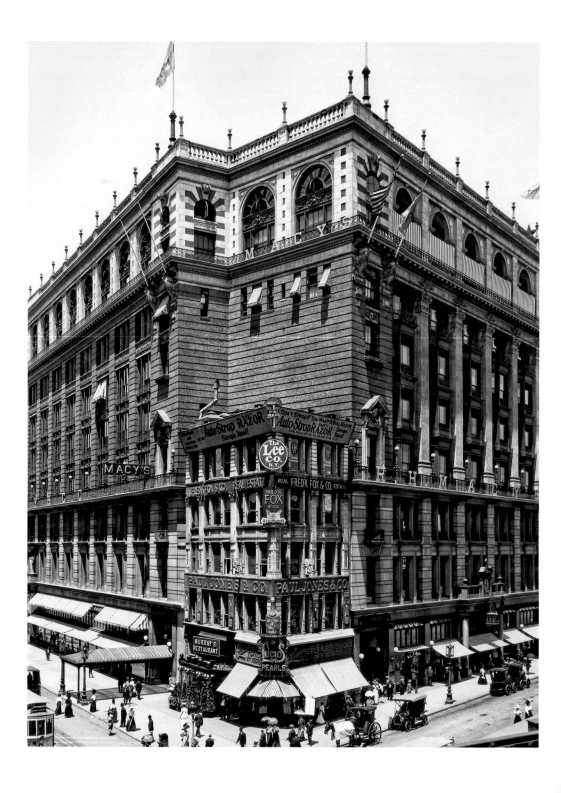

ARTHUR MILLER (1915)
RITA HAYWORTH (1918)

Fred Gailey: "Is it true that you're the owner of one of the biggest department stores in New York City?" Mr. R. H. Macey: "THE biggest!"

MIRACLE ON 34ᵀᴴ STREET, 1947

Anonymous

The world-famous department store Macy's was previously in the area known as "Ladies Mile," the chic shopping district that stretched from Ninth Street up to 23rd Street on Broadway. In 1902, the flagship store moved uptown, to Herald Square, on 34th Street and Broadway. It is still there today, but it now occupies a wide city block, 1908.

Das weltberühmte Kaufhaus Macy's. Es hatte zunächst seinen Sitz in einem Gebiet namens „Ladies Mile", dem eleganten Einkaufsviertel von der 9th bis zur 23rd Street am Broadway. 1902 wurde das Vorzeigekaufhaus weiter nach Norden an den Herald Square, 34th Street und Broadway, verlegt. Dort steht es immer noch, nimmt jedoch einen ganzen Häuserblock ein, 1908.

Célèbre dans le monde entier, le grand magasin Macy's se trouvait auparavant dans le quartier de shopping élégant surnommé «Ladies Mile» (le mile des dames) entre la 9ᵉ Rue et la 23ᵉ Rue à Broadway. En 1902, il s'installa sur Herald Square, sur la 34ᵉ Rue et Broadway. Il s'y trouve toujours, mais occupe aujourd'hui la totalité de son bloc, 1908.

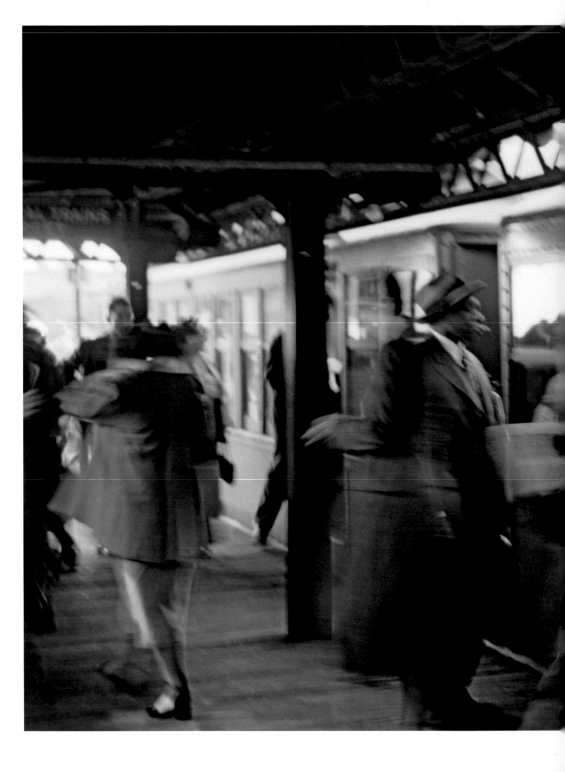

Esther Bubley

People getting on the Third Avenue elevated train (El) on the East Side of Manhattan, the last remaining above-ground track, which was eventually torn down in 1955, 1951.

Passagiere beim Einsteigen in die Third-Avenue-Hochbahn (El) auf der East Side von Manhattan. Dies war die letzte oberirdische Bahnlinie; sie wurde 1955 abgerissen, 1951.

Voyageurs montant à bord du train suspendu (El) de la Troisième Avenue dans l'East Side de Manhattan. Dernière ligne surélevée encore en service, elle fut démolie en 1955, 1951.

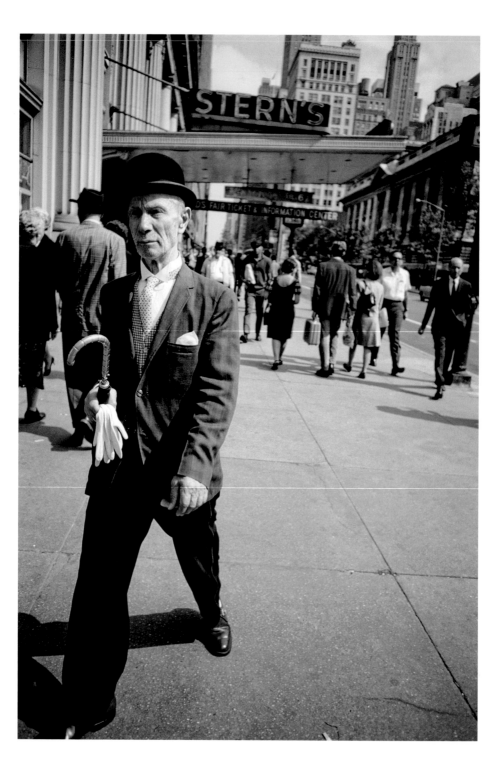

"I'm walking here!
I'm walking here!"

MIDNIGHT COWBOY, DUSTIN HOFFMAN, 1969

Joel Meyerowitz

The Swinging Sixties seem to be passing by this man, whose bowler hat and stance is from a much earlier time. The wide street and the facade of the New York Public Library, that just about hovers in view, would suggest that this was taken on 42nd Street, 1965.

Die Swinging Sixties scheinen spurlos an diesem Mann vorüberzugehen, dessen Melone und Haltung an eine längst vergangene Zeit erinnern. Die breite Straße und die Fassade der New York Public Library, die gerade noch sichtbar ist, lassen vermuten, dass die Aufnahme in der 42nd Street entstanden ist, 1965.

Les «Swinging Sixties» ne semblent guère avoir touché cet homme dont le chapeau melon et l'attitude renvoient à une époque bien antérieure. La largeur de la rue et la façade de la New York Public Library, à droite, suggèrent que la scène a été prise sur la 42e Rue, 1965.

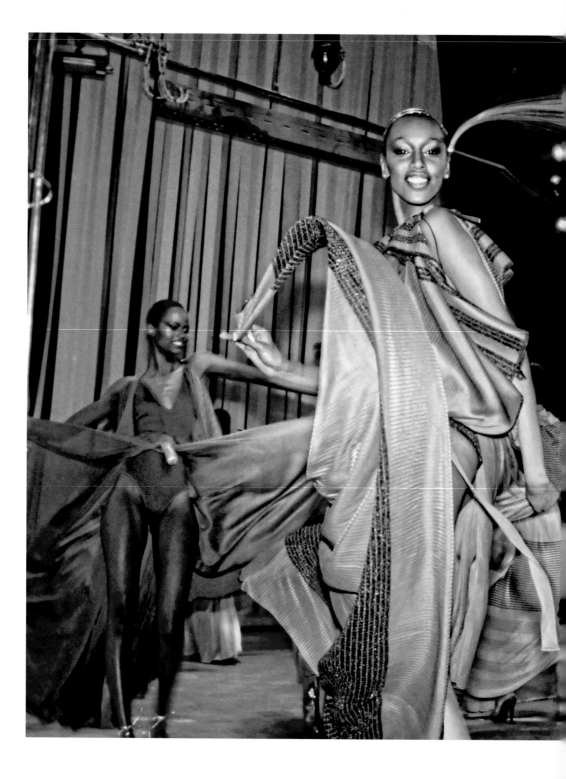

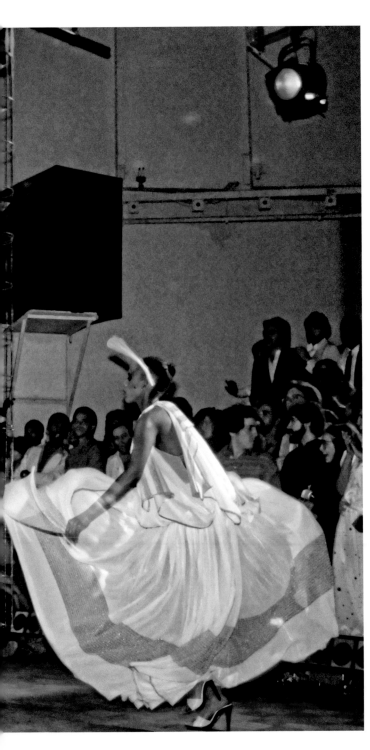

Allan Tannenbaum

A fashion show for Fiorucci at
Studio 54, 1978.

Eine Modenschau für Fiorucci
im Studio 54, 1978.

Défilé de mode Fiorucci au
Studio 54, 1978.

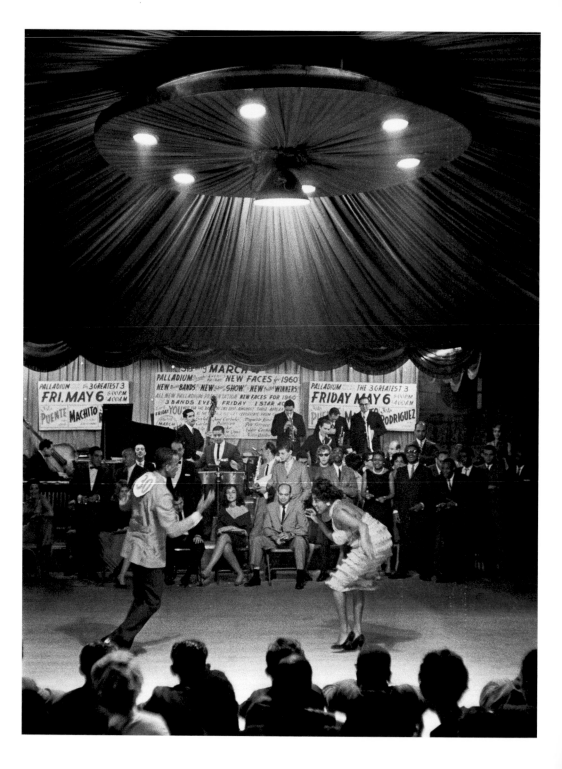

JOHN BIRKS "DIZZY" GILLESPIE (1917)

"Everything I'd ever heard about New York City was exciting—things like Broadway's bright lights and the Savoy Ballroom and the Apollo Theater in Harlem, where great bands played and famous songs and dance steps and Negro stars originated."

MALCOLM X

William Claxton

The Palladium Ballroom, 1960.

Der Palladium Ballroom, 1960.

Le Palladium Ballroom, 1960.

*"The streets of New York were
like pipes running, not with air
and light, but with melted dust."*

ATLAS SHRUGGED, AYN RAND, 1957

Drahomir Ruzicka

The magnificent facade of Pennsylvania Station, a suitable temple to the golden age of the railroad, 1920.

Die prachtvolle Fassade der Pennsylvania Station, ein angemessenes Symbol für die Blütezeit der Eisenbahn, 1920.

La magnifique façade de Pennsylvania Station, temple adéquat pour l'âge d'or du chemin de fer, 1920.

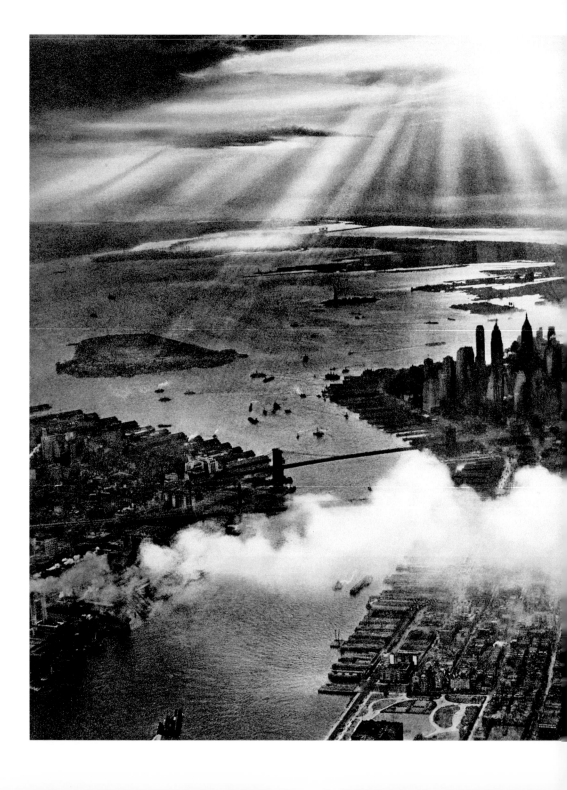

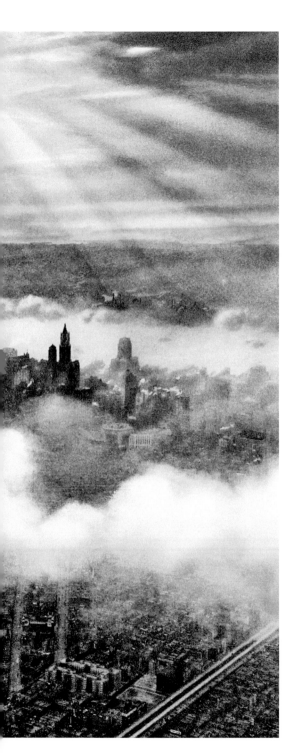

Anonymous

Sunset over the smog-filled
metropolis, c. 1934.

Sonnenuntergang über der in Rauch
gehüllten Großstadt, um 1934.

Coucher de soleil sur la métropole
embrumée, vers 1934.

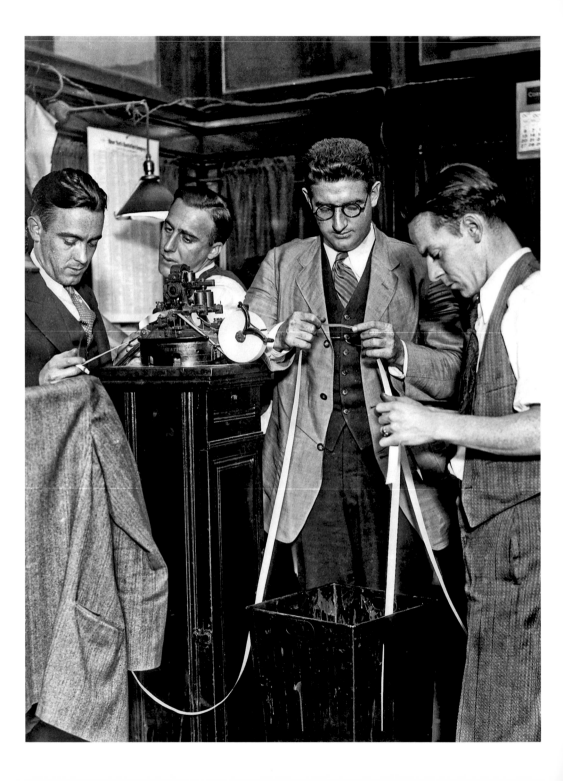

ZAC POSEN (1980)

"Wall St. Lays an Egg."

VARIETY MAGAZINE,1929

Anonymous

Wall Street employees at the New York Stock Exchange reading a ticker tape on "Black Thursday," October 24, 1929. The ticker recorded the day's transactions.

Angestellte der New Yorker Börse lesen am „Schwarzen Donnerstag", dem 24. Oktober 1929, Papierstreifen des Telegrafen. Darauf waren die Transaktionen des Tages aufgezeichnet.

Des employés de la Bourse de New York lisent une bande de télex pendant le «Jeudi noir», le 24 octobre 1929. La bande enregistrait les transactions du jour.

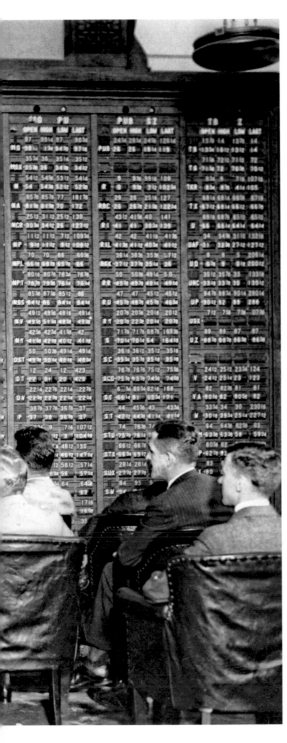

Anonymous

The world's first automatic stock exchange display, early 1930s.

Die weltweit erste automatische Anzeigetafel der Börse, Anfang der 1930er-Jahre.

Le premier panneau d'affichage automatique des cours de la Bourse au monde, début des années 1930.

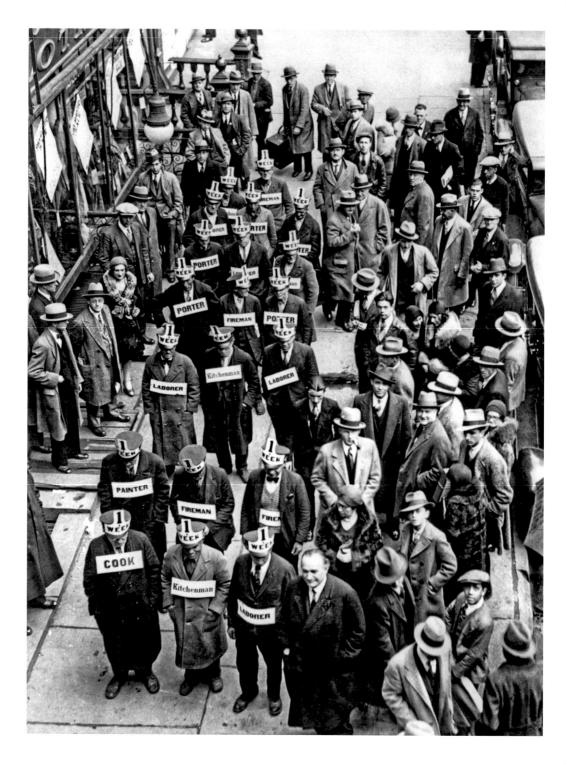

"Confusion spreads throughout the canyons of New York's financial district. And men stare wild-eyed at the spectacle of complete ruin. More than 16 and a half million shares change hands in a single day of frenzied selling."

THE ROARING 20s, 1939

Anonymous

A demonstration by unemployed work-
ers (their various trades are on display)
prepared to labor for $1 a week during
the Great Depression, 1930s.

Eine Kundgebung von Arbeitslosen
(mit Schildern, auf denen ihr Beruf
steht), die in der Weltwirtschaftskrise
bereit waren, für einen Dollar die
Woche zu arbeiten, 1930er-Jahre.

Une manifestation de chômeurs (qui affi-
chent leur profession), prêts à travailler
pour un dollar par semaine pendant la
Grande Dépression, années 1930.

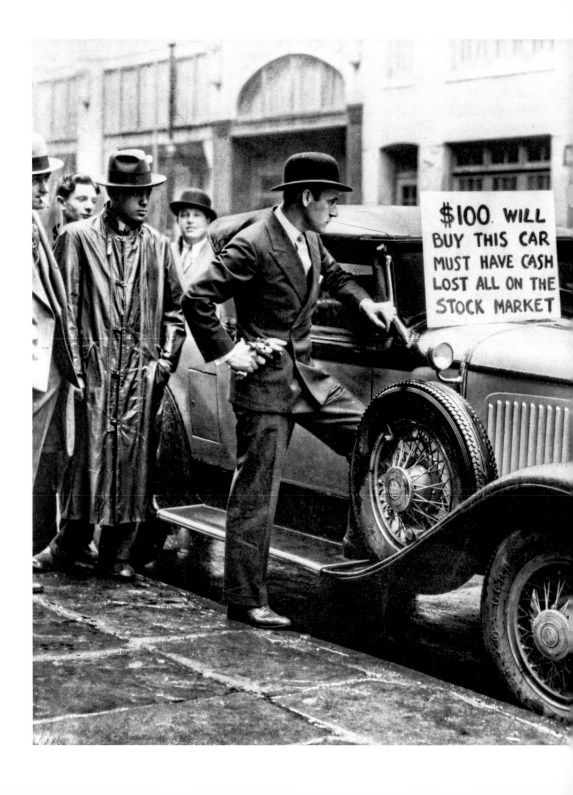

THEODORE ROOSEVELT (1858)
ROY LICHTENSTEIN (1923)

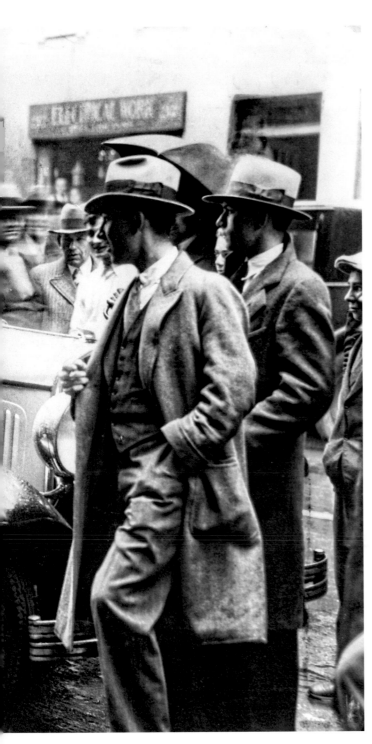

Anonymous

An investor who lost everything in the Wall Street crash is selling his automobile for $100, 1929.

Ein Anleger, der durch den Börsenkrach alles verloren hat, verkauft sein Auto für 100 Dollar, 1929.

Un investisseur, qui a tout perdu dans le crash de Wall Street, vend sa voiture pour 100 dollars, 1929.

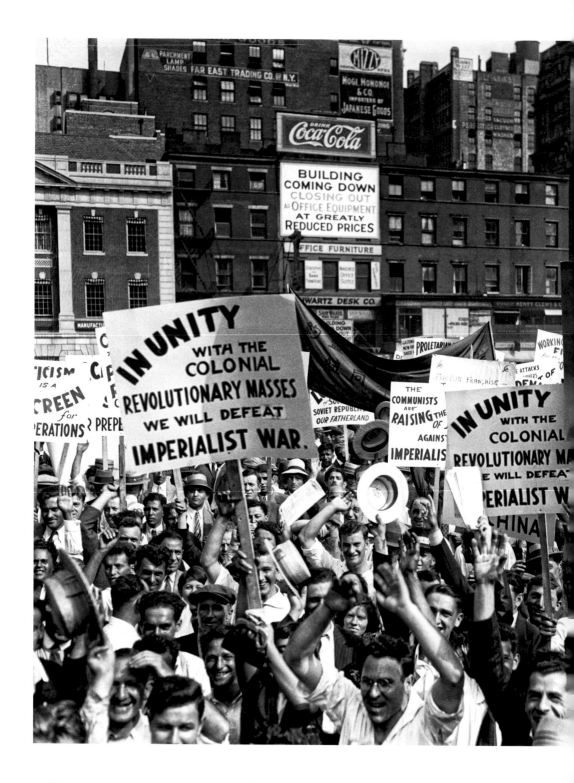

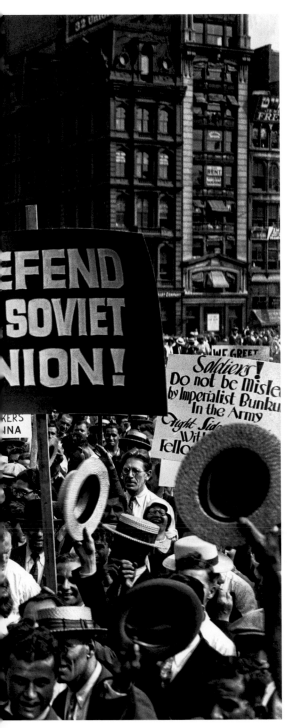

Anonymous

Card-carrying members of the Communist Party showing their support for the Soviet Union. The imperialist war that the banners are referring to is a minor conflict that arose in 1929 between the Soviet Union and China over a railway in Manchuria, 1929.

Eingetragene Mitglieder der kommunistischen Partei zeigen ihre Unterstützung für die Sowjetunion. Der imperialistische Krieg, auf den die Plakate verweisen, ist ein kleinerer Konflikt im Jahr 1929 zwischen der Sowjetunion und China um eine Eisenbahnlinie in der Mandschurei, 1929.

Des membres actifs du Parti communiste manifestent leur soutien à l'Union soviétique. La guerre impérialiste à laquelle se réfèrent les bannières est un conflit mineur, en 1929, entre l'URSS et la Chine au sujet d'une voie ferrée en Mandchourie, 1929.

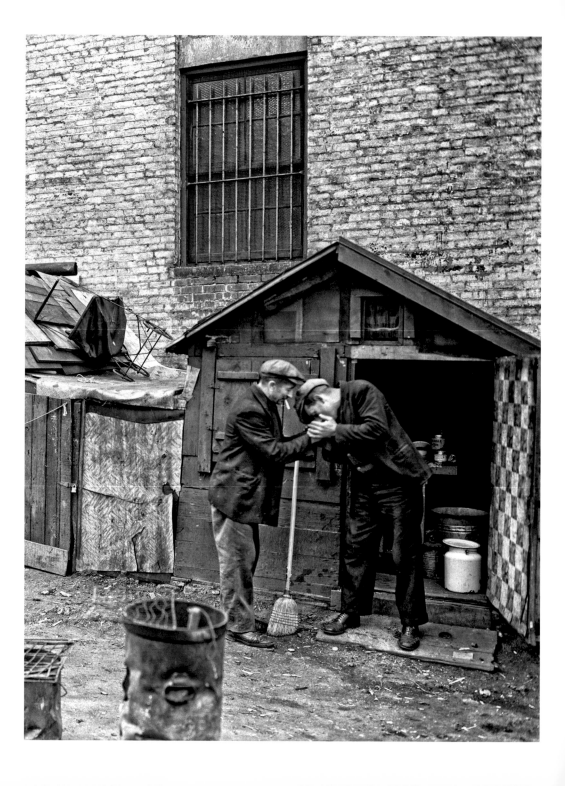

FANNY BRICE (1891)
RICHARD DREYFUSS (1947)

"Prices of Stocks Crash in Heavy Liquidation, Total Drop of Billions. Paper Loss $4,000,000,000. 2,600,000 Shares Sold in the Final Hour in Record Decline. Many Accounts Wiped Out."

THE NEW YORK TIMES, 1929

Berenice Abbott

Huts and the Unemployed. Despite the New Deal and the ambitious public works program initiated by President Franklin D. Roosevelt, it took World War II to finally lift America out of the Great Depression, 1935.

Hütten und Arbeitslose. Trotz des New Deal und der ehrgeizigen, von Präsident Franklin D. Roosevelt eingeführten öffentlichen Projekte erholte sich Amerika erst mit dem Zweiten Weltkrieg von der Weltwirtschaftskrise, 1935.

Huttes et chômeurs. Malgré la politique du New Deal et de grands travaux ambitieux initiés par le président Franklin D. Roosevelt, il fallut la Seconde Guerre mondiale pour que l'Amérique sorte enfin de la Grande Dépression, 1935.

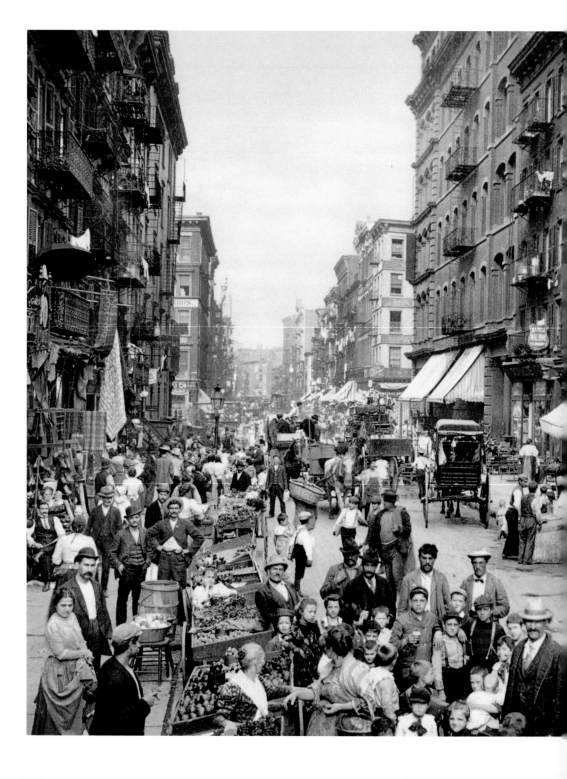

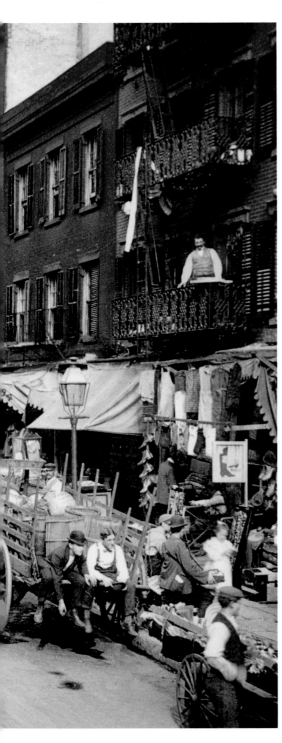

Anonymous

Mulberry Street. The heart of the Italian
district on the Lower East Side and,
at the time, one of the most crowded
places on earth, 1900.

Mulberry Street, das Herz des italieni-
schen Viertels auf der Lower East
Side. An kaum einem anderen Ort
der Erde lebten damals so viele Men-
schen wie dort, 1900.

Mulberry Street, cœur du quartier
italien dans le Lower East Side, un
des lieux les plus densément peuplés
de la planète, 1900.

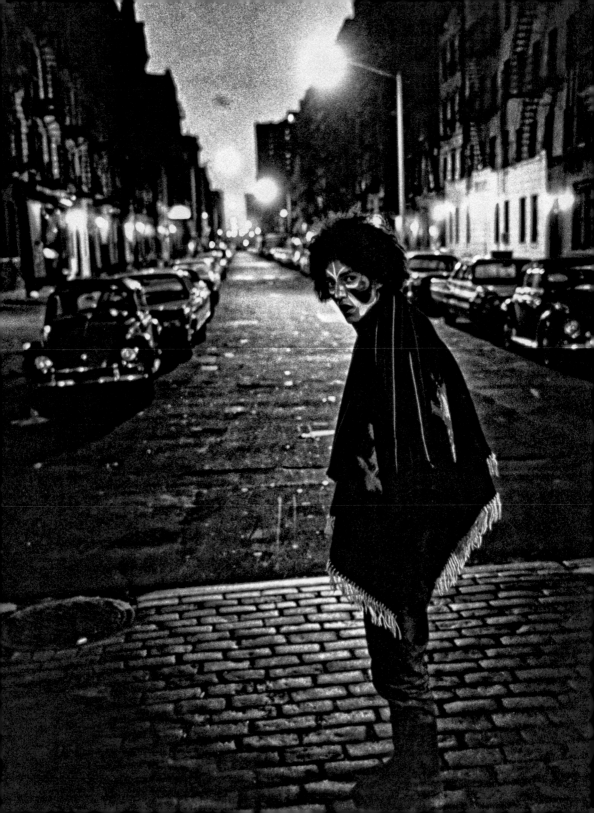

"AD-ROCK" ADAM HOROVITZ (1966)

"Follow the wind song
Follow the thunder
Follow the neon in young lovers' eyes

"Down to the gutter
Up to the glitter
Into the city
Where the truth lies."

"WHERE DO I GO," *HAIR,* **1968**

Larry Clark

Acid, Lower East Side, 1968. The streetlights emphasize the man's hazy state of mind.

Acid, Lower East Side, 1968. Das diffuse Licht der Straßenlaternen betont den benebelten Geisteszustand des Mannes.

Acide, Lower East Side, 1968. L'éclairage public fait ressortir la perte de sentiment de soi.

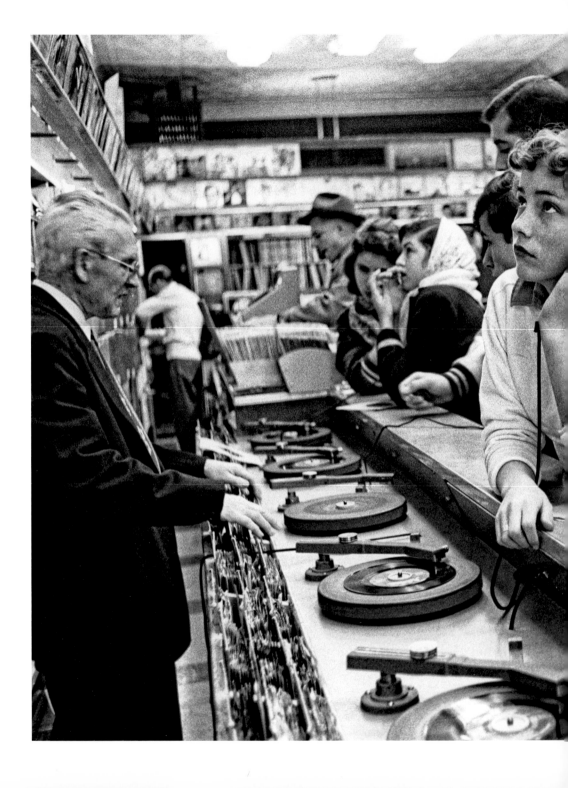

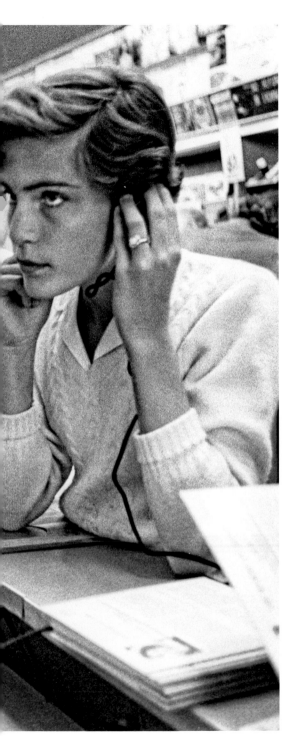

Esther Bubley

Teenage fledglings listening
to the latest hits, 1957.

Teenager lauschen den
neusten Hits, 1957.

Adolescents écoutant les
derniers succès, 1957.

Harold Corsini

Street Prophet. The words on the board
end with the plea: "be a family to
God." This strange New York moment
is enhanced by the poster for the
movie *Dark Victory*, which lent the
prophet's words further credence, 1935.

Straßenprophet. Die Predigt auf dem
Schild endet mit der Bitte „Seid eine
Familie in Gott". Dieser merkwürdige
Moment in New York wird von dem
Plakat des Films *Opfer einer großen
Liebe* noch verstärkt, das den Worten
des Predigers Glaubwürdigkeit verleiht,
1935.

Prophète de rue. Le tableau se termine
par «soyez une famille en Dieu».
L'étrangeté de ce spectacle new-yorkais
est renforcée par l'affiche pour le film
Sombre Victoire, qui donne aux paroles
du «prophète» une sorte de crédibilité
supplémentaire, 1935.

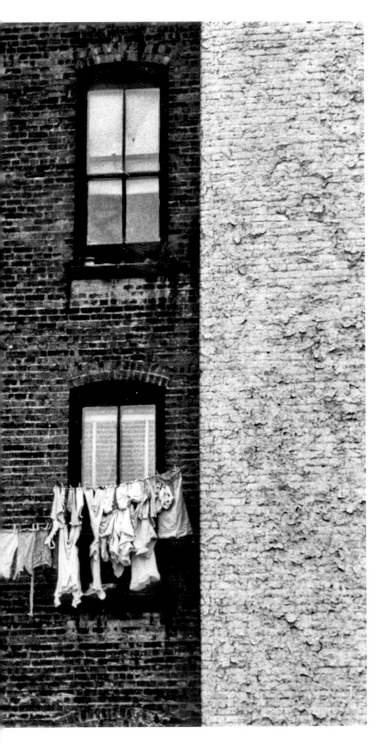

Erika Stone

Lower East Side. This is the back of a tenement building and there is a wonderful juxtaposition between the bright billboard and the grim reality of laundry day, 1947.

Lower East Side. Rückseite eines Mietshauses. Das Foto zeigt den wunderbaren Kontrast eines bunten Werbeplakats mit der nüchternen Realität eines Waschtags, 1947.

Lower East Side. L'arrière d'un immeuble de rapport. Superbe juxta-position de l'affiche éclairée et de la triste réalité d'un jour de lessive, 1947.

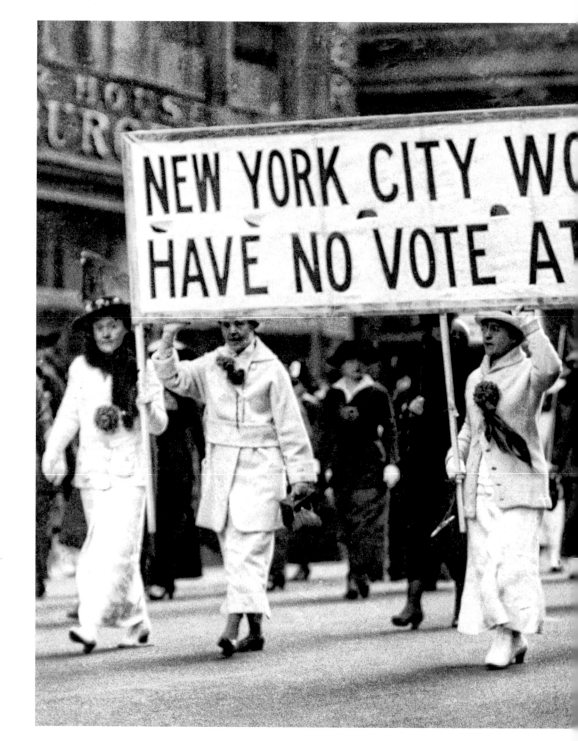

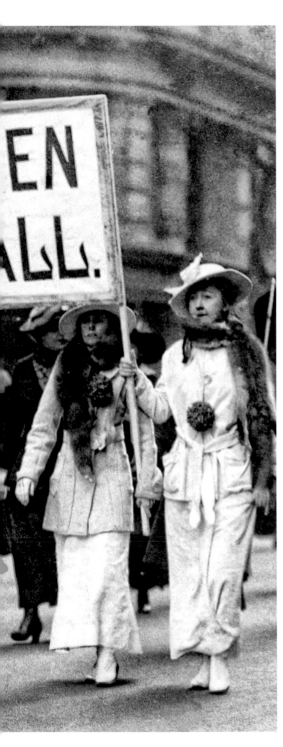

Anonymous

Suffragettes marching in a parade,
supporting their right to vote. In 1919,
New York became the first Eastern state
to enfranchise women, 1913.

Suffragetten auf einer Demonstration
für das Frauenwahlrecht. 1919 gewährte
New York als erste Stadt im Osten der
USA den Frauen das Wahlrecht, 1913.

Des suffragettes défilent pour défendre
leur droit au vote. En 1919, l'État de New
York fut le premier de l'Est des États-Unis
à l'accorder aux femmes, 1913

David Fenton

A policeman in Central Park is chasing
a boy for burning the American flag.
This was presumably during one of
the many 1960s anti-Vietnam War
demonstrations, 1968.

Ein Polizist verfolgt im Central Park
einen Jungen, der die amerikanische
Flagge verbrannt hat. Dieses Bild wurde
vermutlich während einer der vielen
Demonstrationen gegen den Vietnam-
krieg aufgenommen, 1968.

Dans Central Park, un policier à cheval
poursuit un garçon qui a brûlé un
drapeau américain. Cette scène s'est
vraisemblablement produite pendant
l'une des nombreuses manifestations
contre la guerre au Vietnam dans les
années 1960, 1968.

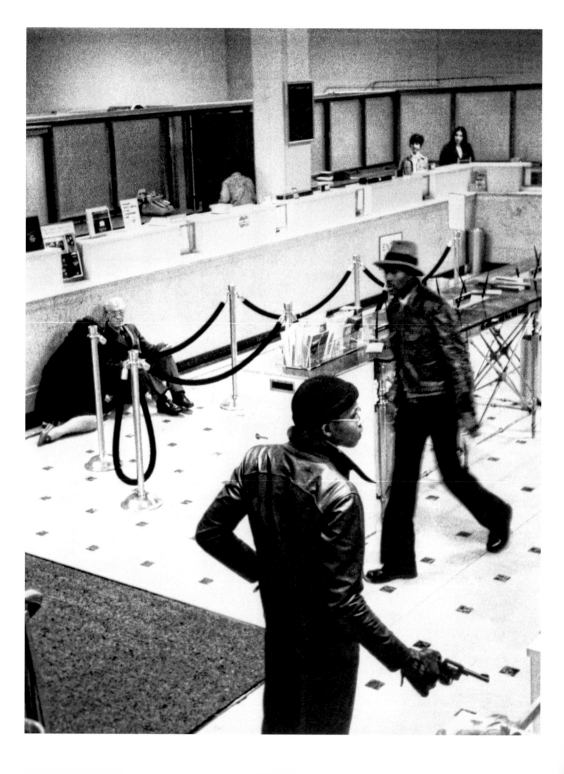

CHARLES HENRY DOW (1851)
HAROLD ROSS (1892)

"I'm robbing a bank because they got money here. That's why I'm robbing it."

DOG DAY AFTERNOON, 1975

Anonymous

A bank robbery. It could be a film still from one of those gritty 1970s New York crime movies, but it is a real heist, caught on camera, 1973.

Ein Banküberfall. Dieses Foto könnte ein Standbild aus einem der düsteren New-York-Krimis der 1970er-Jahre sein, aber es handelt sich um einen echten Überfall, festgehalten mit der Kamera, 1973.

Une attaque de banque. Ce pourrait être une image tirée de l'un de ces films noirs sur le New York des années 1970, mais c'est un vrai « casse » filmé par une caméra de sécurité, 1973.

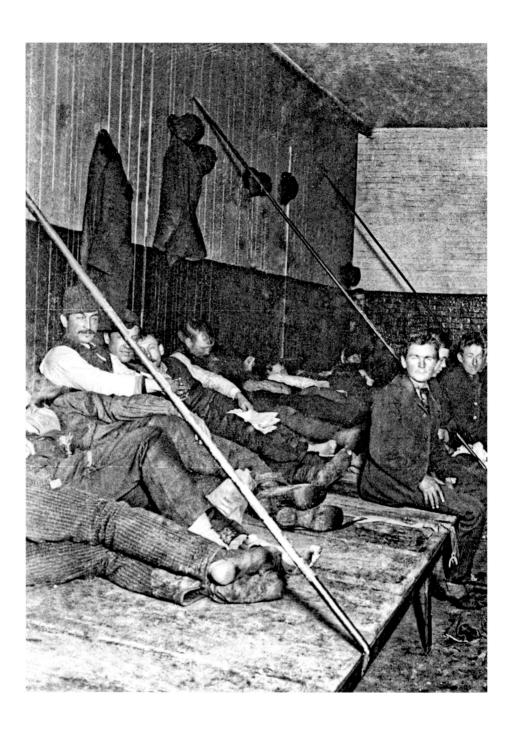

"The thief is infinitely easier to deal with than the pauper, because the very fact of his being a thief presupposes some bottom to the man.... To the pauper there is none. He is as hopeless as his own poverty."

HOW THE OTHER HALF LIVES, JACOB RIIS, 1890

Jacob Riis

Lodgers at Oak Street Police Station, 1892.

Untermieter in der Polizeistation Oak Street, 1892.

Au poste de police d'Oak Street, 1892.

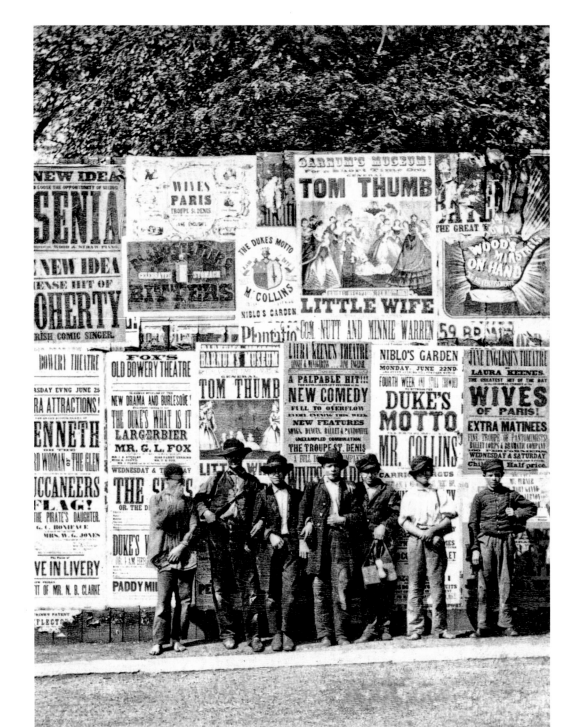

"Here we are, Marv. New York City, the land of opportunity."

HOME ALONE 2: LOST IN NEW YORK, 1992

E. & H. T. Anthony

A brigade of bootblacks posing a little awkwardly for the camera, near City Hall, in Downtown Manhattan. Bootblacks were poorly paid laborers, mainly children, who made a meager living by shining shoes, 1860s.

Eine Schuhputzerbrigade, die etwas unbeholfen für die Kamera posiert, in der Nähe des Rathauses in Downtown Manhattan. Die schlecht bezahlten Schuhputzer waren überwiegend Kinder, die damit ein paar Cent verdienten, 1860er-Jahre.

Un groupe de «noircisseurs de bottes» (bootblacks) posant avec timidité devant l'objectif, près de City Hall dans le Downtown Manhattan. Les bootblacks étaient des travailleurs mal payés, surtout des enfants, qui tiraient de maigres ressources du cirage des chaussures, années 1860.

"You see more life experience in one trip to the corner to buy the paper in New York than you do in a month in another place."

PETER BOYLE, 2002

Marvin Newman

A man working in a café or bar, preparing a snack, 1952.

Ein Mann, der in einem Café oder in einer Bar arbeitet, richtet einen Snack an, 1952.

Homme préparant un sandwich dans un café ou un bar, 1952.

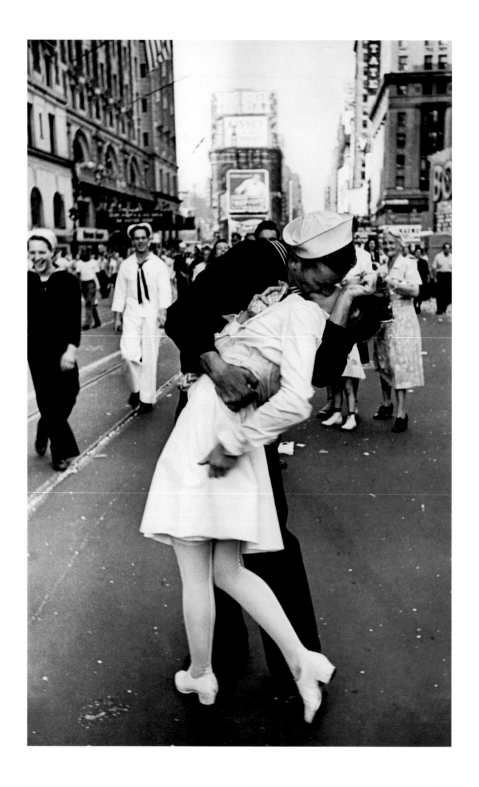

"I noticed a sailor coming my way. He was grabbing every female he could find and kissing them all—young girls and old ladies alike."

ALFRED EISENSTAEDT

Alfred Eisenstaedt

V-J Day in Times Square. The photographer says that he saw the embrace out of the corner of his eye and quickly shot four images in a few seconds, before the couple disappeared into the crowd. Three women later identified themselves as the nurse, while at least ten men claimed to be the sailor, 1945.

V-J Day in Times Square (Tag der Kapitulation Japans am Times Square). Der Fotograf beschrieb, dass er das küssende Paar aus dem Augenwinkel gesehen hatte und ganz schnell vier Aufnahmen machte, bevor das Paar in der Menge verschwand. Drei Frauen behaupteten später, die Krankenschwester gewesen zu sein, und mindestens zehn Männer waren angeblich der Matrose, 1945.

V-J Day in Times Square (Jour de la capitulation du Japon à Times Square). Le photographe a raconté qu'il avait capté la scène du coin de l'œil et pris quatre images en quelques secondes, avant que le couple ne disparaisse dans la foule. Plus tard, trois femmes prétendirent être l'infirmière et dix hommes au moins le marin, 1945.

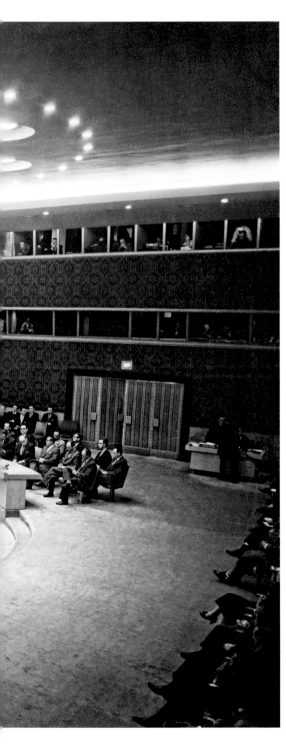

Sam Schulman

The 11 members of the UN Security
Council in session to discuss the Suez
Crisis in the Middle East, 1956.

Die elf Mitglieder des UN-Sicherheits-
rats der Vereinten Nationen tagen,
um über die Suezkrise im Nahen Osten
zu beraten, 1956.

Les onze membres du Conseil de sécu-
rité de l'ONU réunis en session pour
discuter de la crise de Suez, 1956.

ANNE HATHAWAY (1982)

"Give me your tired, your poor,
Your huddled masses yearning to breathe free,
The wretched refuse of your teeming shore.
Send these, the homeless, tempest-tost to me.
I lift my lamp beside the golden door."

EMMA LAZARUS, 1886

Gus Powell

Lady Liberty in 2002 glimpsed through the haze of New York harbor. The statue is on a 12-acre island, and it was designated a national monument in 1924. After years of decay, she was beautifully restored for her centennial in 1986.

Die Freiheitsstatue im nebligen New Yorker Hafen, 2002. Die Statue steht auf einer knapp sechs Hektar großen Insel und wurde 1924 zum Nationaldenkmal erklärt. Nach Jahren des Verfalls wurde sie anlässlich ihres 100. Geburtstags 1986 liebevoll restauriert.

«Lady Liberty» surprise dans la brume du port de New York en 2002. La statue qui se dresse sur une île de six hectares a été déclarée monument national en 1924. Après des années de négligence, elle a été magnifiquement restaurée pour son centenaire en 1986.

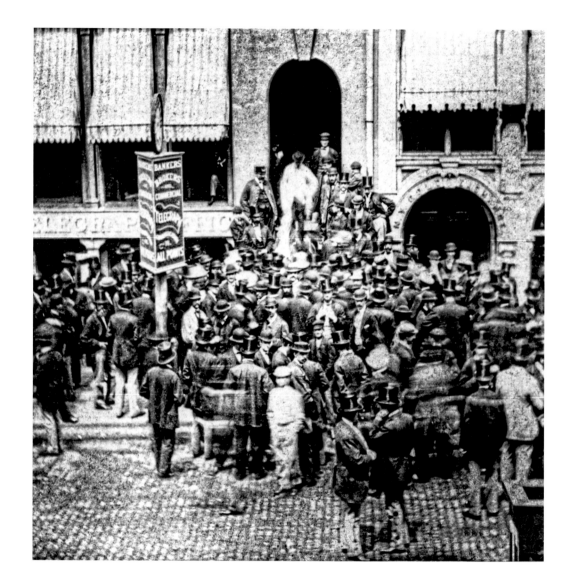

*"All the beautiful day on Tuesday,
when the dearly beloved President was
borne through the great city, it was
impossible not to feel that… no oration
could be so eloquent as the spectacle
of the vast population, hushed and
bareheaded, under the bright spring
sky, gazing upon his coffin."*

HARPER'S WEEKLY, 1865

Anonymous

The Stock Exchange after President Abraham Lincoln's assassination. Lincoln's emergence onto the national political stage began in New York in 1860, with his famous speech in the Great Hall at Cooper Union, calling for the abolition of slavery, 1865.

Die Börse nach der Ermordung von Präsident Abraham Lincoln. Lincolns Karriere auf der politischen Bühne des Landes nahm mit seiner berühmten Rede zur Abschaffung der Sklaverei im Jahr 1860 in der Cooper Union Hall in New York ihren Anfang, 1865.

La Bourse de New York après l'assassinat du président Abraham Lincoln. L'émergence de Lincoln sur la scène politique nationale avait débuté à New York lors de son fameux discours appelant à l'abolition de l'esclavage tenu au Great Hall de Cooper Union en 1860, 1865.

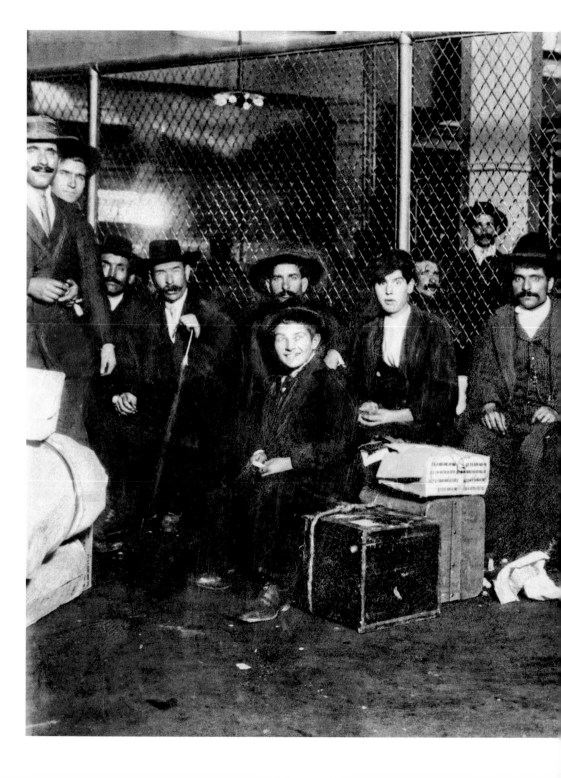

NOVEMBER 14

AARON COPLAND (1900)
"DJ RUN" JOSEPH SIMMONS (1964)

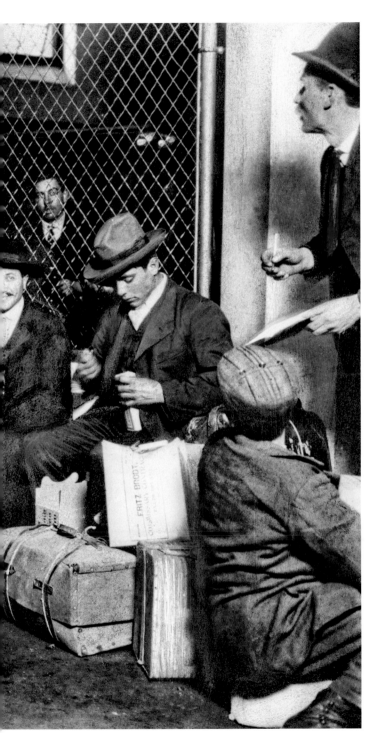

Lewis Hine

Ellis Island immigrants, 1905.

Einwanderer auf Ellis Island, 1905.

Immigrants à Ellis Island, 1905.

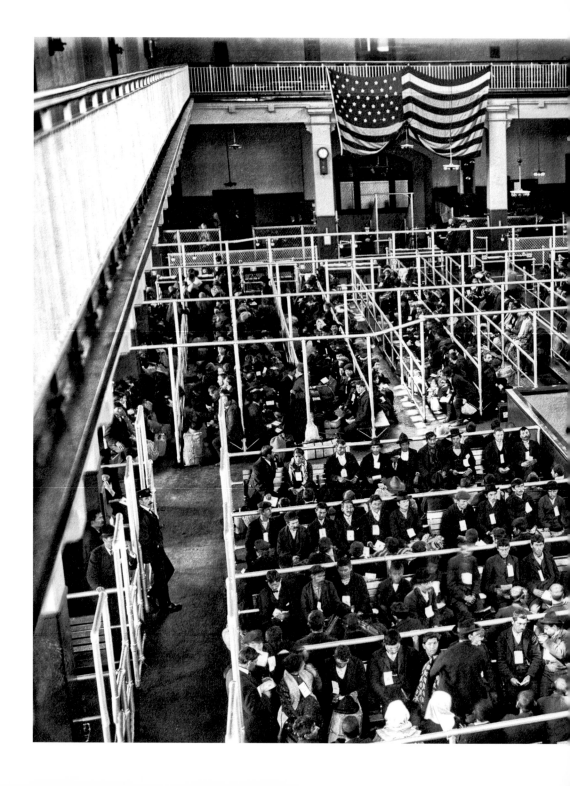

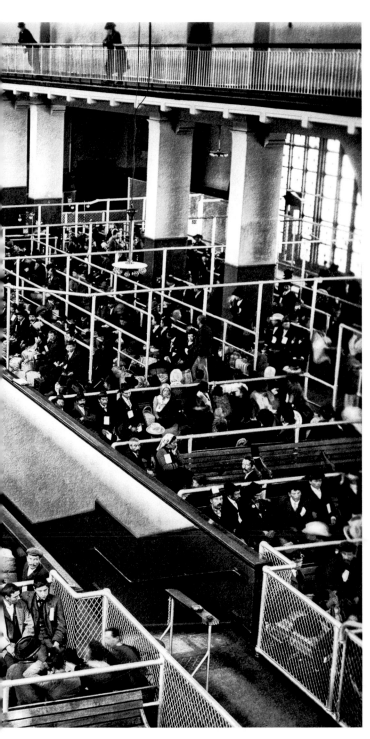

Anonymous

The main hall of Ellis Island, including the holding pens where people waited for processing. First- and second-class passengers were spared the Ellis Island experience, and waved through after a cursory inspection on board, 1902.

Die Haupthalle von Ellis Island mit den Absperrungen, in denen die Menschen auf ihre Abfertigung warteten. Passagieren der ersten und zweiten Klasse blieb die Prozedur auf Ellis Island erspart, denn sie wurden nach einer flüchtigen Prüfung an Bord einfach durchgewunken, 1902.

Le hall principal d'Ellis Island, comprenant des stalles dans lesquelles les immigrés attendaient avant de passer les formalités. Les passagers de première et de seconde classe se voyaient épargner cette expérience et passaient l'inspection des douanes à bord de leur bateau, 1902.

Victor Prevost

Building belonging to a lock-and-safe
company on Hudson Street, in what
came to be known as the Meatpacking
District, on the West Side of Manhattan.
Prevost, a Frenchman, was a pioneering
photographer who made New York
his subject, 1853.

Dieses Foto zeigt das Gebäude einer
Schlosserei in der Hudson Street im spä-
teren Meatpacking District auf der West
Side von Manhattan. Das bevorzugte
Motiv des französischen Fotopioniers
Prevost war New York, 1853.

Cet immeuble occupé par une entreprise
de verrous et de coffres sur Hudson
Street se trouvait dans ce qui s'est appelé
plus tard le Meatpacking District, sur le
côté ouest de Manhattan. Victor Pre-
vost, un Français, fut l'un des premiers
photographes à faire de New York son
principal sujet, 1853.

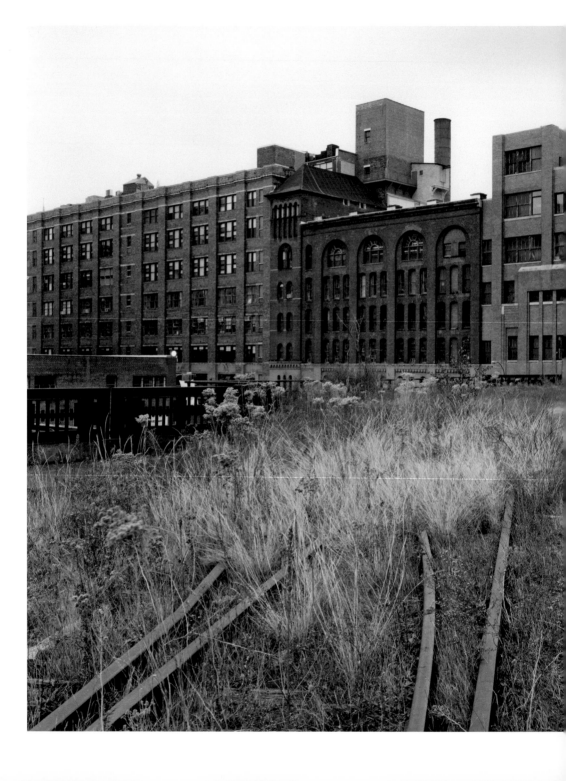

LEE STRASBERG (1901)
MARTIN SCORSESE (1942)
LAUREN HUTTON (1943)

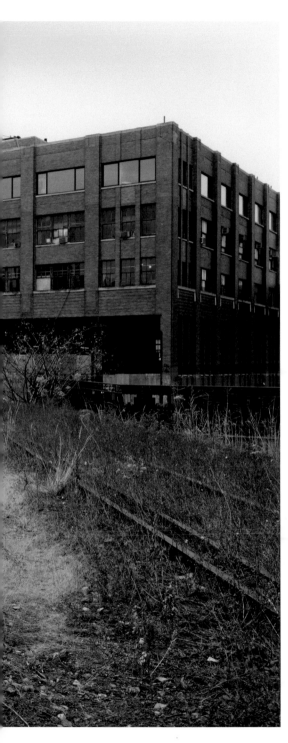

Joel Sternfeld

Looking South towards Chelsea Market, 2000. The High Line was an abandoned railroad track running between West Chelsea and 34th Street. In June 2009, an ambitious and distinct public space above the city streets finally opened, and the High Line has since become one of the city's must-see landmarks.

Blick nach Süden in Richtung Chelsea Market, 2000. Die High Line ist ein stillgelegtes Bahngleis zwischen West Chelsea und der 34th Street. Im Juni 2009 wurde hier ein einzigartiger öffentlicher Platz über den Straßen der Stadt eröffnet; die High Line gehört seither zu den Sehenswürdigkeiten der Stadt, die man auf keinen Fall verpassen darf.

Vue vers le sud en direction de Chelsea Market, 2000. La Highline était une voie ferrée suspendue abandonnée qui reliait West Chelsea et la 34e Rue. En 2009, son ambitieuse transformation en espace vert public, qui passe donc au-dessus du réseau des rues, a été inaugurée, et la Highline est devenue l'un des endroits incontournables de la ville.

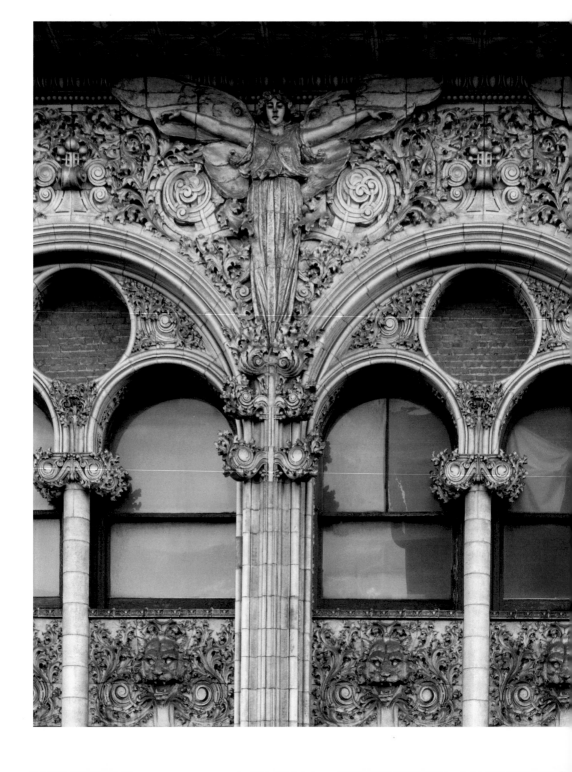

Reinhart Wolf

65 Bleecker Street between Lafayette
Street and Broadway is a 13-story white
terra-cotta office building completed
in 1899 and is the only New York City
structure designed by the famed Chicago
architect Louis Sullivan, c. 1980s.

65 Bleecker Street ist ein dreizehnstö-
ckiges Bürogebäude mit weißer
Terrakotta-Fassade. Es wurde 1899
fertiggestellt und ist das einzige Bauwerk
des berühmten Chicagoer Architekten
Louis Sullivan in New York, um 1980.

Le 65 Bleecker Street, entre Lafayette
Street et Broadway, est un immeuble de
bureaux de 13 niveaux à façade ornée
de terre cuite blanche achevé en 1899.
C'est le seul immeuble de New York dû
au célèbre architecte de Chicago, Louis
Sullivan, années 1980.

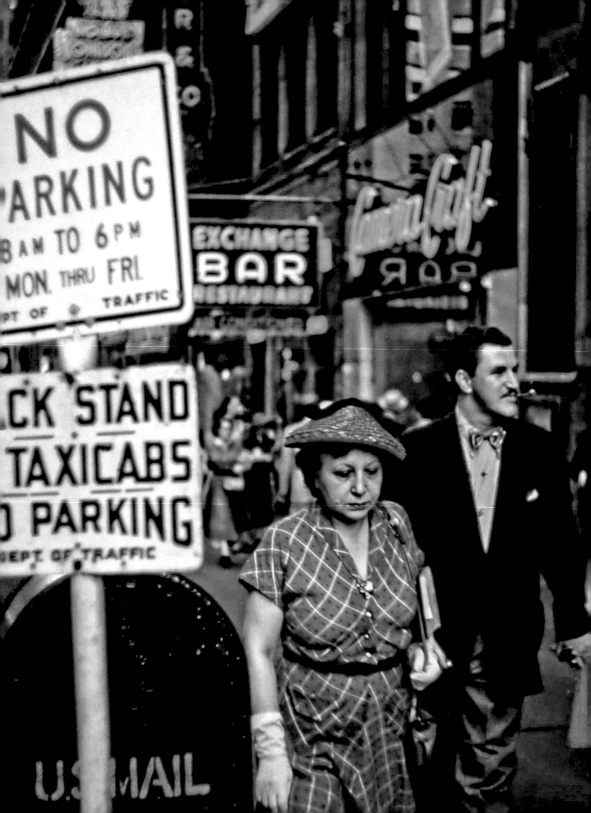

*"When two people love each other,
they come together — WHAM! —
like two taxis on Broadway."*

REAR WINDOW, 1954

Ruth Orkin

A woman in a colorful red hat, deep in thought as she makes her way along a bustling New York sidewalk, early 1950s.

Eine tief in Gedanken versunkene Frau mit knallrotem Hut bahnt sich ihren Weg auf einem geschäftigen New Yorker Bürgersteig, Anfang der 1950er-Jahre.

Plongée dans ses pensées, une femme à chapeau rouge s'avance sur un trottoir encombré, début des années 1950.

Arnold Newman

A simple but engaging shot of residential New York buildings, photographed from the back, location unknown, 1948.

Eine einfache, aber fesselnde Aufnahme der Rückseite von New Yorker Wohnhäusern, Aufnahmeort unbekannt, 1948.

Une vue simple, mais efficace, d'immeubles résidentiels new-yorkais vus de l'arrière. Adresse inconnue, 1948.

"On Wall Street he and a few others — how many? — 300, 400, 500? — had become precisely that... Masters of the Universe."

THE BONFIRE OF THE VANITIES, TOM WOLFE, 1987

Ernst Haas

The Trump Tower. This is the best-known creation of New York's most famous property developer. Near Central Park, across from the Plaza Hotel, the gaudy Trump Tower is a monument to conspicuous consumption and a symbol of 1980s excess, 1986.

Der Trump Tower. Dies ist die bekann-teste Schöpfung des berühmtesten Bau-unternehmers New Yorks. Der protzige Turm nahe am Central Park gegenüber dem Plaza Hotel ist ein Denkmal offen-kundigen Konsums und ein Symbol für den Exzess der 1980er-Jahre, 1986.

La Trump Tower. C'est la création la plus connue du fameux promoteur immobi-lier de New York, Donald Trump. Proche de Central Park, face au Plaza Hotel, cette tour très voyante est un monument à la richesse ostensible, et un symbole des excès des années 1980, 1986.

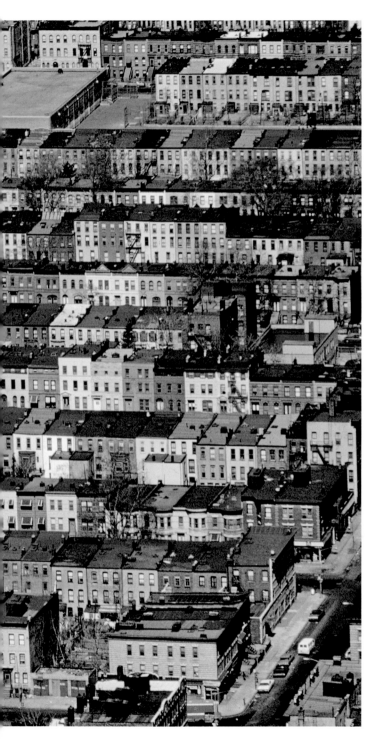

SCARLETT JOHANSSON (1984)

Ernst Haas

A residential neighborhood, probably in Brooklyn, taken from high above, 1956.

Aufnahme eines Wohngebiets, wahrscheinlich in Brooklyn, aus der Vogelperspektive, 1956.

Vue aérienne d'un quartier résidentiel, probablement à Brooklyn, 1956.

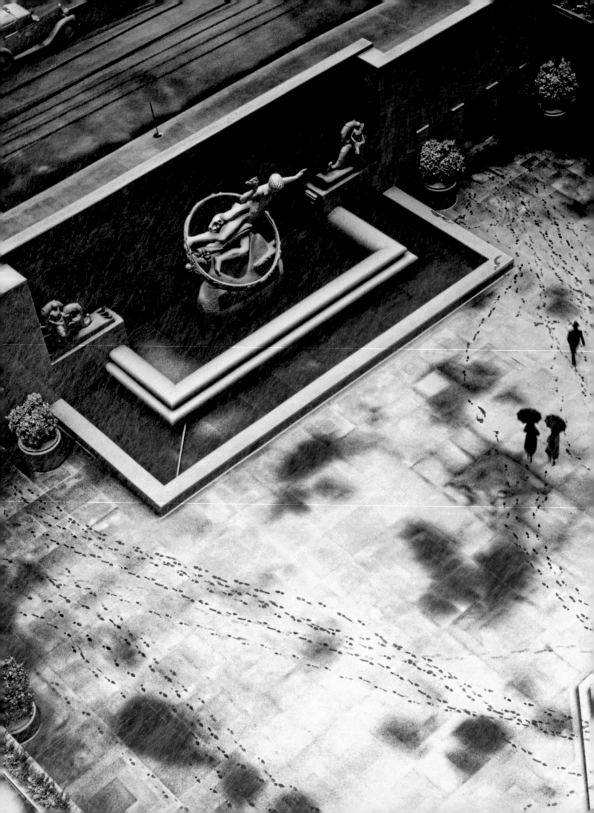

ADOLPH "HARPO" MARX (1888)

*"New York is a great
diamond, hard and dry,
sparkling, triumphant."*

LE CORBUSIER, 1964

Wendell Scott MacRae

Rockefeller Center. An overhead shot of the sunken plaza, featuring a gilded bronze statue of the Titan Prometheus from Greek mythology, in front of 30 Rockefeller Center (the RCA Building). During the winter months, the plaza is converted into an ice skating rink, 1930s.

Rockefeller Center. Eine Aufnahme der tiefer gelegenen Plaza von oben, mit der vergoldeten Bronzestatue der griechischen Sagengestalt Prometheus vor Rockefeller Center 30 (RCA Building). In den Wintermonaten wird der Platz in eine Eislaufbahn verwandelt, 1930er-Jahre.

Rockefeller Center. Vue du haut de la place en creux, qu'un ensemble de statues en bronze doré, illustrant la légende grecque du titan Prométhée, vient décorer, devant le 30 Rockefeller Center (RCA Building). Pendant l'hiver, la place se transforme en patinoire, années 1930.

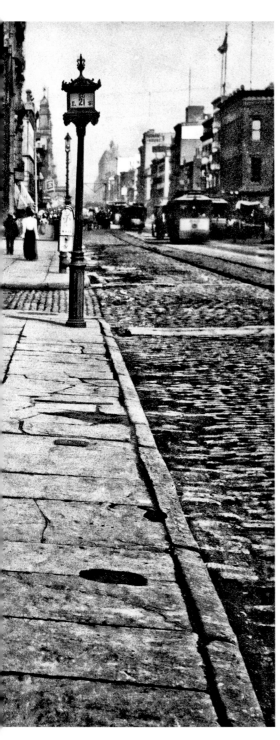

CASS GILBERT (1859)
CHARLIE "LUCKY" LUCIANO (1897)
JOHN V. LINDSAY (1921)

Anonymous

Fourth Avenue. Just north of the East Village, this avenue is an extension of the Bowery. It becomes Union Square East at 14th Street, then Park Avenue South, and then, at 33rd Street, it becomes Park Avenue, 1900.

Fourth Avenue. Diese Avenue etwas nördlich vom East Village ist eine Verlängerung der Bowery, wird an der 14th Street zum Union Square East, dann zur Park Avenue South und an der 33rd Street zur Park Avenue, 1900.

Quatrième Avenue. Juste au nord de l'East Village, cette avenue est une extension du Bowery. Elle devient Union Square East à la 14ᵉ Rue, puis Park Avenue South, et enfin, à la hauteur de la 33ᵉ Rue, Park Avenue, 1900.

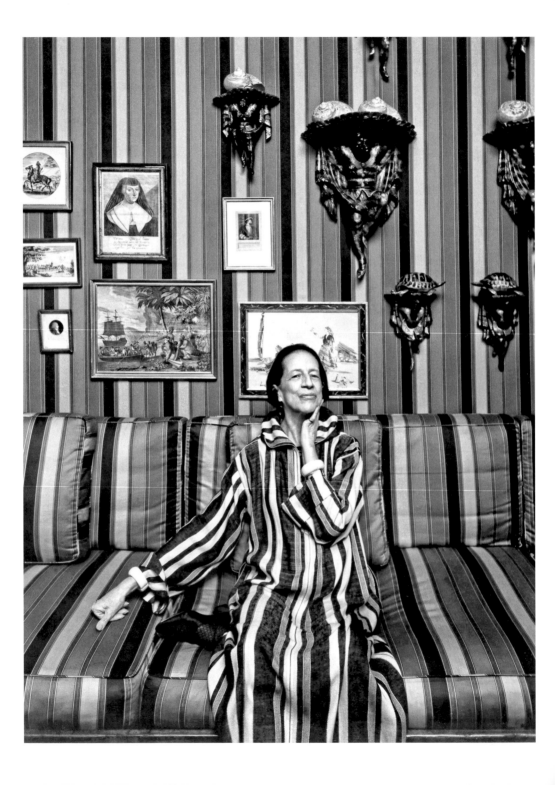

JOE DIMAGGIO (1914)
JOHN F. KENNEDY, JR. (1960)

*"Never worry about the facts.
Just present an image to the public."*

DIANA VREELAND

Arnold Newman

Diana Vreeland. The fashion writer and editor was one of the key figures in the city's ever-evolving fashion scene. She started out at *Harper's Bazaar* in the 1930s and from 1963 to 1971 she was *Vogue*'s editor in chief, 1974.

Diana Vreeland. Die Modejournalistin und -redakteurin war eine der Schlüsselfiguren der sich ständig wandelnden Modeszene der Stadt. Sie fing in den 1930er-Jahren bei *Harper's Bazaar* an und war von 1963 bis 1971 Chefredakteurin der *Vogue*, 1974.

Diana Vreeland. Rédactrice en chef et journaliste de mode, elle fut l'une des principales figures d'une scène de la mode en perpétuelle ébullition. Elle débuta à *Harper's Bazaar* dans les années 1930, et fut rédactrice en chef de *Vogue* dans les années 1963–71, 1974.

Elliott Erwitt

Truman Capote's *Black and White Ball*. Held at the Plaza Hotel, the author, flush from the critical and commercial success of *In Cold Blood*, treated himself to a spectacular masked ball and invited 500 of his closest "friends." Guests included Frank Sinatra, Robert F. Kennedy, Norman Mailer, and Greta Garbo, 1966.

Truman Capotes *Black and White Ball*. Nachdem der Erfolg des Romans *Kaltblütig* bei Kritik und Publikum sein Konto gefüllt hatte, gönnte sich der Autor einen spektakulären Maskenball im Plaza Hotel, zu dem er 500 seiner engsten „Freunde" einlud, darunter Frank Sinatra, Robert Kennedy, Norman Mailer und Greta Garbo, 1966.

Le bal noir et blanc donné par Truman Capote au Plaza Hotel. L'auteur, enivré par le succès commercial et critique de son roman *De sang-froid*, s'offrit un bal masqué spectaculaire auquel il invita cinq cents de ses plus proches «amis». Parmi les invités figuraient Frank Sinatra, Robert Kennedy, Norman Mailer et Greta Garbo, 1966.

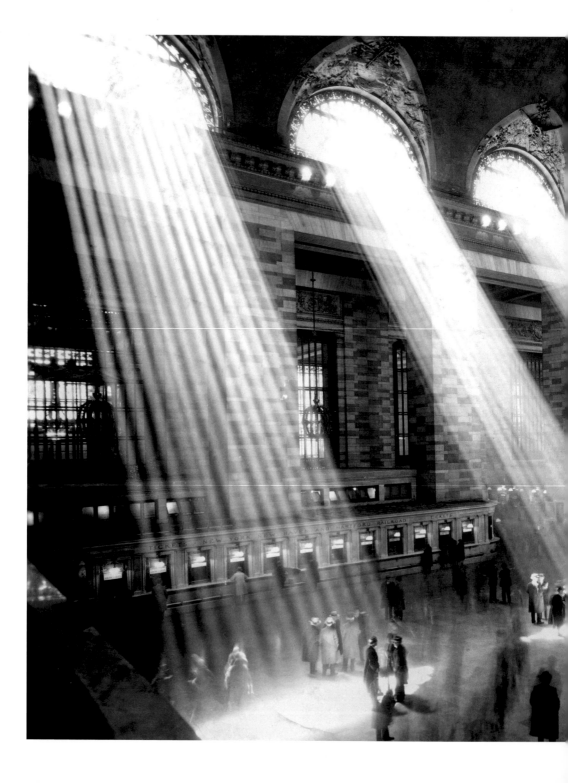

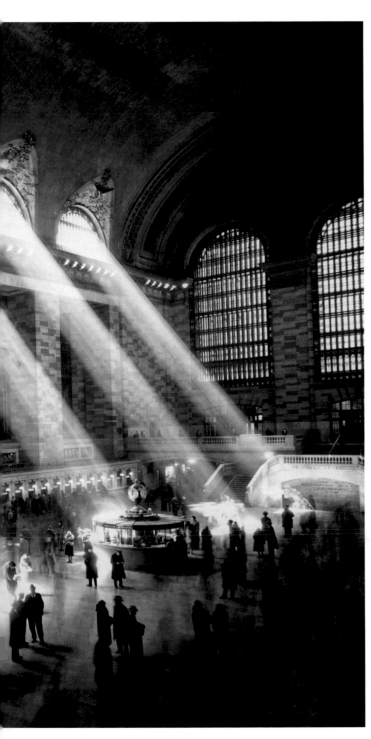

Anonymous

The main concourse at Grand Central Terminal. Grand Central, which heralded the age of electric rails, cost $80 million to build ($2 billon today) and opened in 1913, after ten years of construction. In the 1990s, Grand Central was lovingly restored after decades of neglect, 1929.

Die Haupthalle des Grand Central Terminal. Grand Central läutete die Ära der elektrischen Eisenbahn ein; der Bahnhof wurde 1913 nach zehnjähriger Bauzeit eröffnet, die 80 Millionen Dollar (heute zwei Milliarden Dollar) gekostet hatten. In den 1990er-Jahren wurde Grand Central nach jahrelangem Verfall liebevoll saniert, 1929.

Le hall central de Grand Central Terminal. Grand Central, qui annonçait l'ère de la locomotive électrique, coûta 80 millions de dollars (2 milliards de dollars actuels), et ouvrit en 1913, après dix ans de travaux. La gare a été restaurée avec amour dans les années 1990, après des décennies de négligence, 1929.

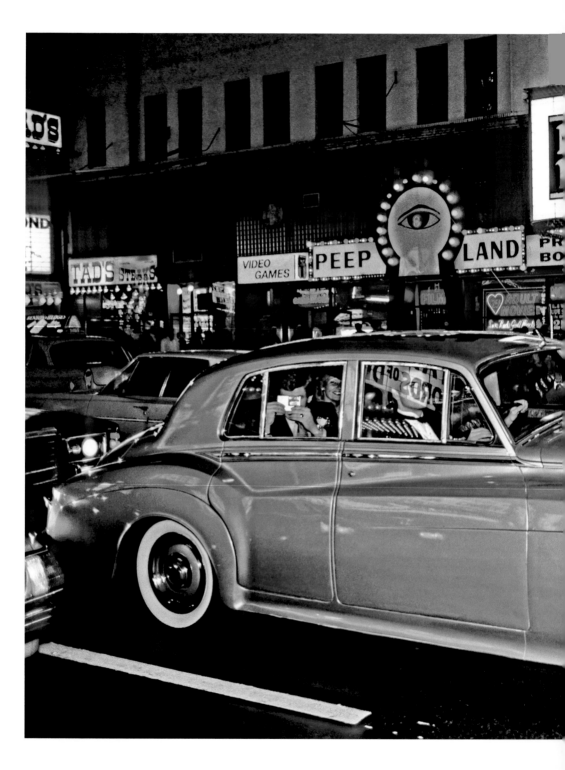

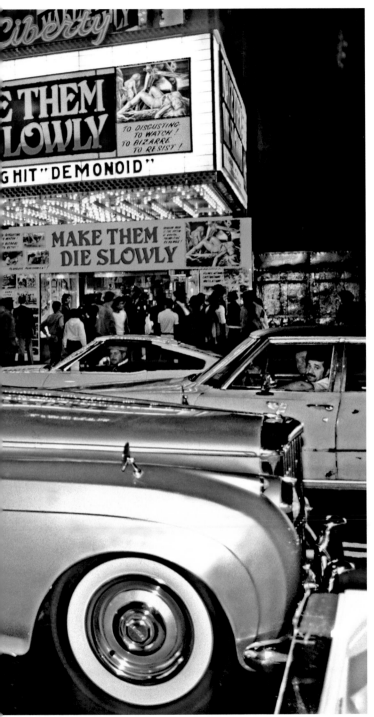

JON STEWART (1962)

Marvin Newman

42nd Street, 1983.

42nd Street, 1983.

42e Rue, 1983

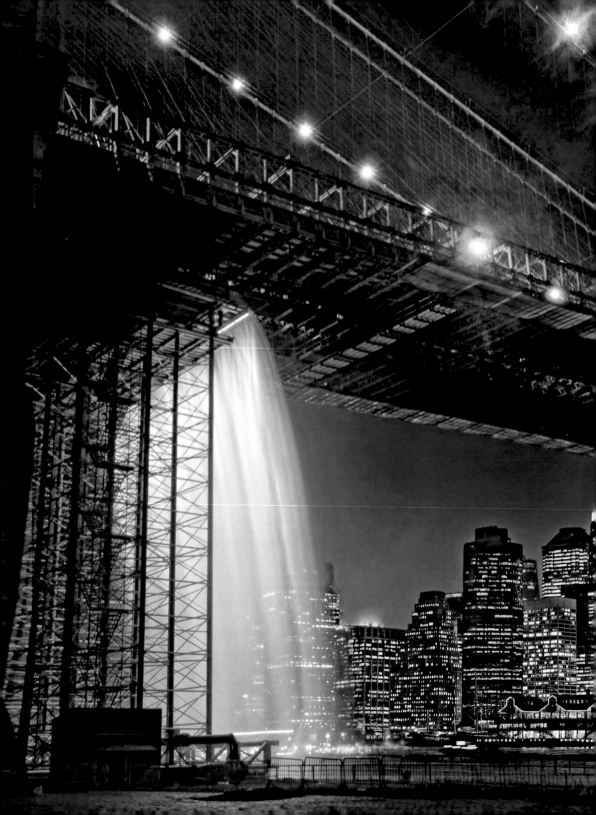

ADAM CLAYTON POWELL, JR. (1908)
JAMES ROSENQUIST (1933)
JOEL COEN (1954)

"Now people can engage in the physical nature of something as epic as a waterfall."

OLAFUR ELIASSON, 2008

Rick Elkins

The New York Waterfalls project. Created by the Danish-Icelandic artist Olafur Eliasson, the four waterfalls gushed during the summer of 2008. This one is just under the Brooklyn Bridge, 2008.

Das New York Waterfalls Project. Die vier von dem dänisch-isländischen Künstler Olafur Eliasson kreierten Wasserfälle strömten im Sommer 2008. Der hier gezeigte Wasserfall befand sich direkt unter der Brooklyn Bridge, 2008.

The New York Waterfalls project. Création de l'artiste danois-islandais Olafur Eliasson, quatre cascades se sont déversées dans l'East River pendant l'été 2008. Celle-ci se trouve juste sous le pont de Brooklyn, 2008.

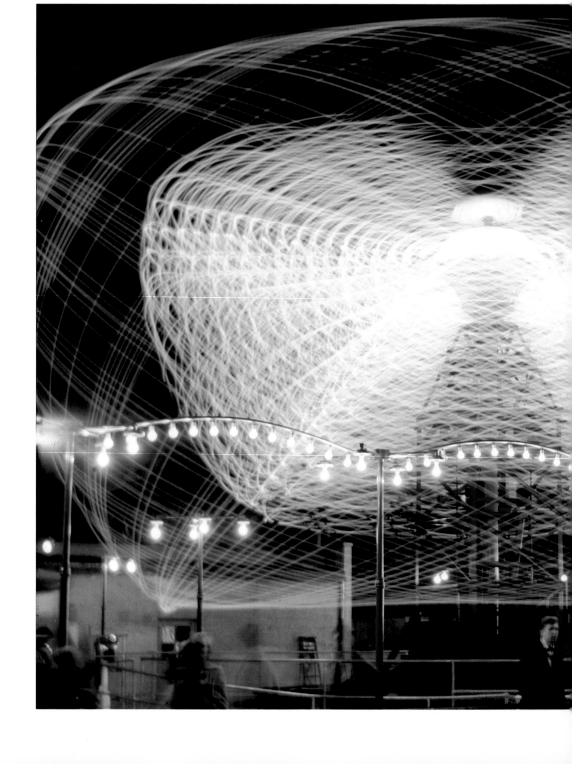

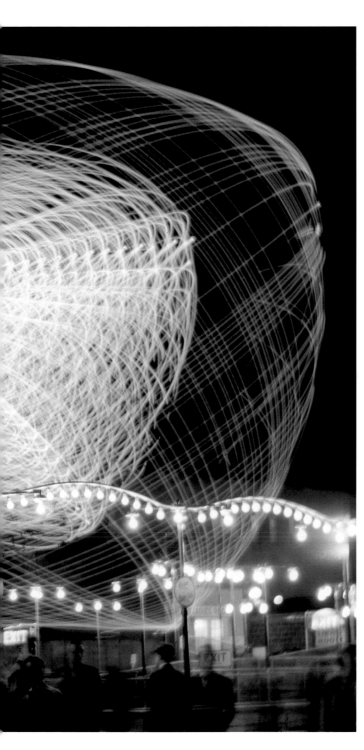

GORDON PARKS (1912)
DICK CLARK (1929)
BEN STILLER (1965)

Andreas Feininger

Crowds gather to witness *The Hurricane*, one of many thrilling rides that could be enjoyed in Coney Island, 1949.

Die Menschenmenge starrt fasziniert auf den *Hurricane*, eines der vielen aufregenden Fahrgeschäfte in Coney Island, 1949.

La foule admire l'*Ouragan*, l'un des nombreux manèges sensationnels que l'on pouvait découvrir à Coney Island, 1949.

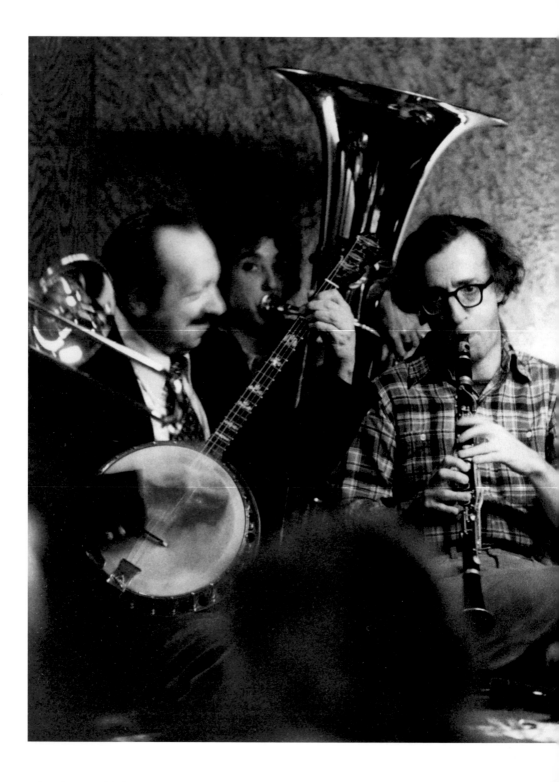

DECEMBER 1

WOODY ALLEN (1935)
BETTE MIDLER (1945)

Anonymous

Woody Allen playing his regular
weekly gig at Michael's Pub on the
East Side, 1978.

Woody Allen spielt im Michael's Pub
seinen wöchentlichen Gig auf der East
Side, 1978.

Woody Allen joue de la clarinette à son
concert hebdomadaire au Michael's Pub
dans l'East Side, 1978.

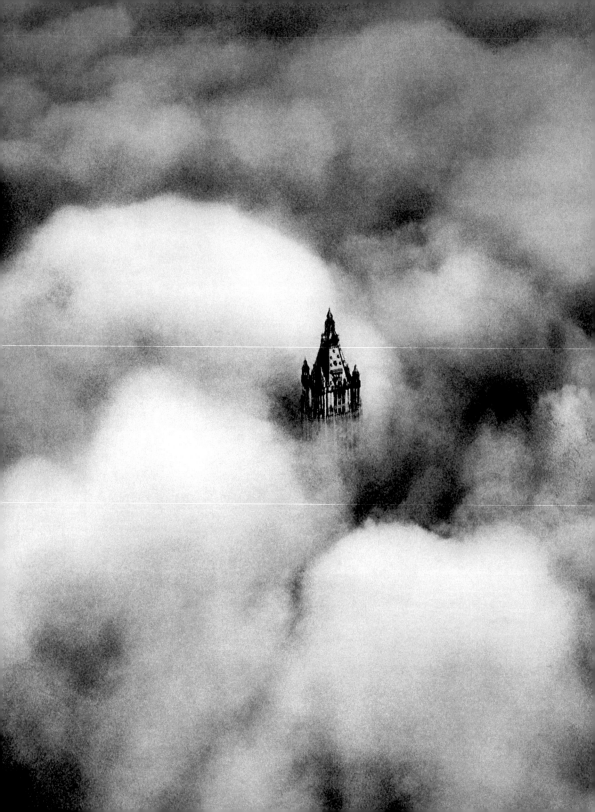

MARIA CALLAS (1923)

"Start spreading the news, I'm leaving today
I want to be a part of it—New York, New York…
These little-town blues, are melting away
I'll make a brand new start of it, in old New York
If I can make it there, I'll make it anywhere
It's up to you, New York, New York."

"NEW YORK, NEW YORK," FRANK SINATRA, 1977

Anonymous

The top of the Woolworth Building. The Gothic Revival skyscraper, designed by Cass Gilbert, was dubbed the "Cathedral of Commerce," c. 1930.

Die Spitze des Woolworth Building. Der von Cass Gilbert entworfene Wolkenkratzer im neogotischen Stil wurde die „Kathedrale des Kommerzes" genannt, um 1930.

Le sommet du Woolworth Building. Ce gratte-ciel néogothique de Cass Gilbert avait été surnommé la «Cathédrale du commerce», vers 1930.

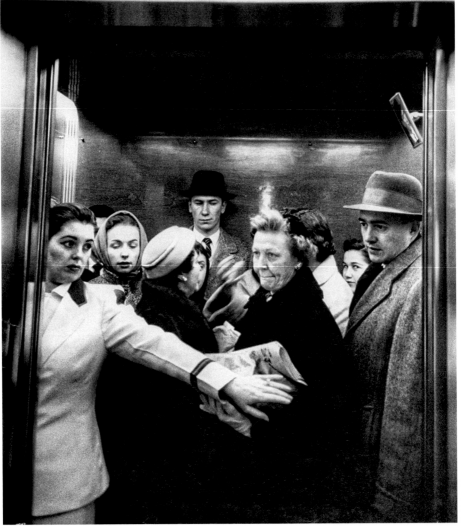

"Harold told about a drugstore he and Kay knew on West 59th Street, where you could get prescription whisky without a prescription."

THE GROUP, MARY MCCARTHY, 1963

Walter Sanders

An elevator somewhere on Madison Avenue crowded with people who seem to be preparing for a hard day at the office, 1957.

Ein Aufzug irgendwo in der Madison Avenue; die Menschen scheinen sich auf einen harten Tag im Büro einzustellen, 1957.

Un ascenseur bondé quelque part sur Madison Avenue dont les voyageurs, à regarder leurs expressions, se préparent à une dure journée de travail de bureau, 1957.

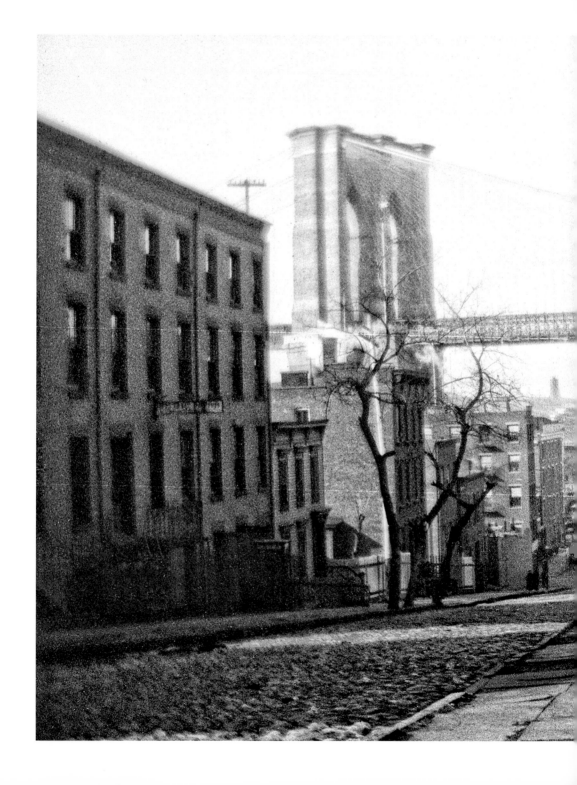

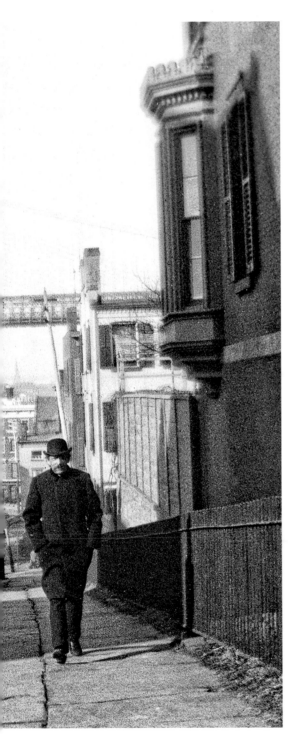

George Bradford Brainerd

Brooklyn Bridge. This is taken from the Brooklyn side, sometime in the 1870s, before the bridge opened. The shot is both an impressive portrait and a city view.

Brooklyn Bridge. Dieses Foto, sowohl beeindruckendes Porträt als auch Stadtansicht, entstand in den 1870er-Jahren auf der Seite von Brooklyn, bevor die Brücke eröffnet wurde.

Brooklyn Bridge. Vue prise de Brooklyn, vers les années 1870, avant son ouverture. C'est à la fois un portrait et un panorama impressionnant de la ville.

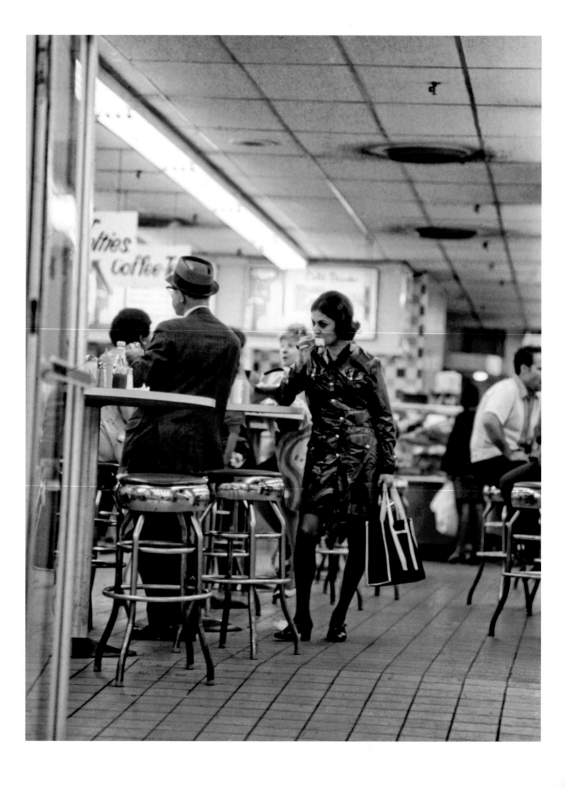

"It's a city of strangers,
Some come to work, some to play.
A city of strangers,
Some come to stare, some to stay."

"ANOTHER HUNDRED PEOPLE," *COMPANY,* 1970

Anonymous

New York coffee shop, 1970.

New Yorker Coffee Shop, 1970.

Coffee shop new-yorkais, 1970.

ALFRED EISENSTAEDT (1898)
ANDREW CUOMO (1957)

*"Harlem: Mecca of
the New Negro."*

SURVEY GRAPHIC MAGAZINE, 1925

Underwood & Underwood

A Harlem mother walking with her two
children, late 1920s.

Eine Mutter aus Harlem mit ihren
beiden Kindern, Ende der 1920er-Jahre.

Dans Harlem, une mère se promène avec
ses deux enfants, fin des années 1920.

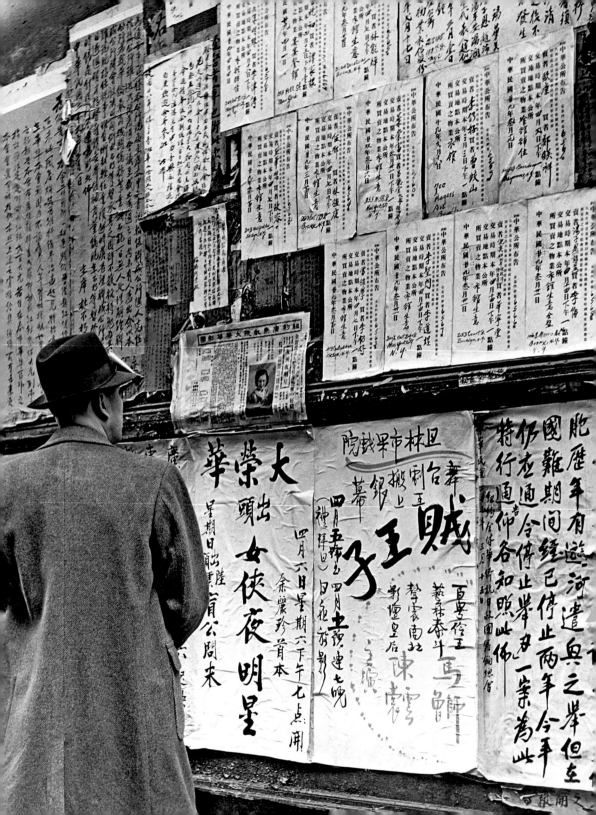

"For most visitors to Manhattan, both foreign and domestic, New York is the Shrine of the Good Time."

"THE TYPICAL NEW YORKER," ROBERT BENCHLEY, 1928

Andreas Feininger

Chinatown, 1940.

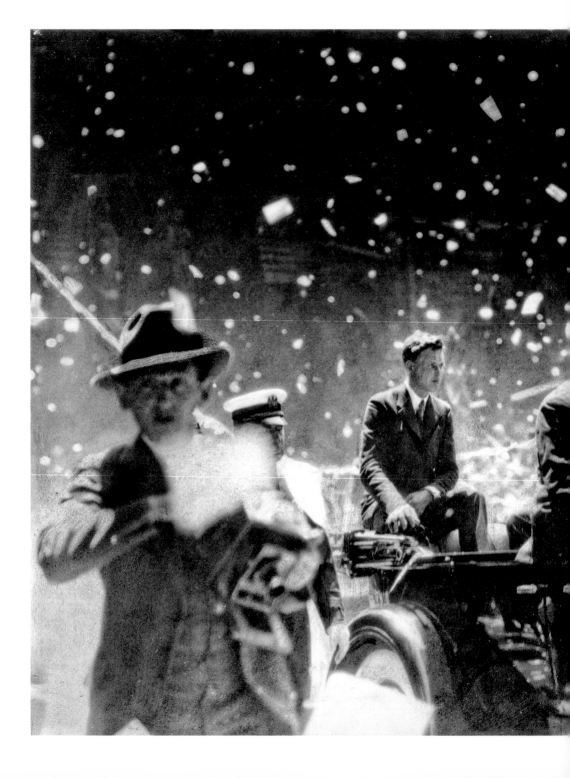

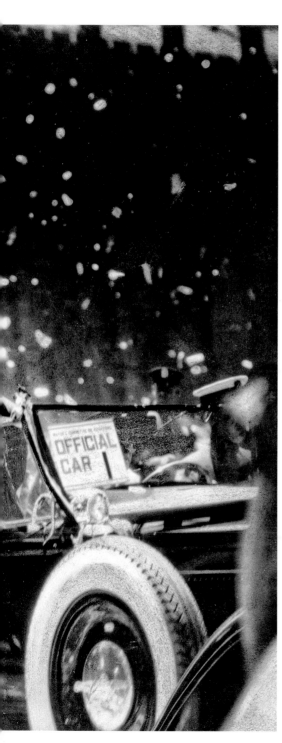

SAMMY DAVIS, JR. (1925)
NICKI MINAJ (1982)

Anonymous

A ticker-tape parade along Fifth Avenue for Charles A. Lindbergh, the aviator and national hero. Lindbergh was the first man to fly solo across the Atlantic Ocean in a single-seat and single-engine aircraft. He flew in his plane, the *Spirit of St. Louis*, from Long Island to Paris, 1927.

Eine Konfettiparade entlang der Fifth Avenue zu Ehren von Charles A. Lindbergh, dem Flieger und Nationalhelden. Lindbergh war der erste Mensch, der den Atlantischen Ozean im Alleinflug in einer einsitzigen, einmotorigen Maschine überquerte. Sein Flugzeug, die *Spirit of St. Louis*, flog 1927 von Long Island nach Paris, 1927.

Grande parade avec confettis sur la Cinquième Avenue pour Charles A. Lindbergh, aviateur et héros national. Lindbergh fut le premier homme à traverser l'Atlantique d'une traite dans un monoplace monomoteur, le *Spirit of St. Louis* entre Long Island et Paris, 1927.

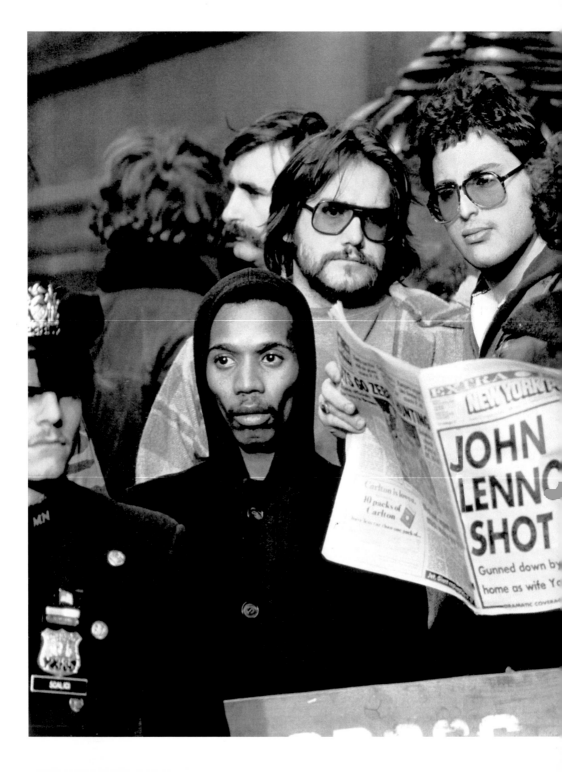

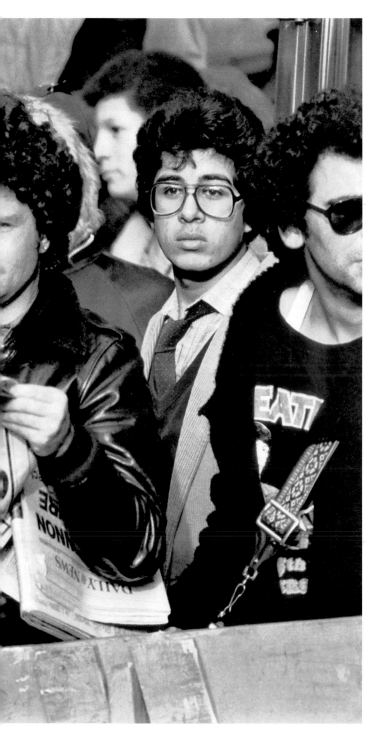

DOUGLAS FAIRBANKS, JR. (1909)
JOHN CASSAVETES (1929)

Frank Paulin

Mourning John Lennon. The former Beatle's violent death shocked even the most hardened New Yorker. Though he was something of a recluse, holed up in the super-swanky Dakota apartment building on 72ⁿᵈ Street, New Yorkers were flattered that the legend had embraced their city, 1980.

Trauer um John Lennon. Der gewaltsame Tod des ehemaligen Beatle entsetzte sogar die härtesten New Yorker. Obwohl er sehr zurückgezogen im luxuriösen Dakota Building in der 72nd Street lebte, fühlten sich die New Yorker geschmeichelt, weil er, der Legendäre, ihre Stadt zu seiner Heimat gemacht hatte, 1980.

John Lennon, le deuil. La mort violente de l'ancien Beatle choqua même les plus endurcis des New-Yorkais. Bien qu'il ait vécu en reclus dans les hauteurs du très chic Dakota Building sur la 72ᵉ Rue, la ville était flattée d'avoir été choisie par cette légende vivante, 1980.

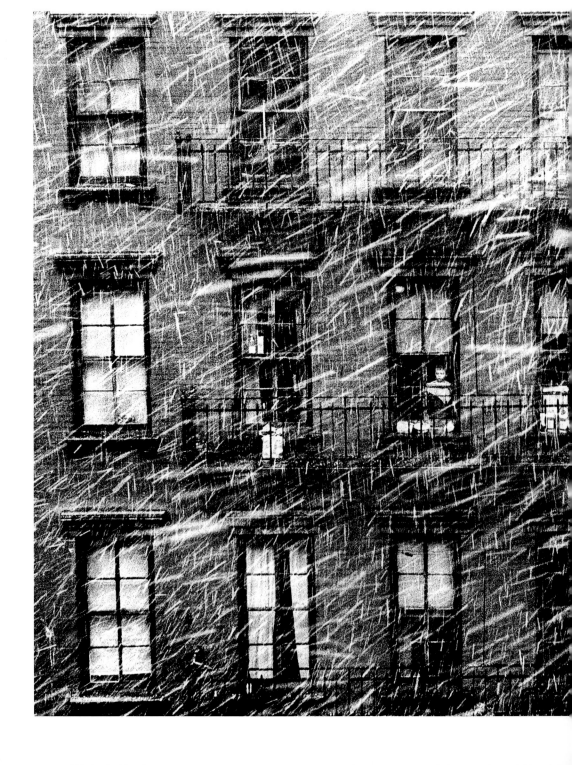

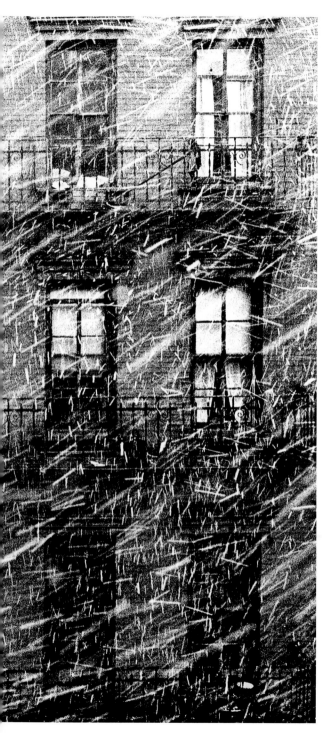

Paul Himmel

The little boy staring out the window can just about be seen amid the falling snow. This image was featured in the seminal 1955 photographic exhibition, *The Family of Man*, curated by Edward Steichen and held at the Museum of Modern Art in New York, 1950.

Der kleine Junge, der aus dem Fenster starrt, ist durch den Schnee hindurch gerade noch erkennbar. Dieses Bild wurde 1955 in der bahnbrechenden Ausstellung *The Family of Man* im Museum of Modern Art in New York gezeigt, deren Kurator Edward Steichen war, 1950.

On aperçoit à peine à travers la neige le petit garçon qui regarde par la fenêtre. Cette photo figurait dans l'exposition historique de photographies de 1955, *The Family of Man*, organisée par Edward Steichen au MoMA, Musée d'art moderne de New York, 1950.

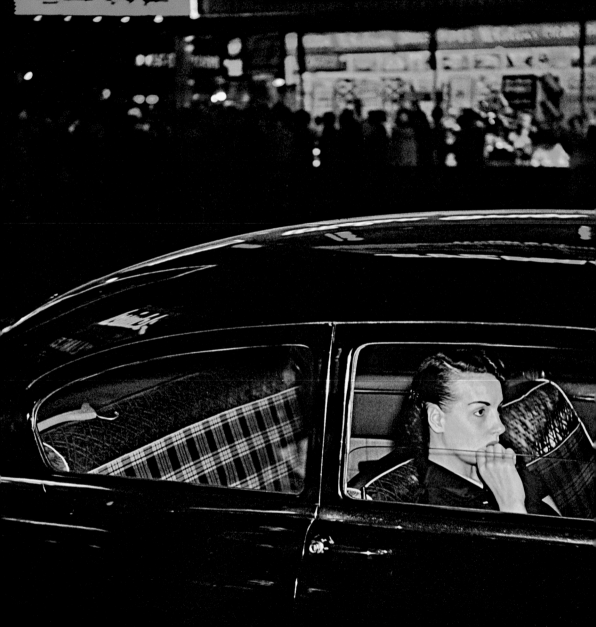

"The Great White Way"

HEADLINE DESCRIBING BROADWAY IN *THE NEW YORK EVENING TELEGRAM*, 1902

Marvin Newman

Lost in Thought on Broadway. The profile of the girl with her slick black hair mirrors that of the automobile, 1954.

Versonnen auf dem Broadway. Das Profil der jungen Frau mit ihrem zurückgesteckten schwarzen Haar passt perfekt zu den Konturen des Automobils, 1954.

Perdue dans ses pensées à Broadway. Le profil de cette jeune femme aux cheveux noirs tirés s'adapte stylistiquement aux formes de la voiture, 1954.

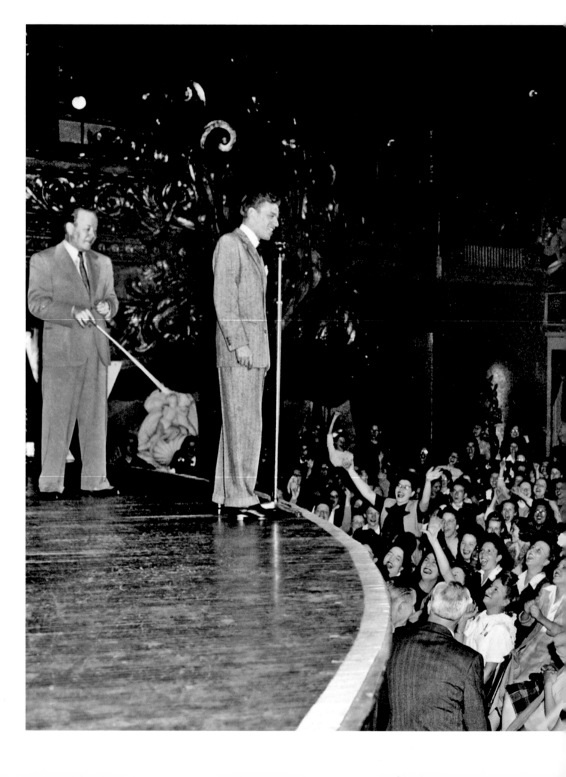

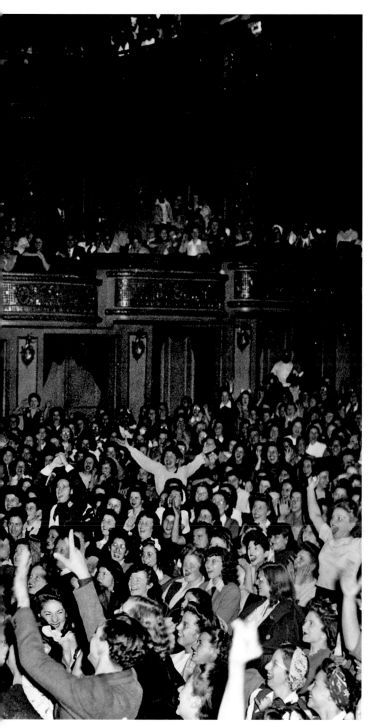

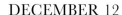

Anonymous

Frank Sinatra at the Paramount. This was a popular World War II spot and the young singer, "Frankie," as he was known to his adoring female fans, would sometimes perform there six or seven times a day. At first, he was just one act among many; within a few months, he was headlining at this Times Square theater, 1944.

Frank Sinatra im Paramount. In diesem während des Zweiten Weltkriegs beliebten Theater trat der junge Sänger „Frankie", wie er von seinen weiblichen Fans genannt wurde, manchmal sechs- oder siebenmal am Tag auf. Zunächst war er einer von vielen, aber innerhalb von wenigen Monaten wurde er der Star dieses Theaters am Times Square, 1944.

Frank Sinatra au Paramount. Ce théâtre était très populaire pendant la guerre et le jeune chanteur, «Frankie» pour les dames qui l'adoraient, y donnait son récital six ou sept fois par jour. Débutant parmi tant d'autres, il se fraya vite un chemin jusqu'à ce grand théâtre de Times Square, 1944.

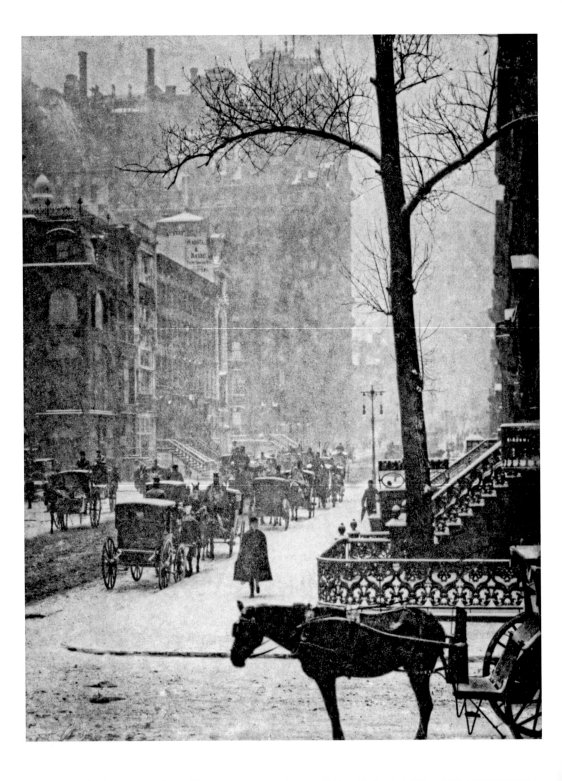

"The temperature began to fall, sleet and snow descended in succession and the wind became boisterous. Before daylight dawned yesterday a remarkable storm... was in full progress."

THE NEW YORK TIMES, 1888

Alfred Stieglitz

The Street—design for a poster. This melancholy take on New York's modernization is a photogravure that was printed in the photographer's highly influential quarterly photography magazine *Camera Work*. The snow intensifies the sense of isolation and foreboding, 1901.

Die Straße – Entwurf für ein Plakat. Diese melancholische Aufnahme von der Erneuerung New Yorks ist eine Fotogravüre, die in der einflussreichen vierteljährlichen Fotozeitschrift *Camera Work* veröffentlicht wurde. Der Schnee verstärkt den Eindruck von Isolation und bevorstehendem Unheil, 1901.

La rue, projet d'affiche. Cette vue mélancolique des travaux de modernisation de New York est une photogravure, parue dans l'influente revue trimestrielle *Camera Work*. La neige amplifie un sentiment de solitude et de mauvais présages, 1901.

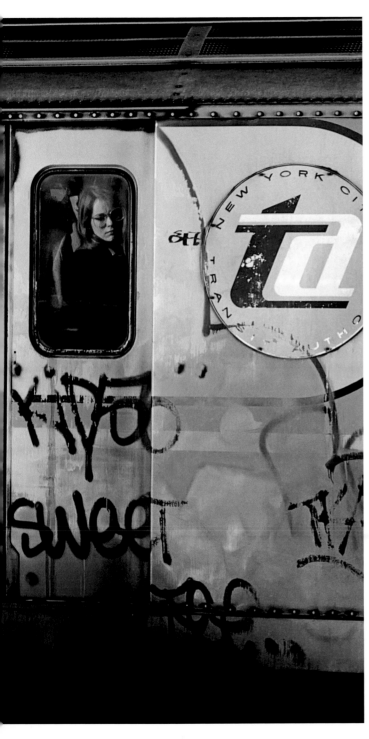

Gerd Racinan

In the 1980s, the New York landscape, and in particular its subway system, was dominated by graffiti. Yet, by the end of the decade, the authorities first tackled New York's social woes and crime epidemic by systematically cleaning up of the subway, train-by-train and car-by-car. It worked! 1981.

In den 1980er-Jahren gab es überall in New York Graffiti, vor allem in der U-Bahn. Bis zum Ende des Jahrzehnts gingen die New Yorker Behörden jedoch zunächst die sozialen Missstände und die Kriminalitätsrate an, indem sie systematisch jeden einzelnen Wagen und Zug der U-Bahn säuberten. Es funktionierte, 1981.

Dans les années 1980, le paysage urbain new-yorkais, et en particulier le métro, étaient envahis de graffiti. Et pourtant, vers la fin de la décennie, les autorités avaient réussi à donner le signal de la reprise en main de la déshérence sociale et de l'épidémie de crimes en nettoyant systématiquement le métro, rame par rame, voiture par voiture. Et ça a marché! 1981.

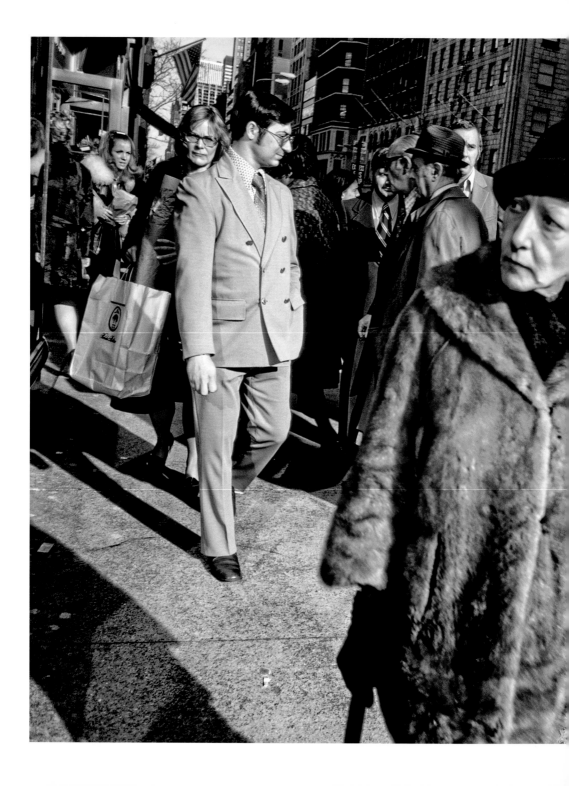

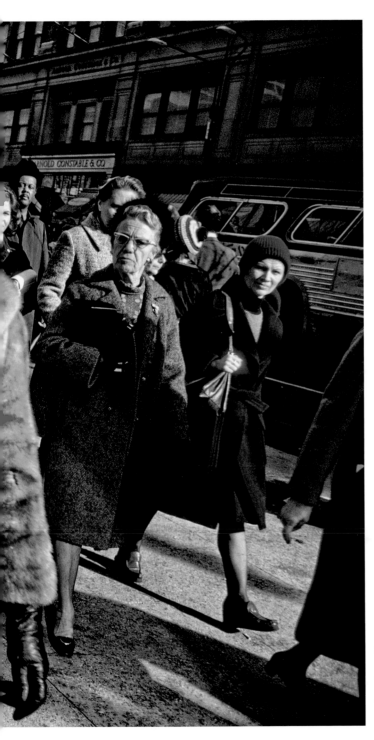

Mitch Epstein

Fifth Avenue, 1974.

Fifth Avenue, 1974.

Cinquième Avenue, 1974.

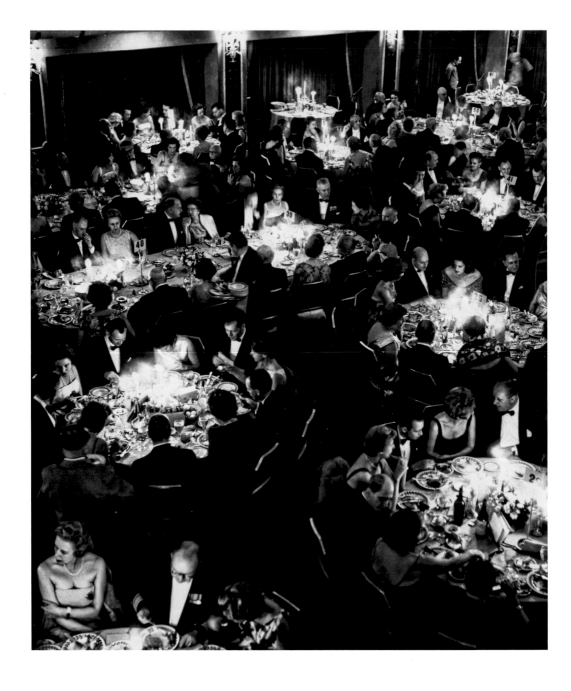

"Vulgar of manner, overfed,
Overdressed and underbred;
Heartless, Godless, hell's delight,
Rude by day and lewd by night…
Crazed with avarice, lust and rum,
New York, thy name's delirium."

BRYON RUFUS NEWTON, 1906

Andreas Feininger

People around tables at a banquet. The unfolding drama of this somewhat stiff evening is riveting, 1962.

Gäste eines Banketts sitzen an ihren Tischen. Die sich entwickelnde Dramatik dieser etwas steifen Veranstaltung fesselt den Blick, 1962.

Personnes autour des tables à l'occasion d'un banquet. Fascinante atmosphère de soirée assez guindée, 1962.

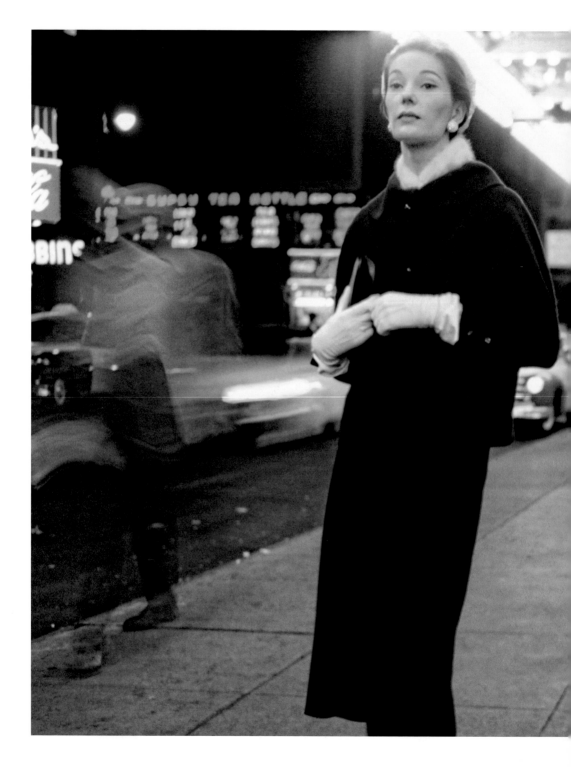

Anonymous

Outside a theater, models displaying the latest winter fashions for *Vogue* magazine, 1954.

Models führen vor einem Theater die neueste Wintermode für die Zeitschrift *Vogue* vor, 1954.

Devant un théâtre, des mannequins présentent la dernière mode de l'hiver pour le magazine *Vogue*, 1954.

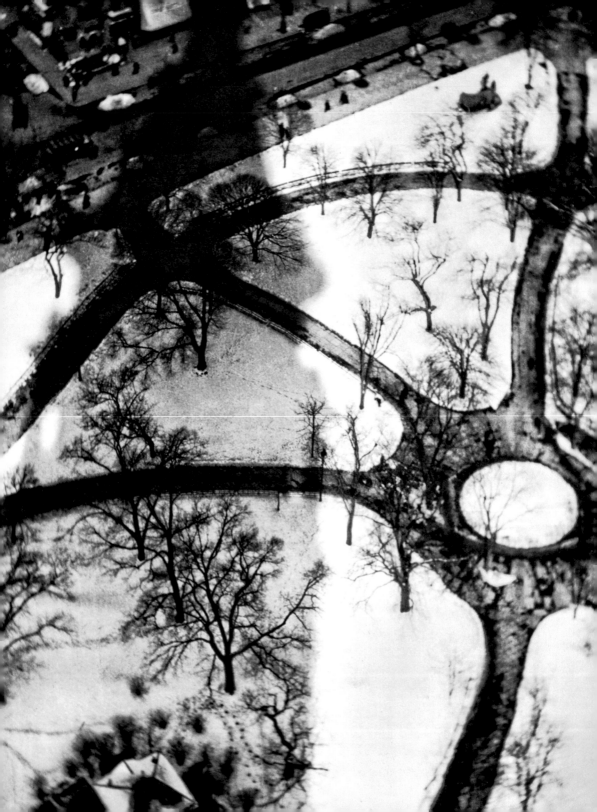

"Give my regards to Broadway,
Remember me to Herald Square,
Tell all the gang at 42nd Street,
That I will soon be there;

Whisper of how I'm yearning
To mingle with the old time throng,
Give my regards to old Broadway,
And say that I'll be there e'er long."

"GIVE MY REGARDS TO BROADWAY," 1904

Alvin Langdon Coburn

The Octopus. Madison Square shot
from the observation tower of the
Metropolitan Life Tower. One of the
first photographs to abstract the city
from above, it presents a detached and
atypically serene view of a noisy and
crowded metropolis, 1912.

The Octopus. Madison Square, foto-
grafiert vom Beobachtungsturm des
Metropolitan Life Tower. Als eines der
ersten abstrakten Fotos der Stadt aus der
Vogelperspektive zeigt es die laute, voll-
gestopfte Metropole aus distanzierter,
ungewöhnlich beschaulicher Sicht, 1912.

The Octopus. Madison Square pris de la
tour d'observation de la Metropolitan Life
Tower. L'une des premières photographies
à donner une image stylisée de la ville vue
d'en haut, elle traduit une vision détachée
et curieusement sereine d'une métropole
bruyante et animée, 1912.

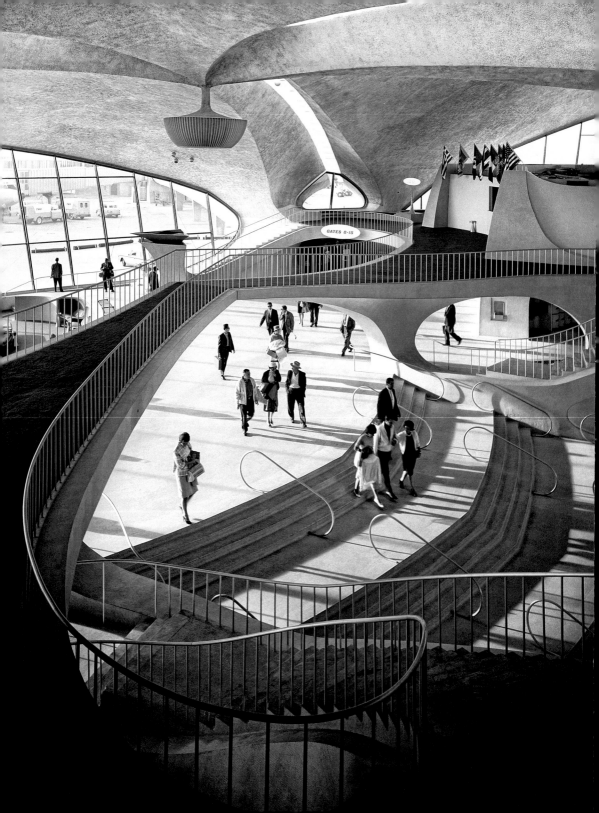

"A place of movement and transition."

EERO SAARINEN

Ezra Stoller

The interior of the TWA Building at Idlewild, now John F. Kennedy Airport, designed by Eero Saarinen. It opened in 1962, and ushered in the age of mass international travel. Its free-flowing curves suggest flight, early 1960s.

Die Halle des von Eero Saarinen entworfenen TWA-Gebäudes am Flughafen Idlewild, heute John F. Kennedy Airport, das 1962 eröffnet wurde und die Ära des Massenflugverkehrs einläutete. Seine dynamische, geschwungene Form symbolisiert das Fliegen, Anfang der 1960er-Jahre.

L'intérieur du terminal de la TWA à l'aéroport John F. Kennedy, conçu par Eero Saarinen et inauguré en 1962, à l'aube de l'âge des voyages internationaux de masse. Ses lignes fluides suggèrent l'envol, début des années 1960.

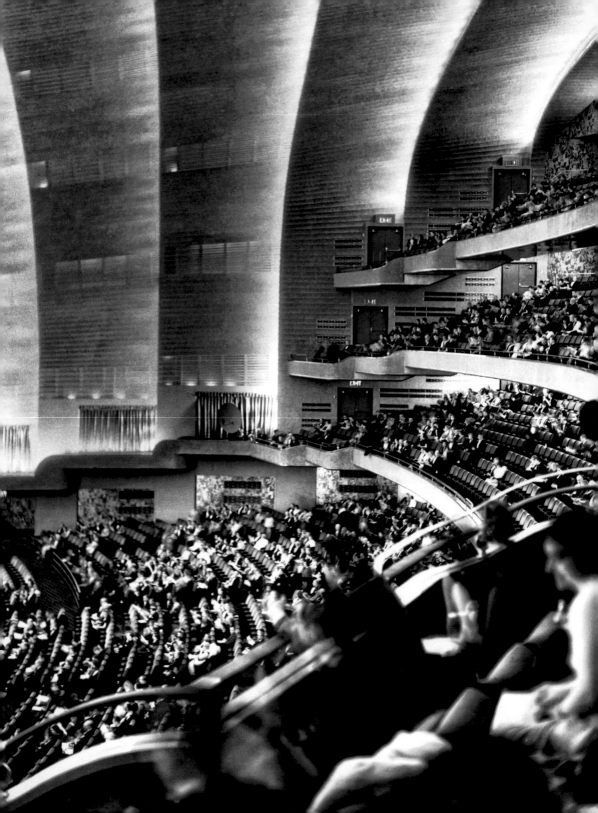

"The enthusiastic reception was far greater than anything I have met with, even in Russia. I was recalled over and over again; handkerchiefs were waved, cheers resounded..."

PETER ILICH TCHAIKOVSKY, 1891

Anonymous

Radio City Music Hall. The famous auditorium is part of the Rockefeller Center complex. It opened in 1932, and combined popular movies with spectacular floor shows. It is also the home of the famous chorus line, the Rockettes, early 1930s.

Radio City Music Hall. Das berühmte, 1932 eröffnete Theater gehört zum Rockefeller Center; dort wurden beliebte Kinofilme und Kabarettshows gezeigt. Auch die berühmten Rockettes sind hier zu Hause, Anfang der 1930er-Jahre.

Radio City Music Hall. Cette fameuse salle de concerts fait partie du complexe du Rockefeller Center. Ouverte en 1932, elle donnait des films populaires et de grands spectacles de music-hall. Elle est aussi le foyer du fameux ballet, les Rockettes, début des années 1930.

"A place of movement and transition."

EERO SAARINEN

Ezra Stoller

The interior of the TWA Building at Idlewild, now John F. Kennedy Airport, designed by Eero Saarinen. It opened in 1962, and ushered in the age of mass international travel. Its free-flowing curves suggest flight, early 1960s.

Die Halle des von Eero Saarinen entworfenen TWA-Gebäudes am Flughafen Idlewild, heute John F. Kennedy Airport, das 1962 eröffnet wurde und die Ära des Massenflugverkehrs einläutete. Seine dynamische, geschwungene Form symbolisiert das Fliegen, Anfang der 1960er-Jahre.

L'intérieur du terminal de la TWA à l'aéroport John F. Kennedy, conçu par Eero Saarinen et inauguré en 1962, à l'aube de l'âge des voyages internationaux de masse. Ses lignes fluides suggèrent l'envol, début des années 1960.

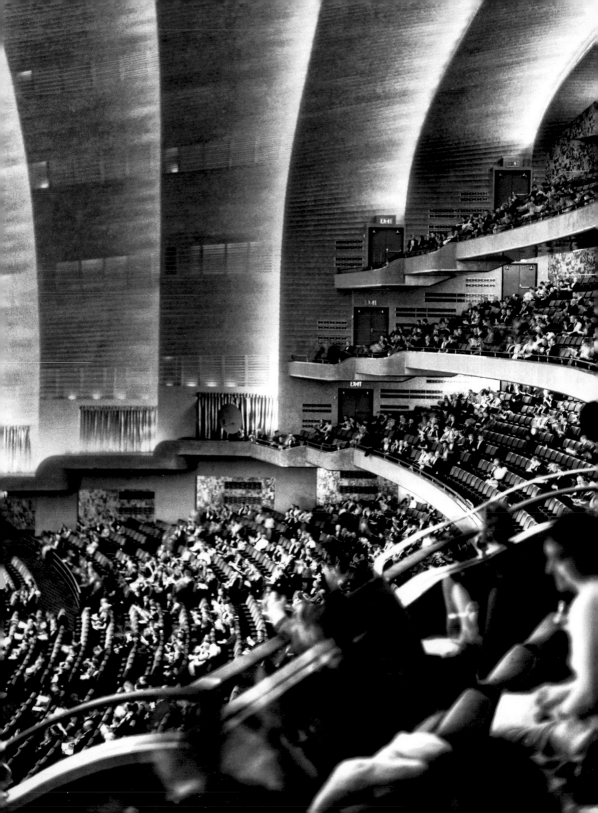

"The enthusiastic reception was far greater than anything I have met with, even in Russia. I was recalled over and over again; handkerchiefs were waved, cheers resounded..."

PETER ILICH TCHAIKOVSKY, 1891

Anonymous

Radio City Music Hall. The famous auditorium is part of the Rockefeller Center complex. It opened in 1932, and combined popular movies with spectacular floor shows. It is also the home of the famous chorus line, the Rockettes, early 1930s.

Radio City Music Hall. Das berühmte, 1932 eröffnete Theater gehört zum Rockefeller Center; dort wurden beliebte Kinofilme und Kabarettshows gezeigt. Auch die berühmten Rockettes sind hier zu Hause, Anfang der 1930er-Jahre.

Radio City Music Hall. Cette fameuse salle de concerts fait partie du complexe du Rockefeller Center. Ouverte en 1932, elle donnait des films populaires et de grands spectacles de music-hall. Elle est aussi le foyer du fameux ballet, les Rockettes, début des années 1930.

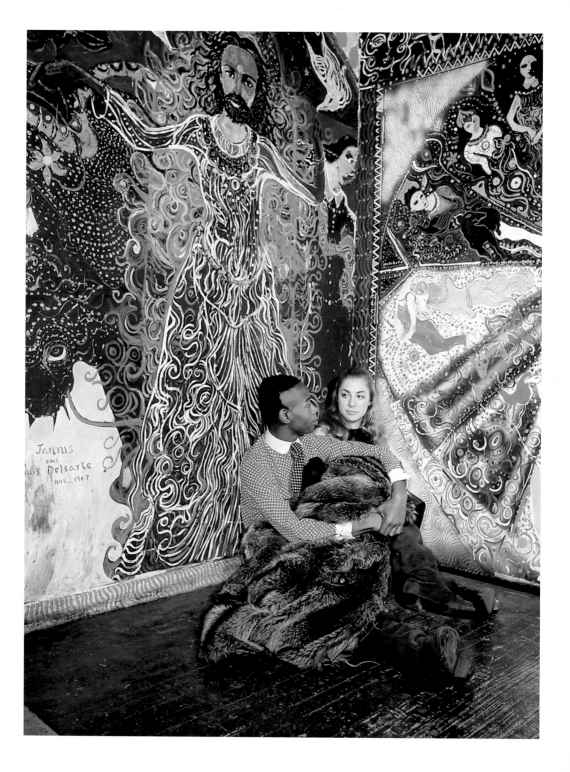

"New York... is a city of geometric heights, a petrified desert of grids and lattices, an inferno of greenish abstraction under a flat sky..."

ROLAND BARTHES, 1959

Anonymous

Hanging out in front of the Electric Circus. The club, opened in 1967 on St. Marks Place in the heart of the East Village, hosted bands such as the Doors, Grateful Dead, and the Velvet Underground, 1968.

Vor dem Electric Circus. Der Club wurde 1967 am St. Marks Place im Herzen des East Village eröffnet; dort traten Bands wie The Doors, Grateful Dead und The Velvet Underground auf, 1968.

On traîne devant l'Electric Circus. Ce club qui avait ouvert en 1967 sur St. Marks Place au cœur de l'East Village, accueillait des groupes comme The Doors, Grateful Dead ou le Velvet Underground, 1968.

Reinhart Wolf

The Twin Towers, 1979.

Die Zwillingstürme, 1979.

Les Twin Towers, 1979.

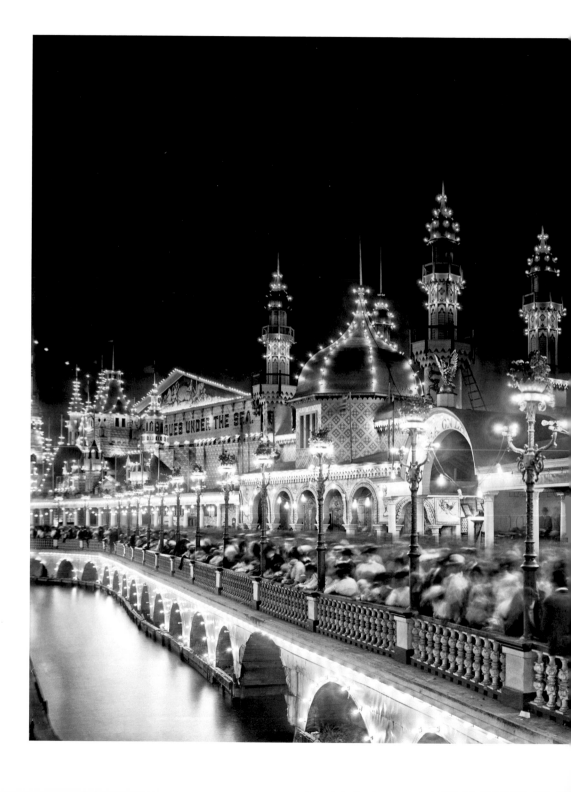

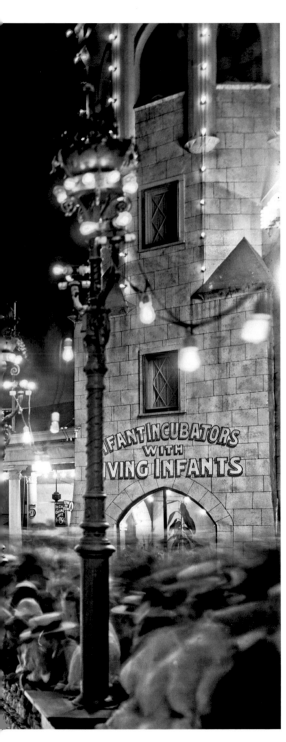

Anonymous

Luna Park at night, lit by more than
1.3 million electric lights at Coney Island.
One attraction being offered here is
"Infant Incubators with Living Infants,"
but the most popular rides were "War of
the Worlds" and "A Trip to the Moon."
Luna Park opened in 1903, and was
demolished in 1945, c. 1905.

Luna Park bei Nacht im Licht von über
1,3 Millionen Glühbirnen, Coney Island.
Zu den Attraktionen gehörte zum
Beispiel der „Säuglingsinkubator mit
lebenden Kindern", aber am beliebtesten
waren Fahrgeschäfte wie „Krieg der
Welten" und „Reise zum Mond". Luna
Park öffnete 1903 seine Tore und wurde
1945 abgerissen, um 1905.

Luna Park la nuit, éclairé par plus de
1 300 000 ampoules électriques. Une
des attractions disponibles proposait des
« incubateurs d'enfants vivants », mais les
manèges les plus populaires étaient ceux
de la Guerre des mondes et du Voyage
sur la lune. Luna Park, ouvert en 1903,
fut démoli en 1945, vers 1905.

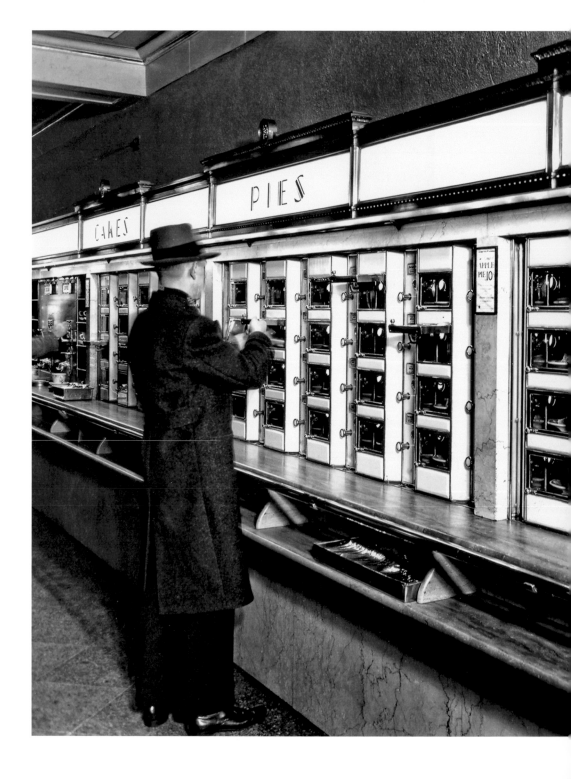

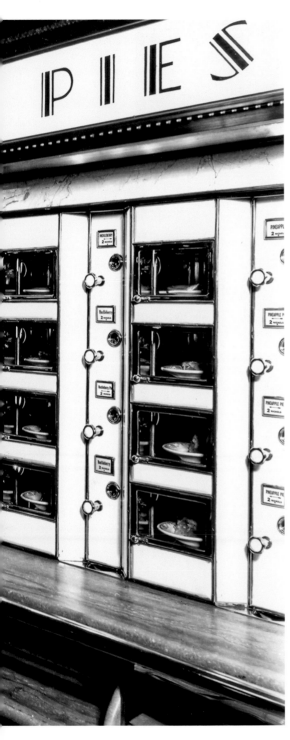

Berenice Abbott

Automat. During the Great Depression in particular, these "waiterless restaurants" provided New Yorkers with cheap food and the allure of something different. This cafeteria was on Eighth Avenue next to Columbus Circle, 1936.

Automat. Besonders während der Weltwirtschaftskrise konnten die New Yorker in diesen Selbstbedienungsrestaurants, die etwas ganz Neues waren, billig essen. Diese Cafeteria befand sich auf der Eighth Avenue gleich neben dem Columbus Circle, 1936.

Distributeurs automatiques. Pendant la Grande Dépression en particulier, ces « restaurants sans serveurs » proposaient aux New-Yorkais de la nourriture bon marché dans un style différent. Cette cafétéria se trouvait Huitième Avenue, près de Columbus Circle, 1936.

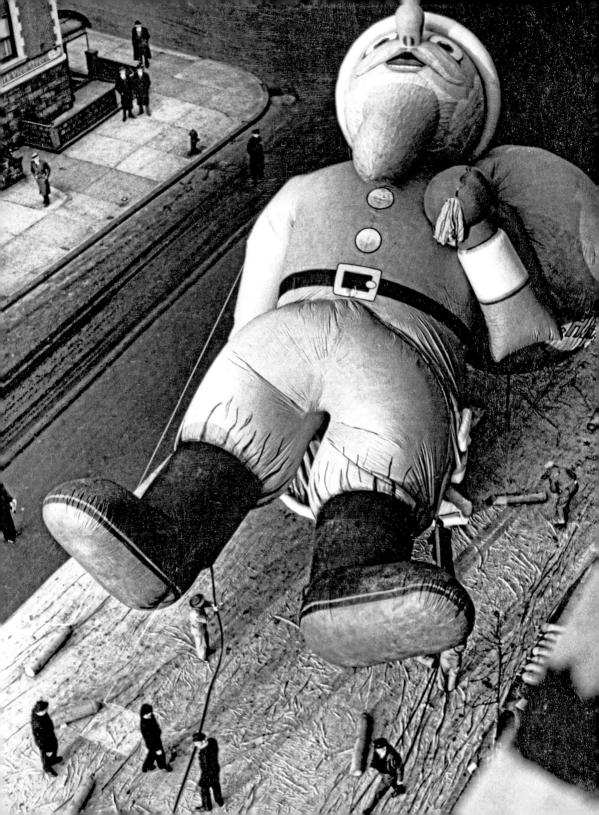

"You better watch out!
You better not cry
Better not pout
I'm telling you why
Santa Claus is coming to town
Santa Claus is coming to town"

"SANTA CLAUS IS COMING TO TOWN," 1934

Weegee

Macy's Santa Claus Comes to Life,
106th Street. The Thanksgiving Macy's
Day Parade is one of New York's grand
traditions, which started in 1925. By
the 1930s, a million people were lining
its route, 1940.

*Macy's Weihnachtsmann erwacht zum
Leben,* 106th Street. Die Thanksgiving
Macy's Day Parade ist eine der großen
Traditionen von New York und fand
1925 erstmalig statt. Bereits in den
1930er-Jahren säumte eine Million
Menschen ihren Weg, 1940.

Naissance du Père Noël de Macy's, 106e
Rue. La parade de Thanksgiving en
novembre, l'une des plus importantes
traditions new-yorkaises, se déroula
pour la première fois en 1925. Dans les
années 1930, elle attirait un million de
personnes sur son parcours, 1940.

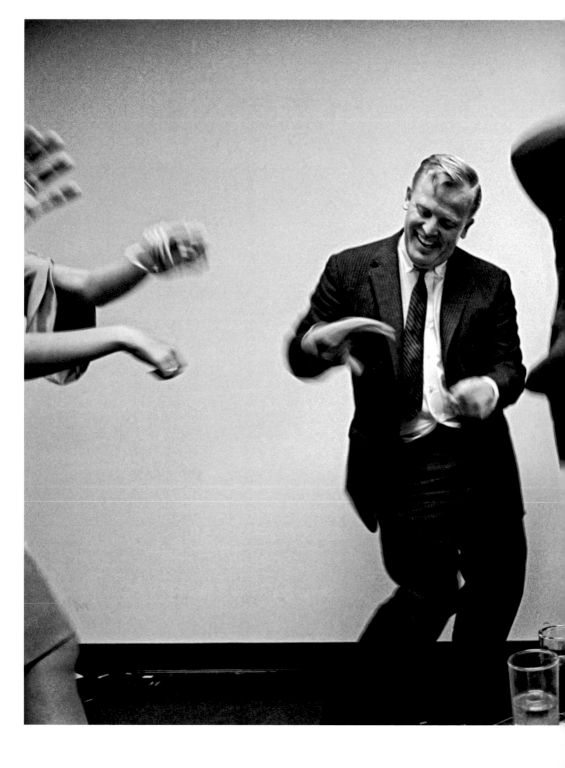

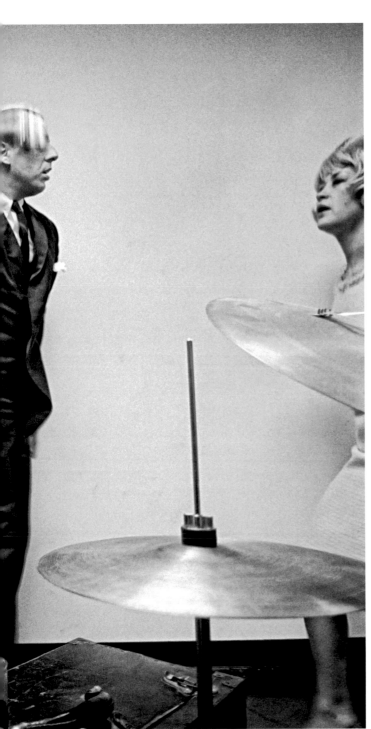

Leonard Freed

An office party, 1966.

Eine Betriebsfeier, 1966.

Une fête de bureau, 1966.

1923

Marvin Newman

Off-season Coney Island: Locals are trying to catch some much needed rays of sunshine, 1953.

Coney Island in der Nebensaison: Einheimische versuchen, noch ein paar Sonnenstrahlen abzubekommen, 1953.

Coney Island hors saison : les passants tentent de profiter de quelques rayons de soleil tant désirés, 1953.

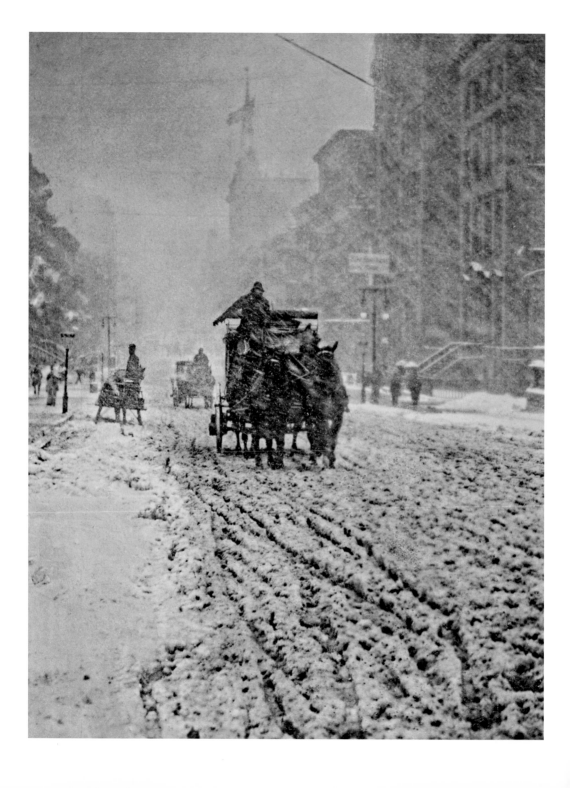

"You folks around the country probably know this, but here in New York City it's freezing cold. It's so cold today that that Bernie Madoff is actually looking forward to burning in hell."

DAVID LETTERMAN, 2008

Alfred Stieglitz

Winter, Fifth Avenue. A technically remarkable photograph, taken with an early handheld camera, which conveys something of the hardships of living in the city, 1893.

Winter, Fifth Avenue. Ein technisch bemerkenswertes Foto, aufgenommen mit einer frühen Handkamera. Es vermittelt einen Eindruck von der Härte des Lebens in der Großstadt, 1893.

Hiver, Cinquième Avenue. Une image techniquement remarquable prise avec l'un des premiers appareils photo réellement portatifs, qui traduit un peu des difficultés de la vie dans la grande ville, 1893.

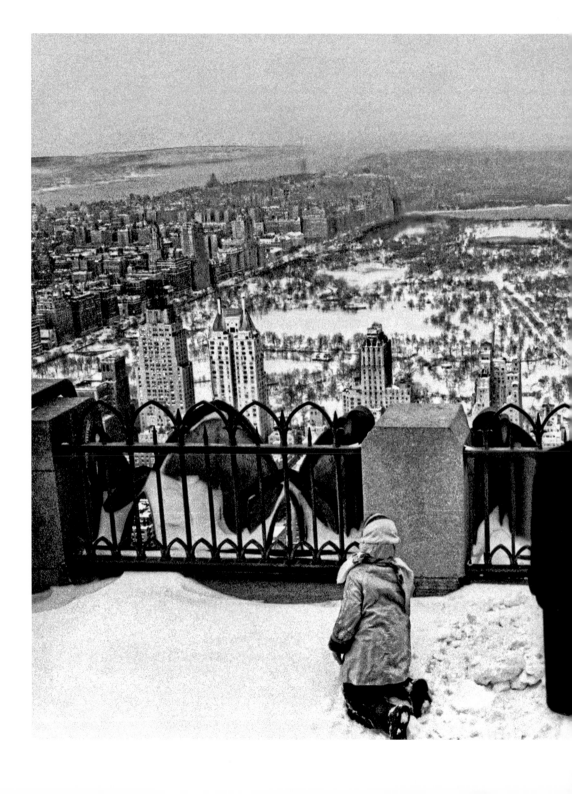

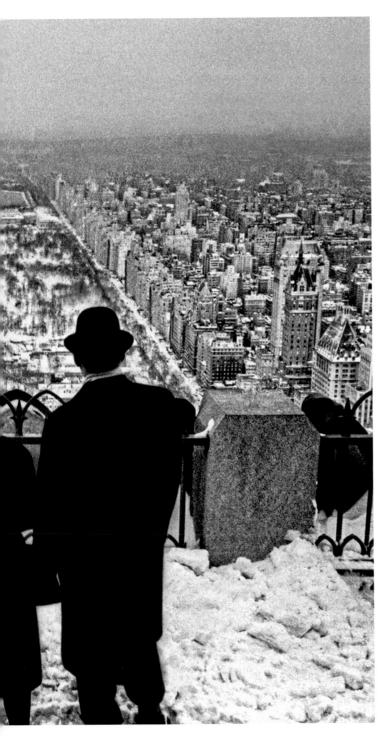

JON VOIGHT (1938)

William C. Eckenberg

A family looks over Central Park,
all covered in white, from the top
of the RCA Building at the
Rockefeller Center, 1960.

Eine Familie schaut vom Dach des RCA
Building im Rockefeller Center auf den
schneebedeckten Central Park, 1960.

Une famille regarde Central Park
entièrement recouvert d'un manteau
blanc, du sommet du RCA Building
au Rockefeller Center, 1960.

"In New York,
Concrete jungle where dreams are made of,
There's nothing you can't do,
Now you're in New York,
These streets will make you feel brand new,
The lights will inspire you,
Let's hear it for New York, New York, New York."

"EMPIRE STATE OF MIND," JAY-Z, 2009

Renato D'Agostin

The classic movie *On the Town* is given
a 21st-century twist, 2006.

Der Filmklassiker *Heut' gehn wir bummeln*
im Gewand des 21. Jahrhunderts, 2006.

Le classique du cinéma, *Un jour à New
York*, version XXIe siècle, 2006.

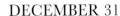

Anonymous

An illumination at City Hall in
Downtown Manhattan welcoming
in the 20th century, c. 1901.

Illumination am Rathaus in Downtown
Manhattan zur Begrüßung des 20. Jahr-
hunderts, um 1901.

Illumination autour de l'hôtel de ville
dans le Downtown Manhattan pour
saluer le XXᵉ siècle, vers 1901.

CREDITS

©Berenice Abbott/George Eastman House September 16

©Eddie Adams – AP/Wide World Photos April 19

RKO/Album/AKG March 07

20th CENTURY FOX/Album/AKG April 08

©John Albok, Courtesy of Daniel Wolf, Inc., New York August 20

©Janette Beckman January 02

©Jean Louis Blondeau/Polaris August 07

©Andrew Bordwin January 31

©Margaret Bourke White/Time & Life Pictures/Getty Images January 24, April 16/20, May 26, August 12, September 04

Brooklyn Public Library/Brooklyn Collection January 25, March 18

Brooklyn MuseUm/Brooklyn Public Library/Brooklyn Collection July 23, December 04

©Esther Bubley, Courtesy of Esther Bubley Archive February 17, March 11/12, October 18, November 01

©Estate of Cornell Capa/International Center of Photography/Magnum Photos February 05

Christopher Cardozo Fine Art February 11, March 20, April 02, May 02, July 02

©Larry Clark, Courtesy of The Artist and Luhring Augustine, New York October 31

©Estate Of William Claxton January 27, April 23, June 04, July 01, October 21

Collection of The New-York Historical Society January 03 (65202), January 04 (31047)/15 (31703), February 19 (66901), March 02 (82891d), April 14 (74021), July 24 (71134)/25 (82888d), September 17 (82889d)/23 (82890d), November 13 (69562)

©Aladdin Color/CORBIS July 18

Condé Nast Archive/CORBIS January 13

©Jerry Cooke/CORBIS February 20

©Estate of Harold Corsini/George Eastman House May 14, November 02

CORBIS March 01, April 21/28, May 13, August 11, November 06, December 06, December 12

Bettmann/CORBIS March 28, May 19, July 13, August 18, September 25, October 28, November 04, December 20

Hulton-Deutsch Collection/CORBIS July 04

©Renato D'agostin December 30

©Bruce Davidson/Magnum Photos June 19, August 14/25

©Arnold Eagle, Courtesy of International Center of Photography, Gift of Arnold Eagle (1987) February 28, March 29, August 28

©William C. Eckenberg – The New York Times/Redux December 29

©Alfred Eisenstaedt/Time & Life Pictures/Getty Images January 12

©Alfred Eisenstaedt/Time-Life Syndication November 10

©Rick Elkins November 29

Morris Engel July 19/22

©William England/George Eastman House March 08

©Mitch Epstein, Courtesy of Sikkema Jenkins & Co., New York August 15, June 18, December 15

©Elliott Erwitt/Magnum Photos October 01, November 26

bpk/New York, The Metropolitan Museum of Art/Walker Evans January 26

Everett Collection

©Estate of Nat Fein January 28

©Estate of Andreas Feininger/Courtesy of Bonni Benrubi Gallery, New York City March 19, April 24, June 25, December 07/16

©Andreas Feininger/Time & Life Pictures/Getty Images February 15, May 11, August 05, November 30

©David Fenton/Getty Images November 05

©Larry Fink, Courtesy of Larry Fink and Katrina Doerner Photographs, Brooklyn, New York June 16, August 16/29, September 20

©floto+warner March 03

©Leonard Freed/Magnum Photos December 26

©Lee Friedlander, Courtesy of The Fraenkel Gallery, San Francisco March 23, August 10, October 09

Courtesy of The Friends of Alice Austen House, Inc. January 17

George Eastman House January 20/22, March 19/21, April 24, June 10/25, July 03/05/31, August 22/31, October 11, December 07/13/16/18/28

©Ralph Gibson May 27, July 14, September 28

©Estate Of Allen Ginsberg October 13

©Burt Glinn/Magnum Photos January 23

©Nan Goldin, Courtesy of Matthews Marks Gallery, New York August 26

©Arlene Gottfried July 11, August 30

Samuel H. Gottscho, Courtesy Daniel Wolf, Inc., New York June 09

Museum of the City of New York, The Gottscho-Scheisner Collection February 13, March 22

©Ernst Haas/Getty Images January 18, November 21, November 22

©Ernst Haas – International Center of Photography, Purchase with funds from an Anonymous Donor, 1992 August 19

©Ernst Haas – International Center of Photography, Purchased with the aid of funds from the National Endowment for the Arts, Washington, D.C., A Federal Agency July 29

©Gail Albert Halaban, Courtesy of Robert Mann Gallery, New York May 22

©Ron Haviv – VII September 12

©Paul Himmel, Courtesy of Keith De Lellis Gallery, New York March 05, December 10

©Lewis Hine/George Eastman House April 01

©Estate of Evelyn Hofer April 05, May 28

©Bernard Hoffman – Time & Life Pictures/Getty Images April 13

bpk/Hanns Hubmann March 15, July 12

Indiana University Archives June 06 (P2703), September 05 (P2303)/18 (P2676)

©Jeff Jacobson/Redux September 27

©James Jowers/George Eastman House March 30, June 14, August 27, September 10

©George Karger/Time & Life Pictures/Getty Images February 14

Courtesy of Steven Kasher Gallery, New York November 24

©Dmitri Kessel/Time & Life Pictures/Getty Images May 23

©Keizo Kitajima, Courtesy of Amador Gallery, New York April 18

©Estate of André Kertész – Higher Pictures April 22, June 24

©Ferit Kuyas October 04

©Elliott Landy/Magnum Photos September 24

Library of Congress, Prints And Photographs Division January 06/11, February 18, October 06

Library of Congress, Prints & Photographs Division, Detroit Publishing Company Collection October 30

Library of Congress, Prints And Photographs Division, Carol M. Highsmith Archive February 07, July 30

Library of Congress, Prints And Photographs Division, Marjory Collins April 03

Library of Congress, Prints and Photographs Division, H.N. Tiemann, New York December 31

Library of Congress, Prints and Photograph Division, NY WT & S Collection February 03

©by the Estate of Wendell Macrae. Reprinted by permission of the Estate and the Witkin Gallery, Inc. June 01/07, November 23

Mary Evans Picture Library December 05

Mary Evans Picture Library/Everett Collection May 12

©Fred Mcdarrah/Getty Images April 12

©Ryan Mcginley February 25

©Patrick Mcmullan October 10

©Brian Merlis – Brooklynpix.com September 01

To stay informed about upcoming TASCHEN titles, please request our magazine at www.taschen.com/magazine or write to TASCHEN, Hohenzollernring 53, D-50672 Cologne, Germany; contact@taschen.com. We will be happy to send you a free copy of our magazine, which is filled with information about all of our books.

EDITORIAL COORDINATION Kathrin Murr, Cologne
ART DIRECTION Josh Baker, Los Angeles
DESIGN Jessica Sappenfield, Los Angeles
LAYOUT ASSISTANCE Janet Kim, Los Angeles
PRODUCTION Jennifer Patrick, Los Angeles
GERMAN TRANSLATION Susanne Ochs, Heidelberg
FRENCH TRANSLATION Jacques Bosser, Paris

FRONT COVER William Claxton, *Big and Little Apples*, 1960

BACK COVER Esther Bubley, *Third Avenue on a Rainy Day*, 1951

FRONTISPIECE Reinhart Wolf, *The Top of the Waldorf-Astoria Hotel at 301 Park Avenue*, 1979

© 2012 TASCHEN GmbH
Hohenzollernring 53, D–50672 Köln
www.taschen.com

Printed in China
ISBN 978-3-8365-3772-8

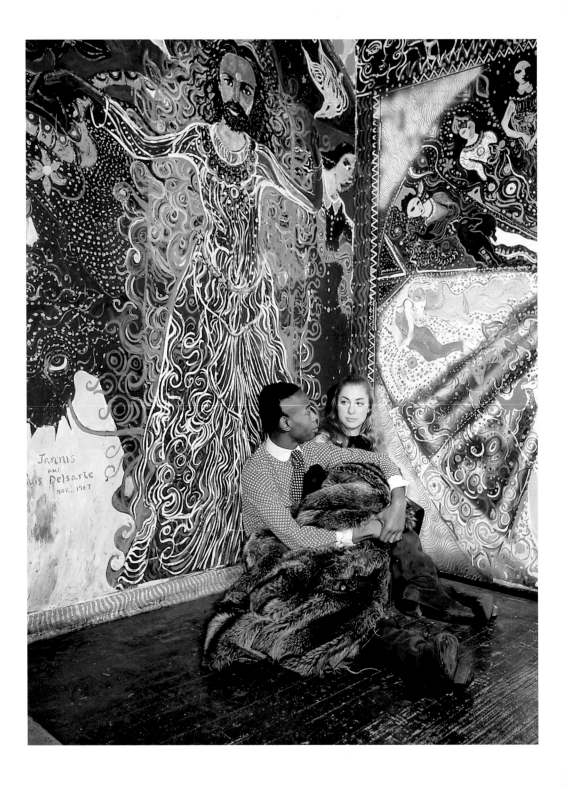